7 DAYS

SEASONS GREETINGS

1989

MANHATTAN

AN ISLAND IN FOCUS

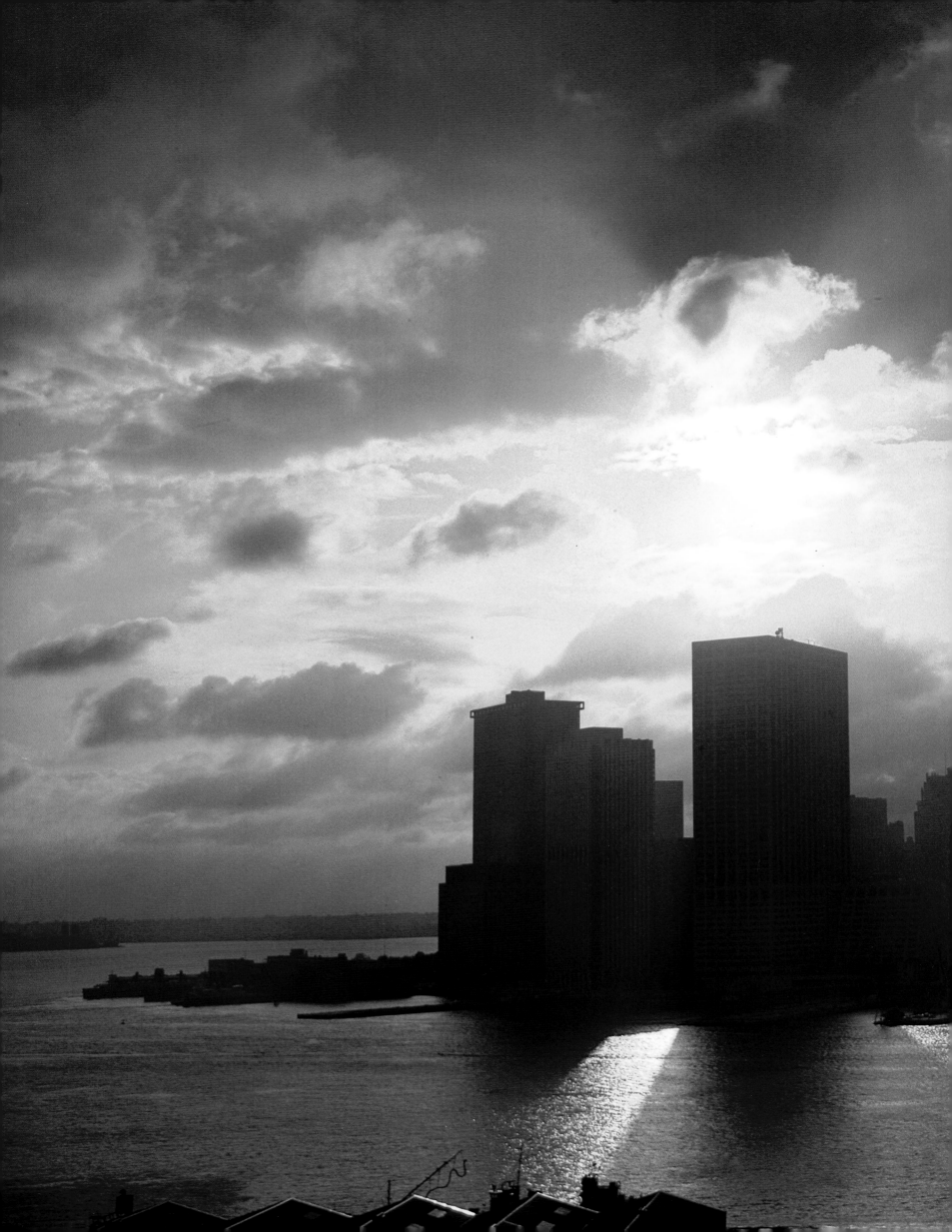

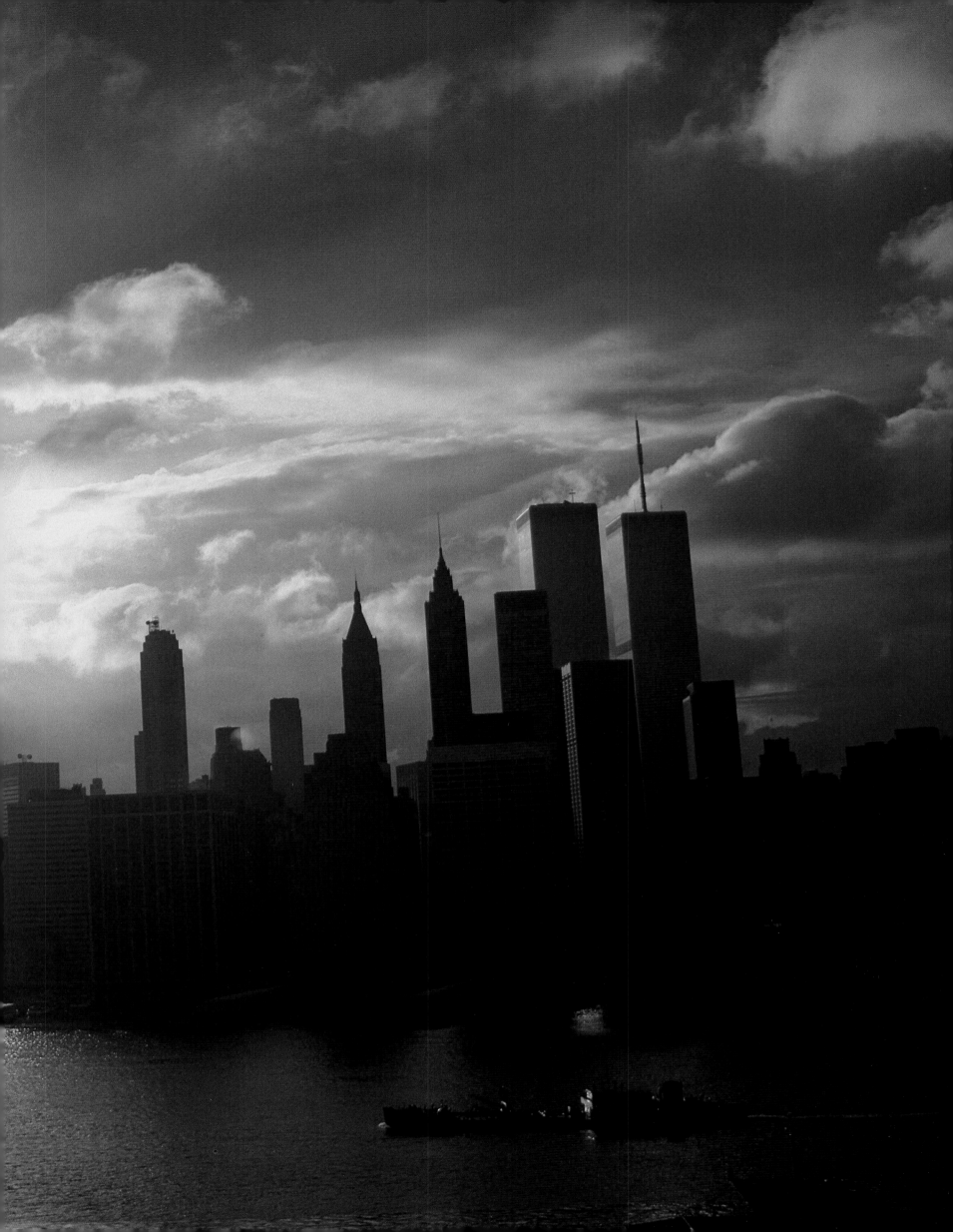

MANHATTAN

AN ISLAND IN FOCUS

PHOTOGRAPHS BY

JAKE RAJS

RIZZOLI NEW YORK

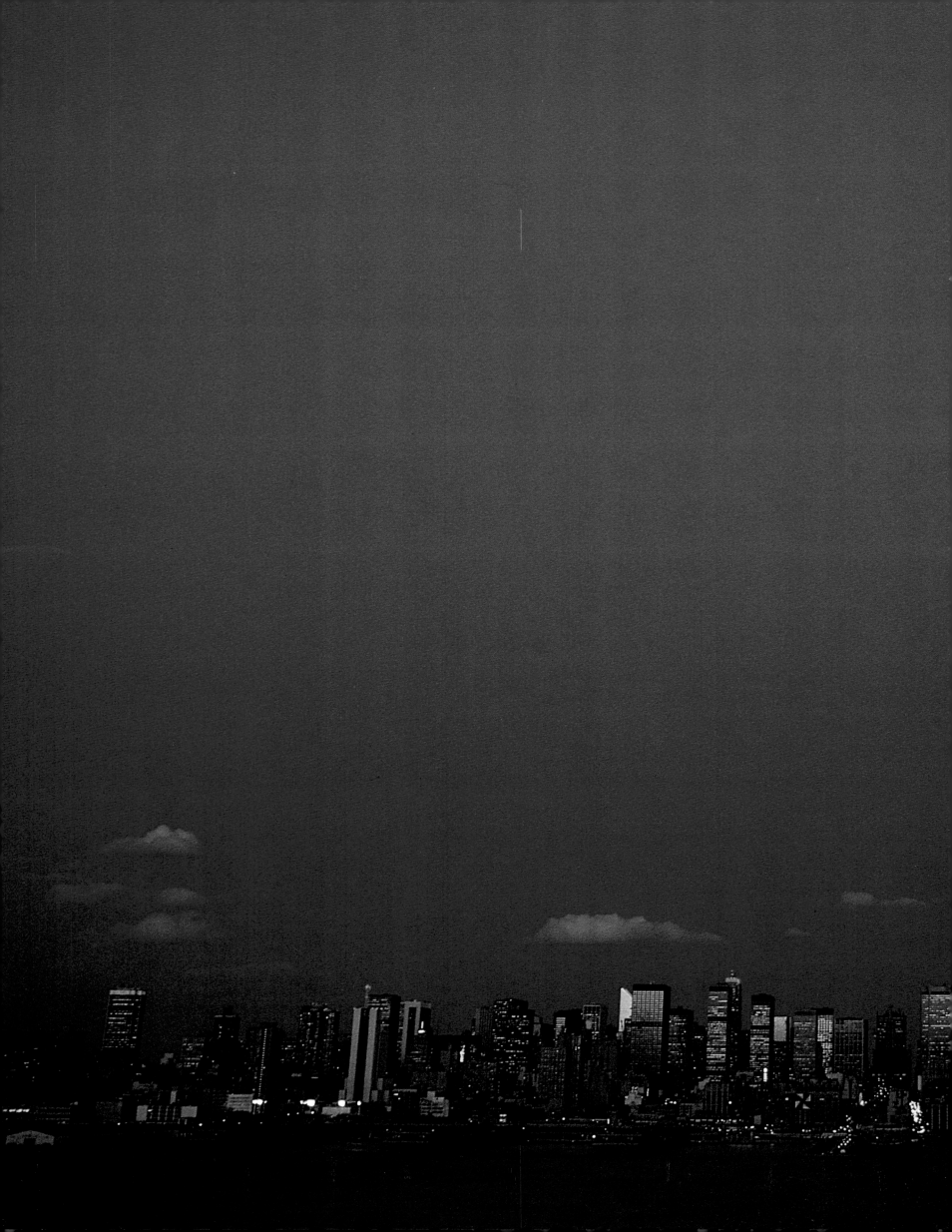

To Francine

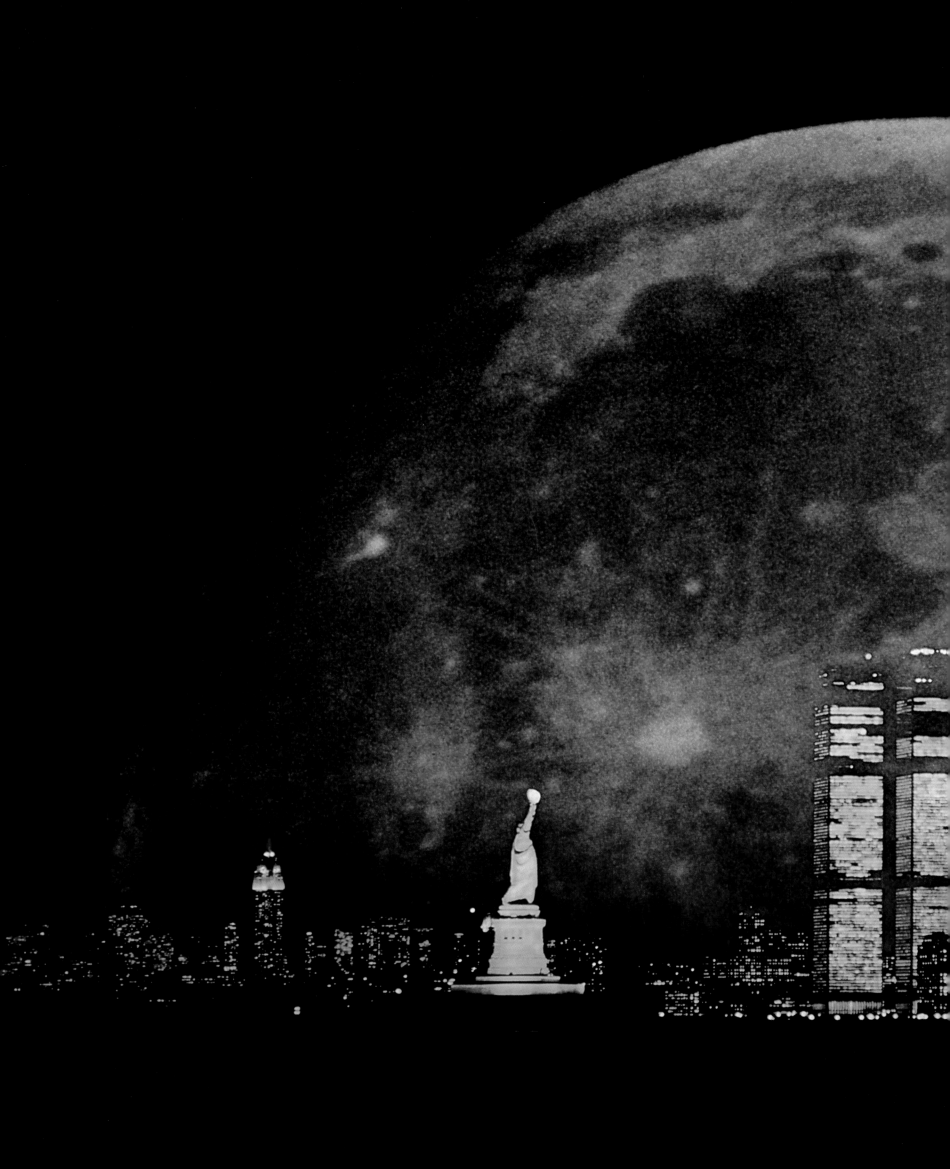

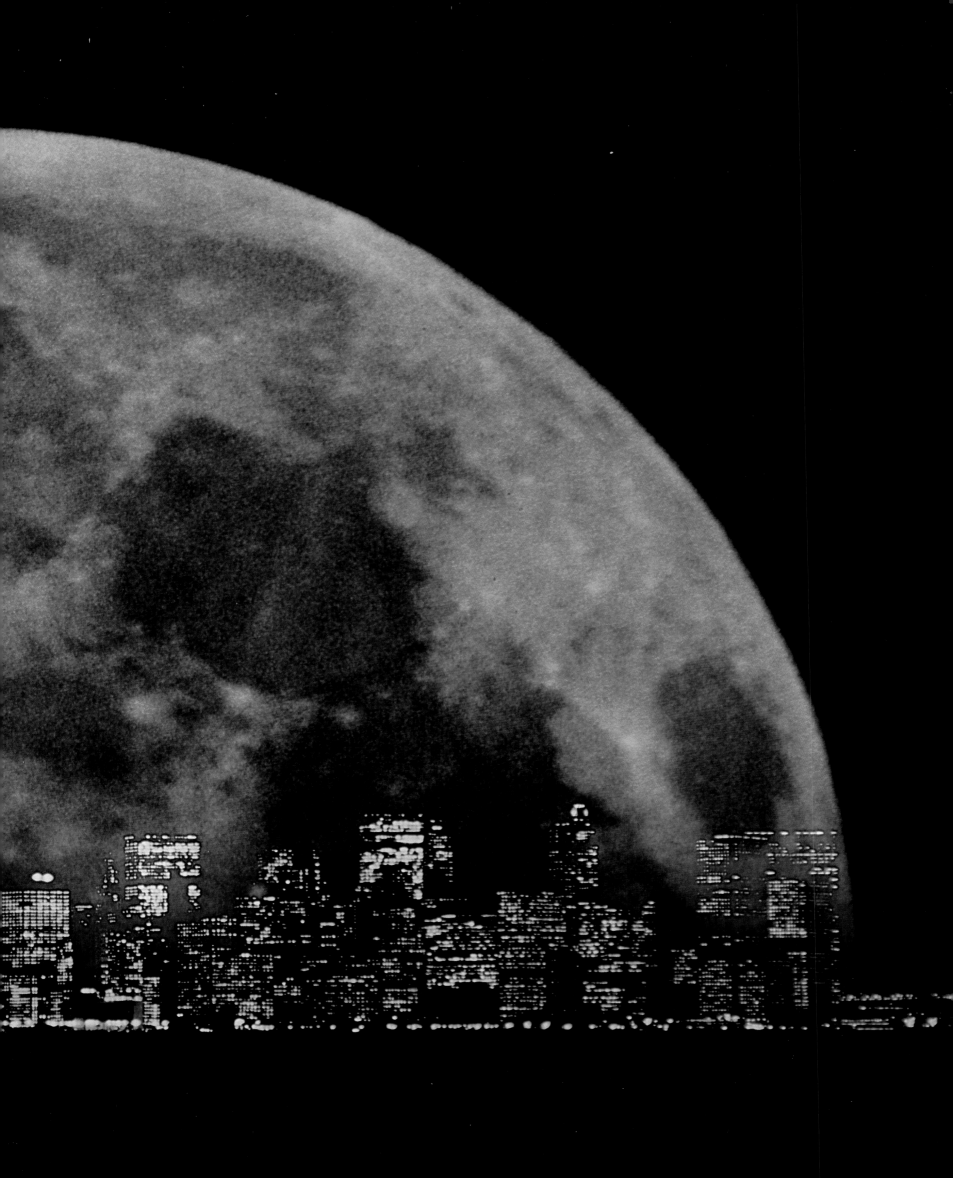

ACKNOWLEDGMENTS

Special thanks to the American Express Company, Phil Chiappone, David Frist, Gilda Hannah, Nick Iversen, Nancy O'Neal, Grant Parrish, Joe Pobereskin, Frances Rajs, Janina Rajs, Julius Rajs, Sam Rosalsky, Jimmy Rudnick, Jordan Schapps, Lauren Shakely, Jules Solo, Mark Speed, and Jimmy Winstead, and to the New Yorkers who contributed their thoughts about Manhattan to this book.

CONTENTS

INTRODUCTION

Manhattan is a romance between the dreams of its people and their reality. As a photographer I try to capture those special visual moments when the dream becomes real.

My earliest memory of the city is the immigrant's introduction to the promised land. I was eight years old. My family had spent two weeks on the ship from Israel, and as we pulled into New York harbor at night, everyone looked up at the Statue of Liberty and began to cry. I was too young to understand what was happening, but I cried too, and that emotion always returns when I see her.

I was trained as a painter and sculptor, but when I picked up a camera and shot that first roll of film, I experienced a sense of freedom, the freedom to leave the studio and make the world my subject. I moved to Manhattan in the early 1970s. Ever since then I have known that I would someday make this book. It is the ultimate challenge for a photographer, since Manhattan is probably the world's most-photographed city.

Manhattan intrigues me so much that I can shoot nearly every day, waiting for that sudden instant when the sun's rays rebound off a skyscraper or a bridge. For the last ten years I have watched the city's seasons change, always finding a new design, a new symbol, or some new image that tells a story about the greatest city in the world.

The city has moods affected by the times of year and the times of day. In the winter, the sun sets below the Statue of Liberty, but by summertime it goes down above Central Park. Each day the light is different, as the sun takes up its new position. It may rise between the twin towers of the World Trade Center, for example, only three days a year, so I have to plan from one year to the next in order to be ready for particular shots.

The experience of photographing Manhattan is so overwhelming that time seems to stop. When the hostages were freed by Iran in 1981 and New York gave them a ticker-tape parade, I got a press pass and found a good vantage point on a ledge high above Broadway. All of a sudden I could hear the roar of the crowd. The roar began to build, then far below the parade began to approach. I was mesmerized. The next thing I knew I was hanging over the ledge, with my assistant holding my feet, firing away, photograph after photograph, until gradually the roar began to die down, and my assistant hauled me back inside. I took a deep breath. What had felt like a second was actually an hour going by.

The photographer uses the camera as a machine to strip away unnecessary information, simplify it so that the image can become a symbol. A friend once called me because there was a huge blaze on Thirty-fourth Street. I rushed down to the scene and found confusion—fire trucks, smoke, and firemen running with hoses. But in the camera the chaos became an image of man's battle with the unknown.

The city sometimes shows its negative side. One morning I decided to photograph the sunrise from the top of the Brooklyn Bridge. I had permission to climb the cables, and about four o'clock in the morning a steelworker, my assistant, and I began the ascent. It was still pitch dark when we got to the top, but we could see a man on the outside cables, ready to jump. The man begged me not to take his picture and I didn't, but after the steelworker went for help, the roadbed below was soon filled with television cameramen and photojournalists. Before rescue police could get to him, the man jumped. His body re-appeared three hundred feet downstream, and they pulled him into a boat. My stomach was in knots and I called it quits for the day. That night I found out the man had miraculously survived. The next day we tried again. The sunrise was gorgeous.

One of the most exciting experiences I have is photographing the city from a helicopter. It's like being Superman, swooping in and around the buildings, circling the Statue of Liberty. Just as the camera is a machine that I can use to extend my vision, the helicopter is another extension, giving me the ability to fly.

A lot of what I shoot comes to me in dreams. I wake up in the morning with a particular image in mind, like the one of the Statue of Liberty between the twin towers of the World Trade Center. I knew somehow that the view had to exist, and I went out looking for what I had imagined until I found it. Other times I use two photographs to create an image. With "New York City on Ice," the ice floes moving below the Brooklyn Bridge reminded me of clouds. By superimposing two images I came up with an unex-pected scene of ice that seems to float in the sky.

I don't expect you to see the way I see. But through the photographs in this book, you will see the way I feel. Enjoy the feelings, as I have, feel the romance for yourself, wherever you are. This book is as much about a way of seeing as it is about Manhattan.

J.R.

THE GOLDEN DOOR

A welcome from the Statue of Liberty

The courage, the heaven-scaling audacity of it all, and the lightness withal, as if there was nothing that was not easy, and the great pulses and bounds of progress, so many in directions all simultaneous that the coordination is indefinitely future, give a kind of <u>drumming</u> background of life that I have never felt before. I'm sure that once <u>in</u> that movement, and at home, all other places would seem insipid.
<div align="right">—William James</div>

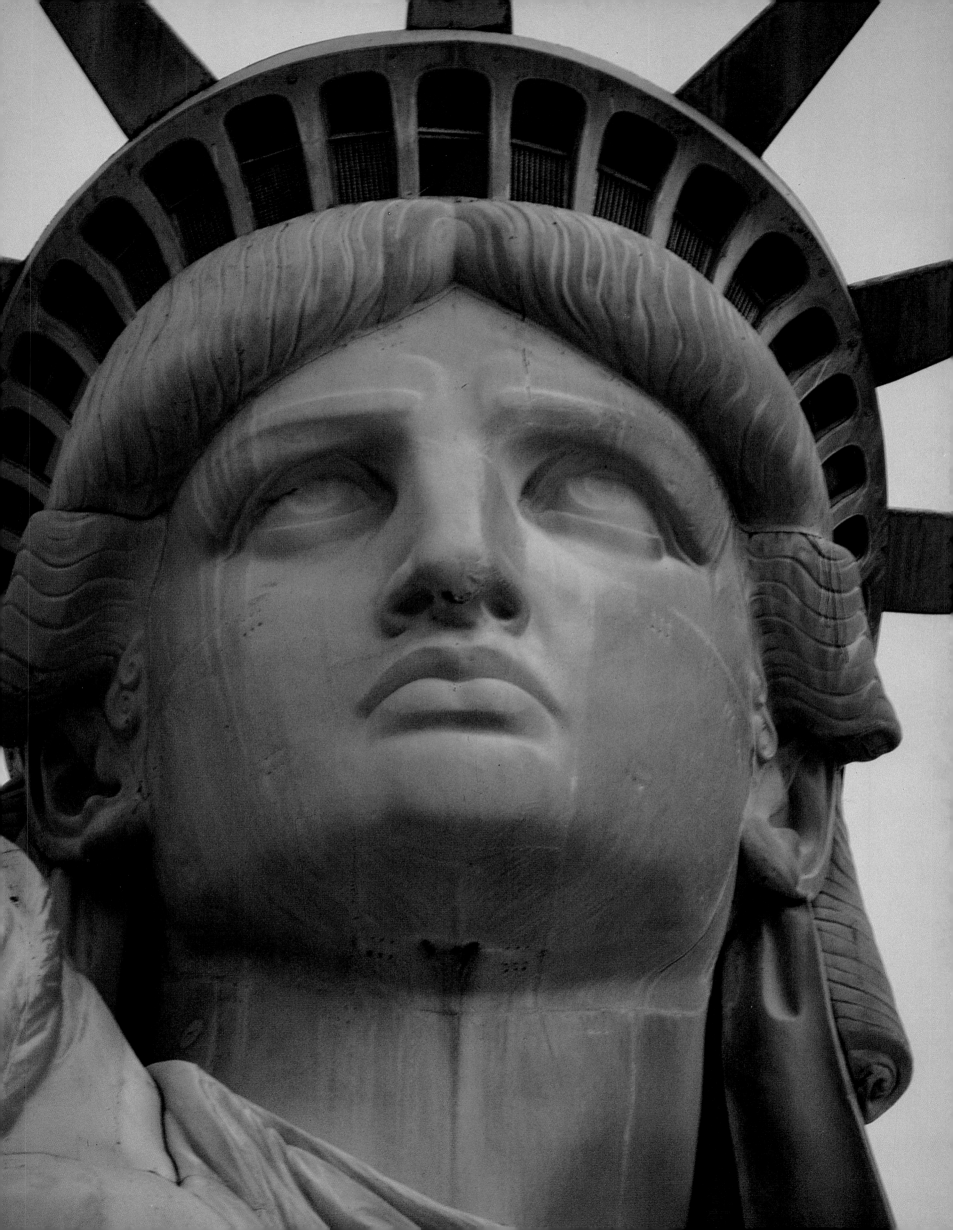

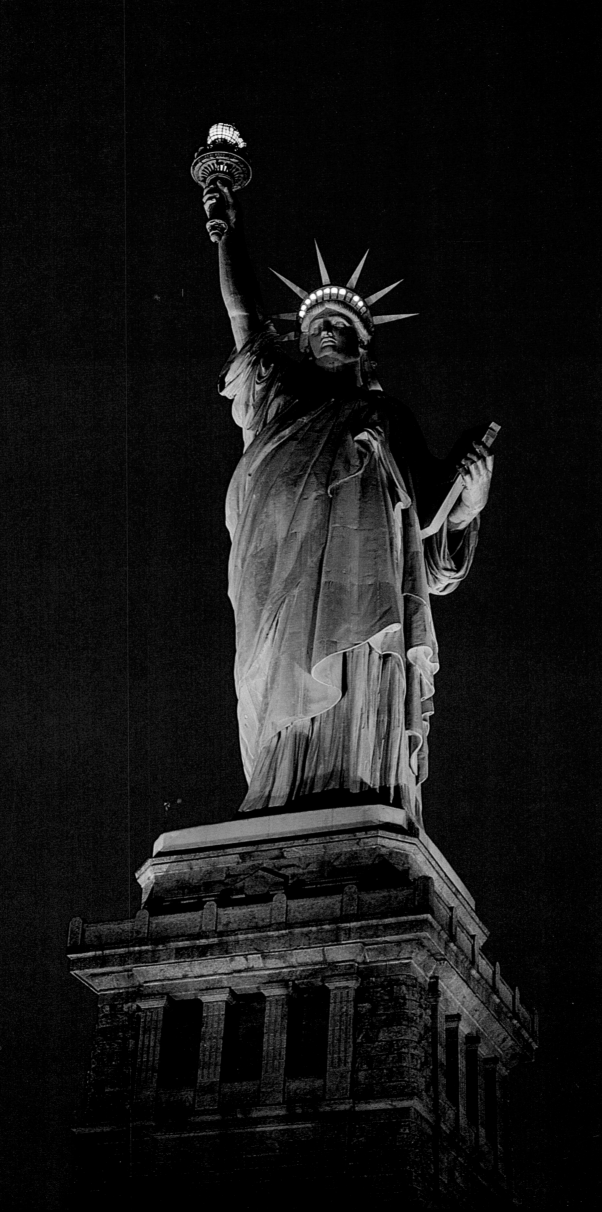

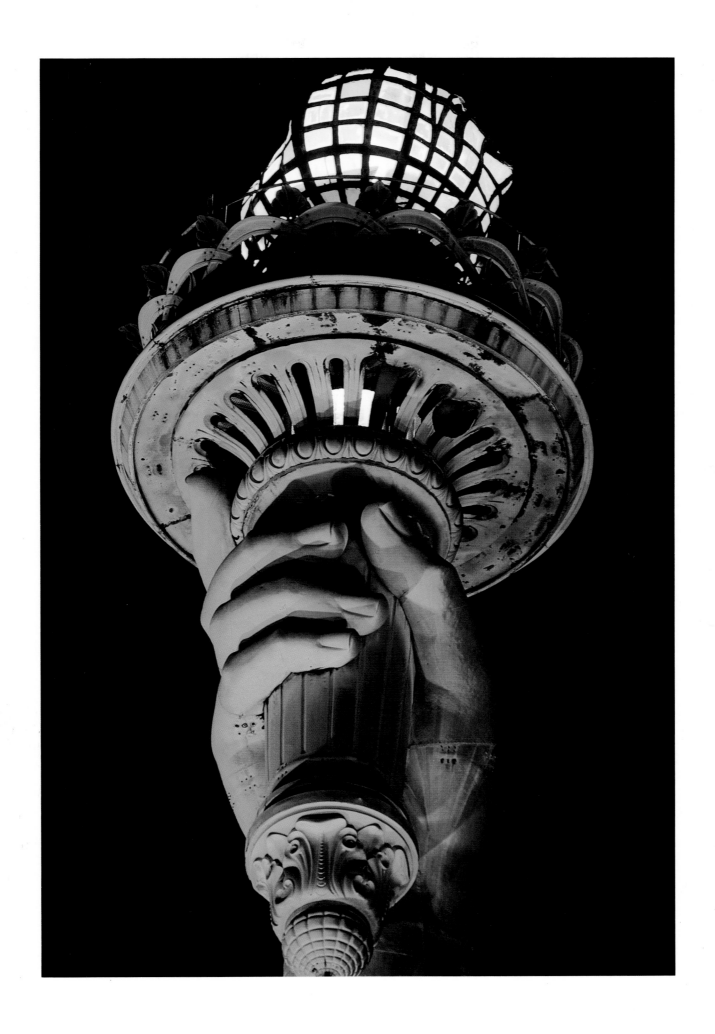

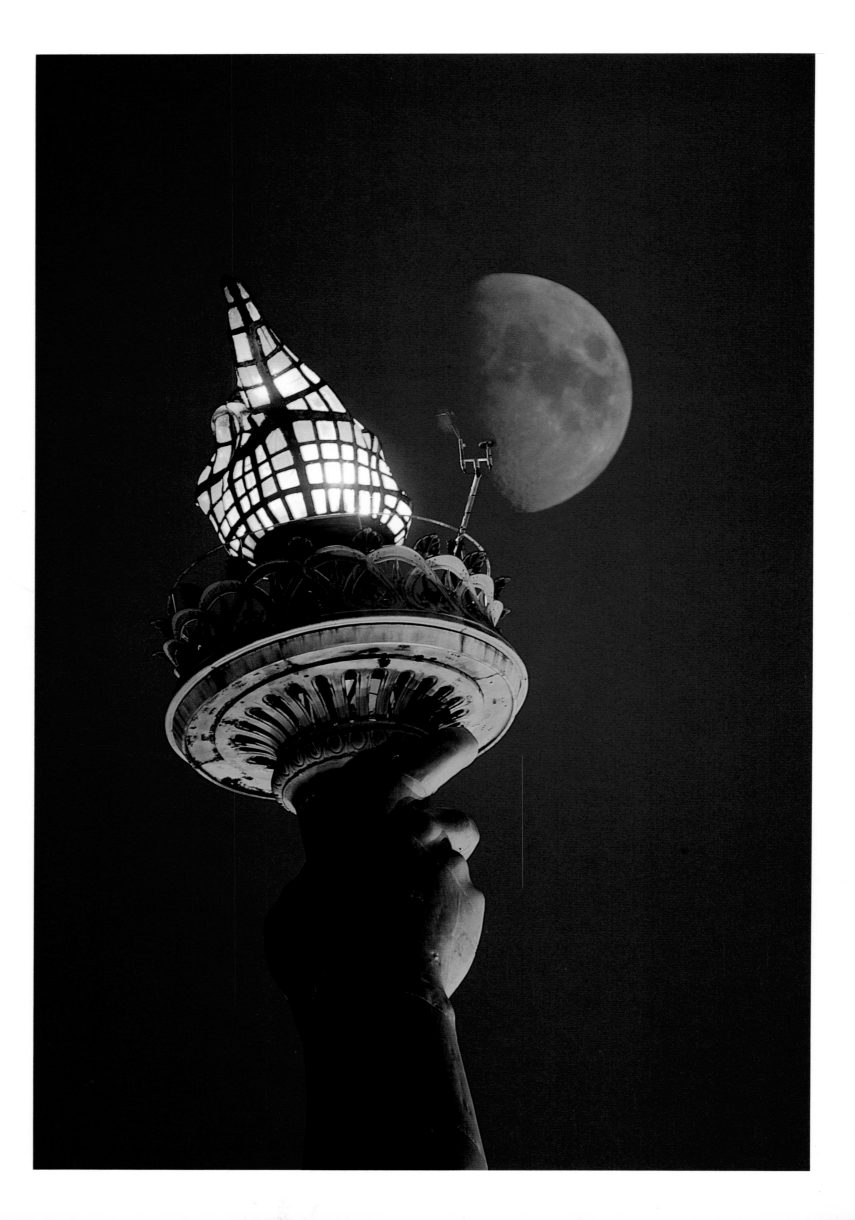

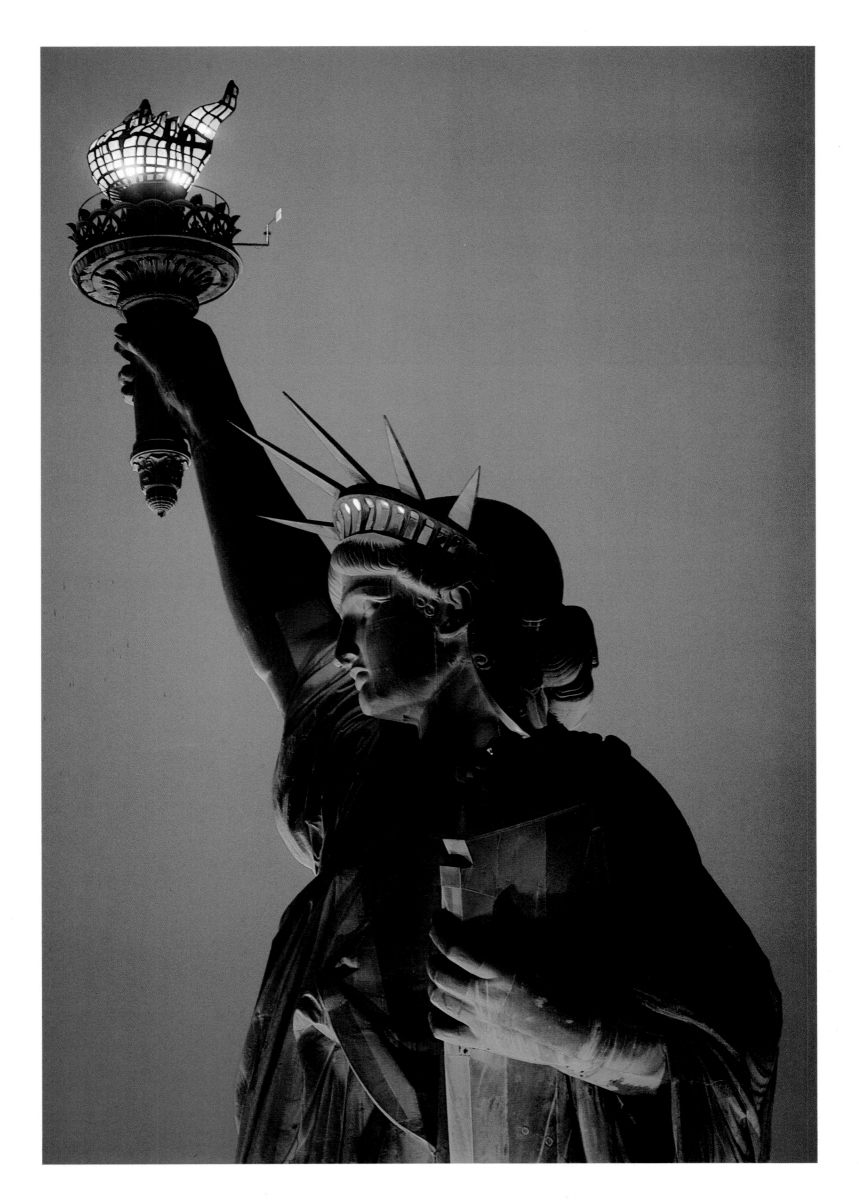

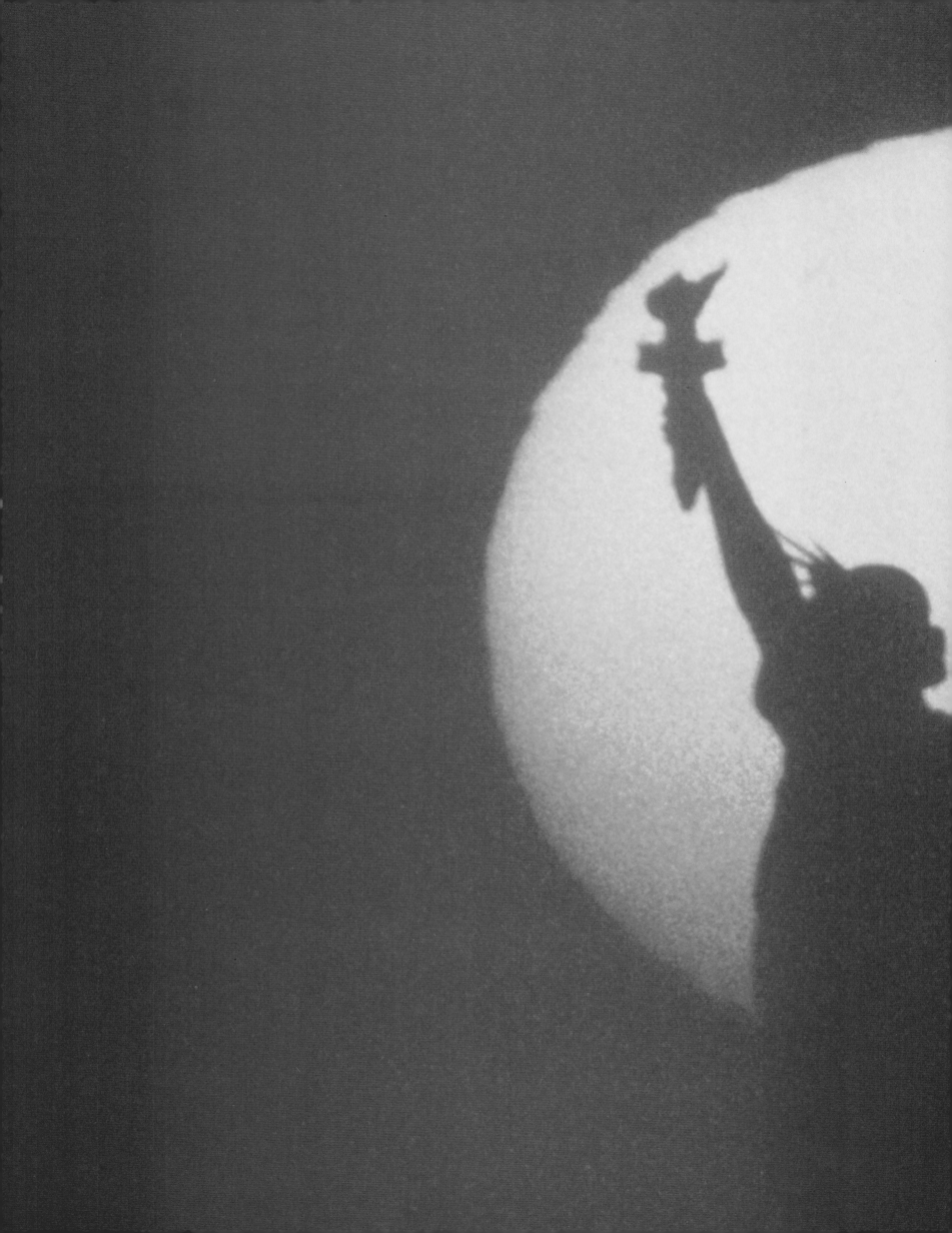

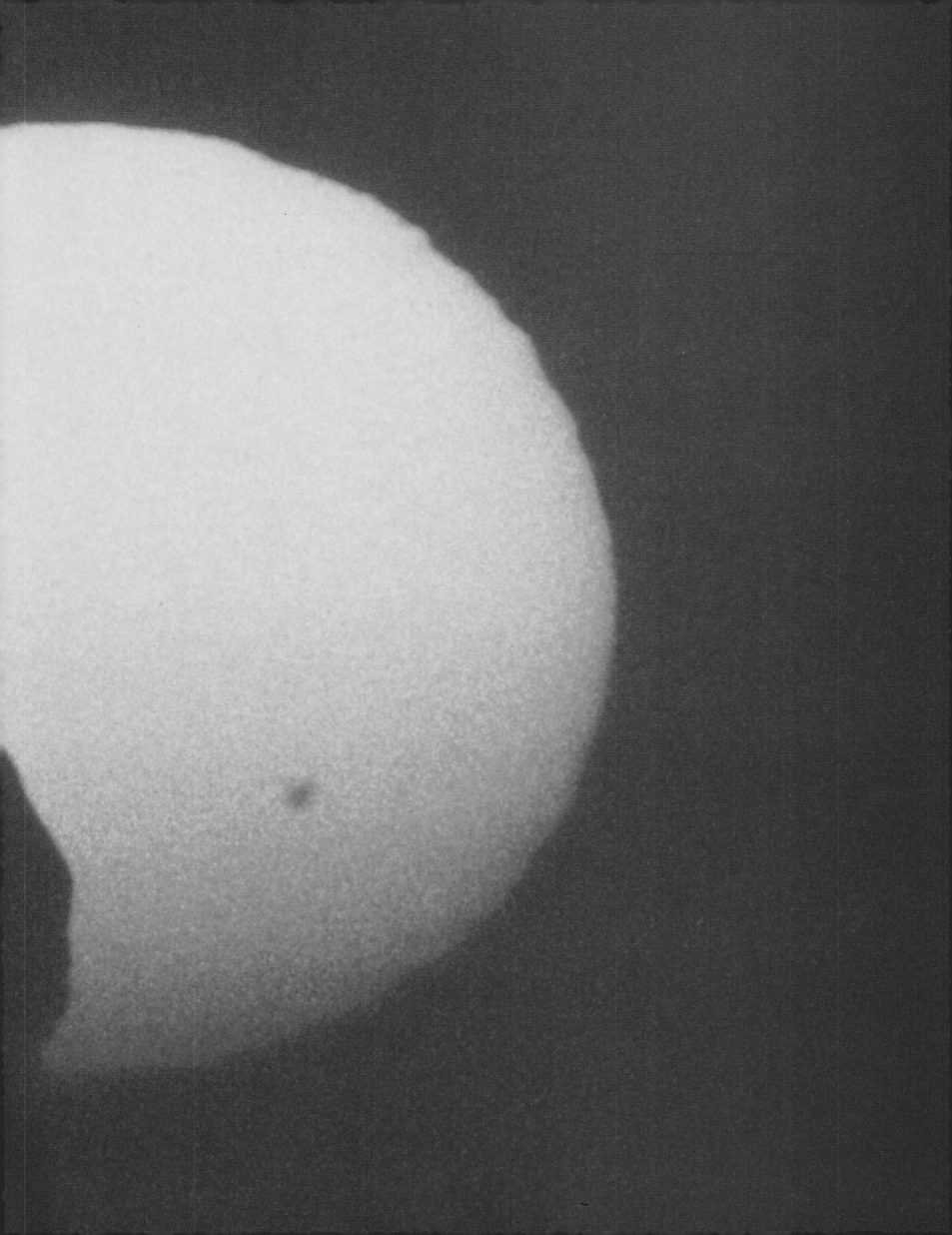

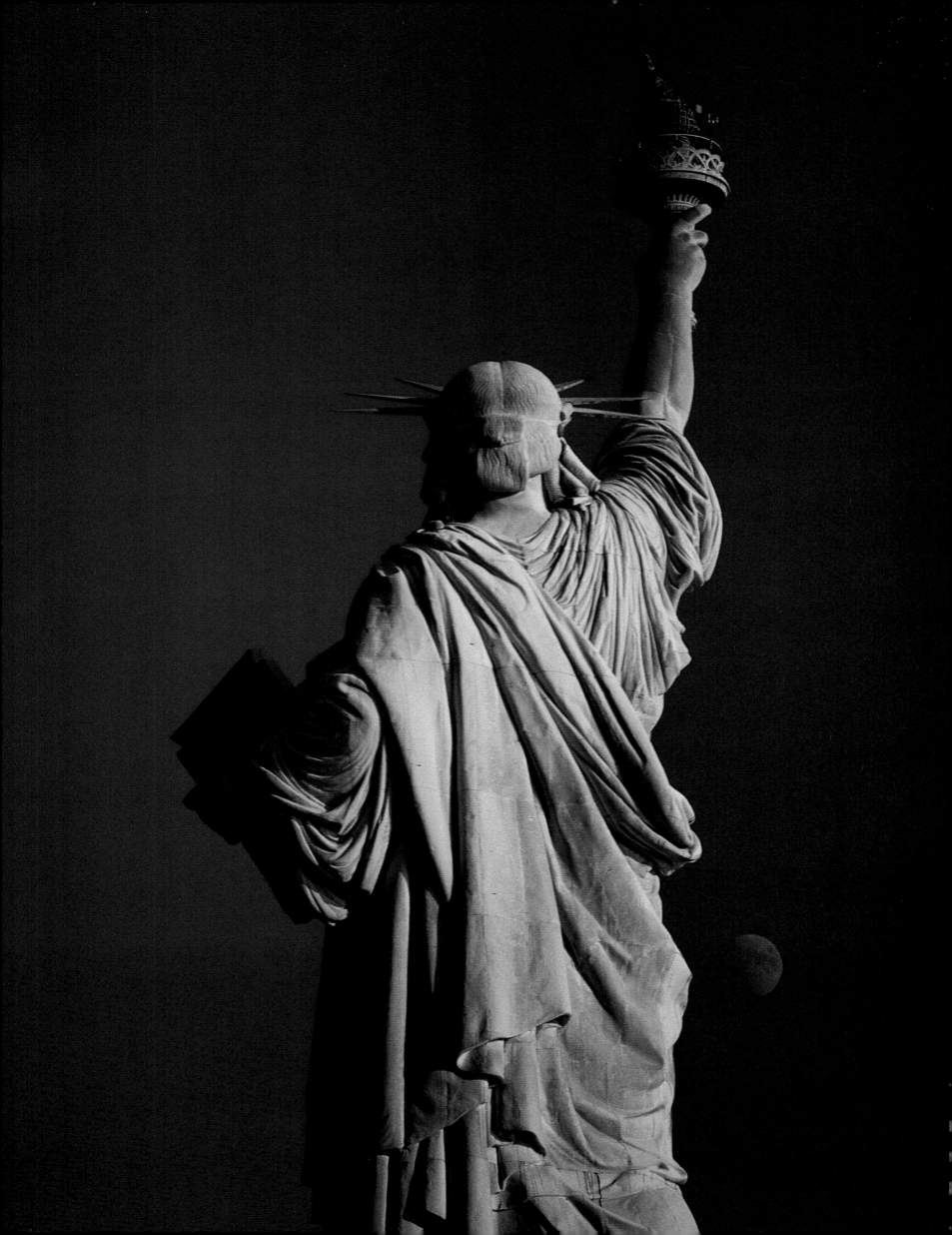

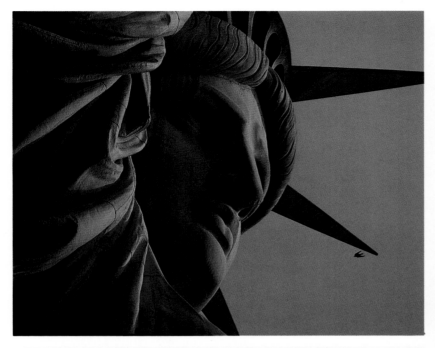

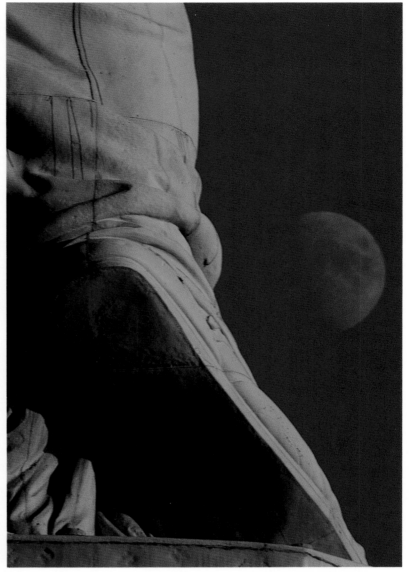

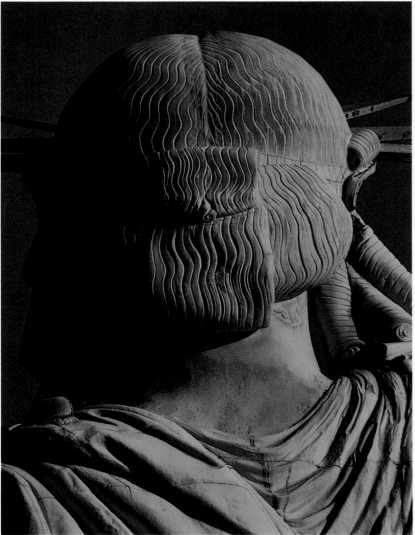

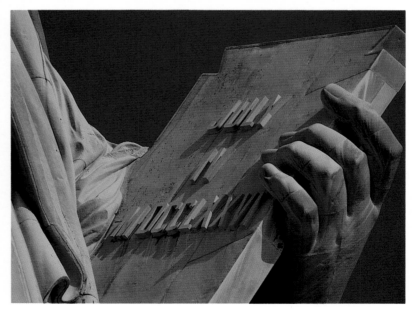

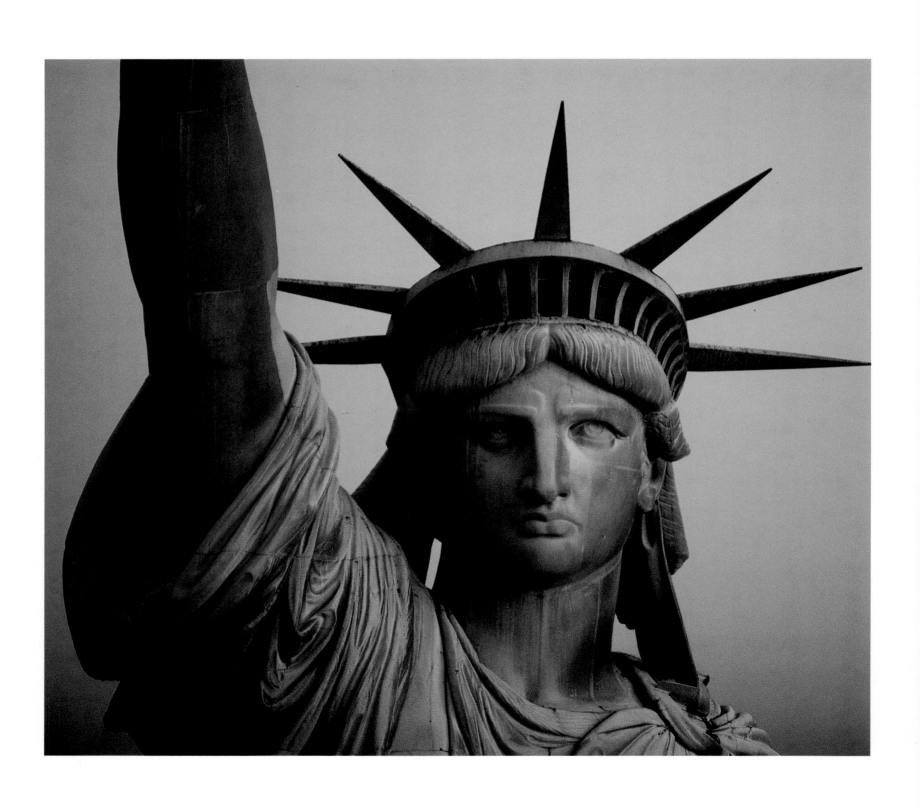

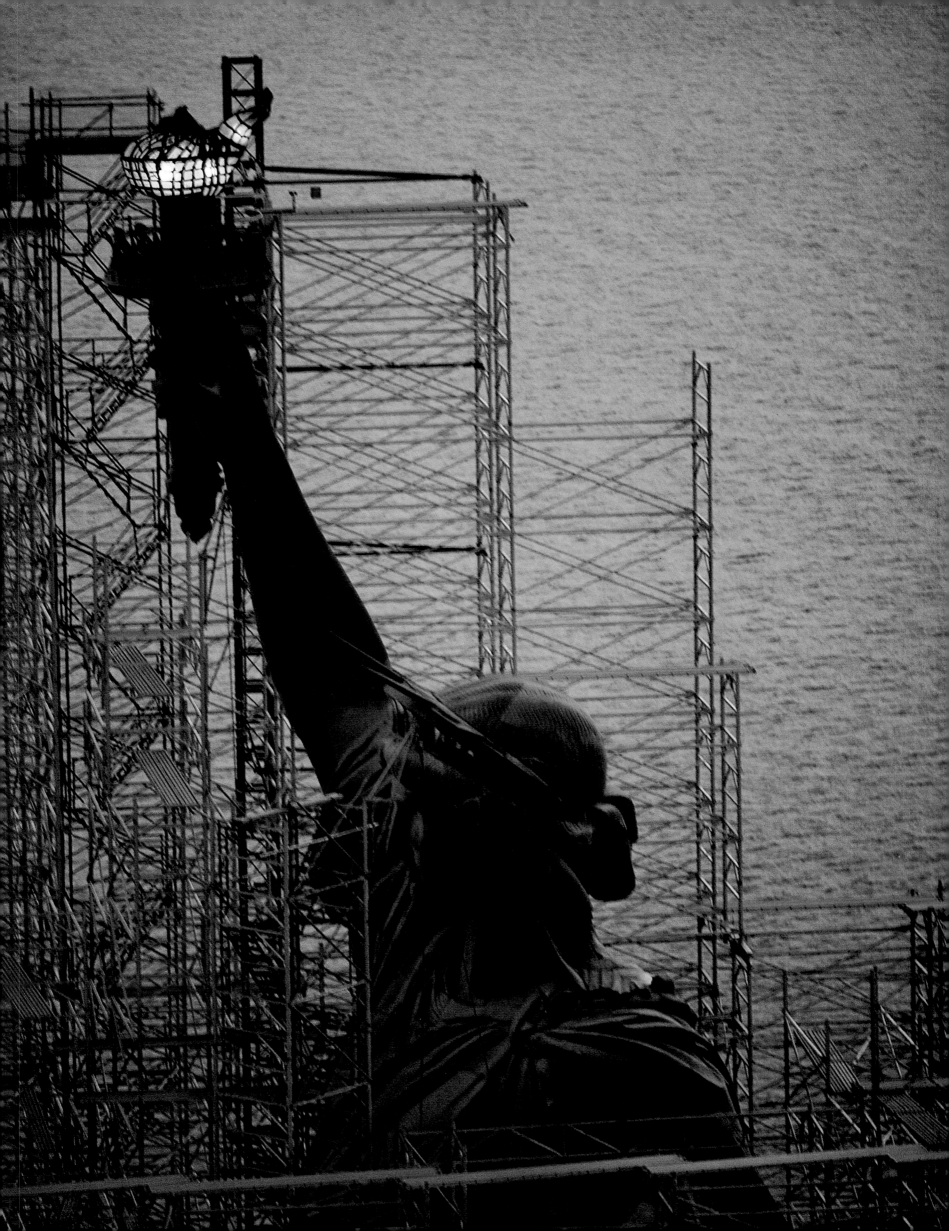

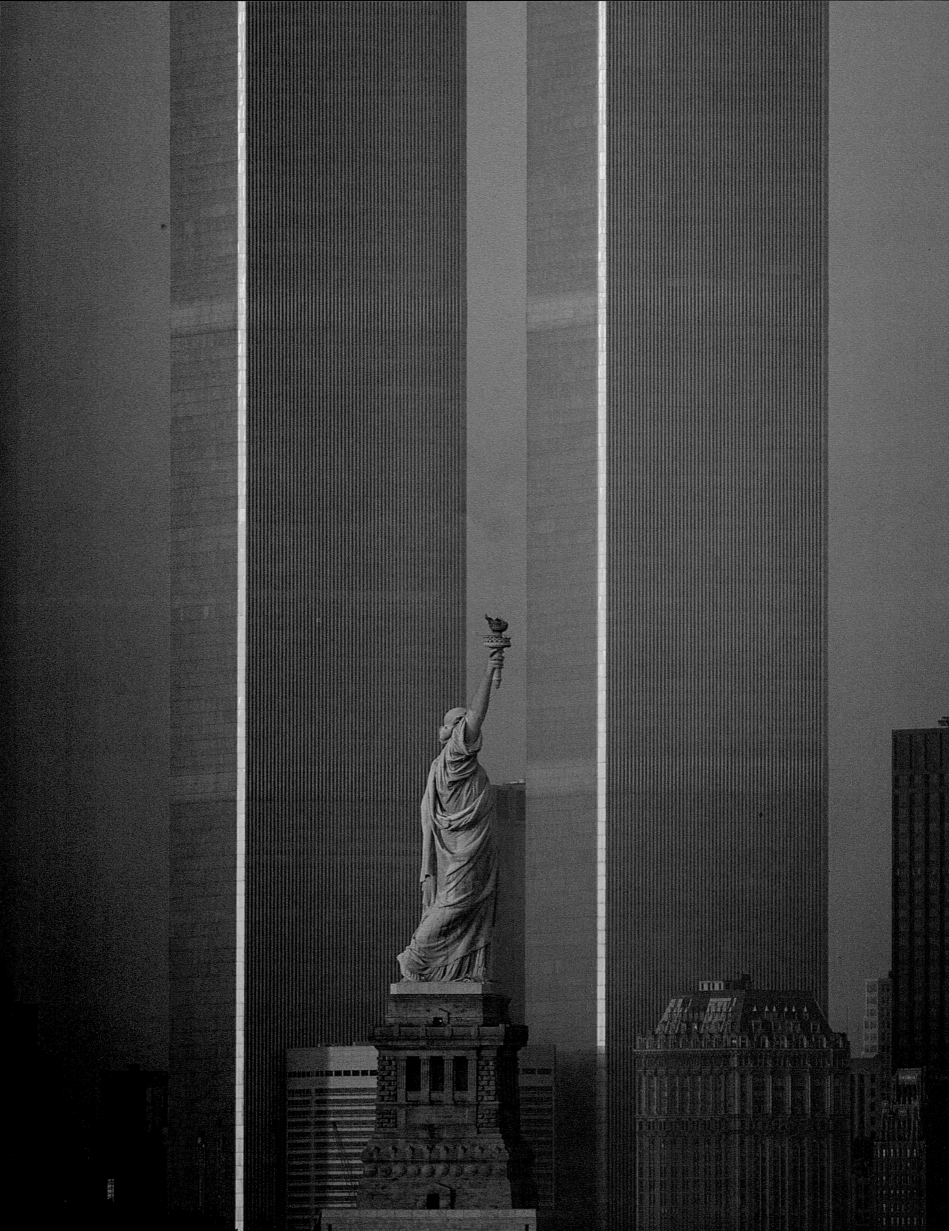

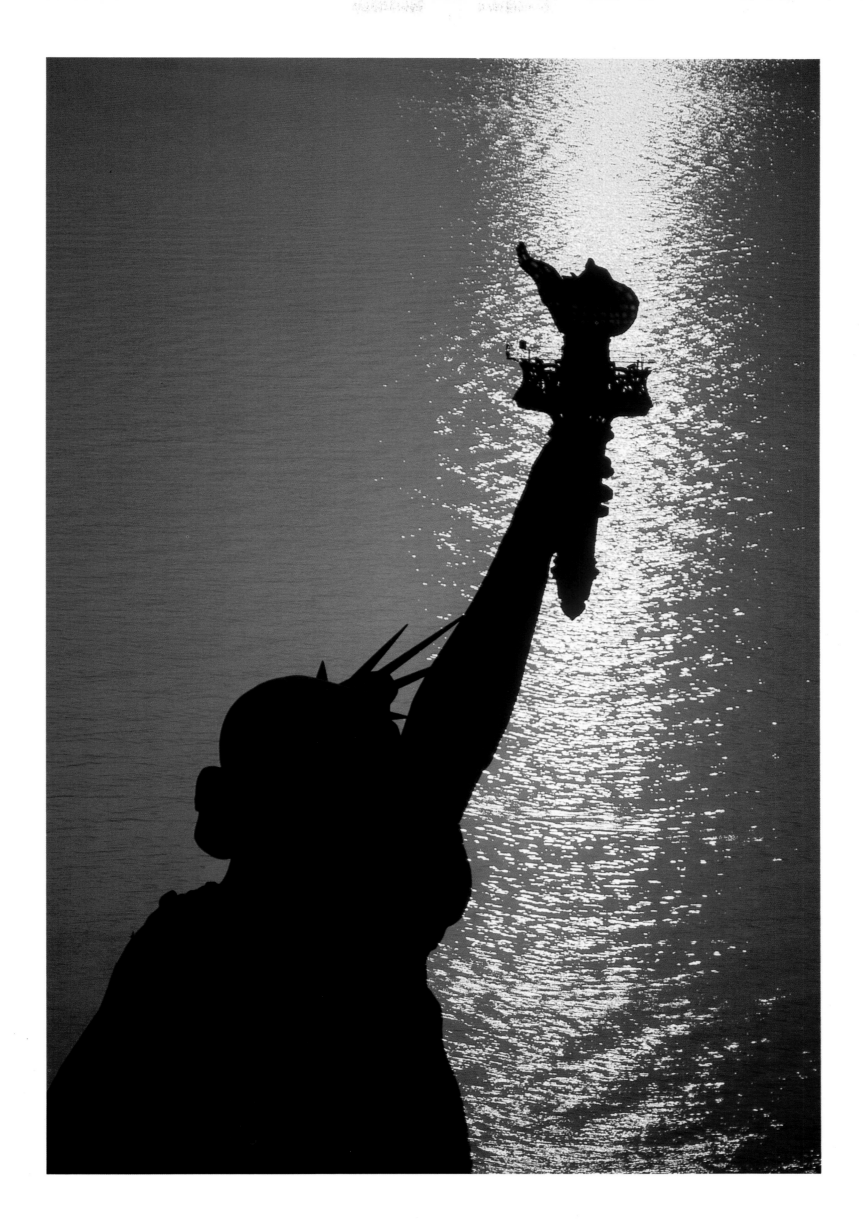

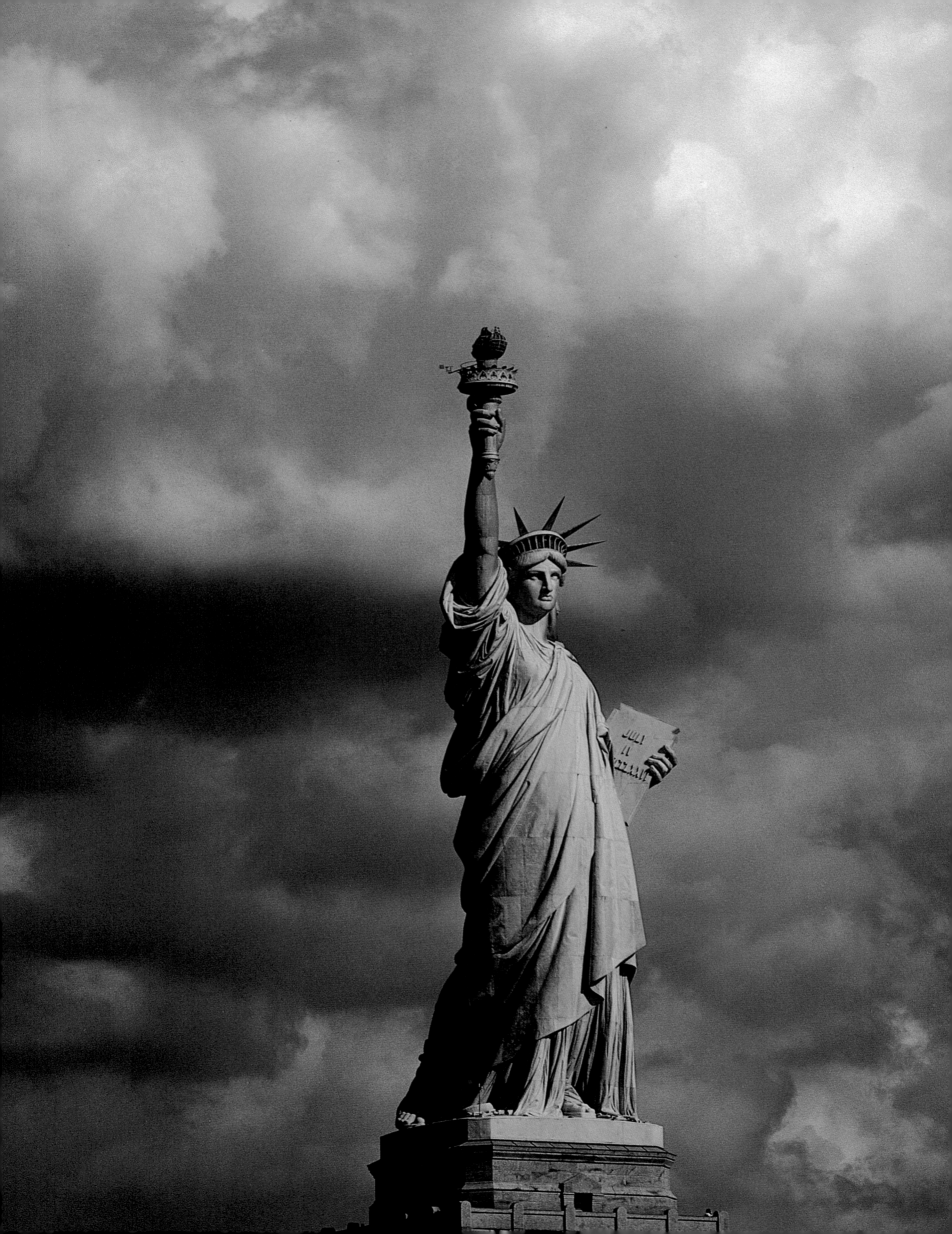

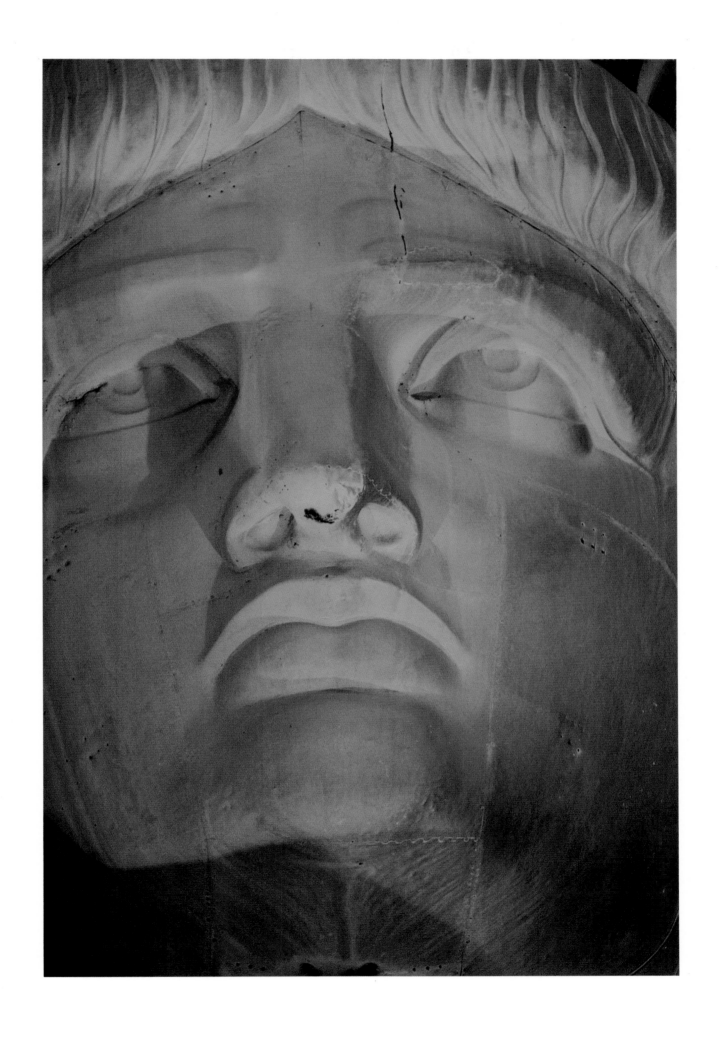

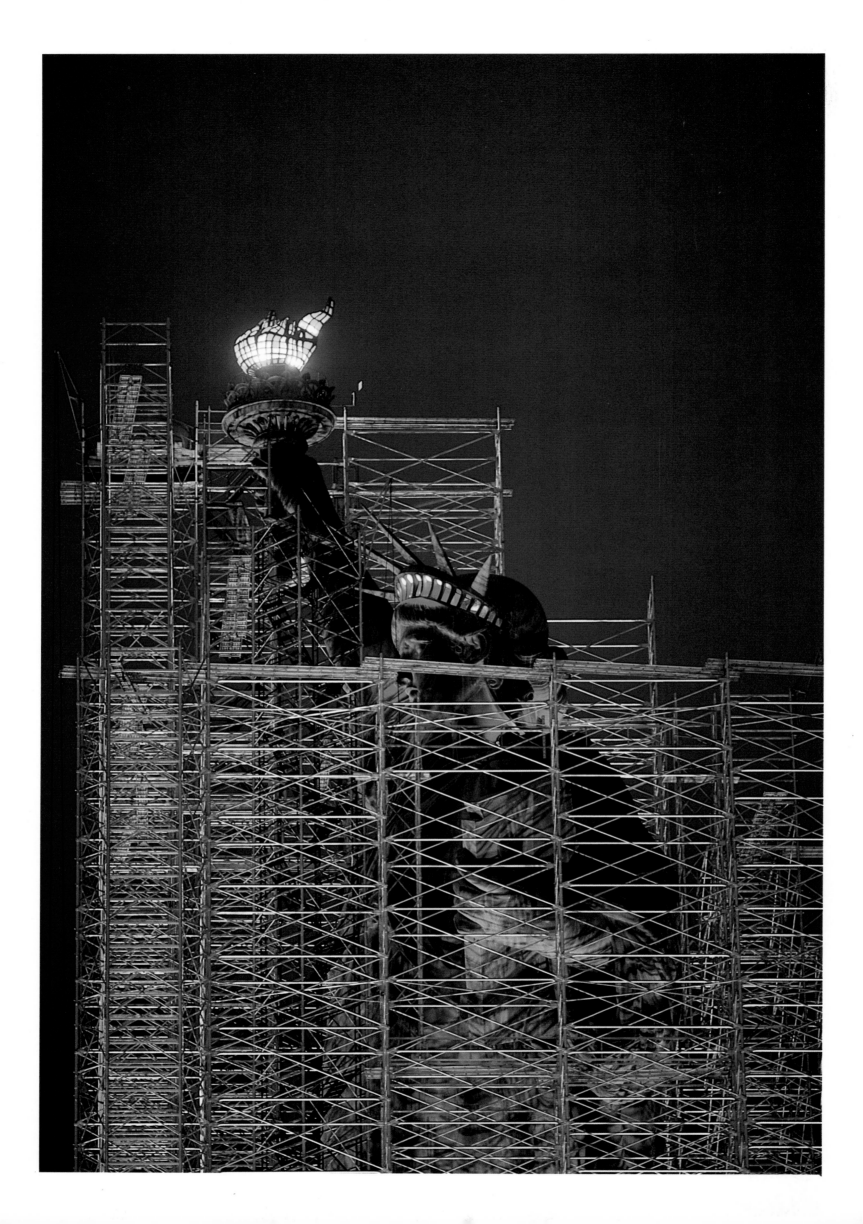

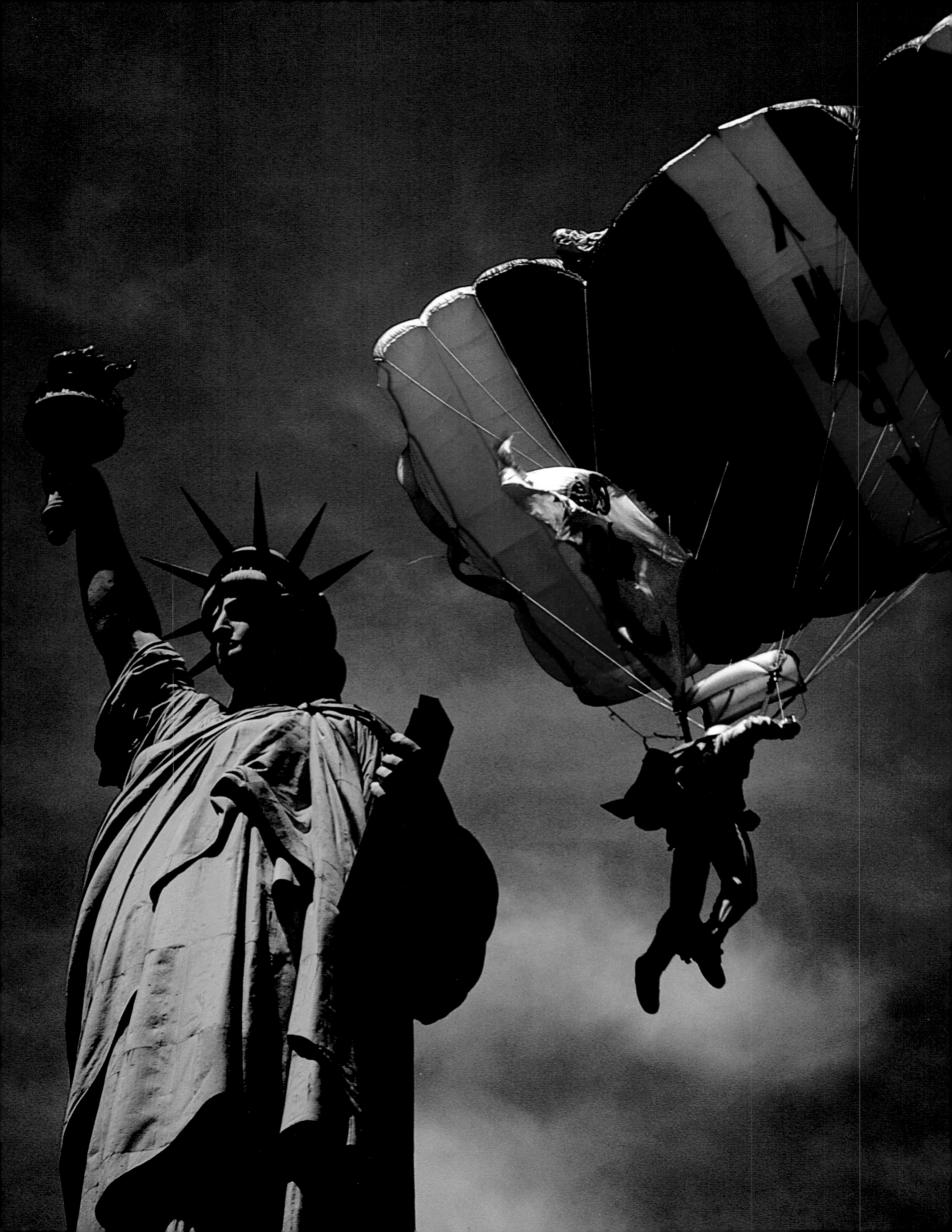

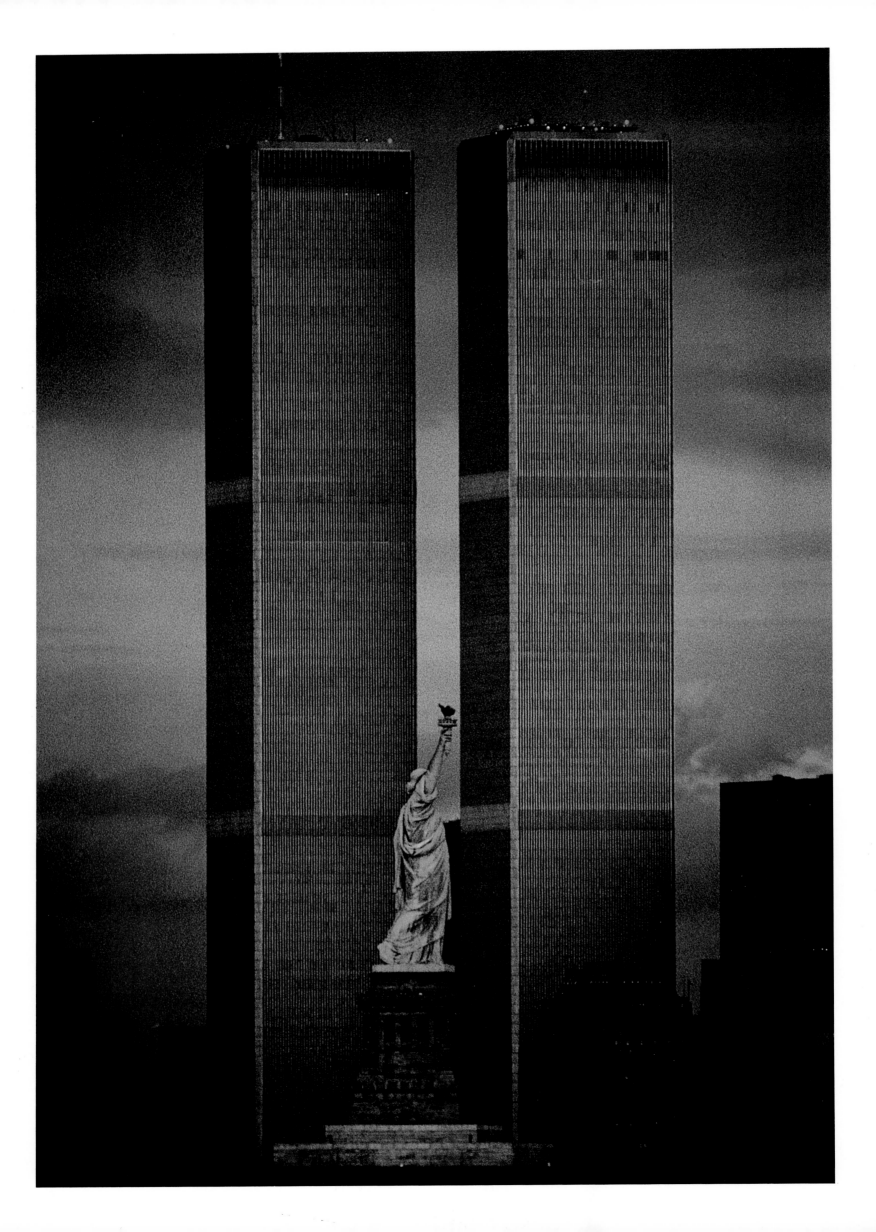

DOWNTOWN

Twin Towers, Wall Street, and
centuries-old churches

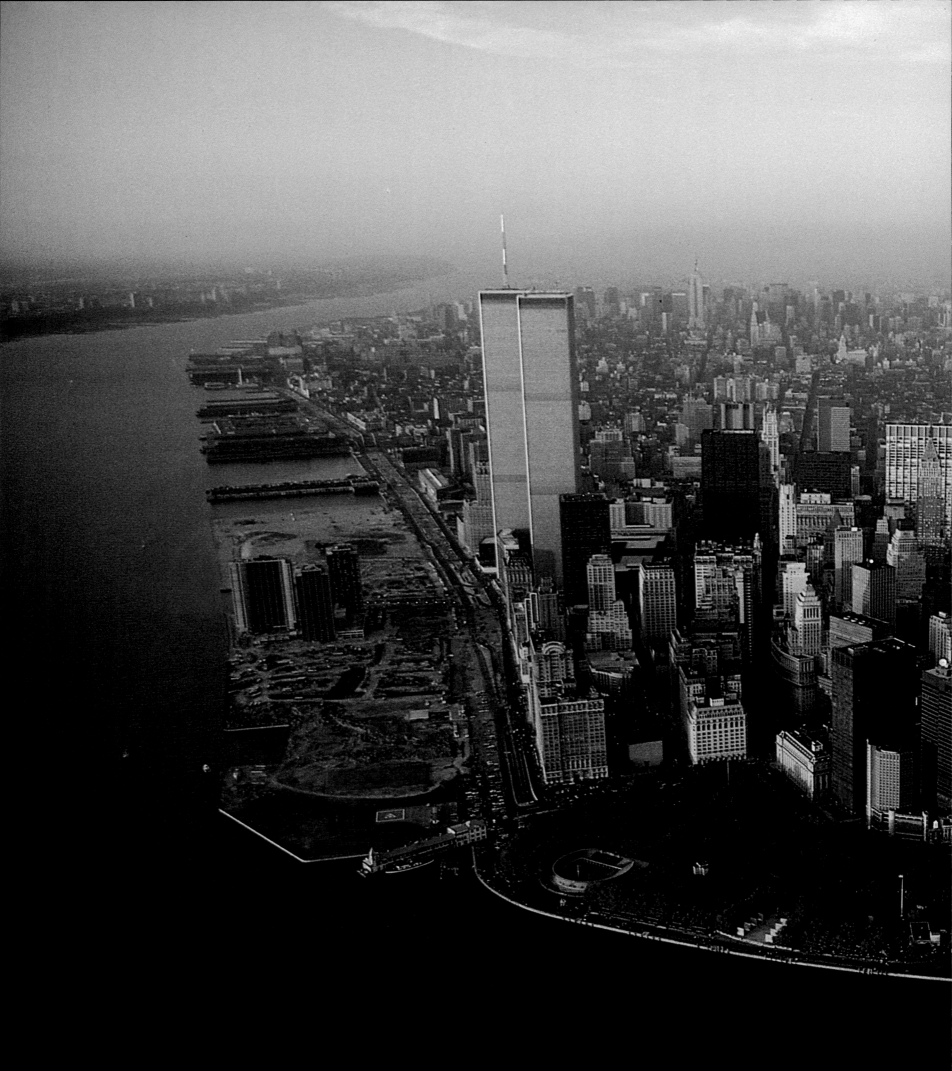

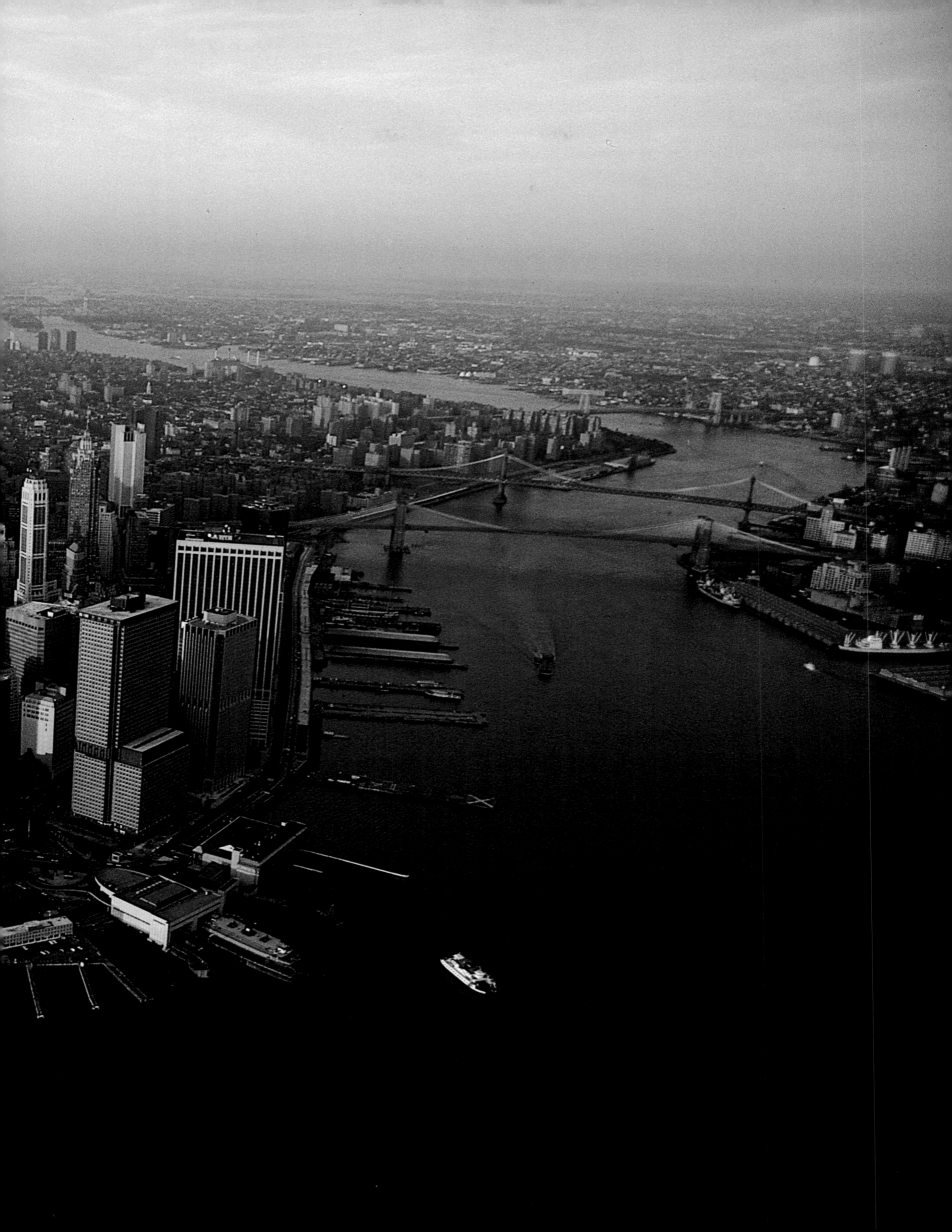

New York is victorious. It is neither the capital of a country, nor is it a perfect place to live. It's got its own way of seducing and keeping the seduction flowing freely because it is New York. Somehow or other it beats the rest of the big cities because it seduces the world. It is too crowded and stuffed with too much, but there is a wonderful fresh air that blows through and around it off the Atlantic. Sometimes this air is hard to find, but it is there, and it keeps us all alive.
—Diana Vreeland

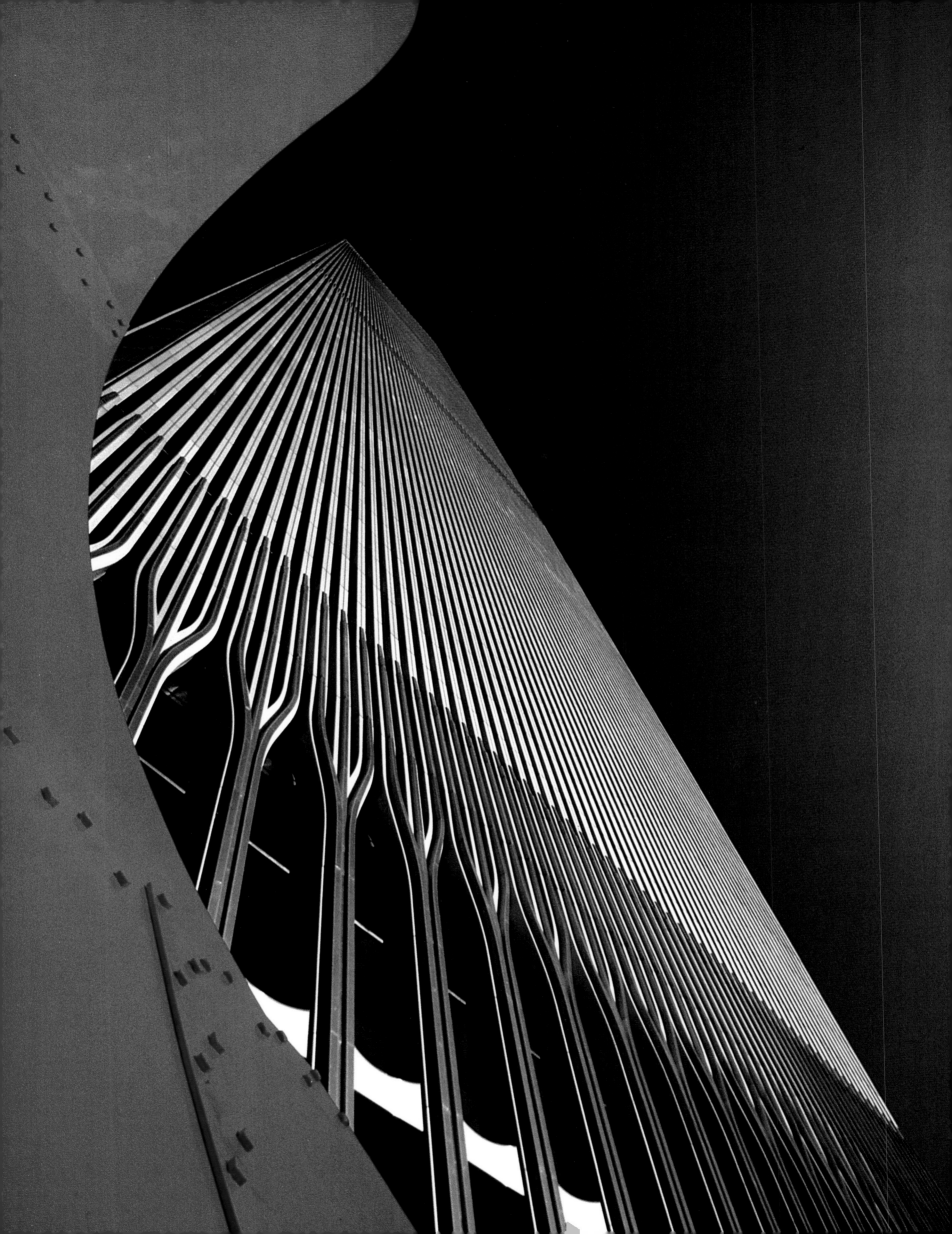

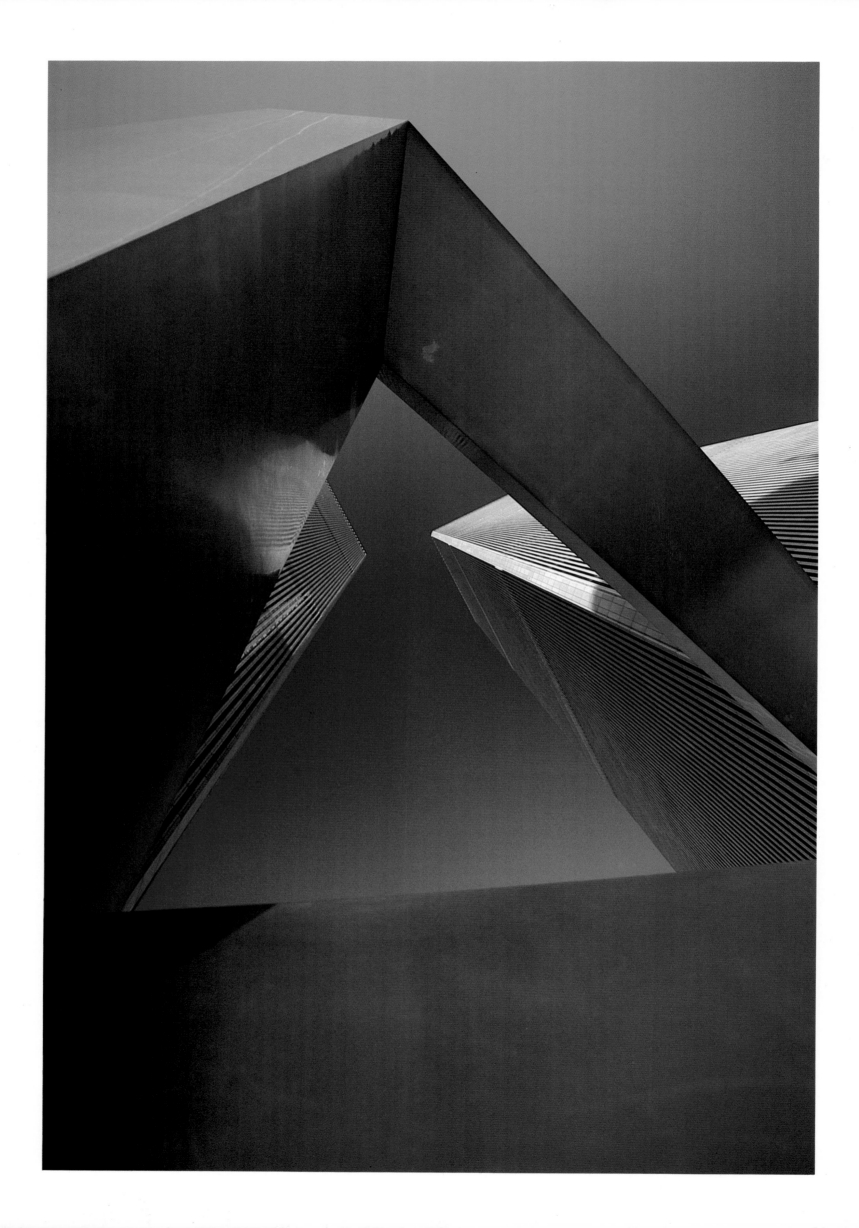

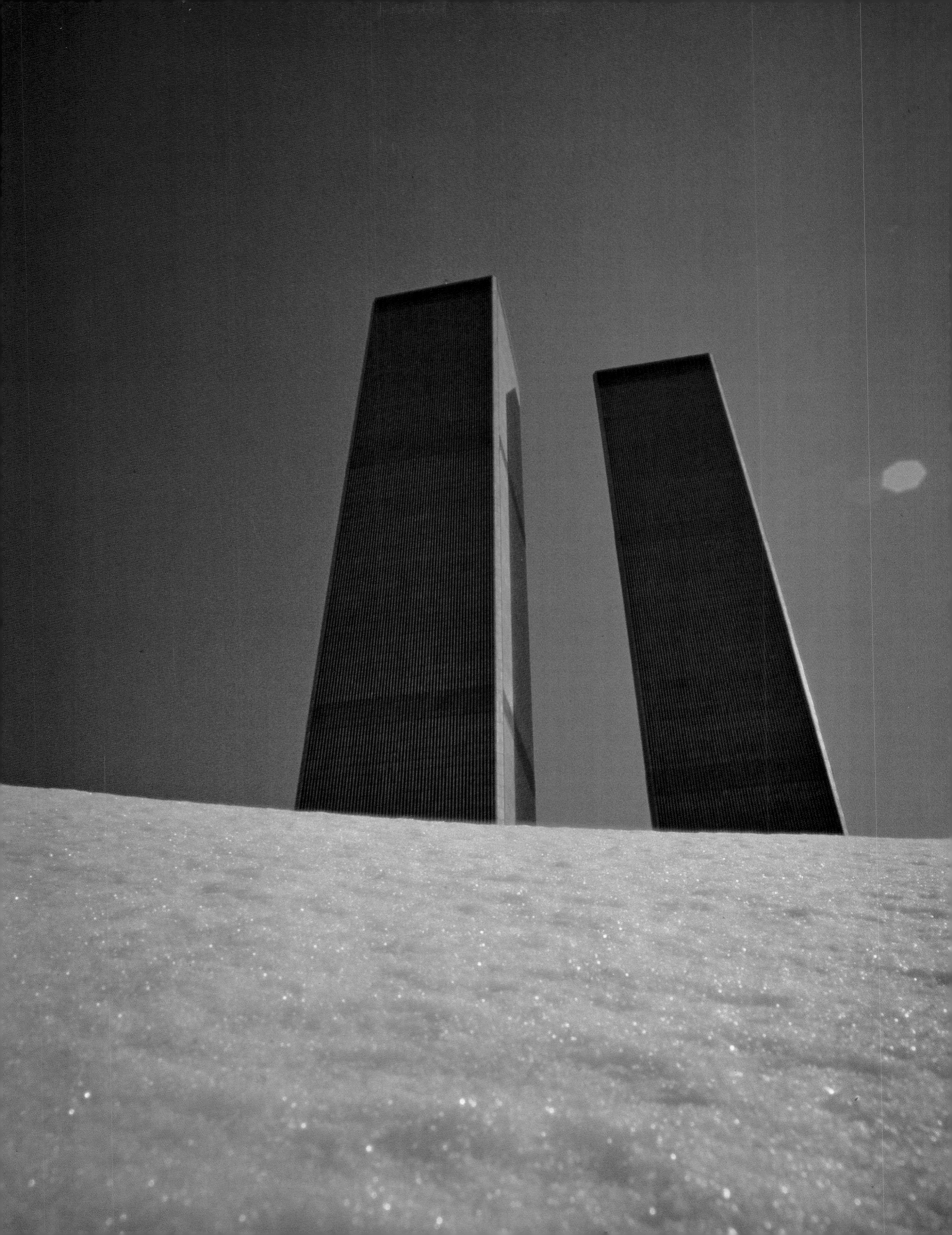

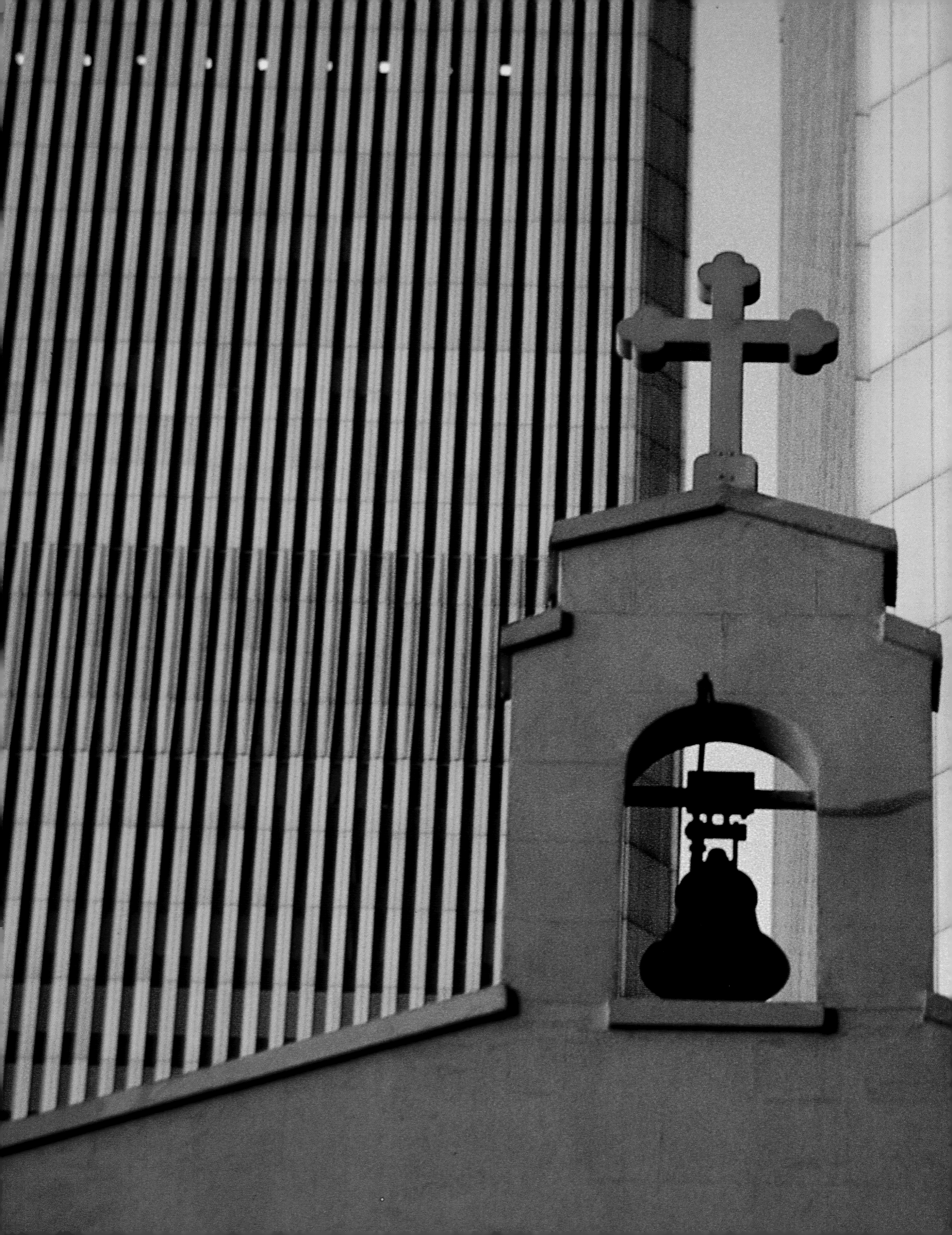

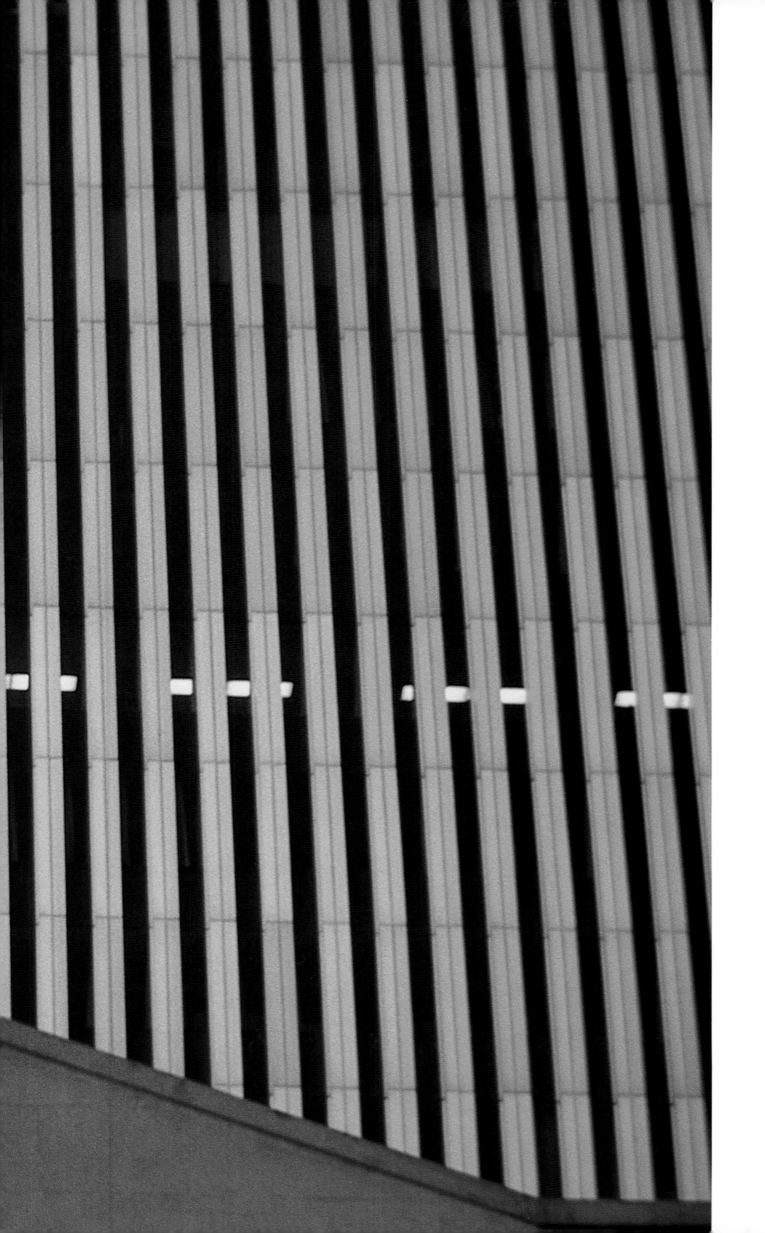

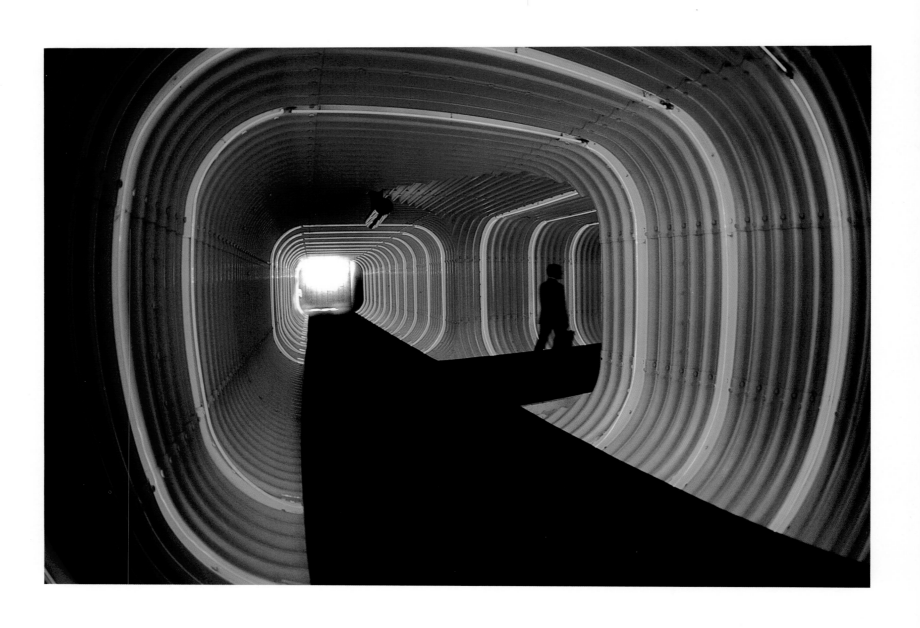

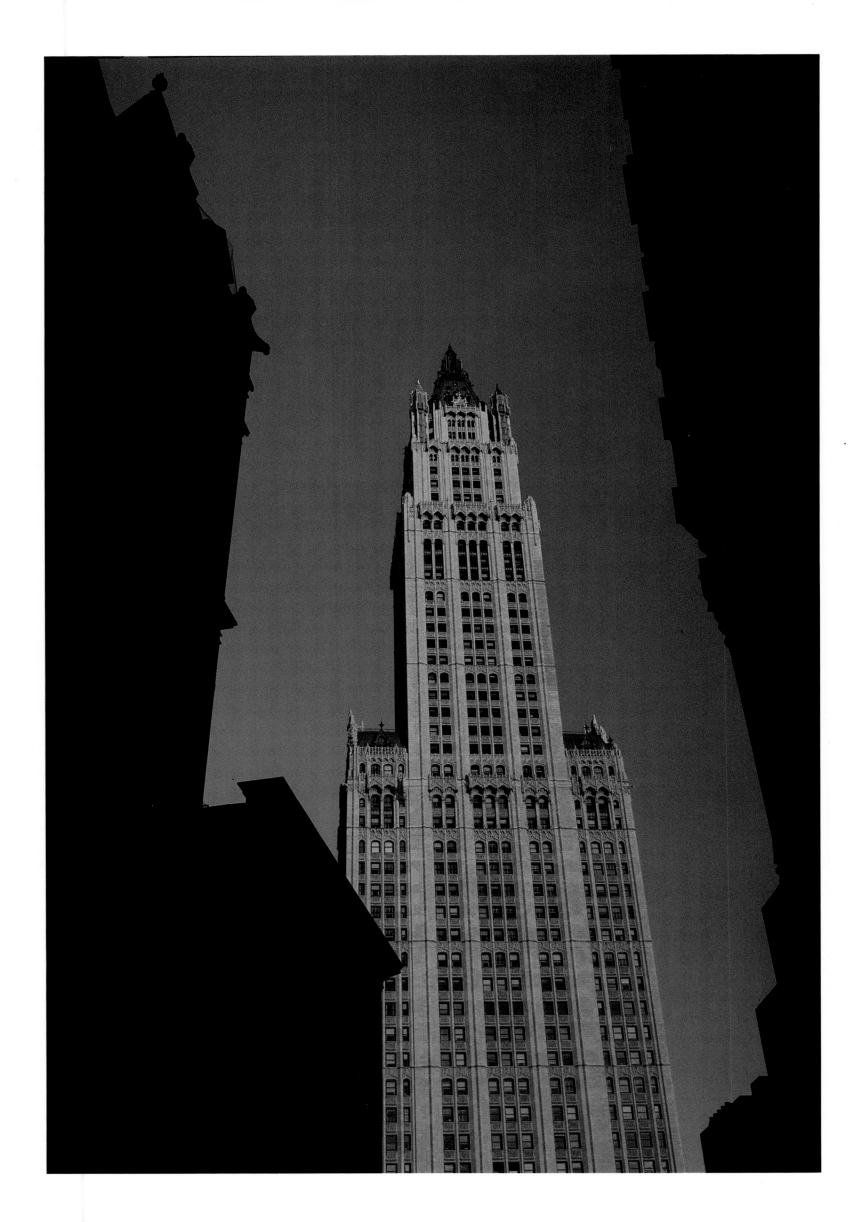

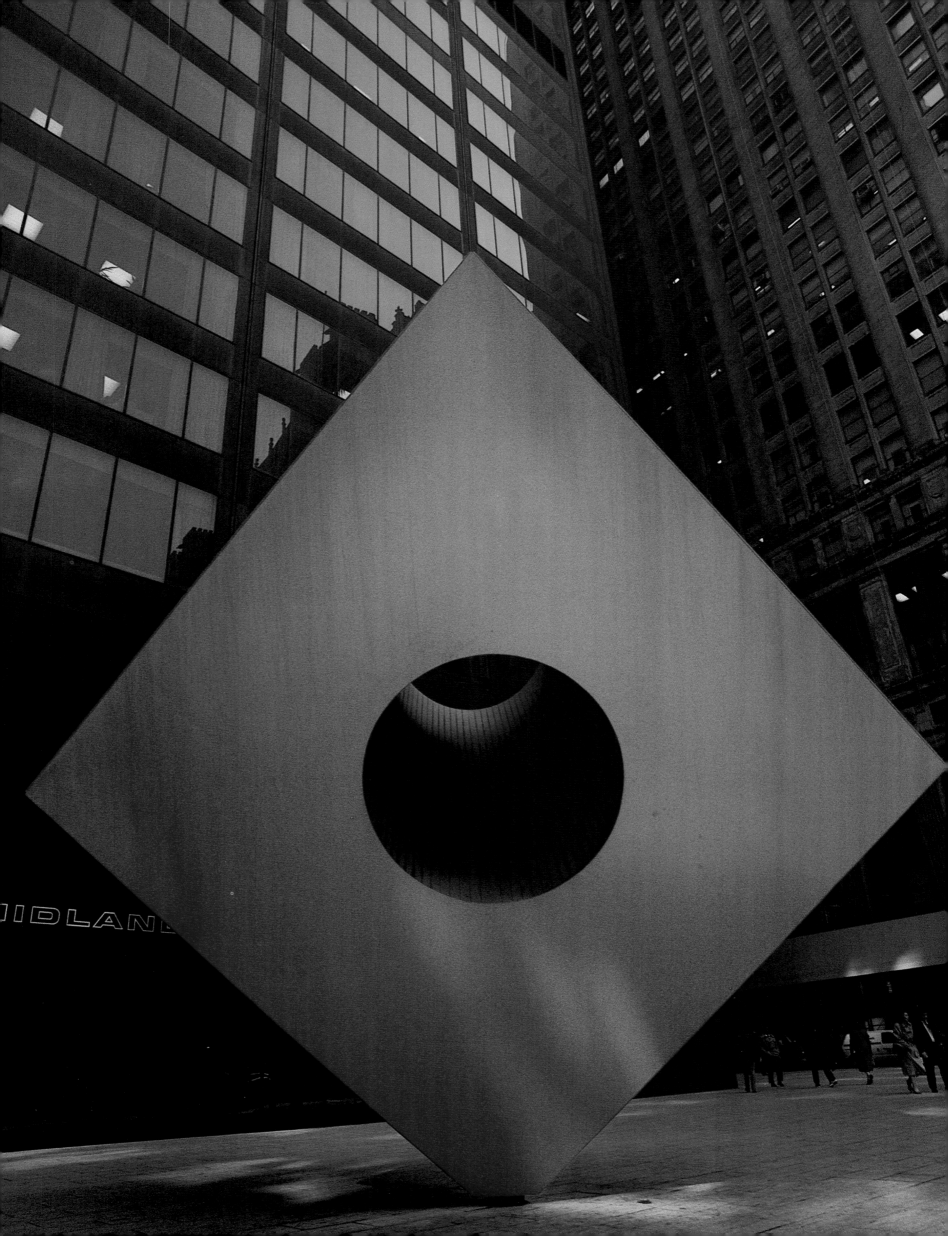

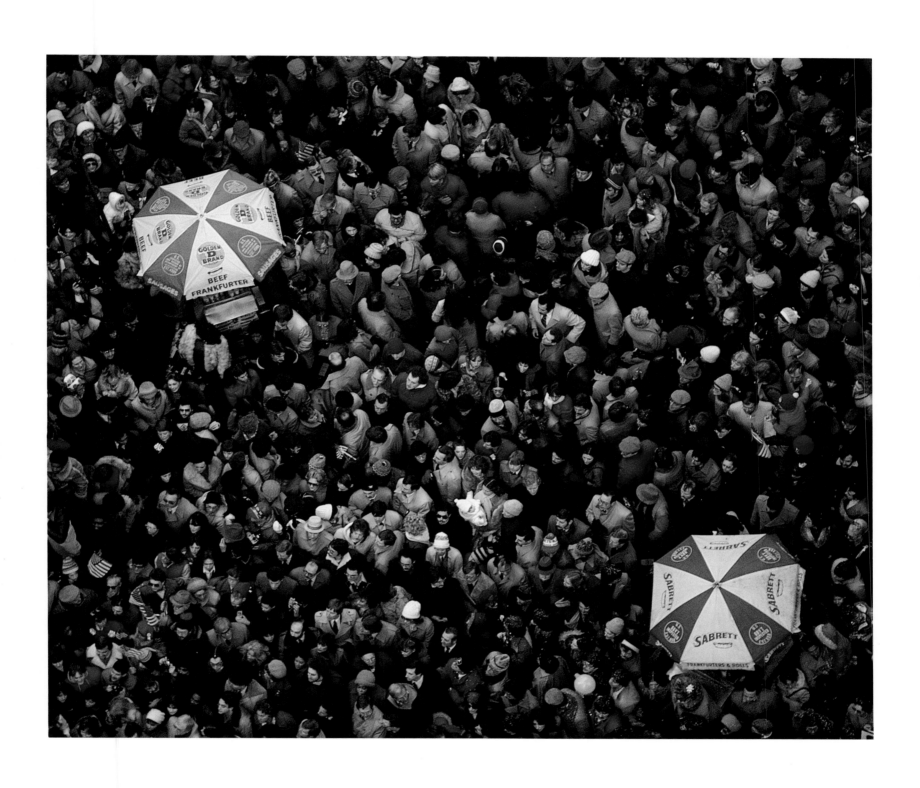

*It was a cruel city, but it was a lively one, a savage city yet
it had such tenderness; a bitter, harsh and violent catacomb
of stone and steel and tunneled rock, slashed savagely with
light . . . yet it was so sweetly and so delicately pulsed . . .
full of warmth, of passion and of love.*
<div align="right">*—Thomas Wolfe*</div>

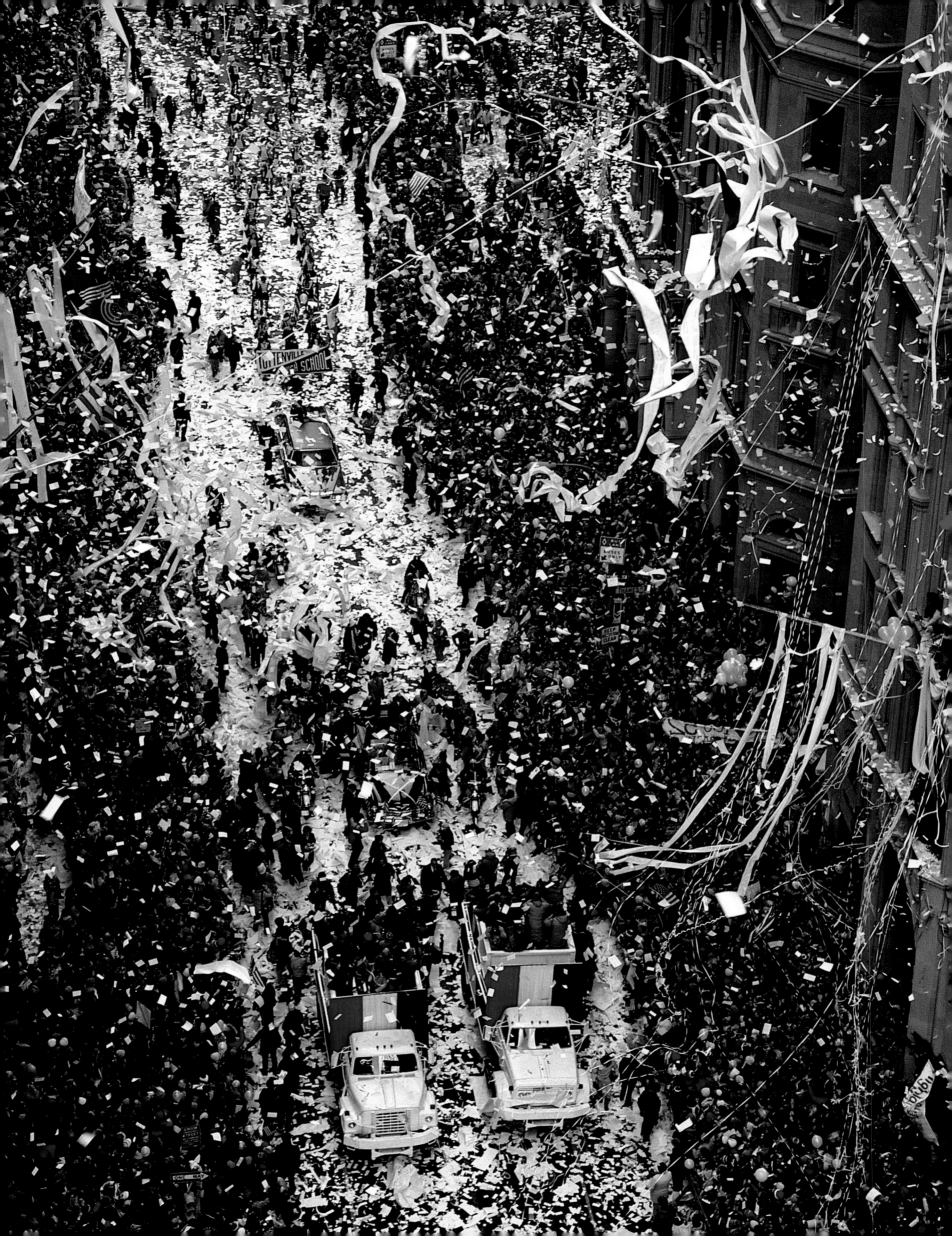

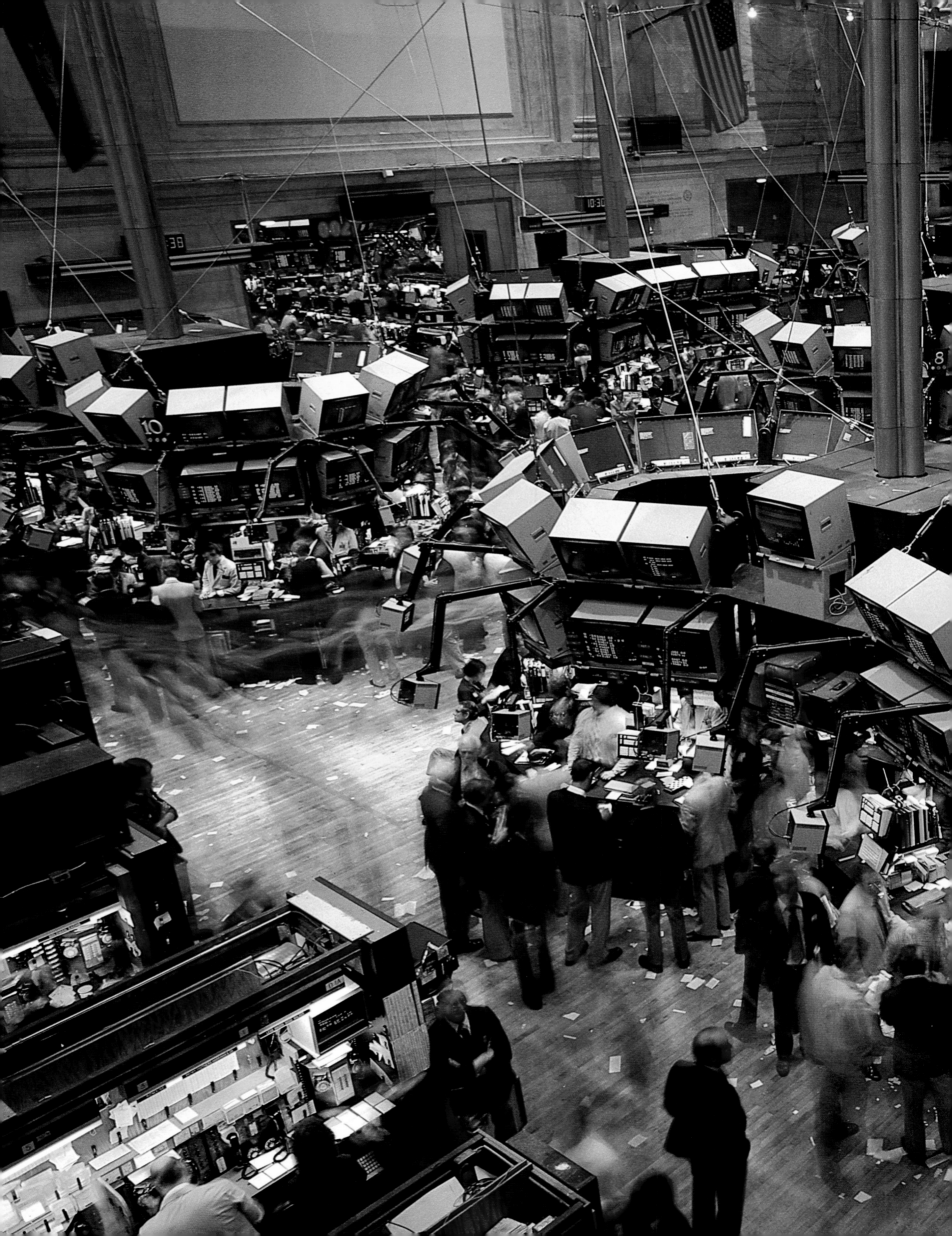

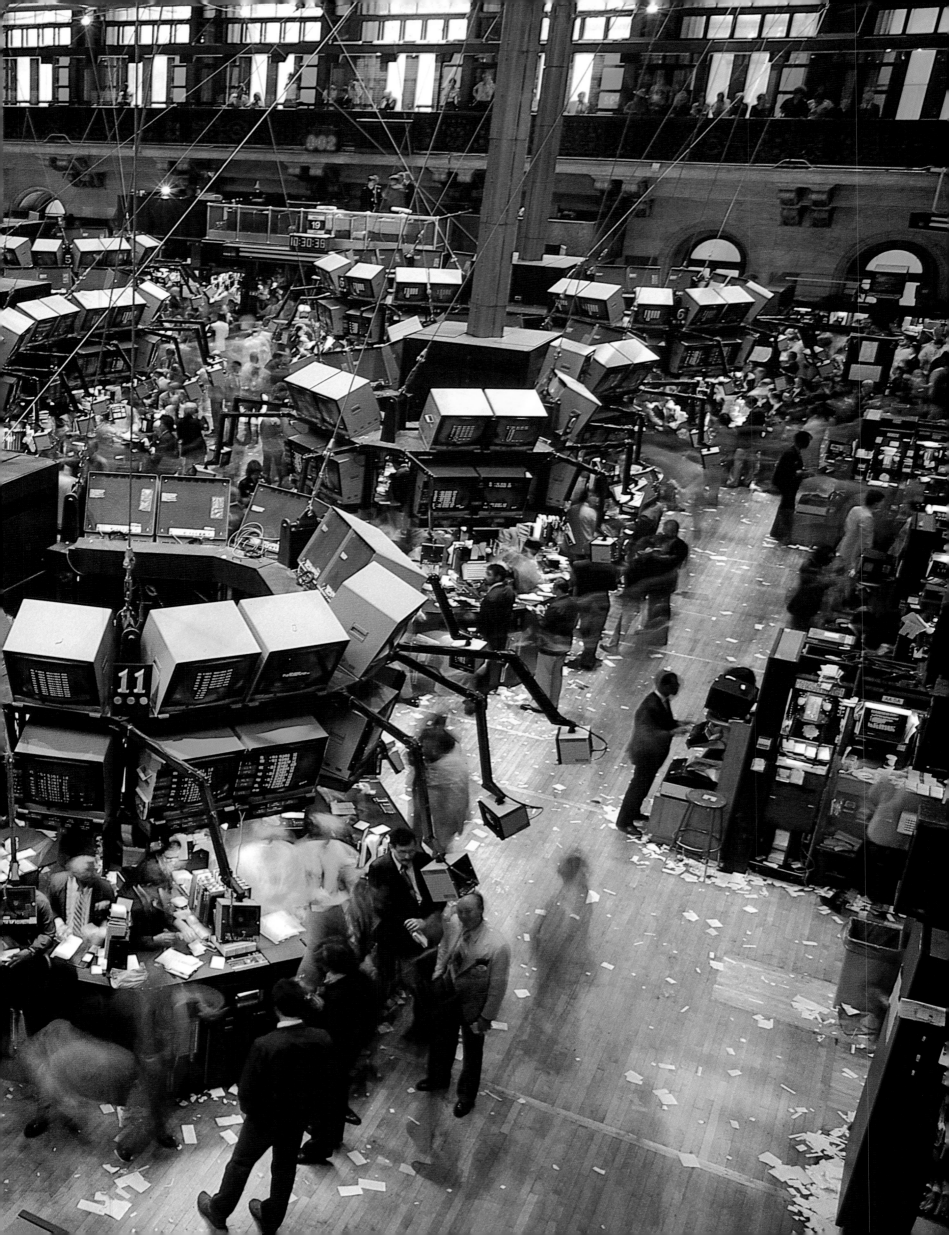

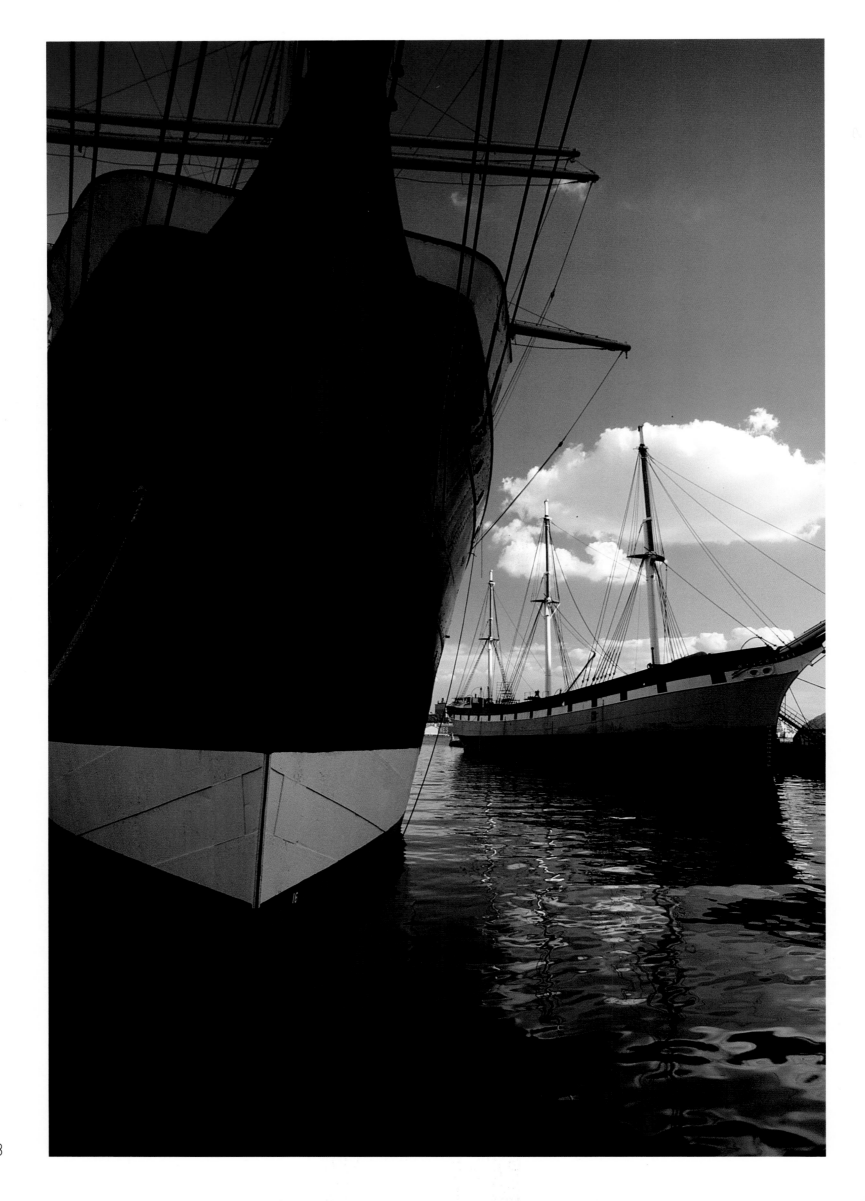

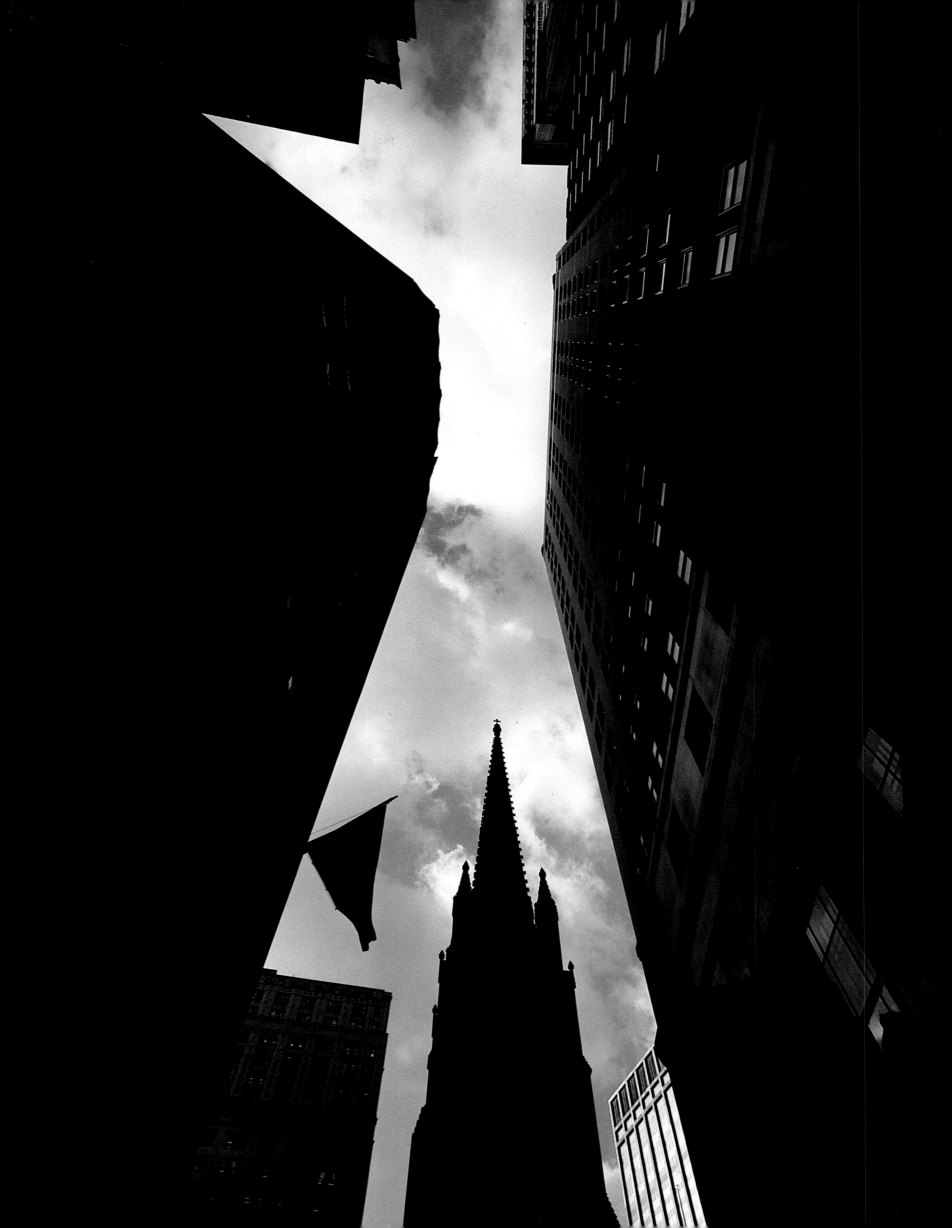

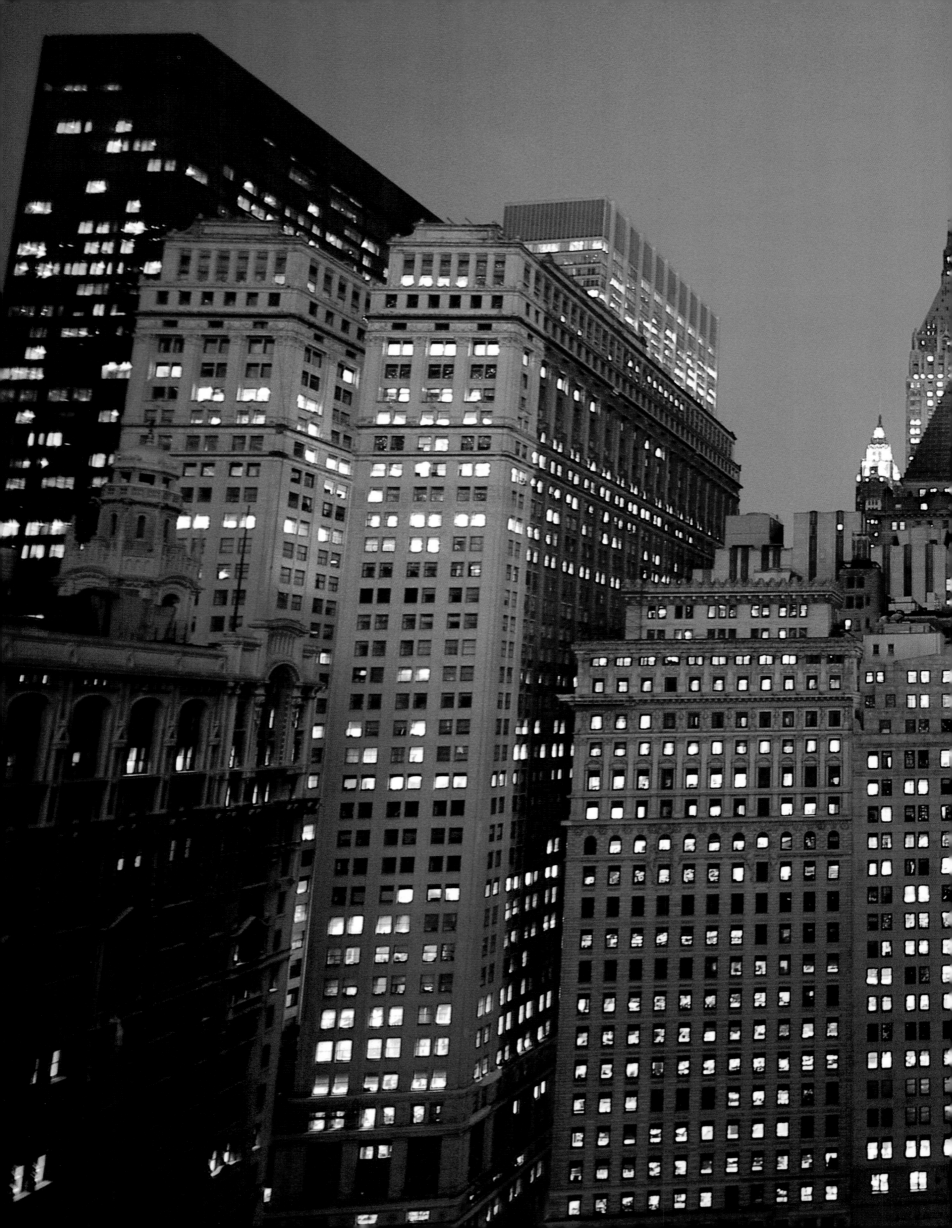

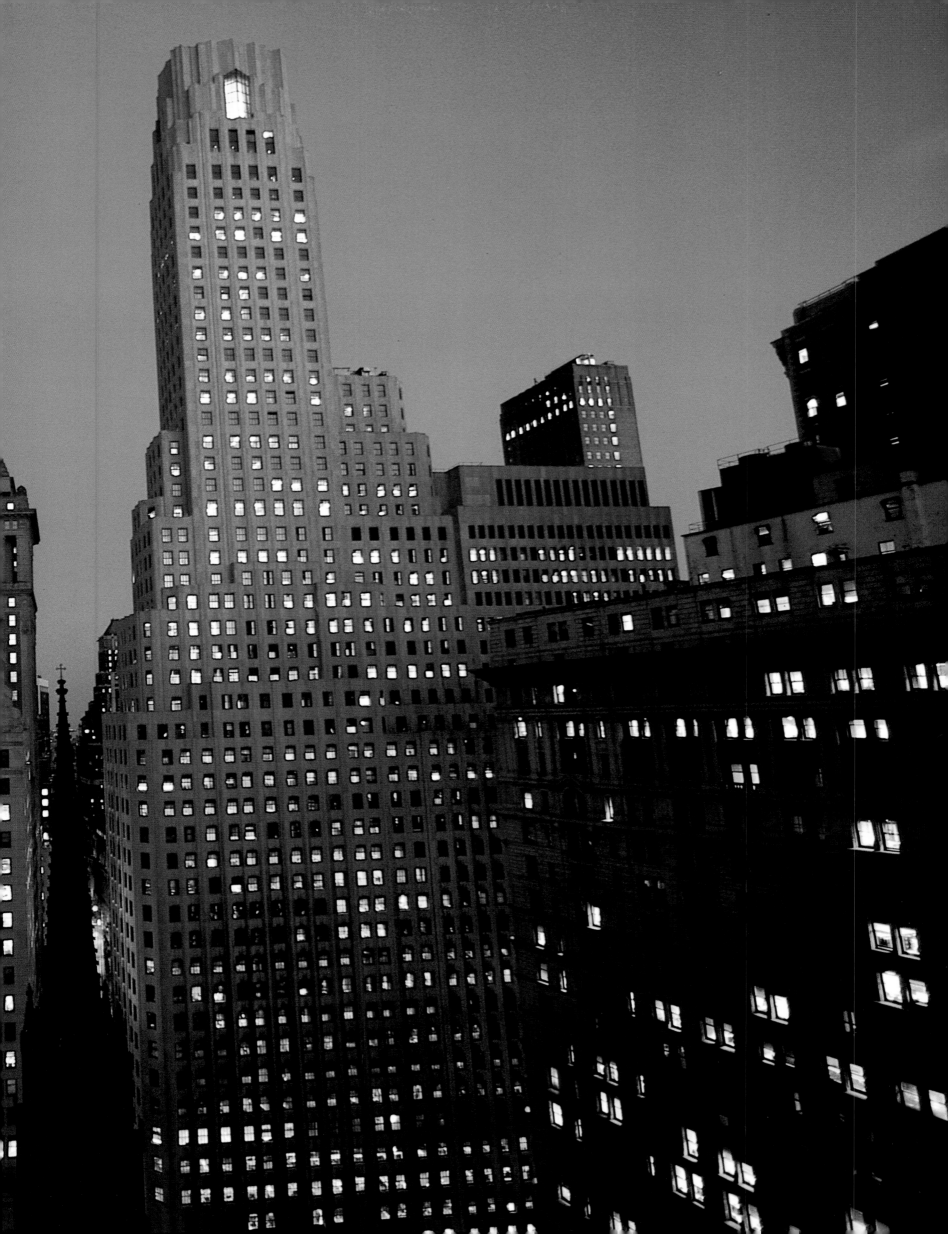

And rising out of the midst, tall-topt, ship-hemm'd, modern,
American, yet strangely oriental, V-shaped Manhattan, with
its compact mass, its spires, its cloud-touching edifices
group'd at the centre—and all the white, brown, and gray
of the architecture well blended under a miracle of limpid
sky and June haze on the surface below.

—Walt Whitman

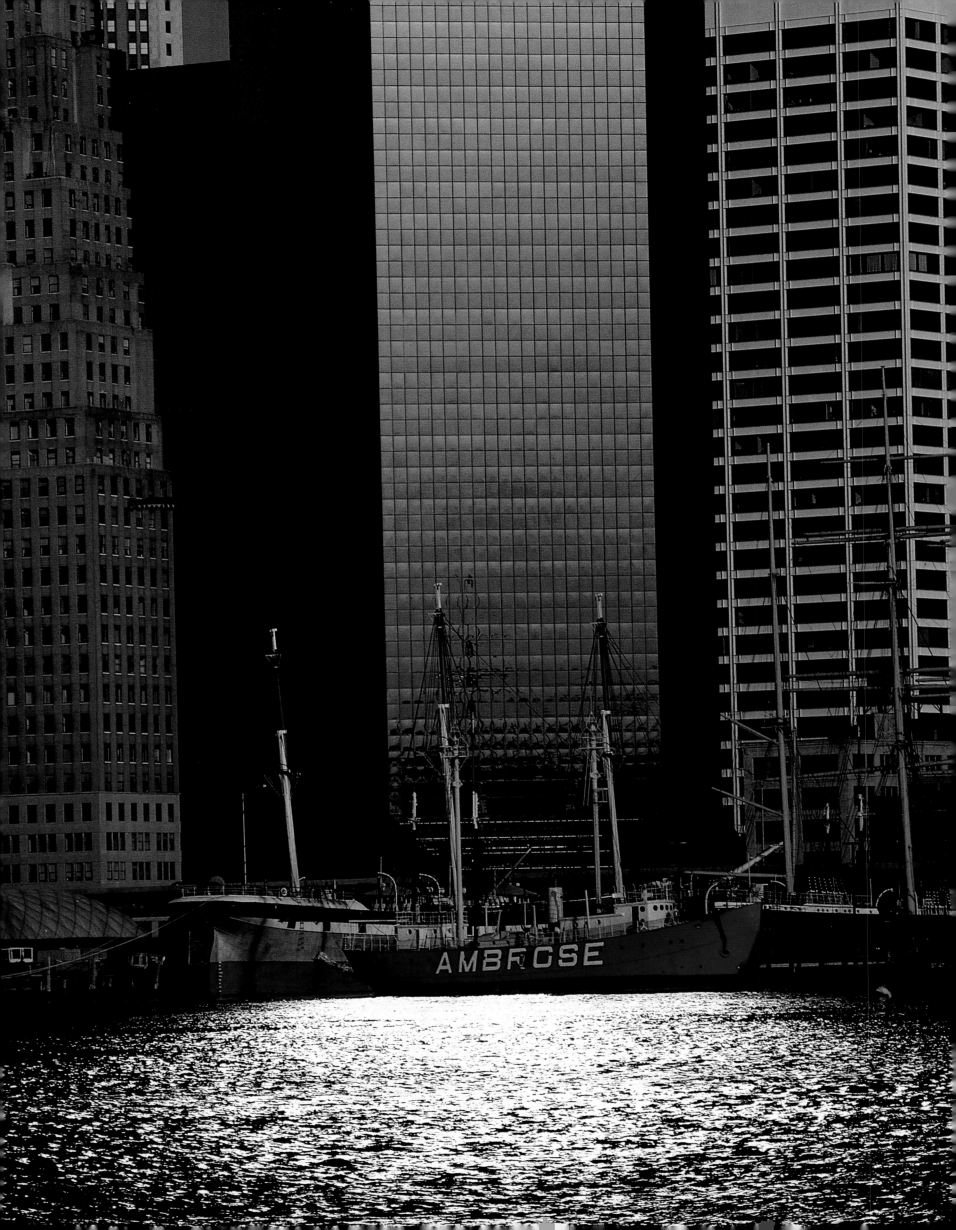

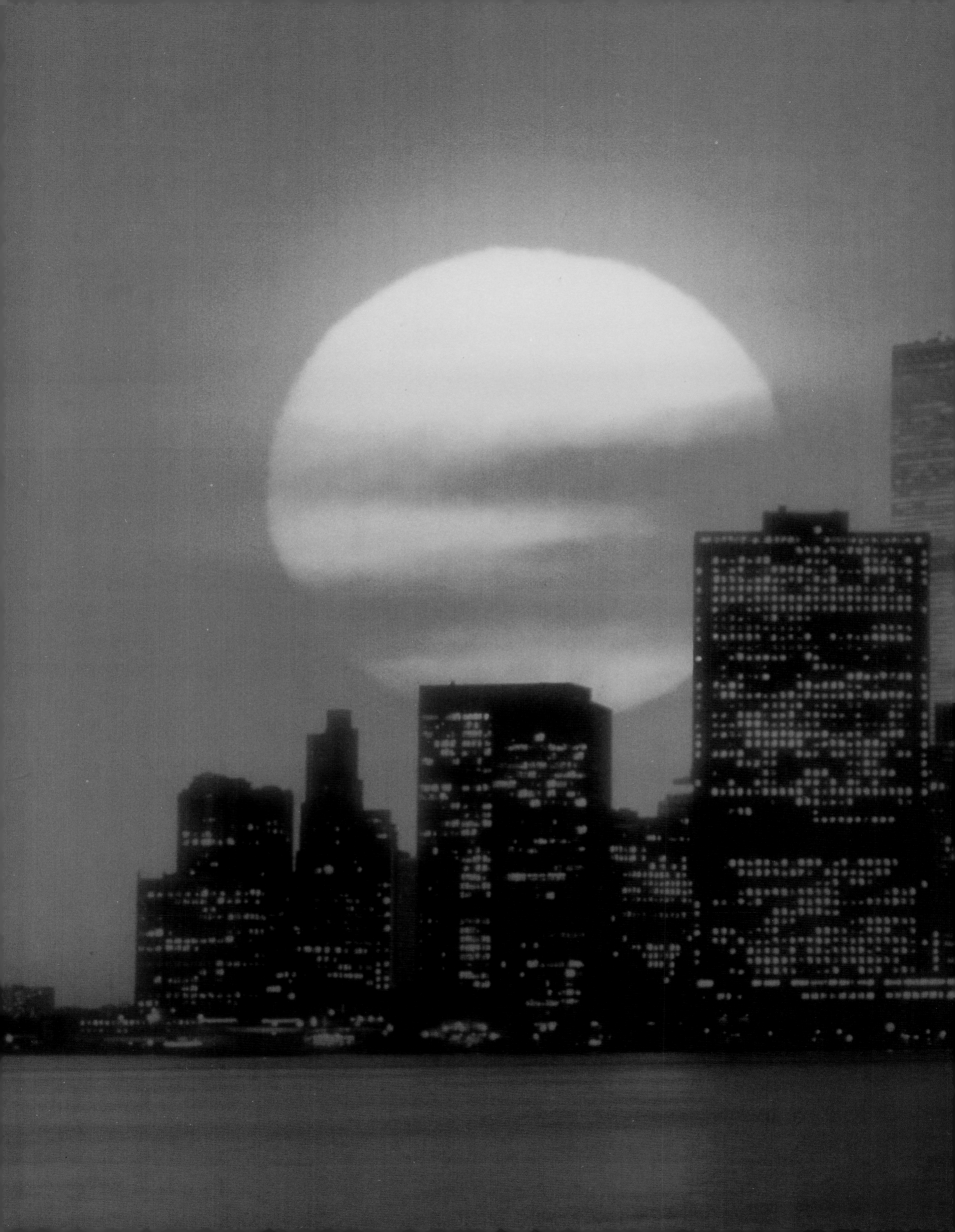

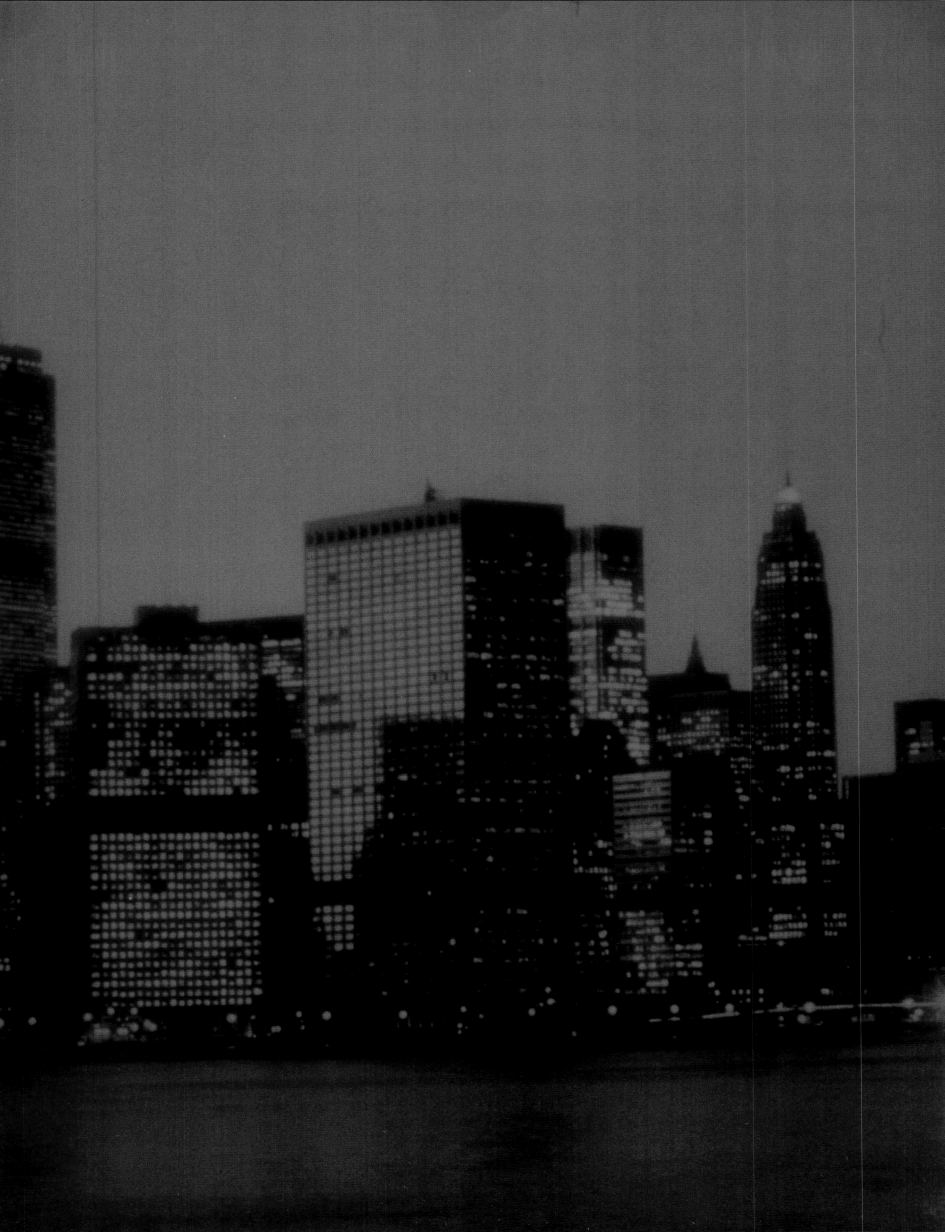

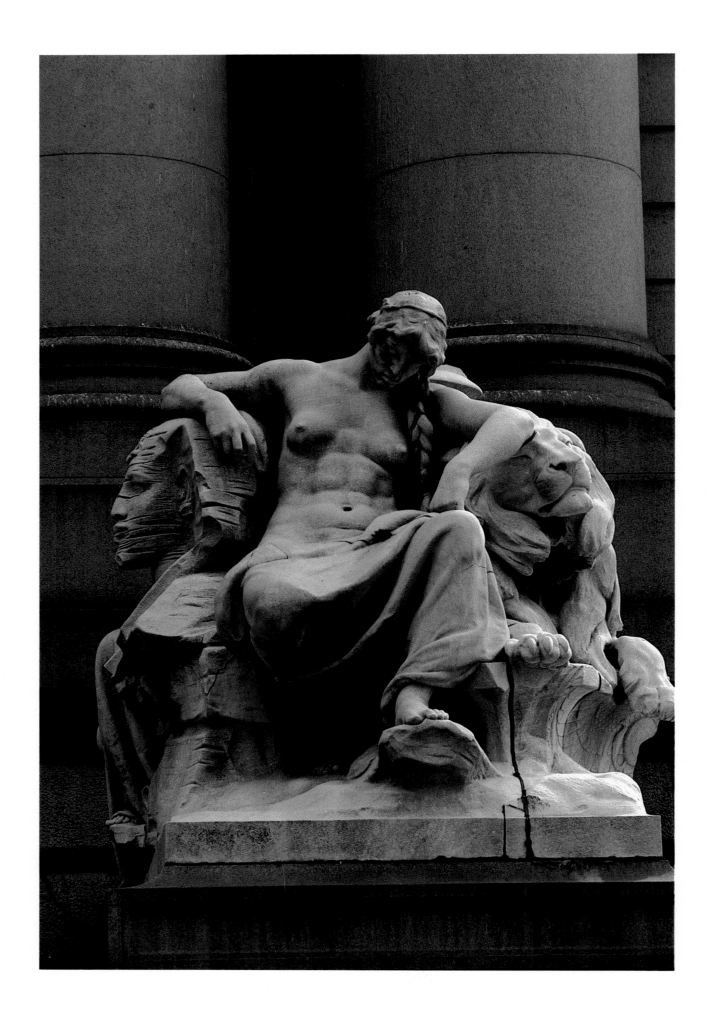

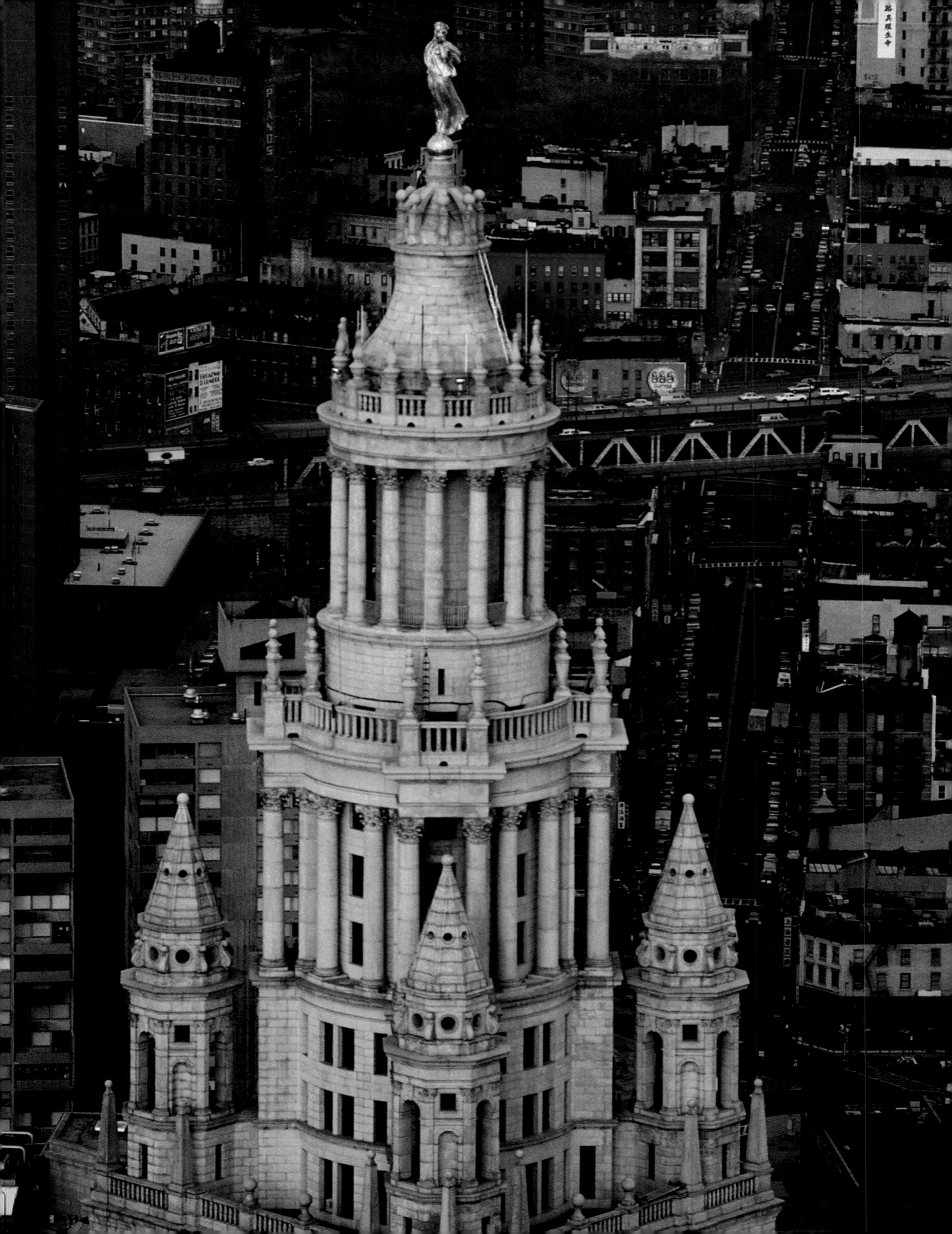

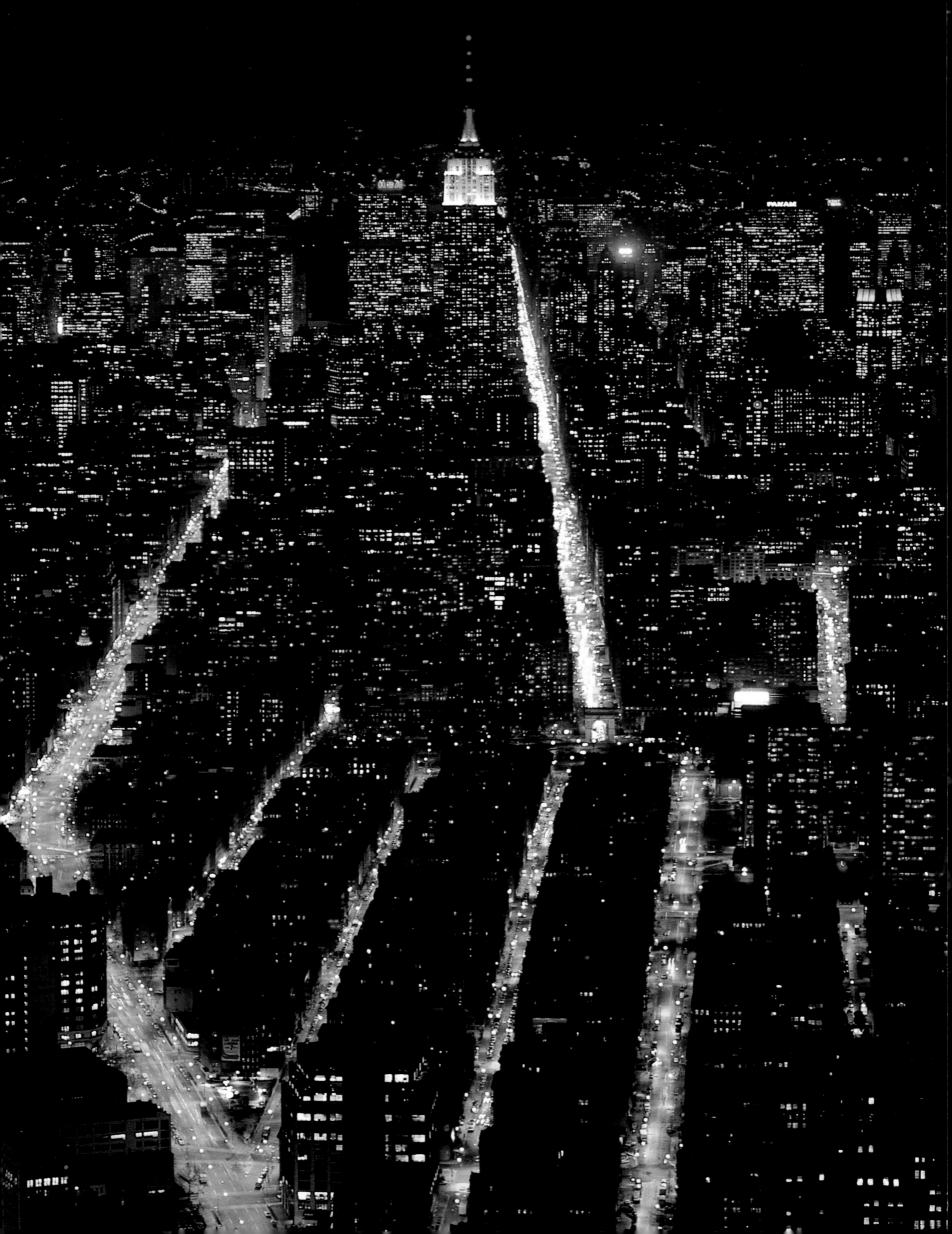

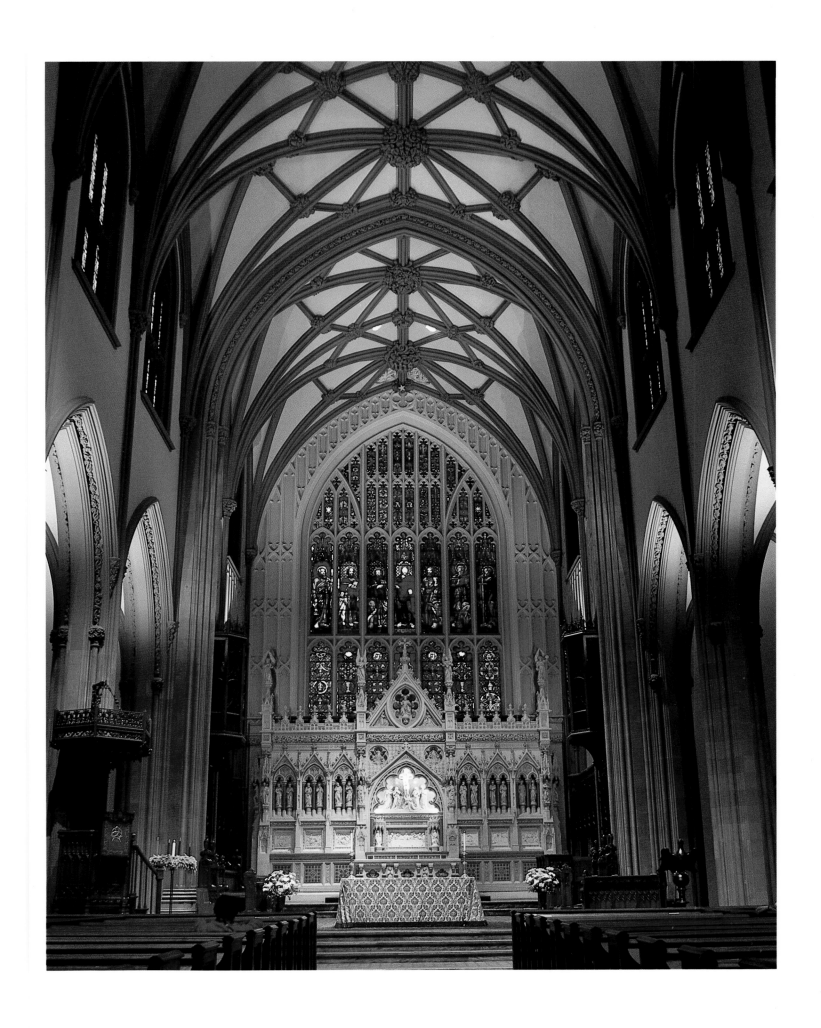

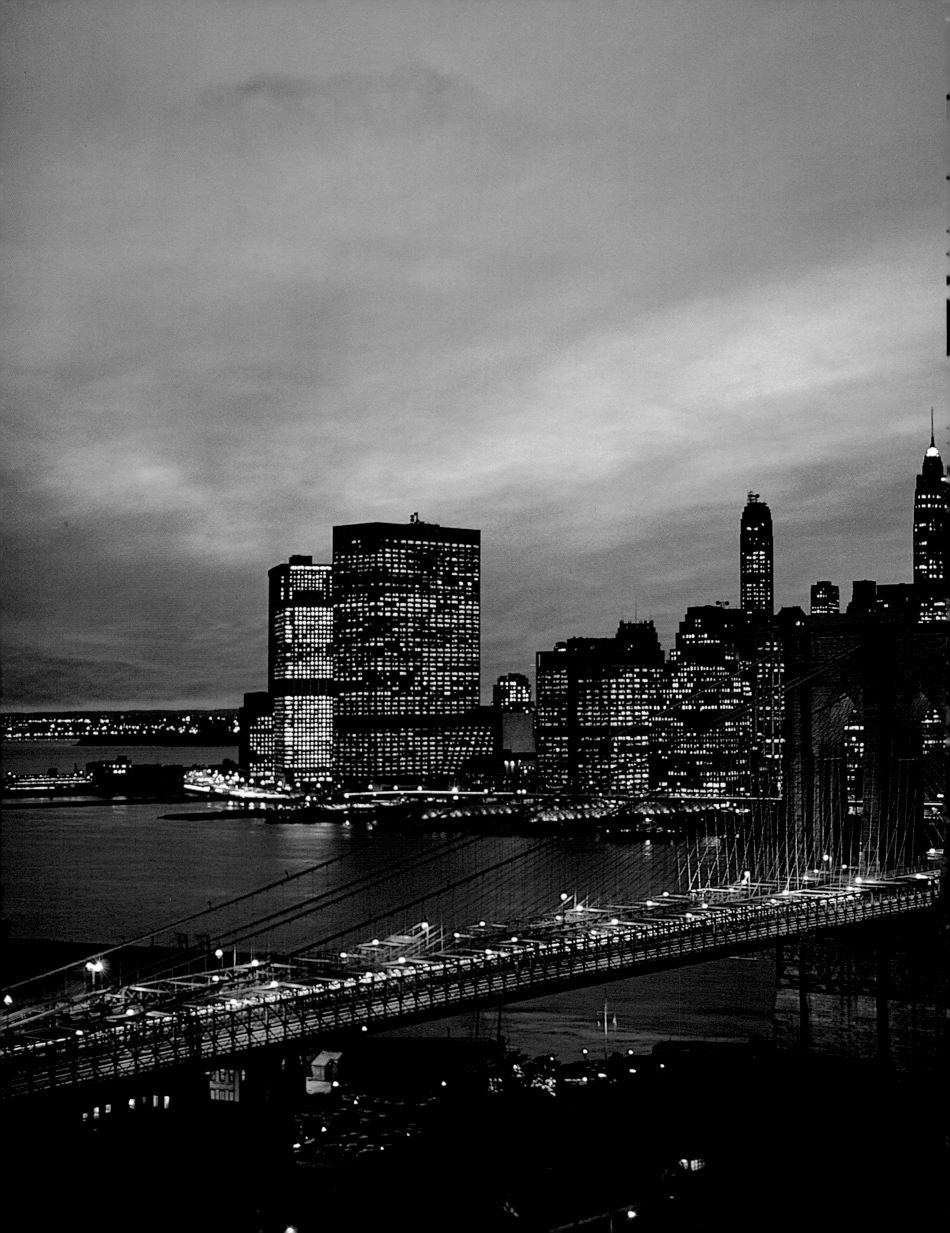

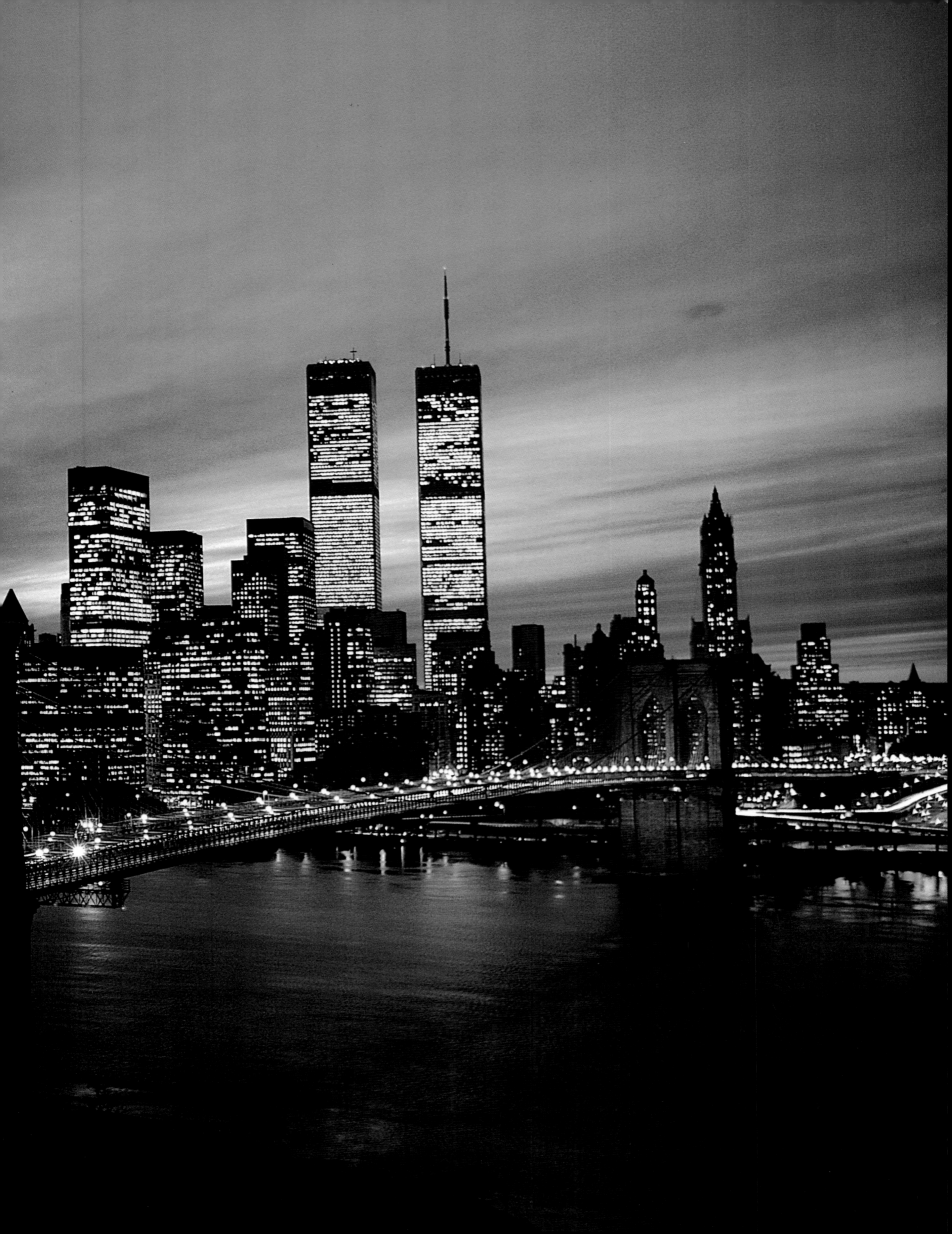

New Yorkers walk faster, talk faster, and think faster. You don't have to be born here to be a New Yorker. But after six months here, you'll be walking faster, talking faster, and thinking faster. At that point, you will have become a New Yorker.

—Edward I. Koch

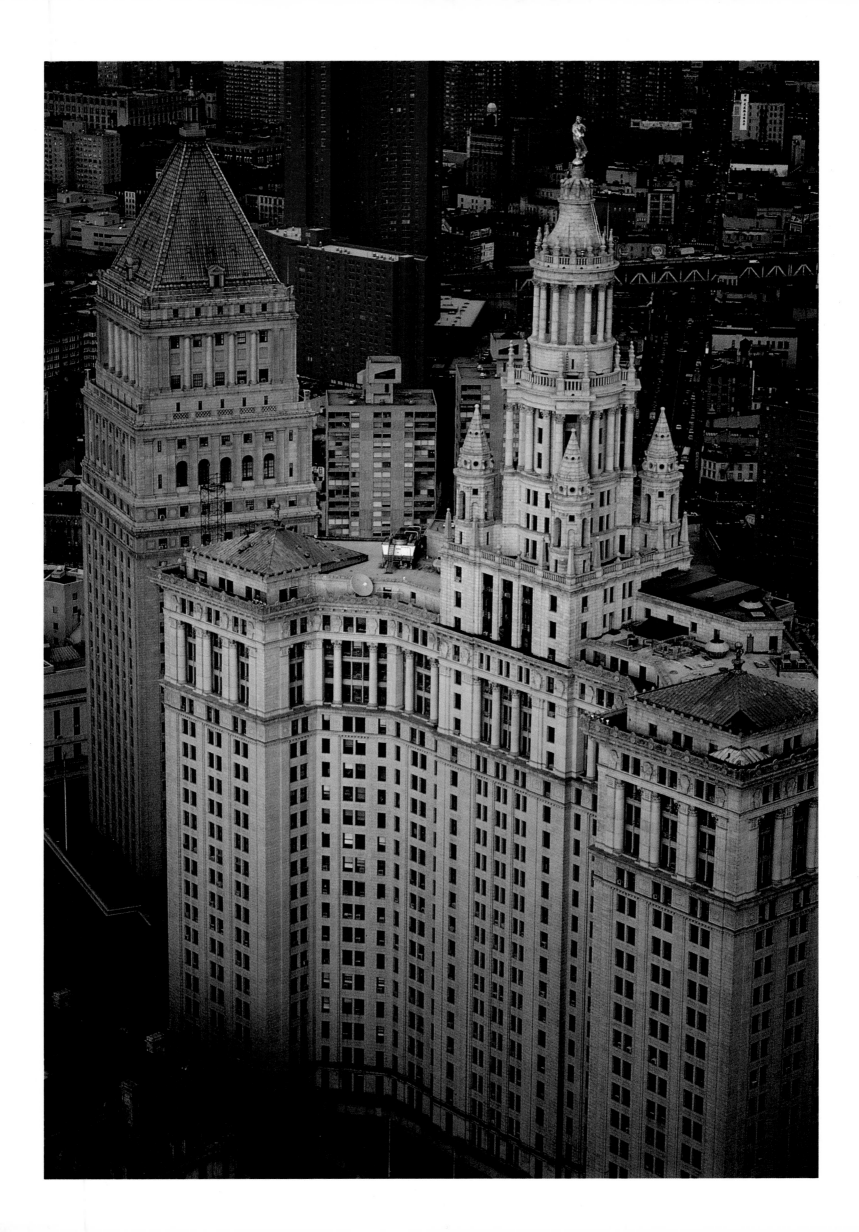

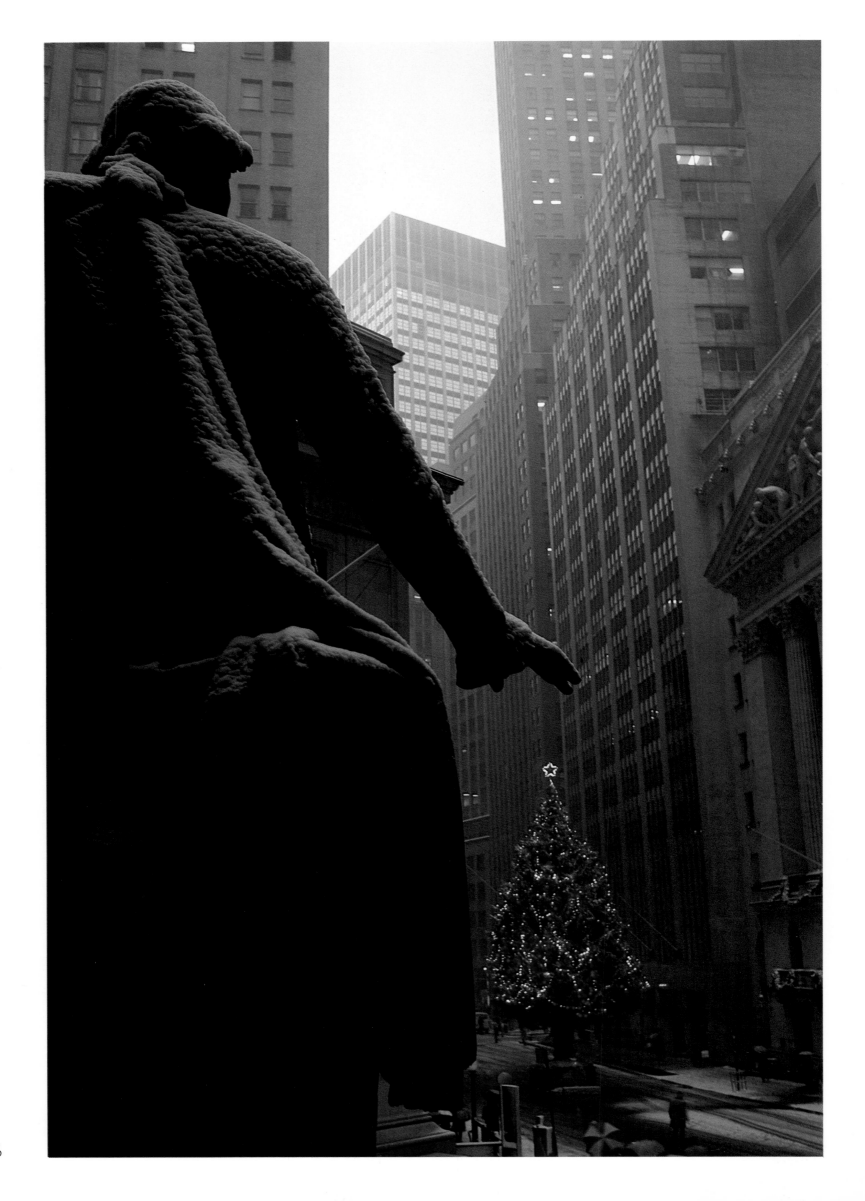

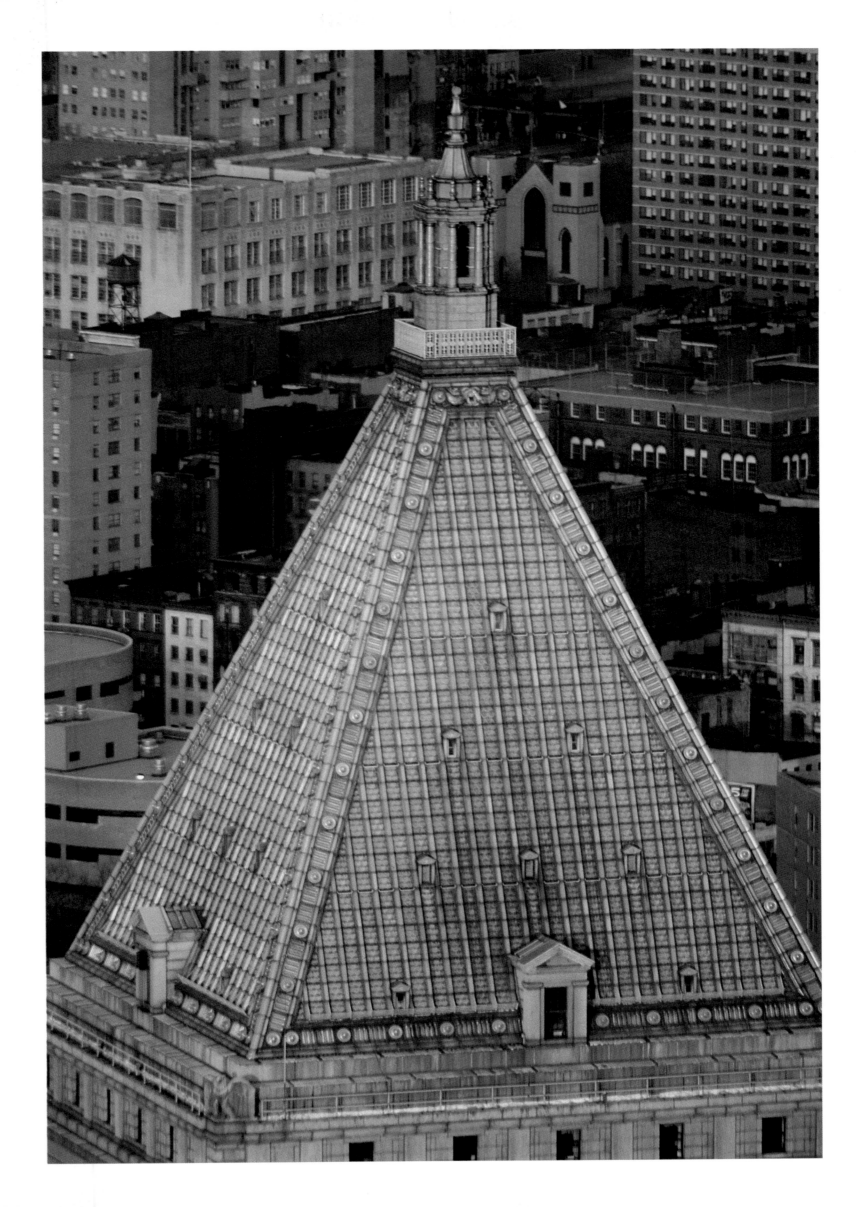

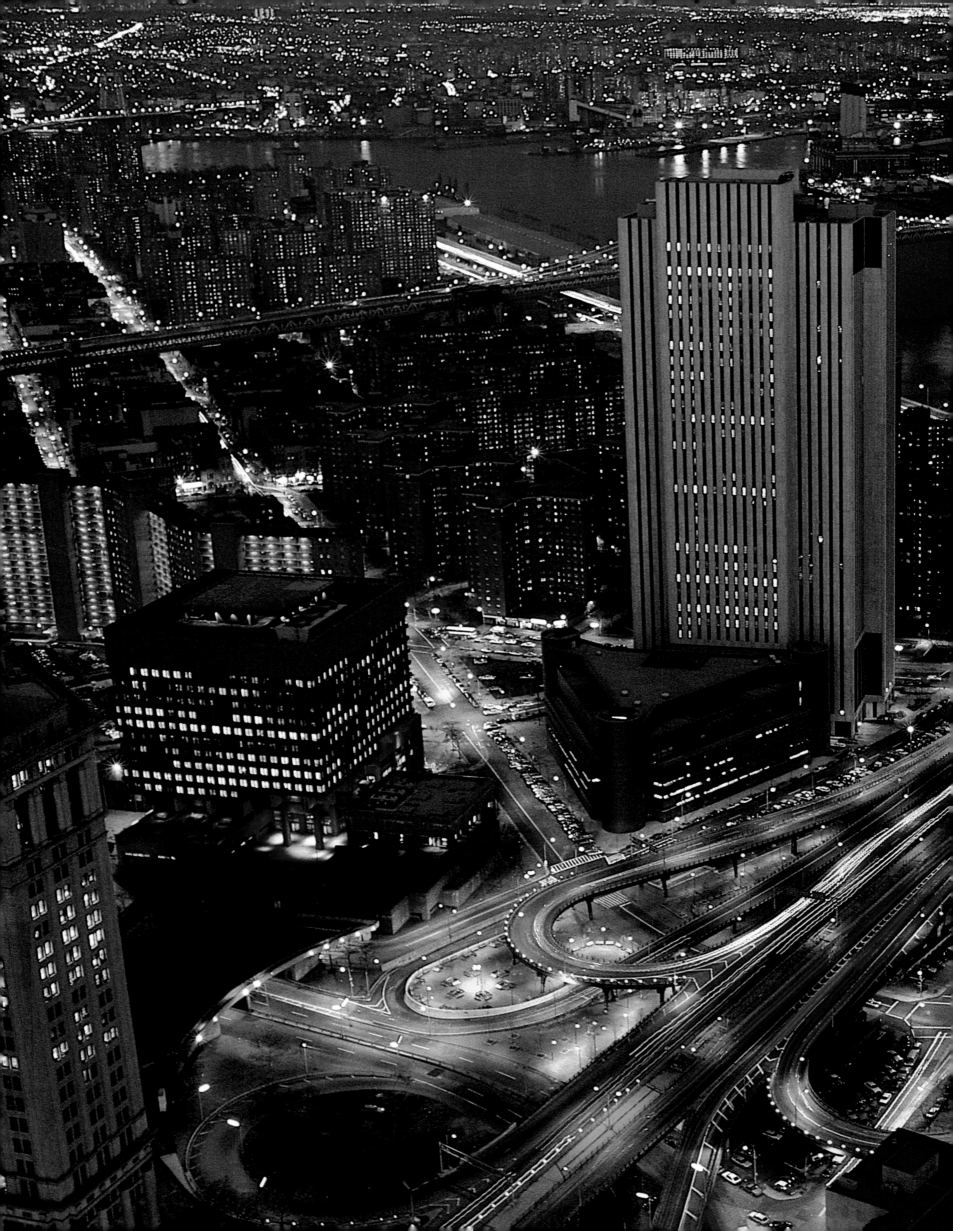

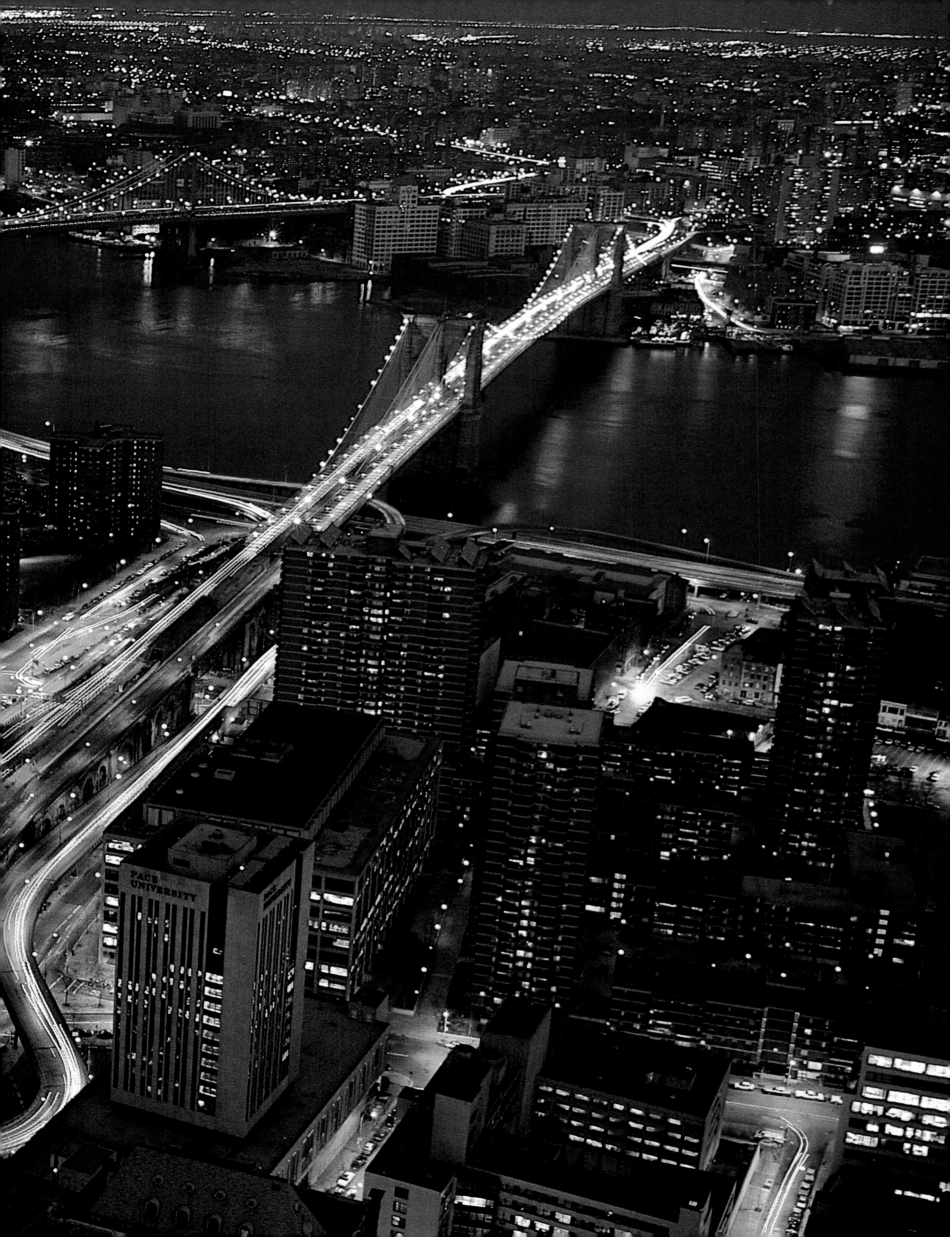

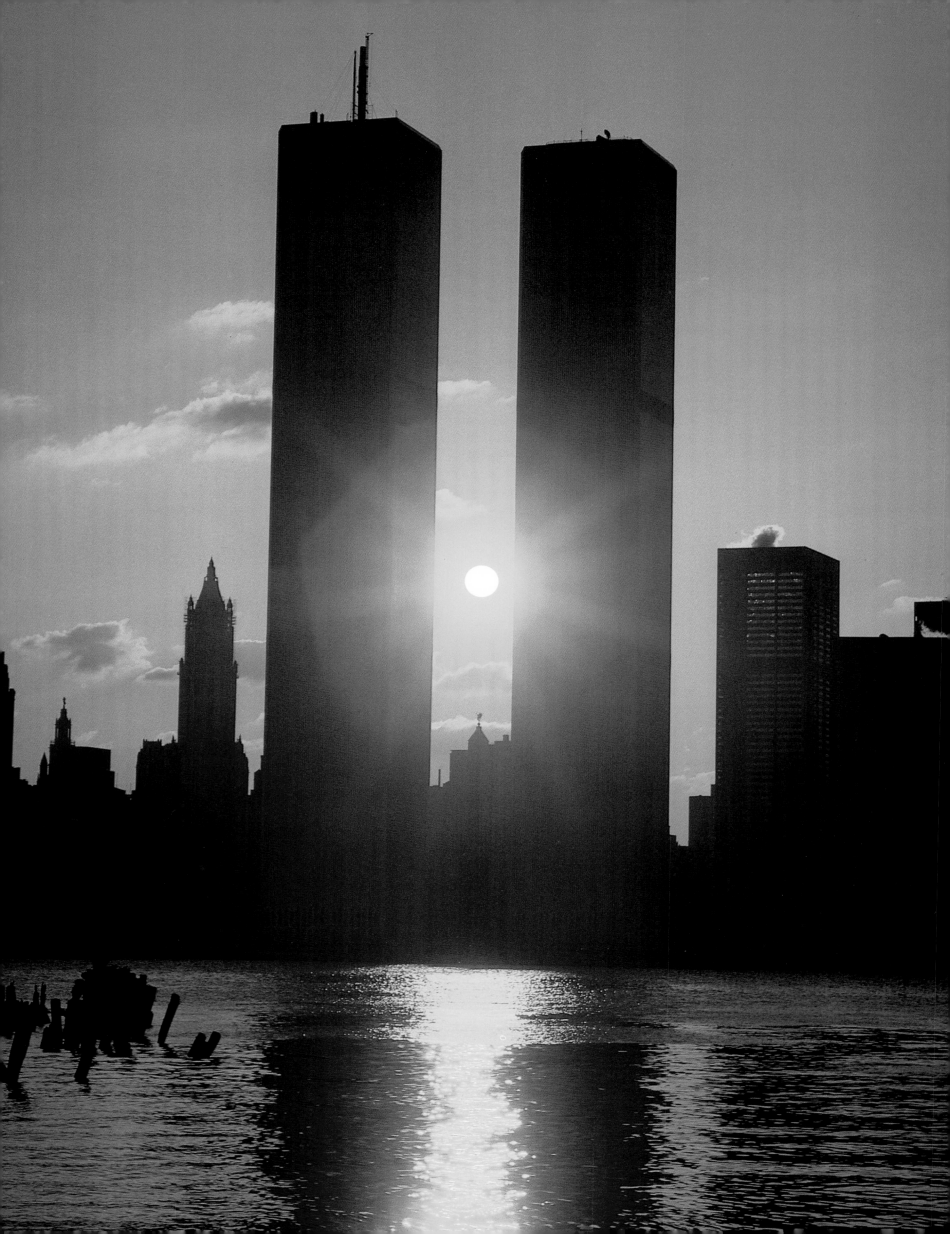

VILLAGES

Artists' and ethnic neighborhoods

*Frantic, eclectic, layered, a compost piled on top of granite
that is laced with hidden seams and underground rivers.*
—Pete Hamill

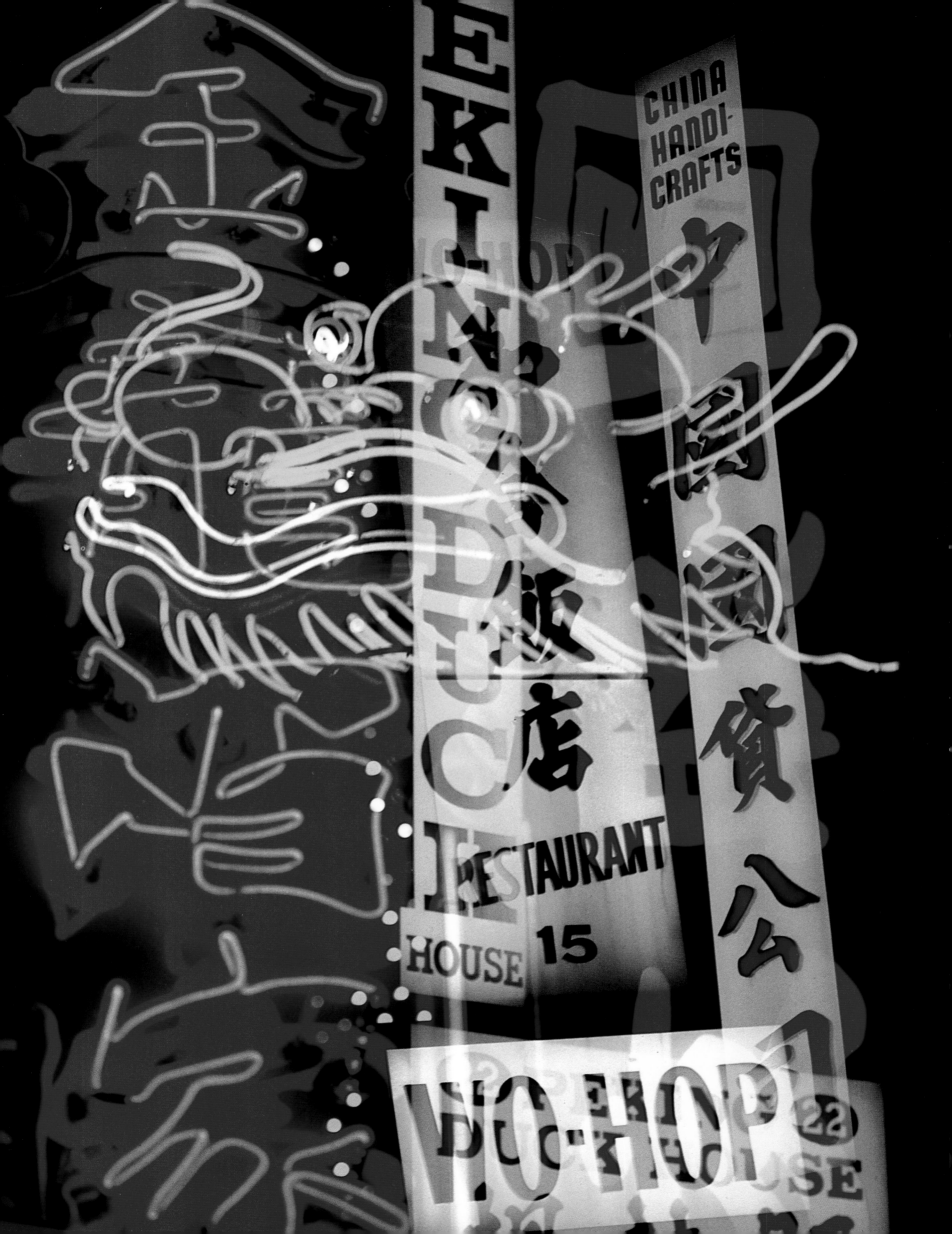

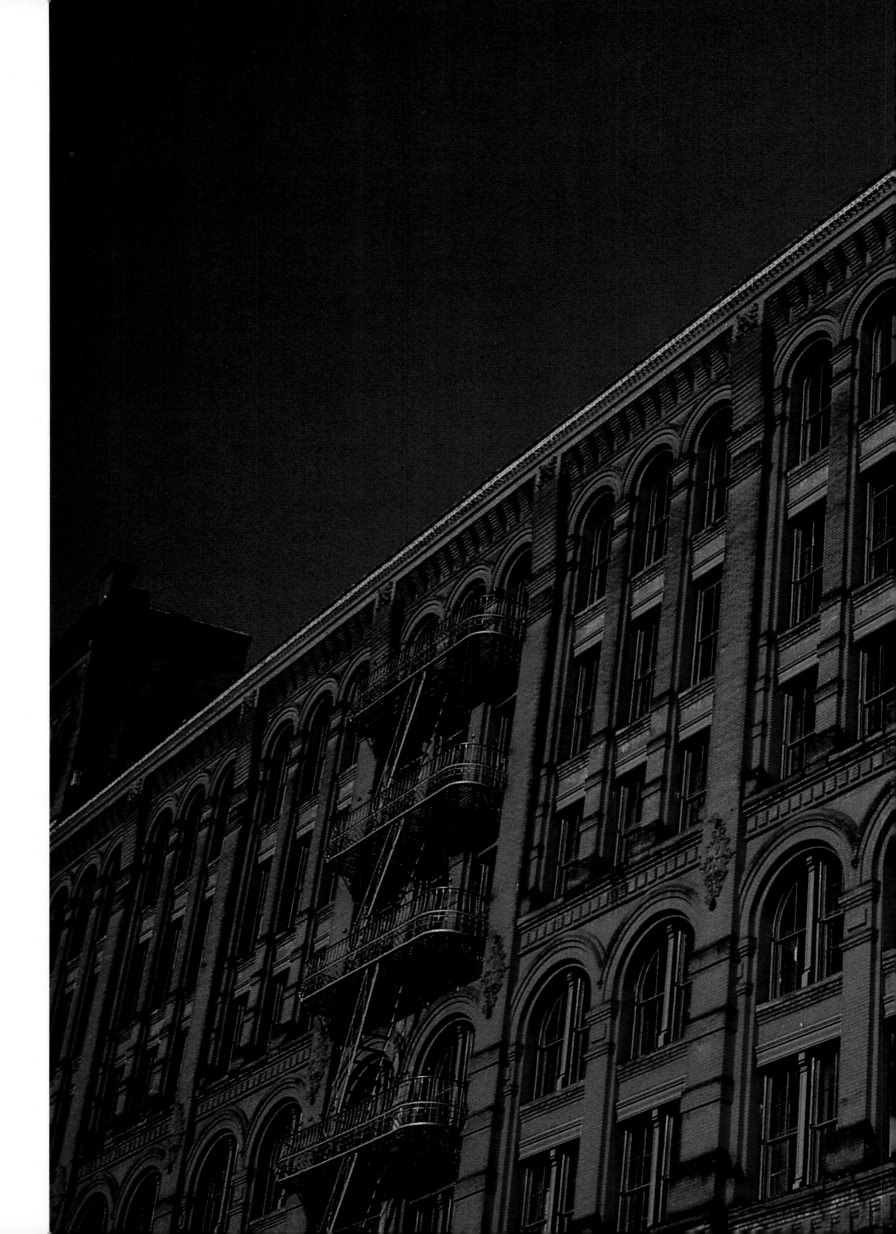

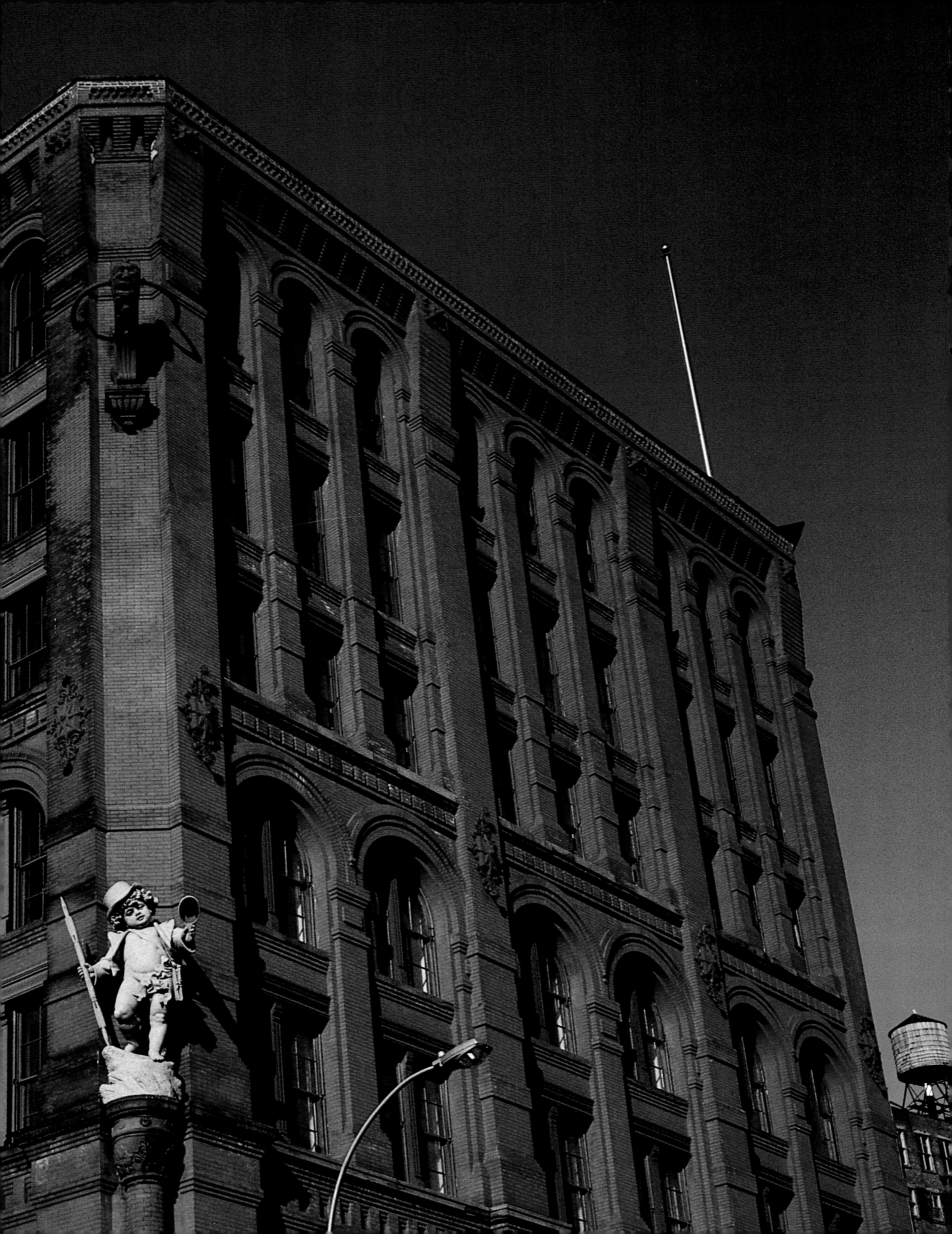

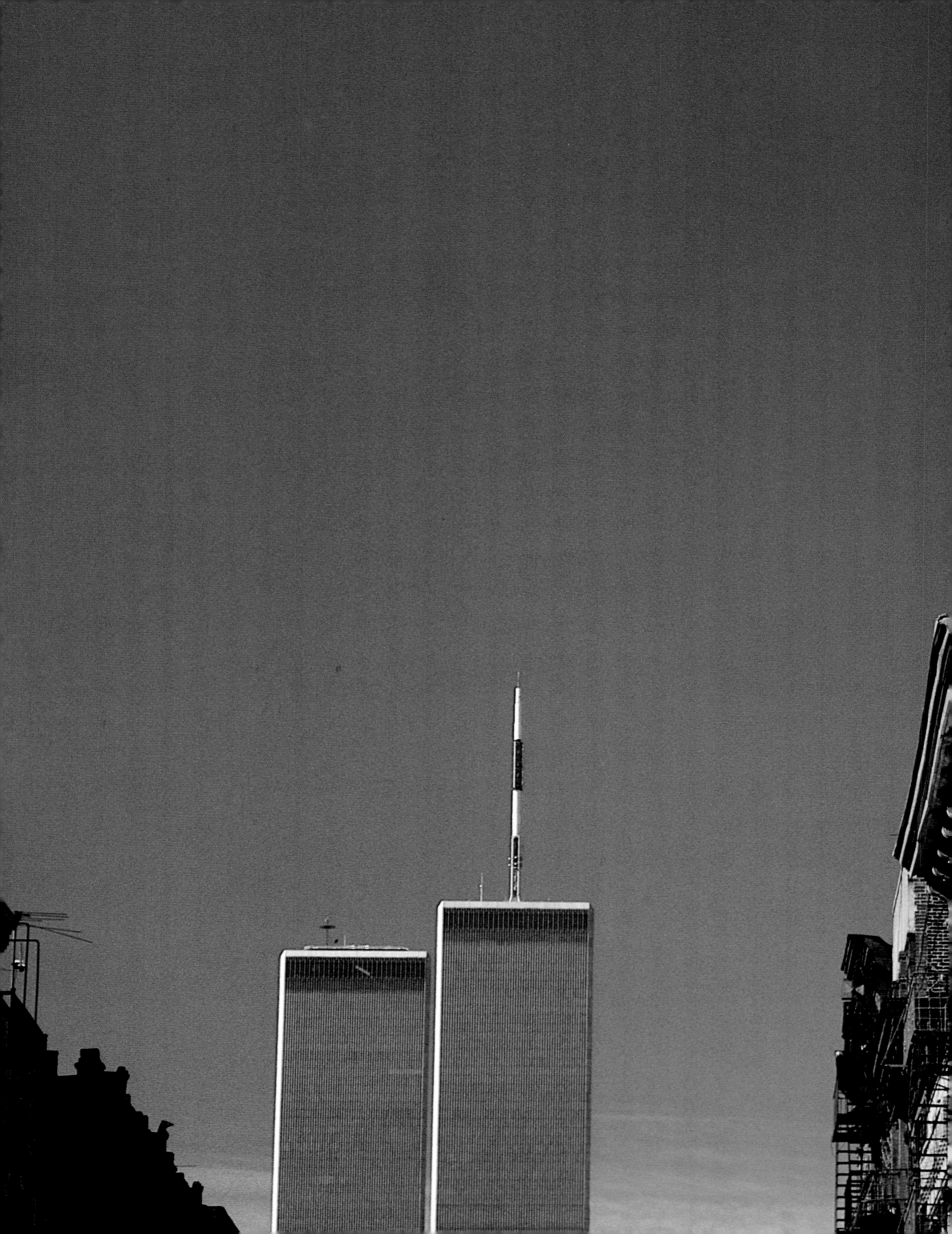

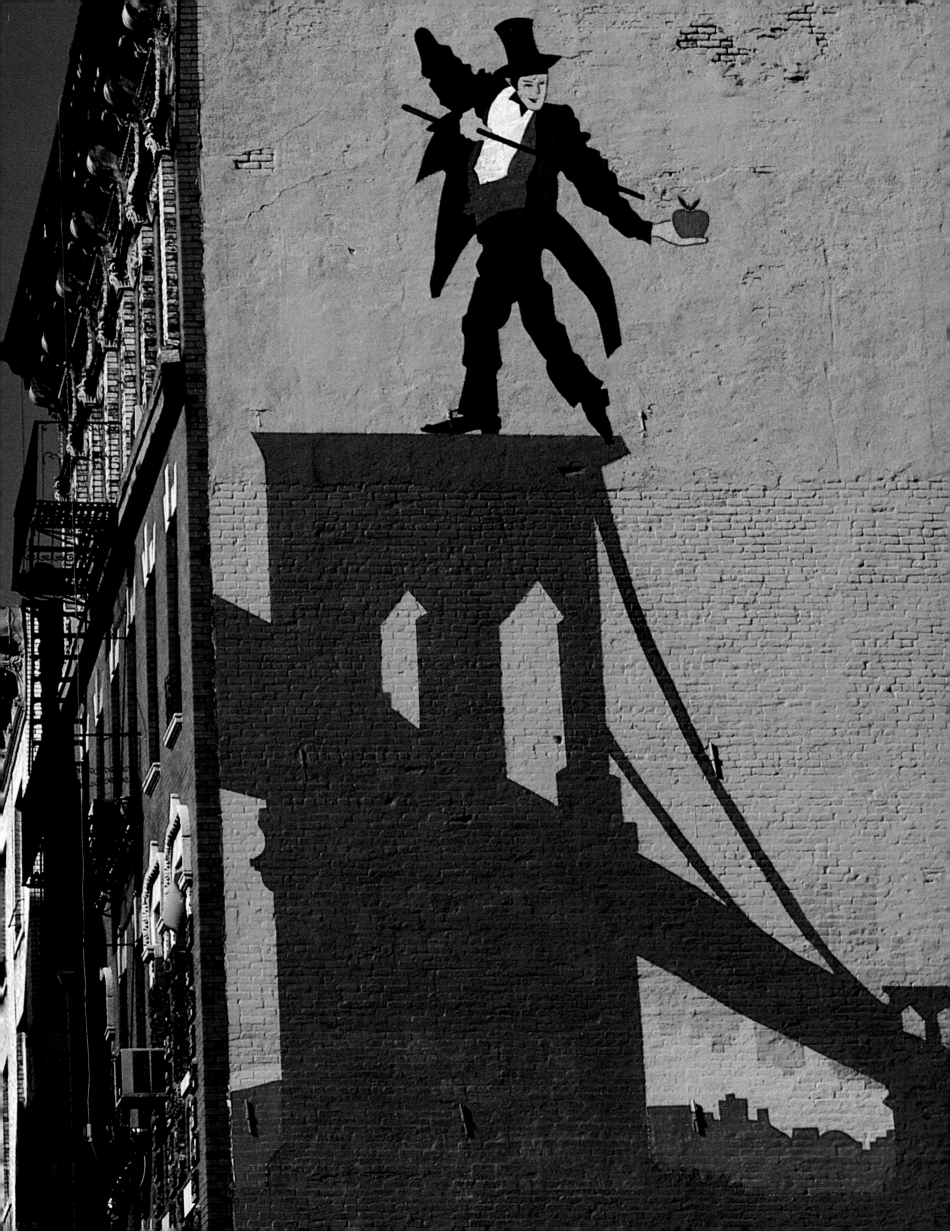

It was too much to believe and so huge, intricate, unfathomable, and beautiful in its distant, smoking, window-flashing, canyon-shadowed realness there, and the pink light glowing on its highest crests as bottomless shadows hung draped in mighty abysms. . . .

—Jack Kerouac

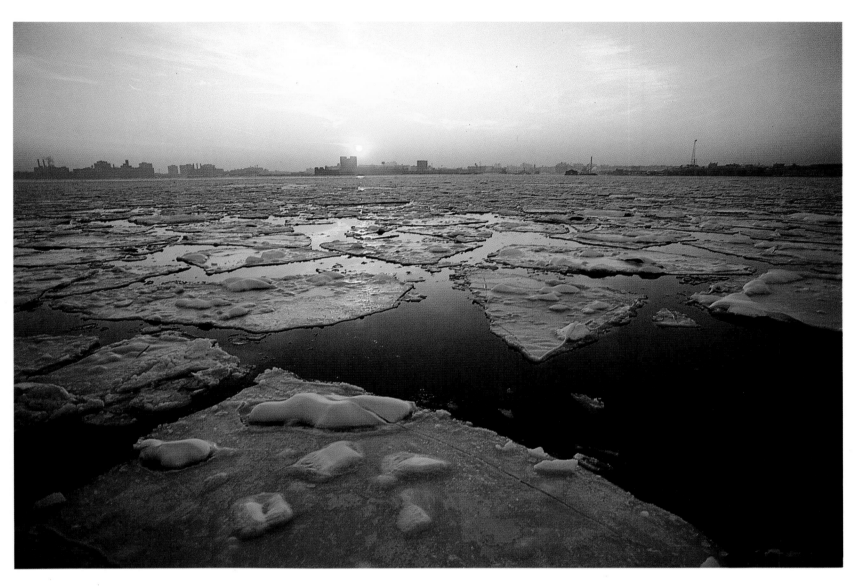
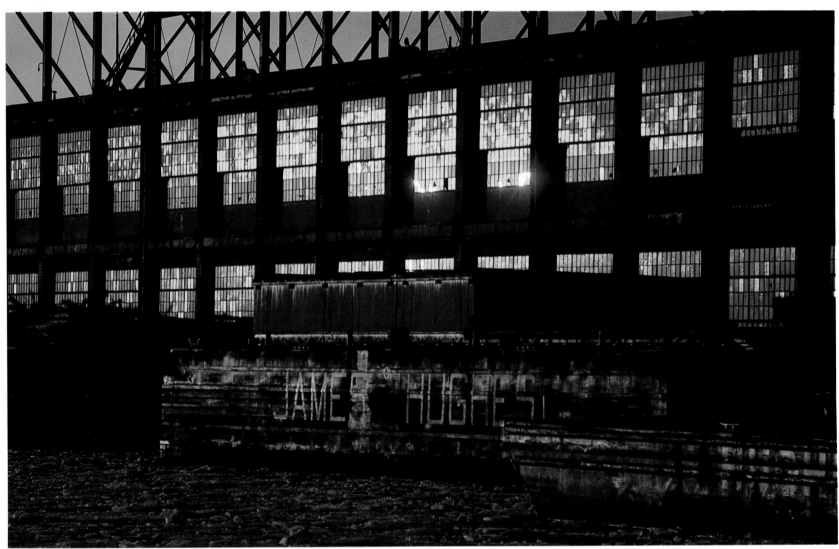

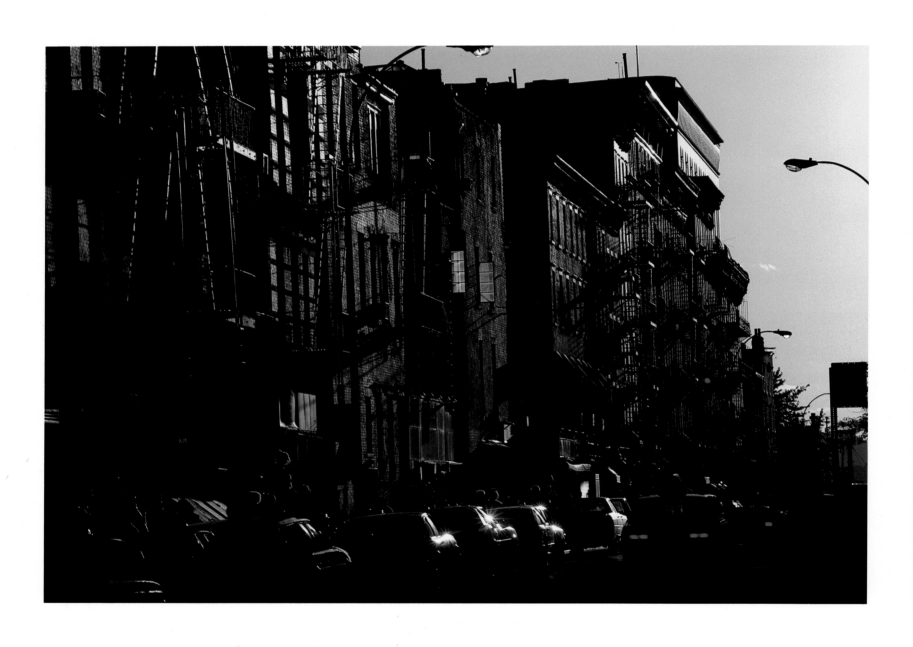

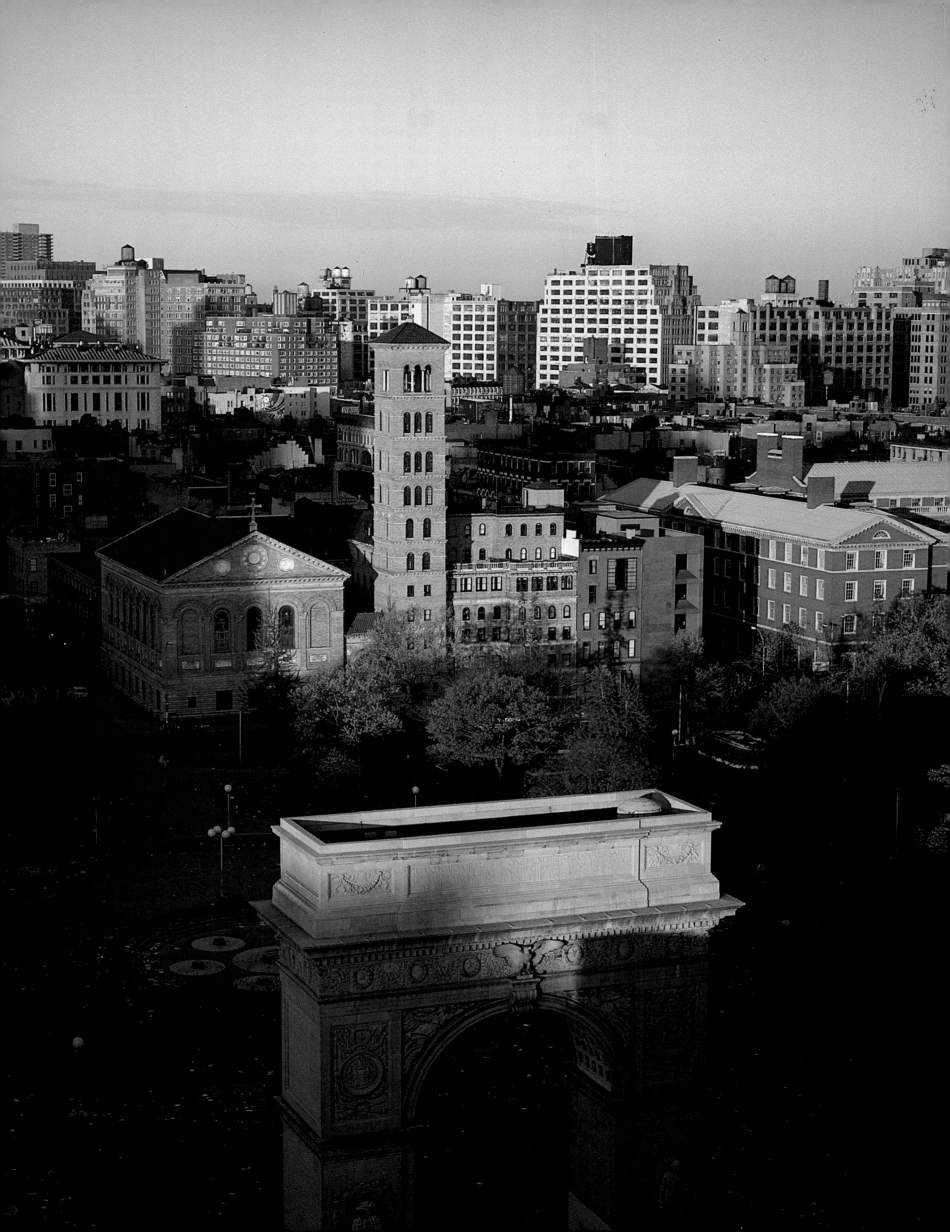

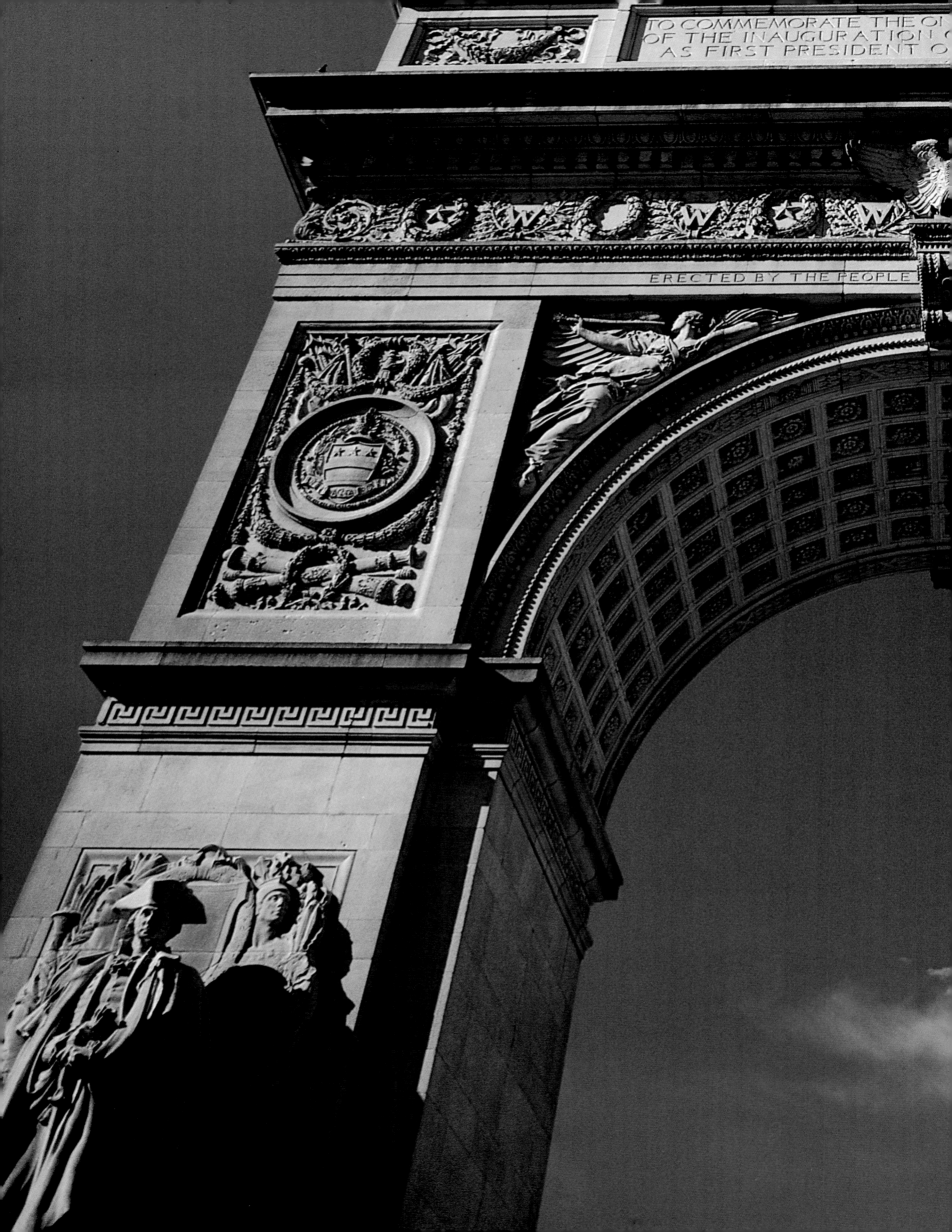

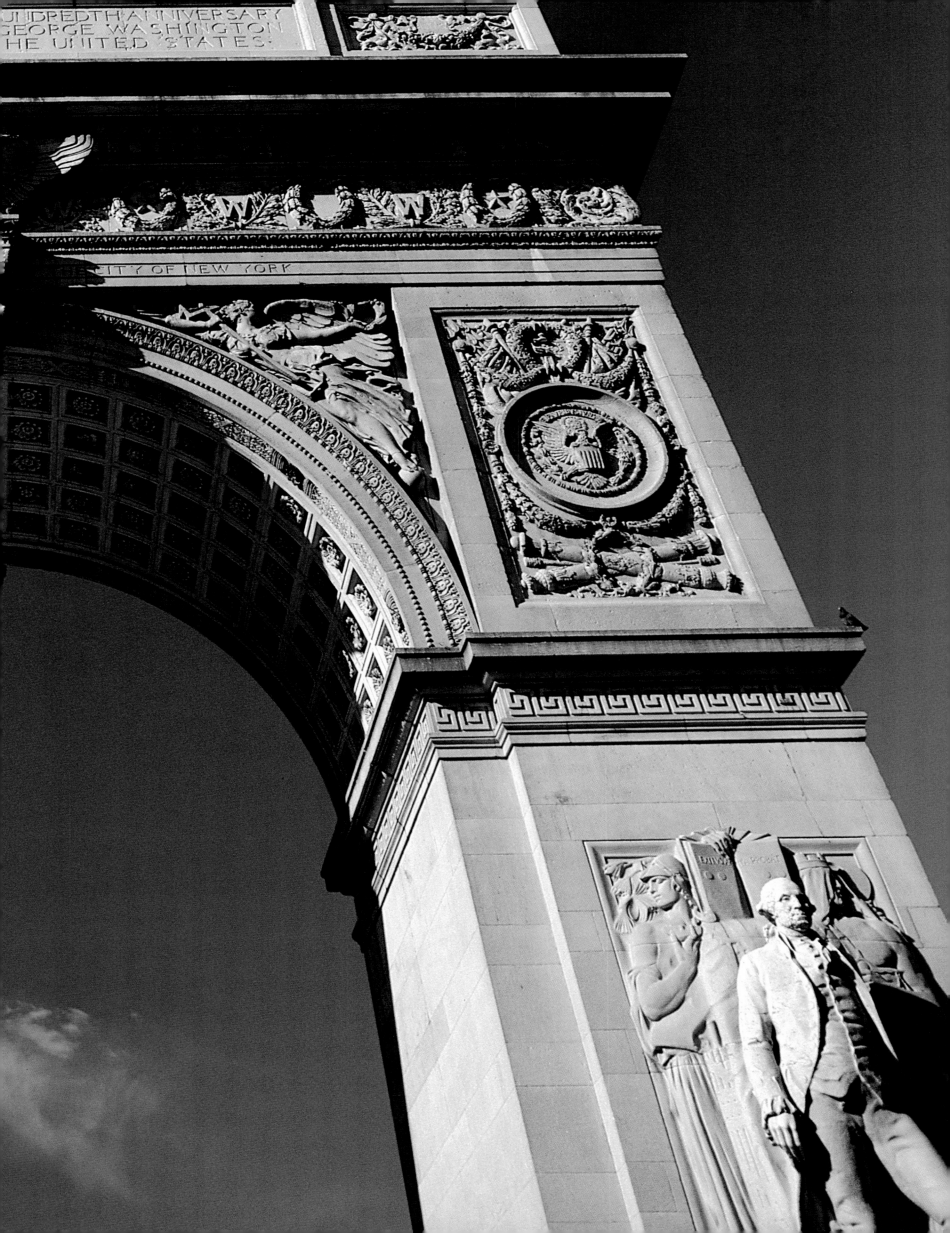

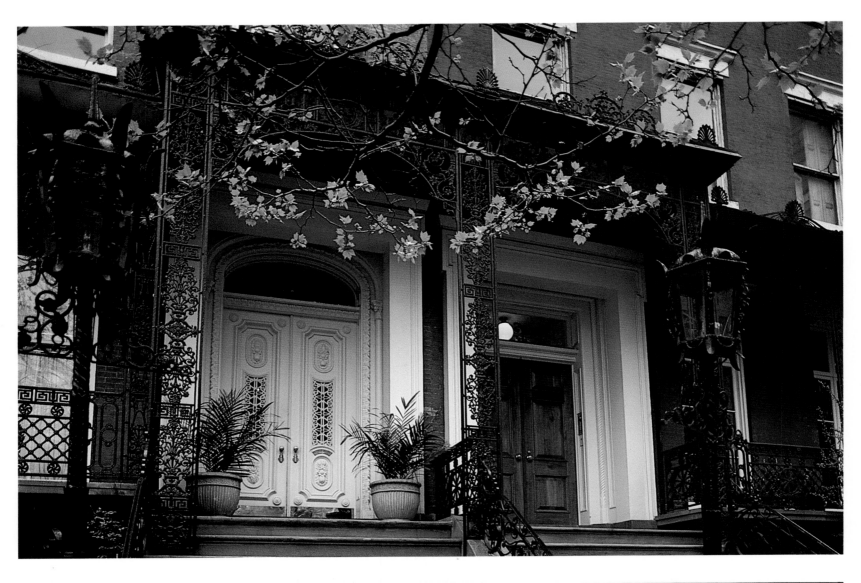

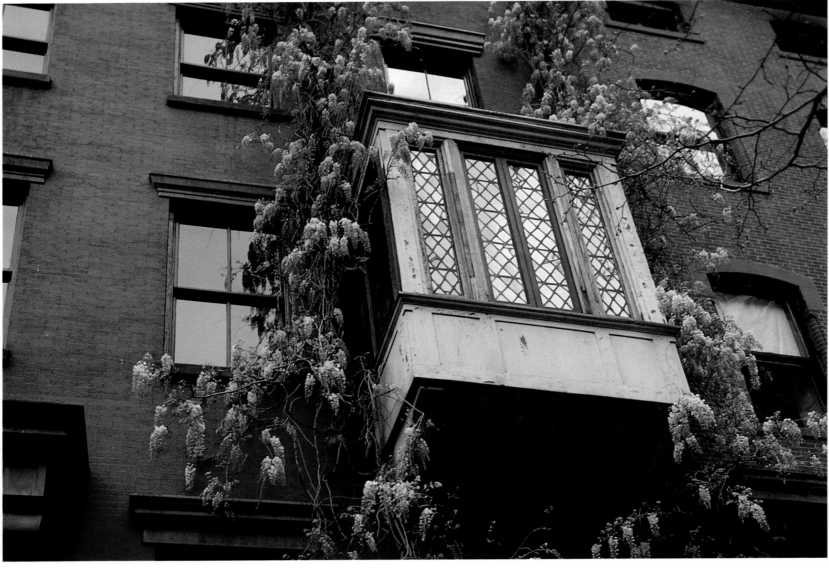

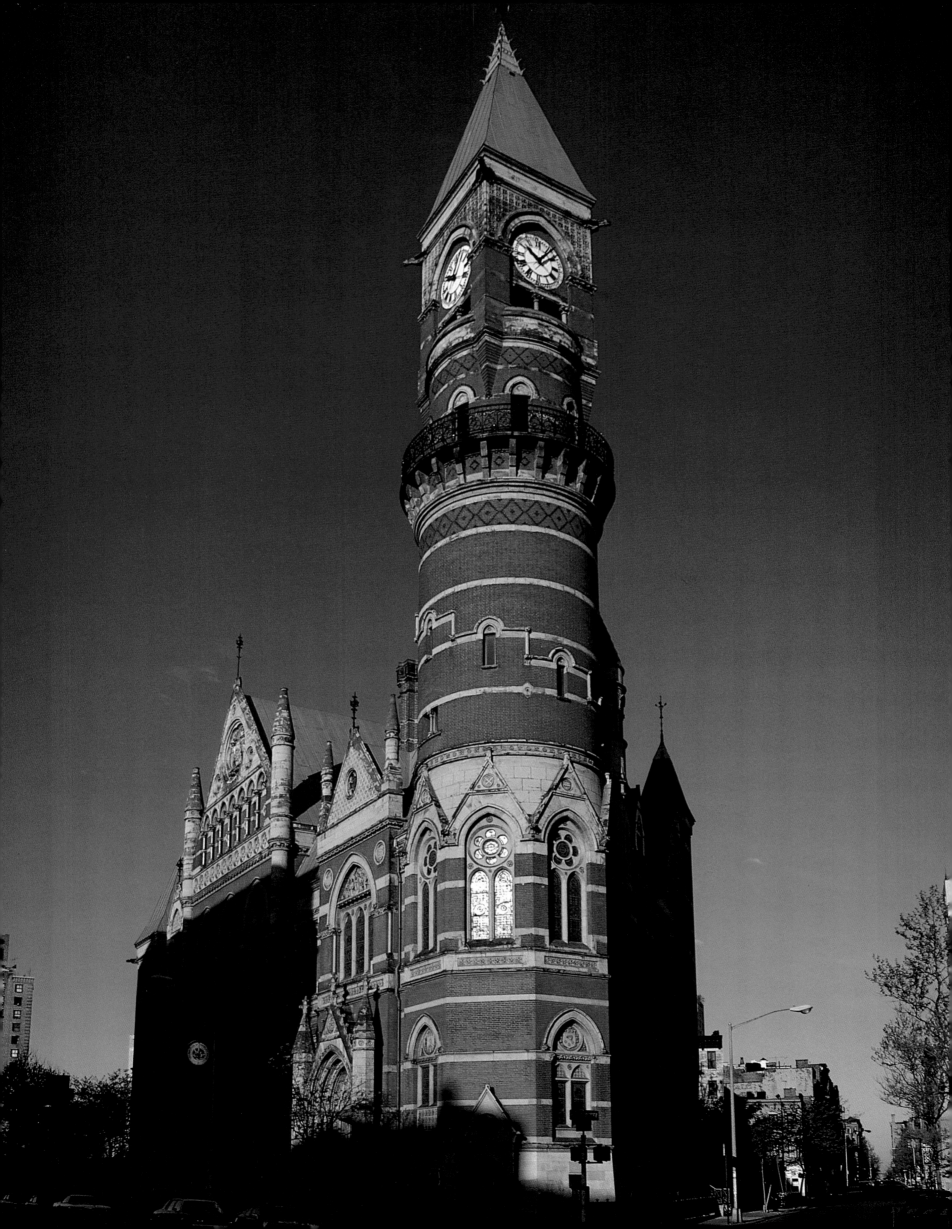

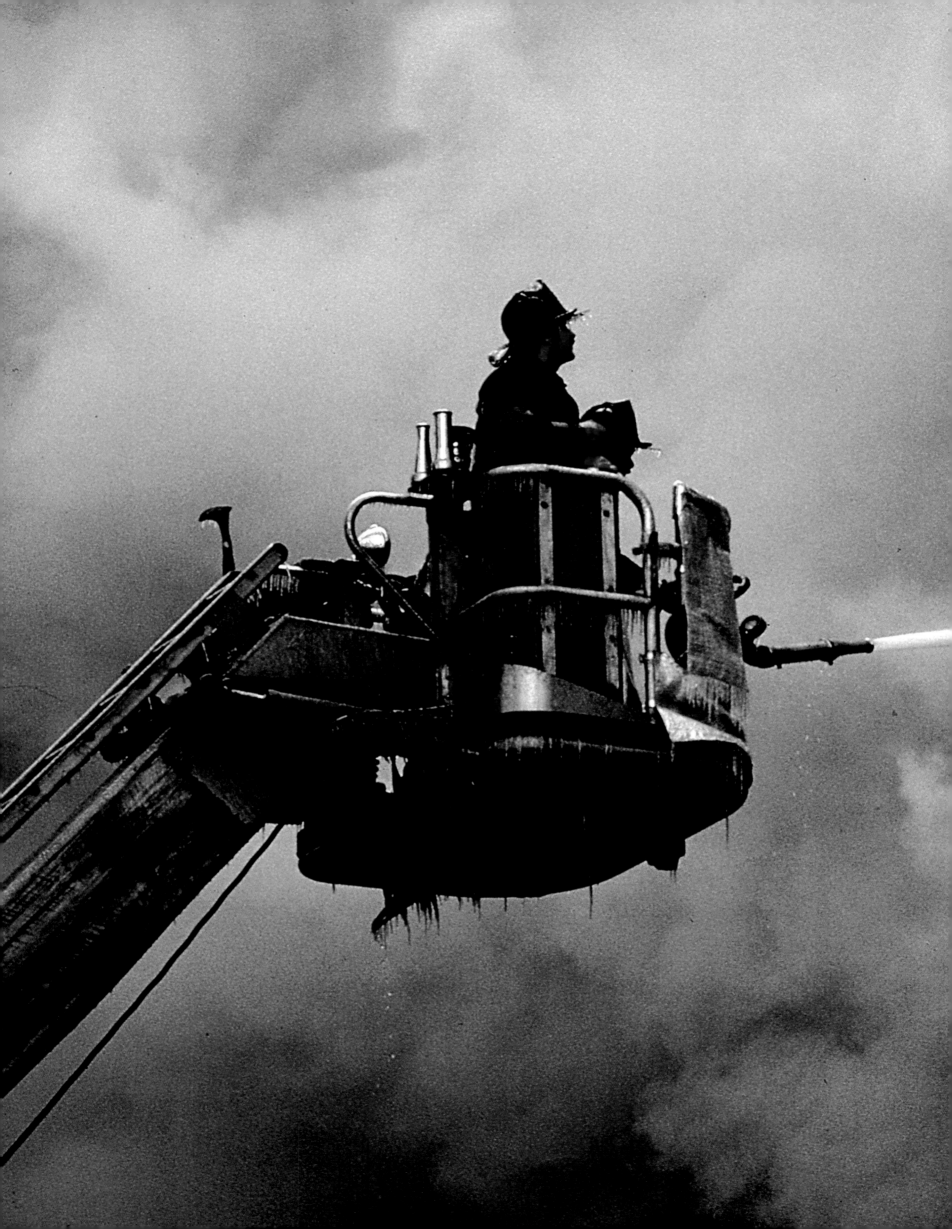

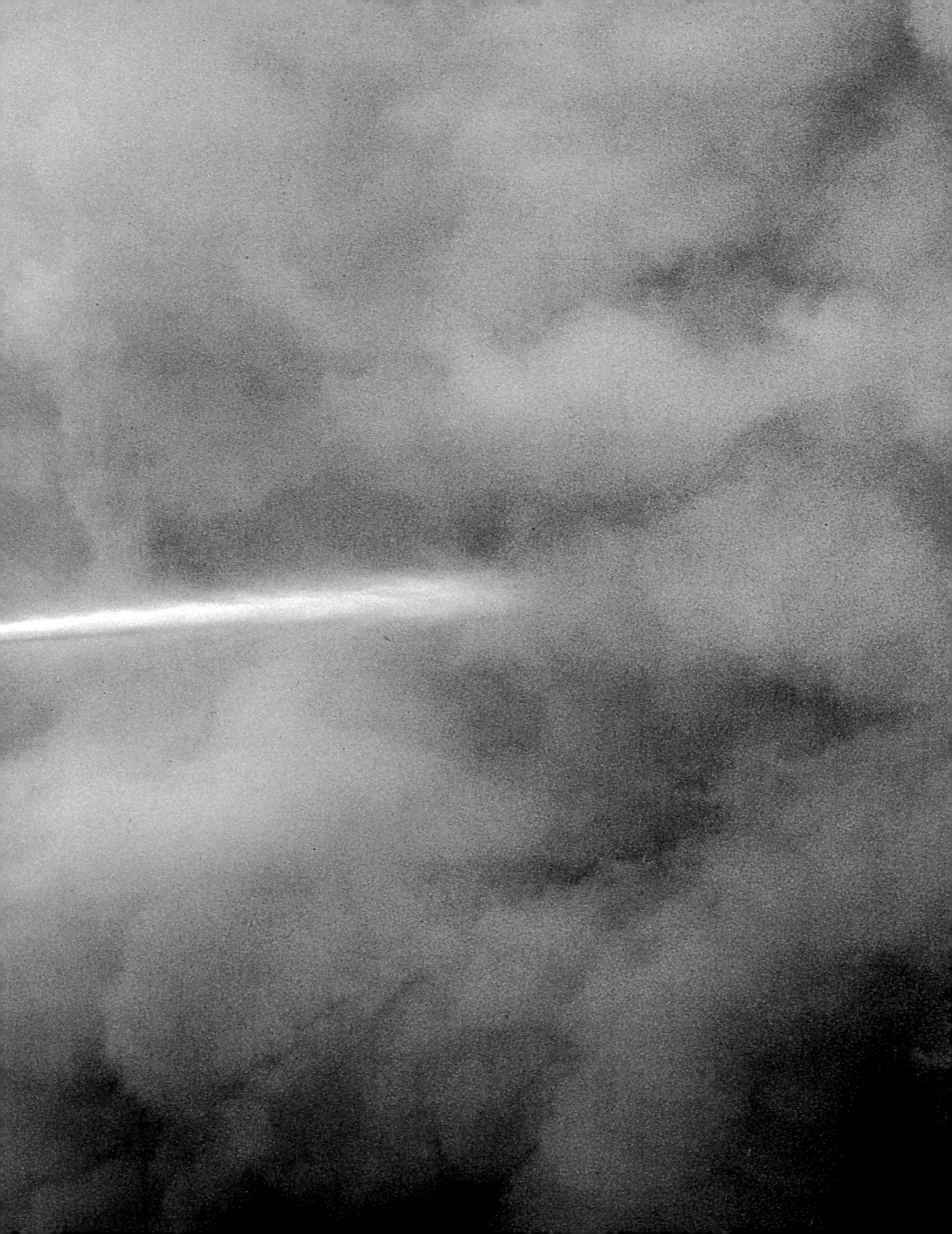

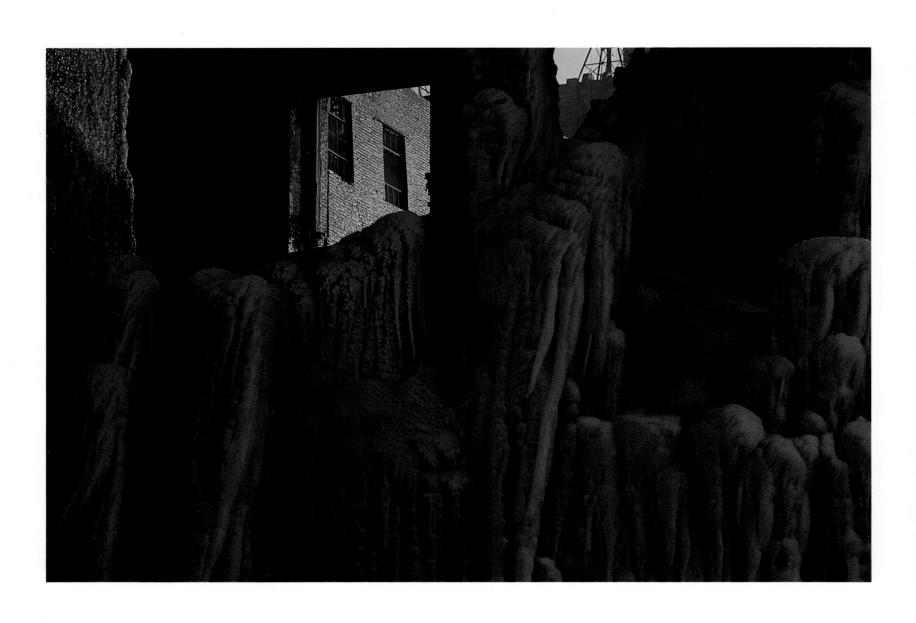

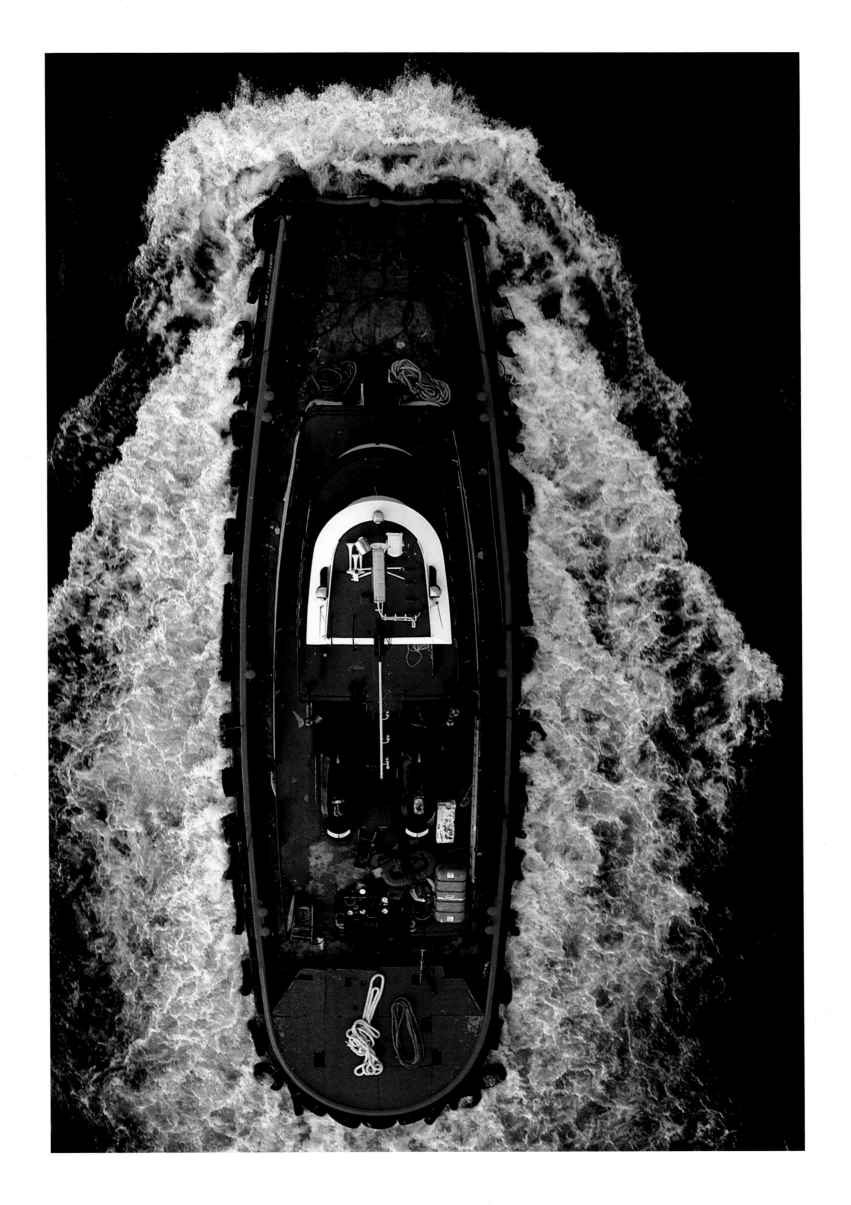

New York is a stone garden. Stone plants send up stems of varying height and at the top these stems bloom. Lawns, flower beds, tennis courts, chaise longues, gaudy parasols crown these gray towers that are forced, watered, sunned in a jungle where cathedrals and Greek temples balance on stilts.

—Jean Cocteau

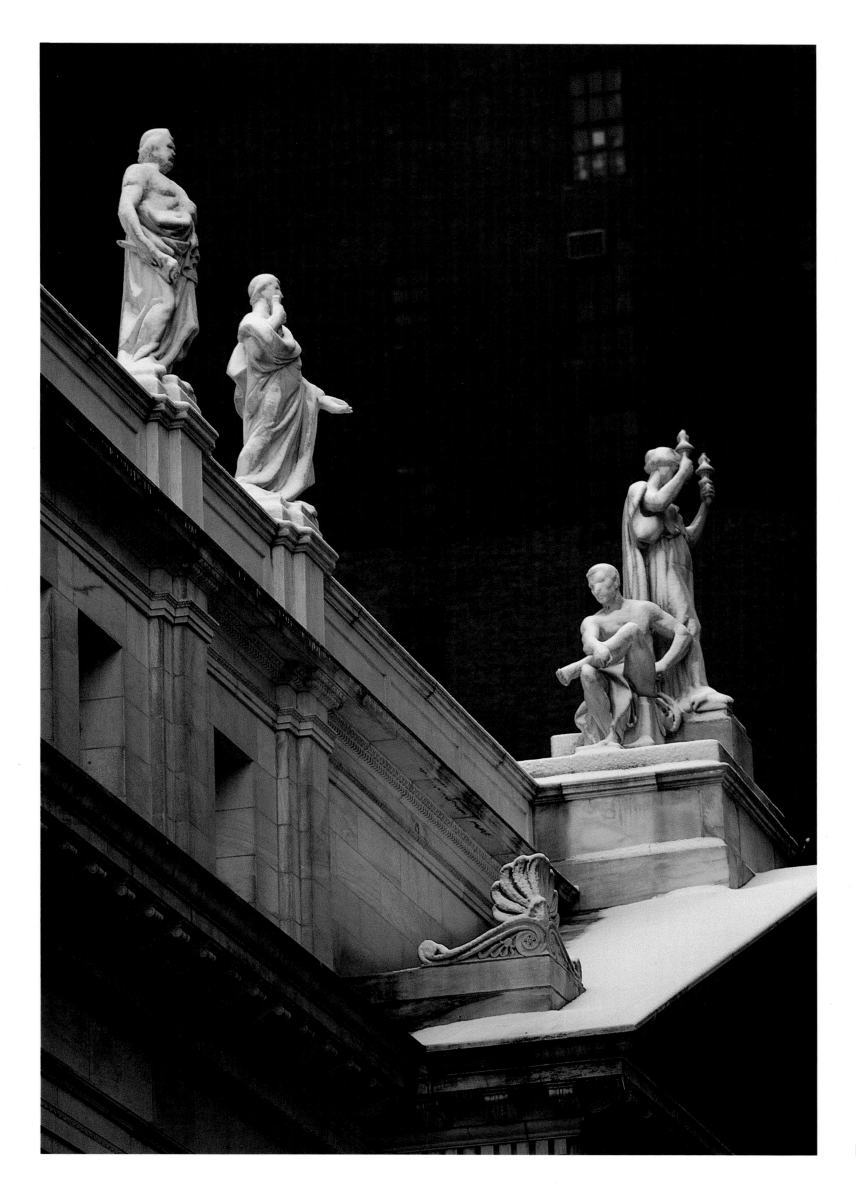

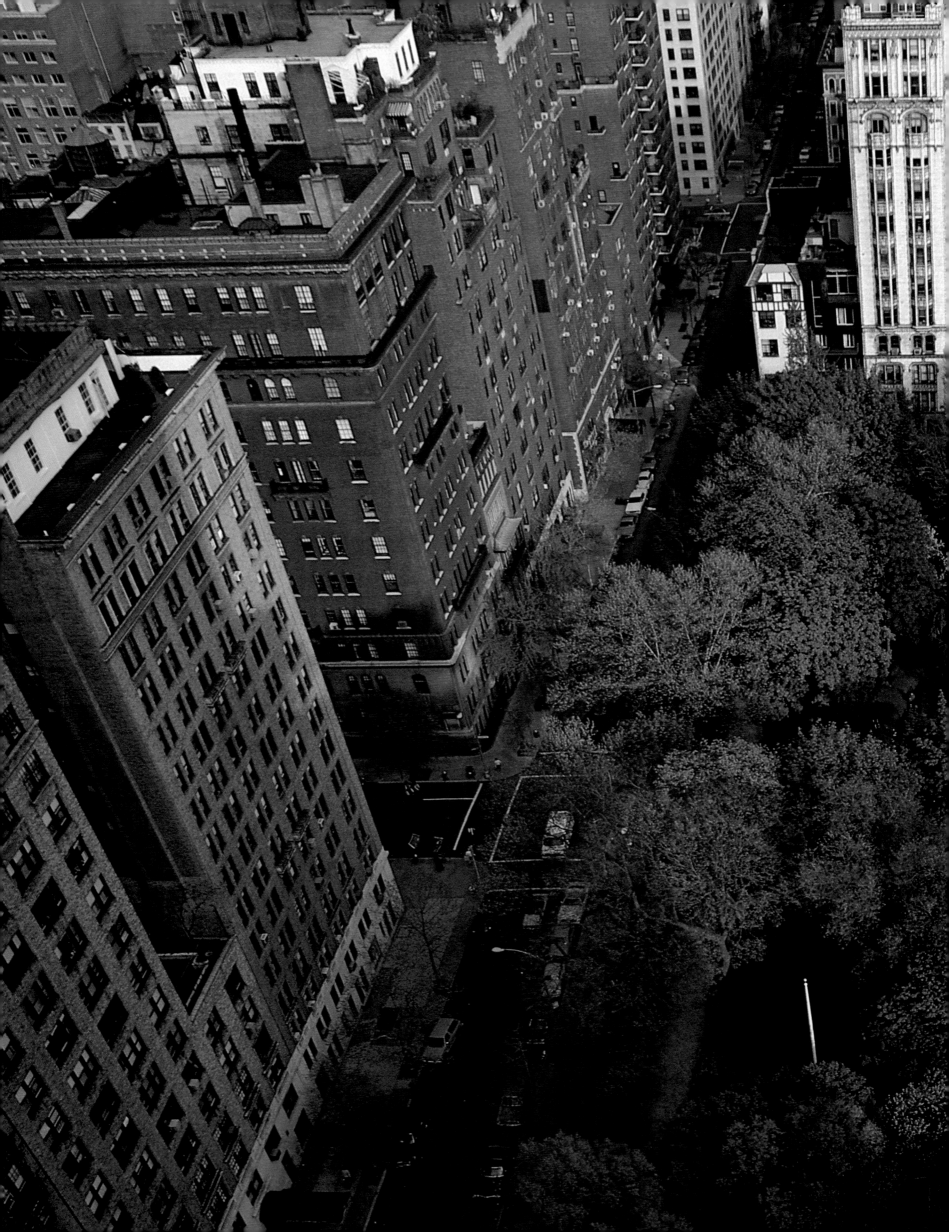

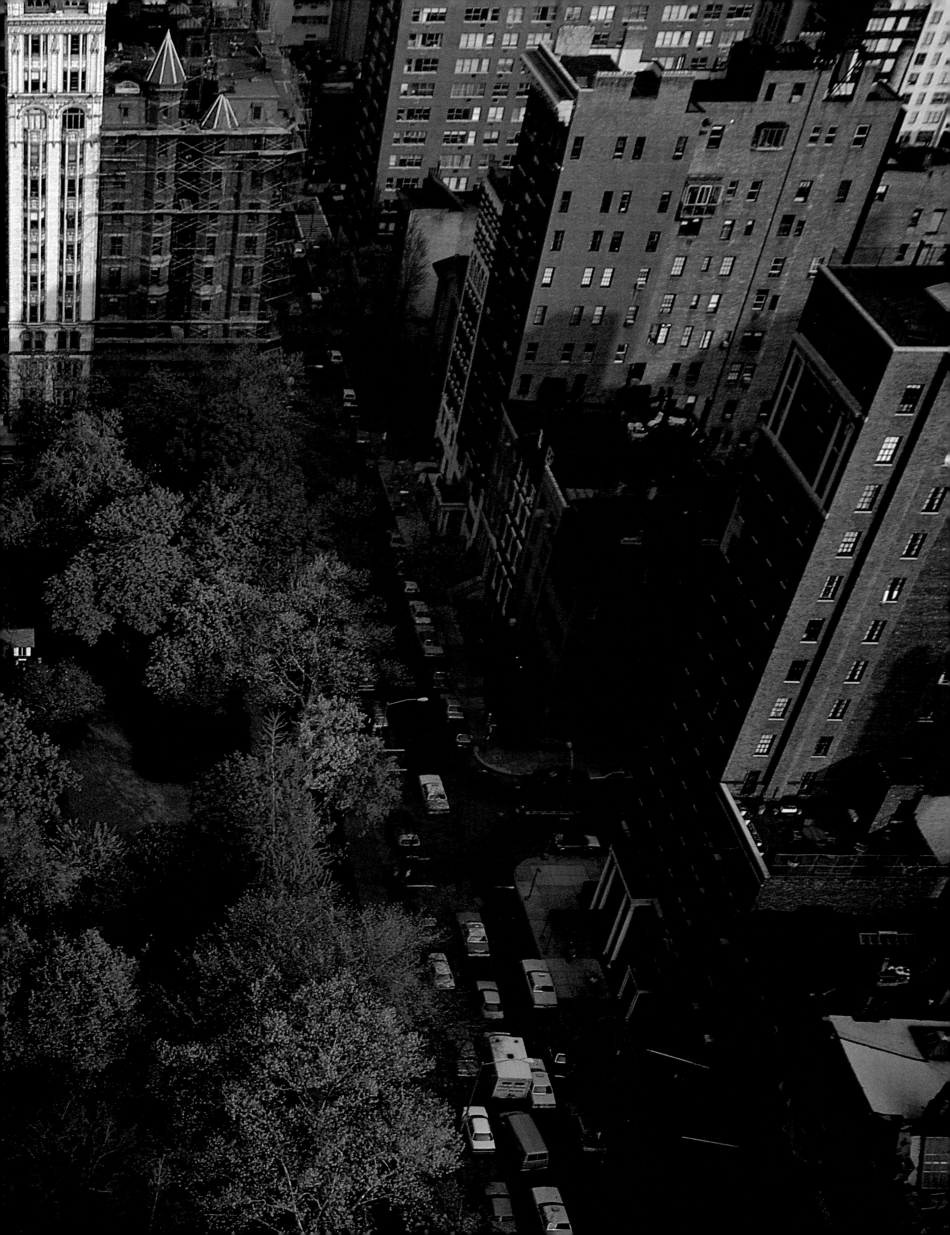

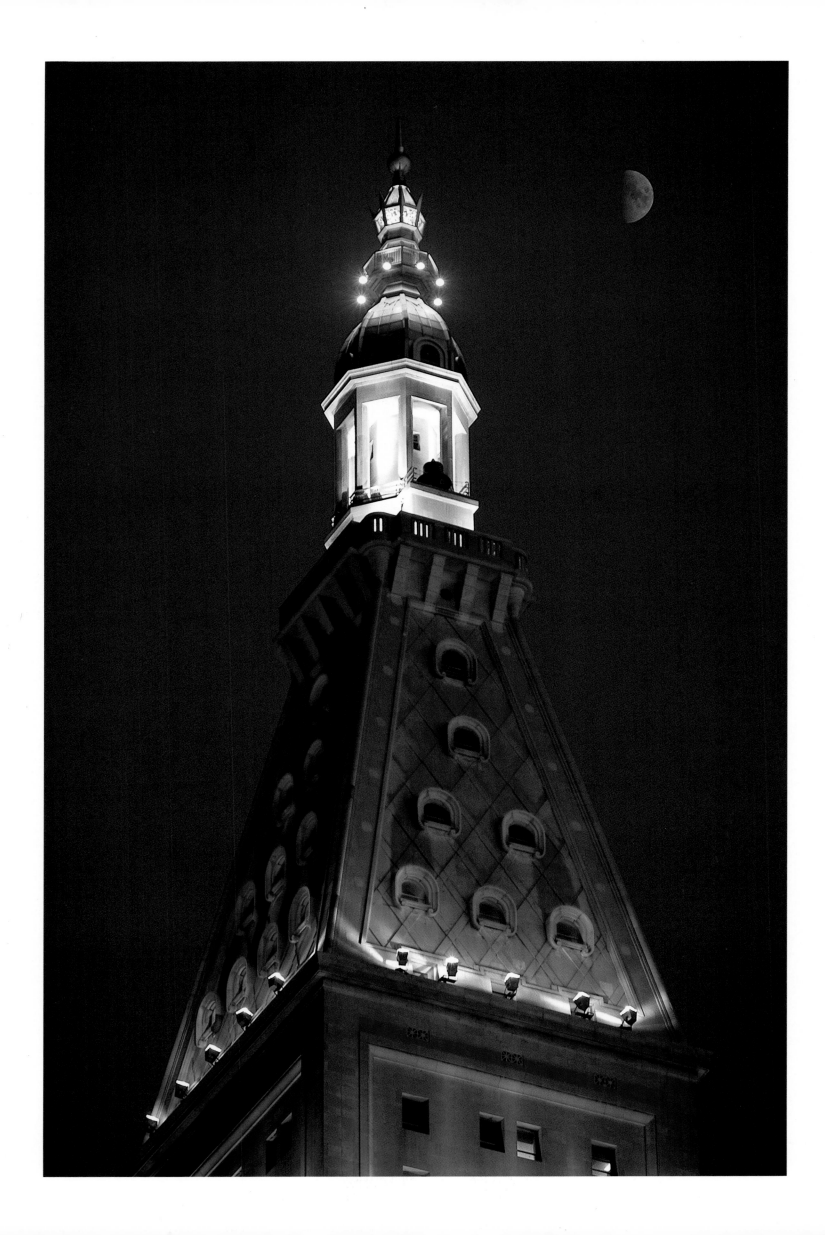

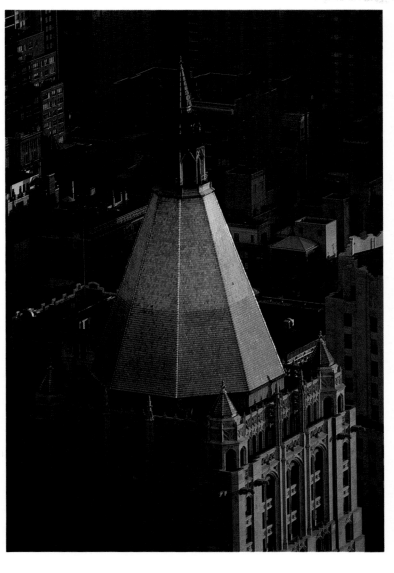

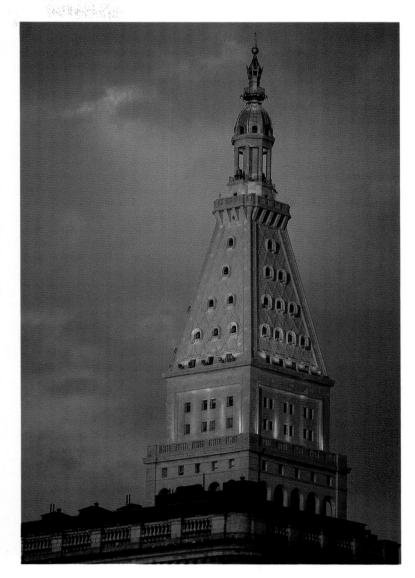

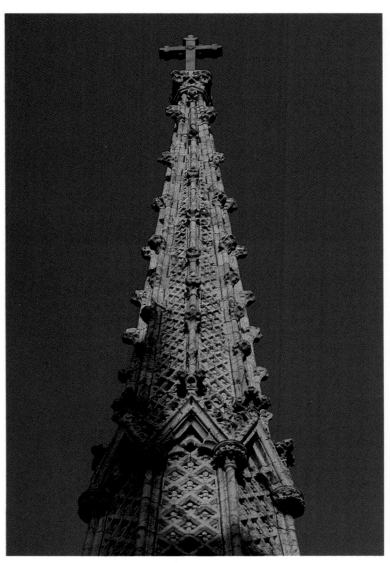

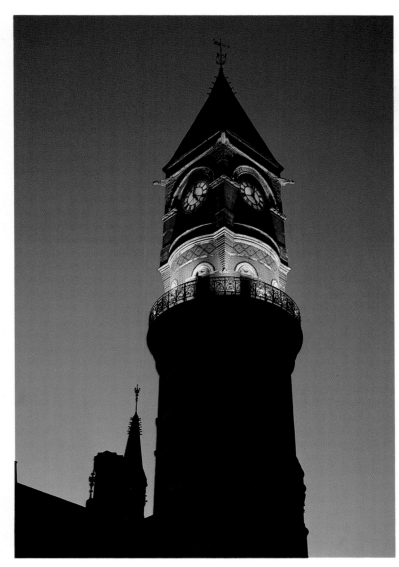

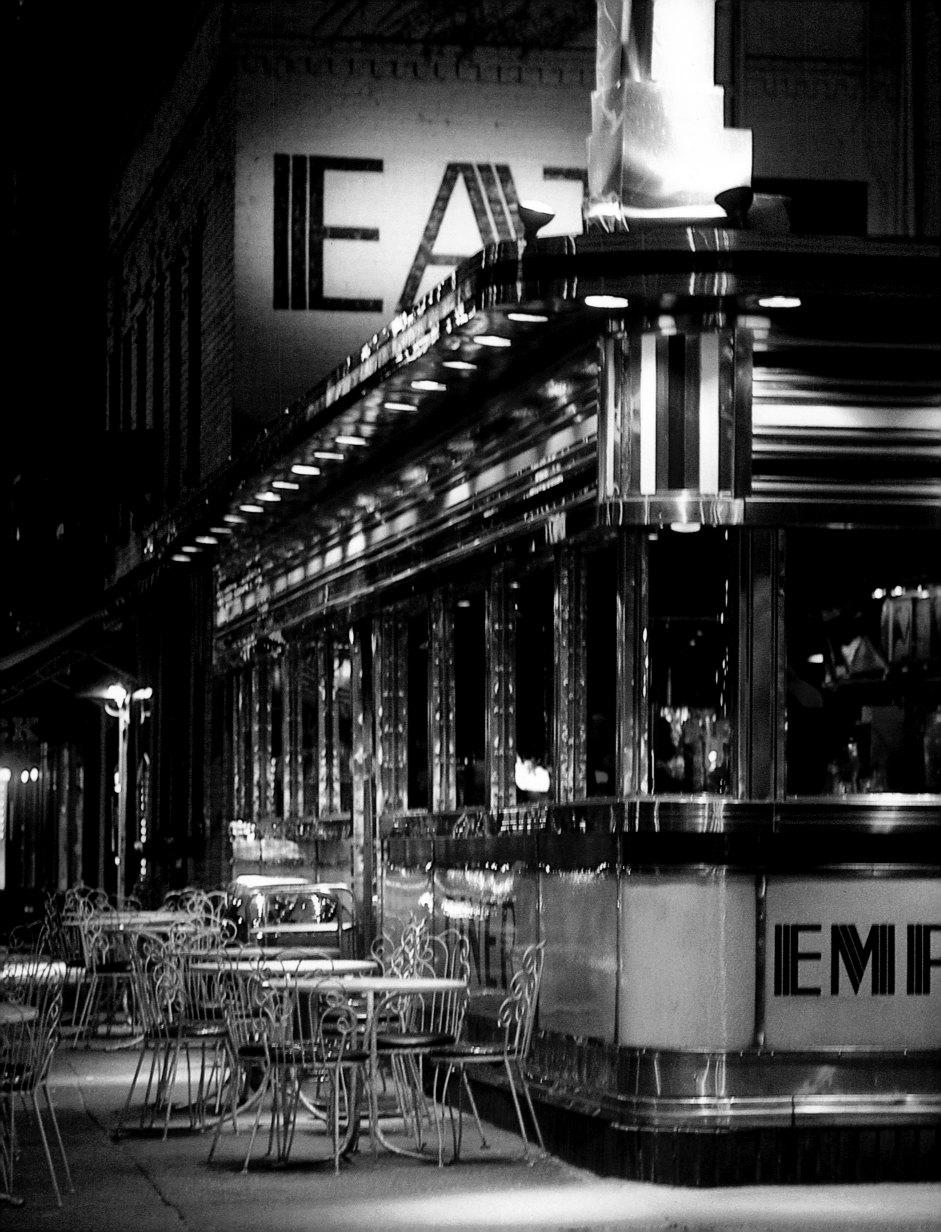

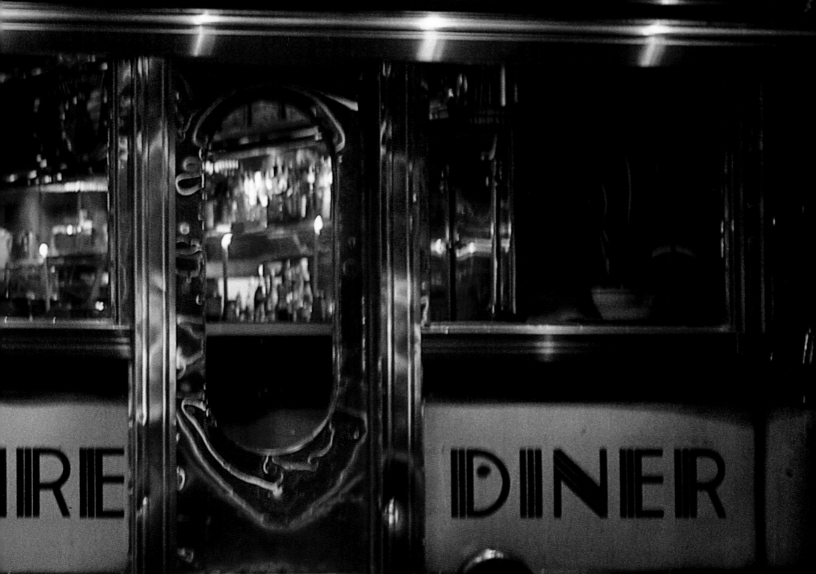

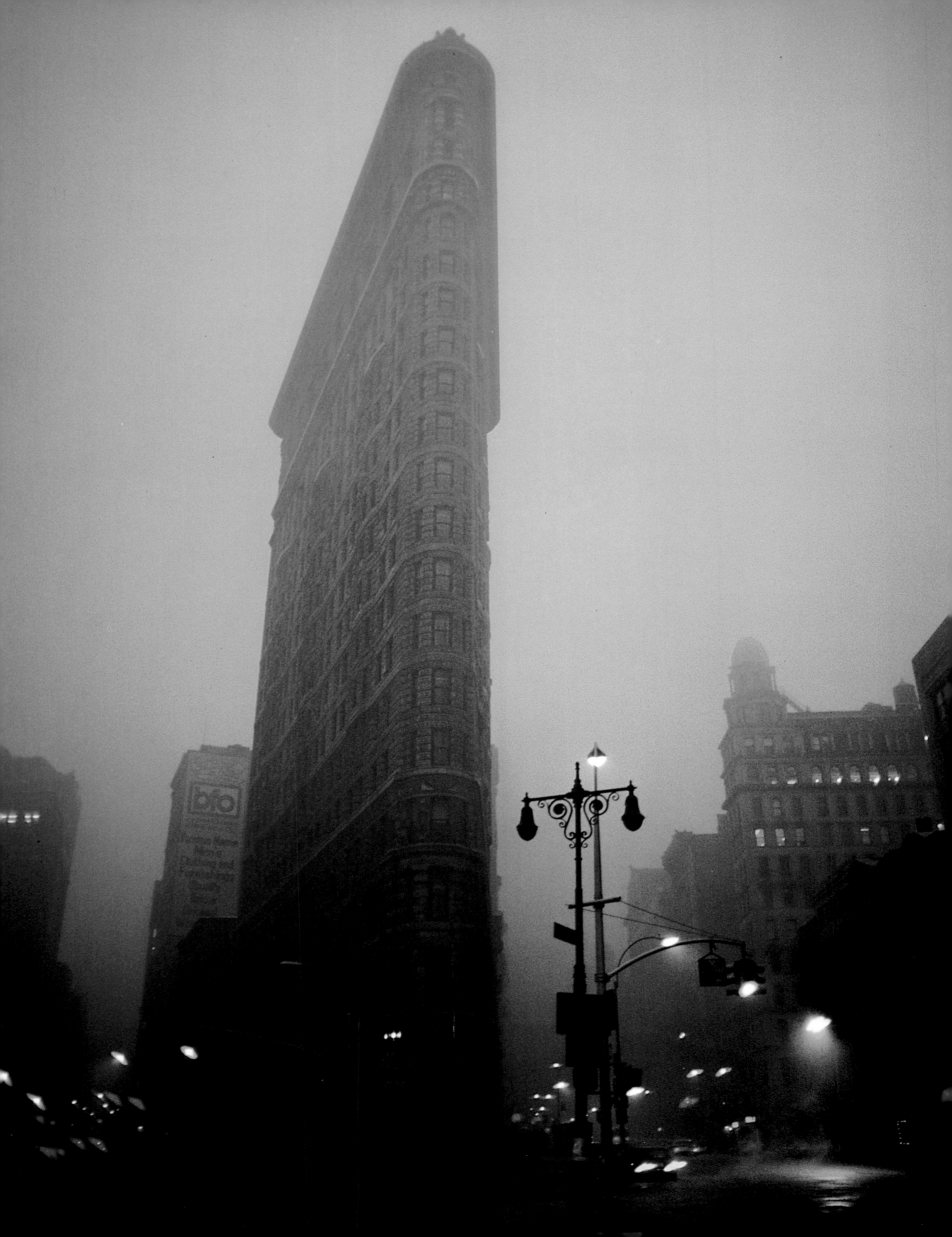

SKYSCAPES

The drama of Midtown—
business and Broadway

In the city, time is visible.

—Lewis Mumford

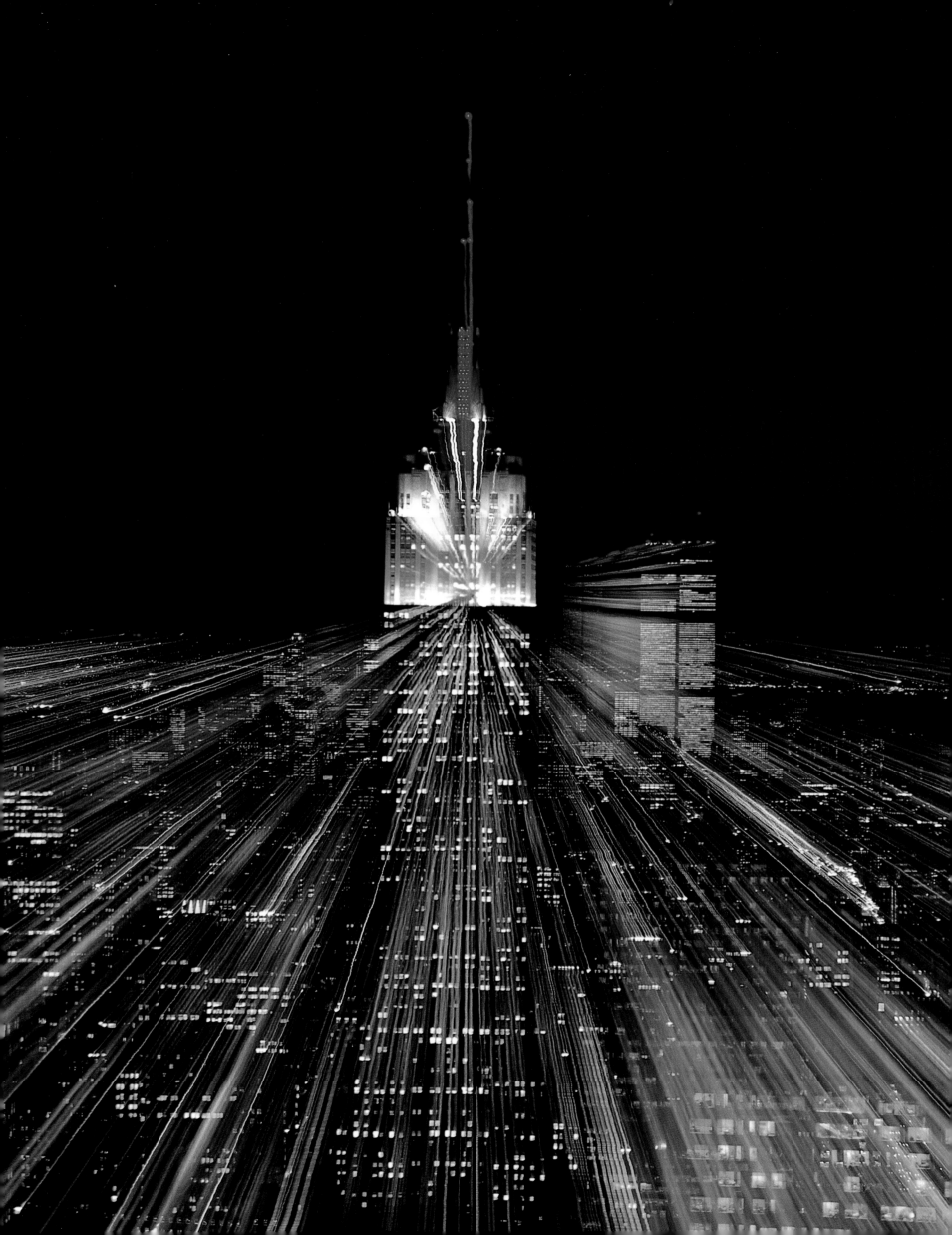

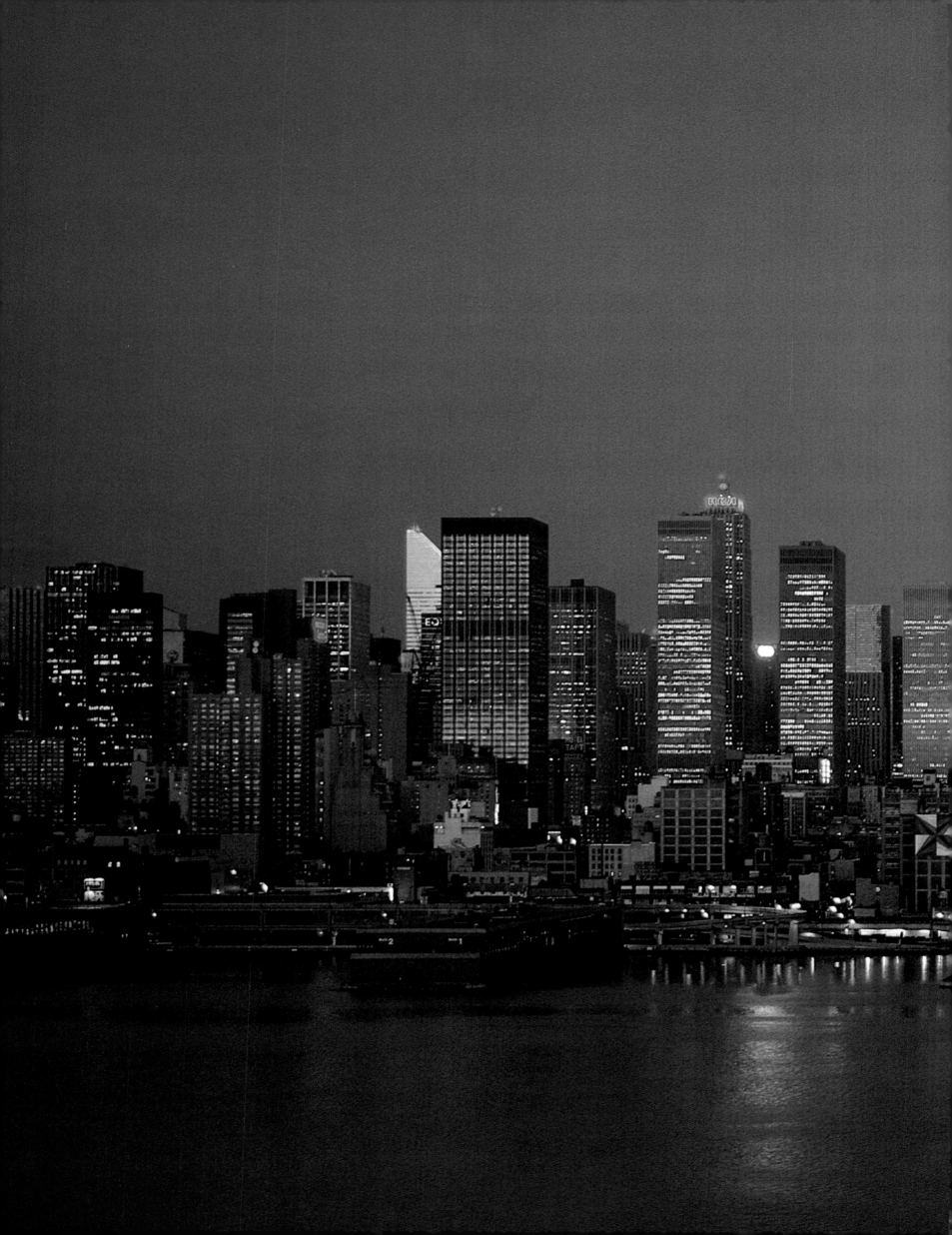

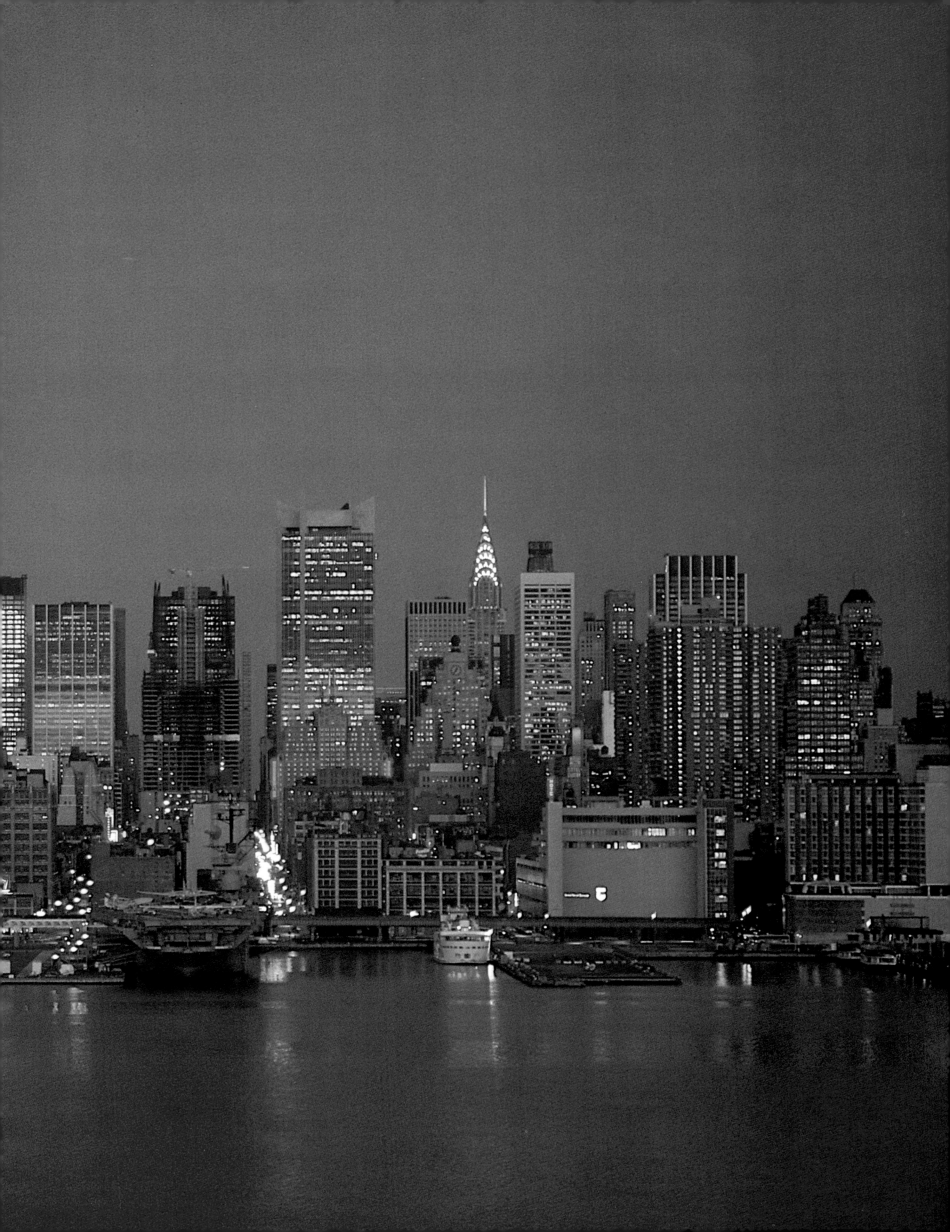

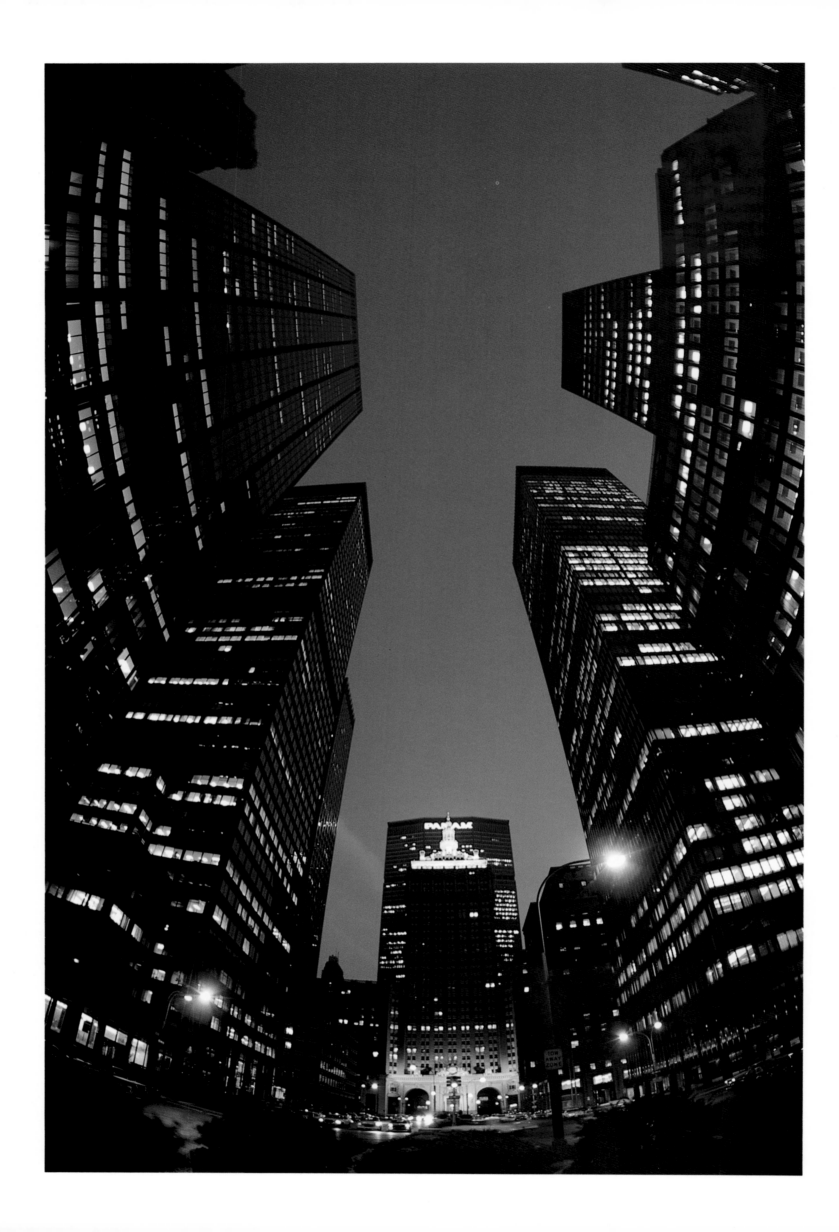

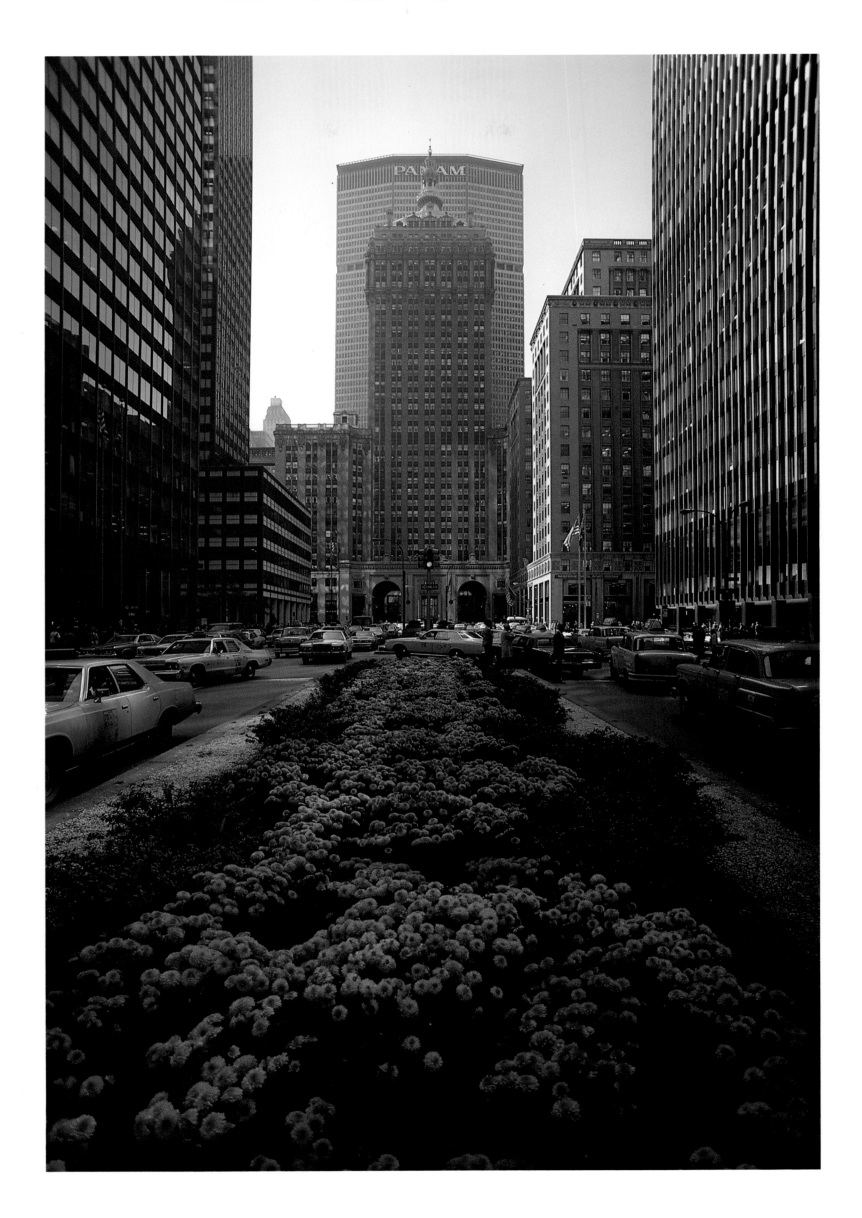

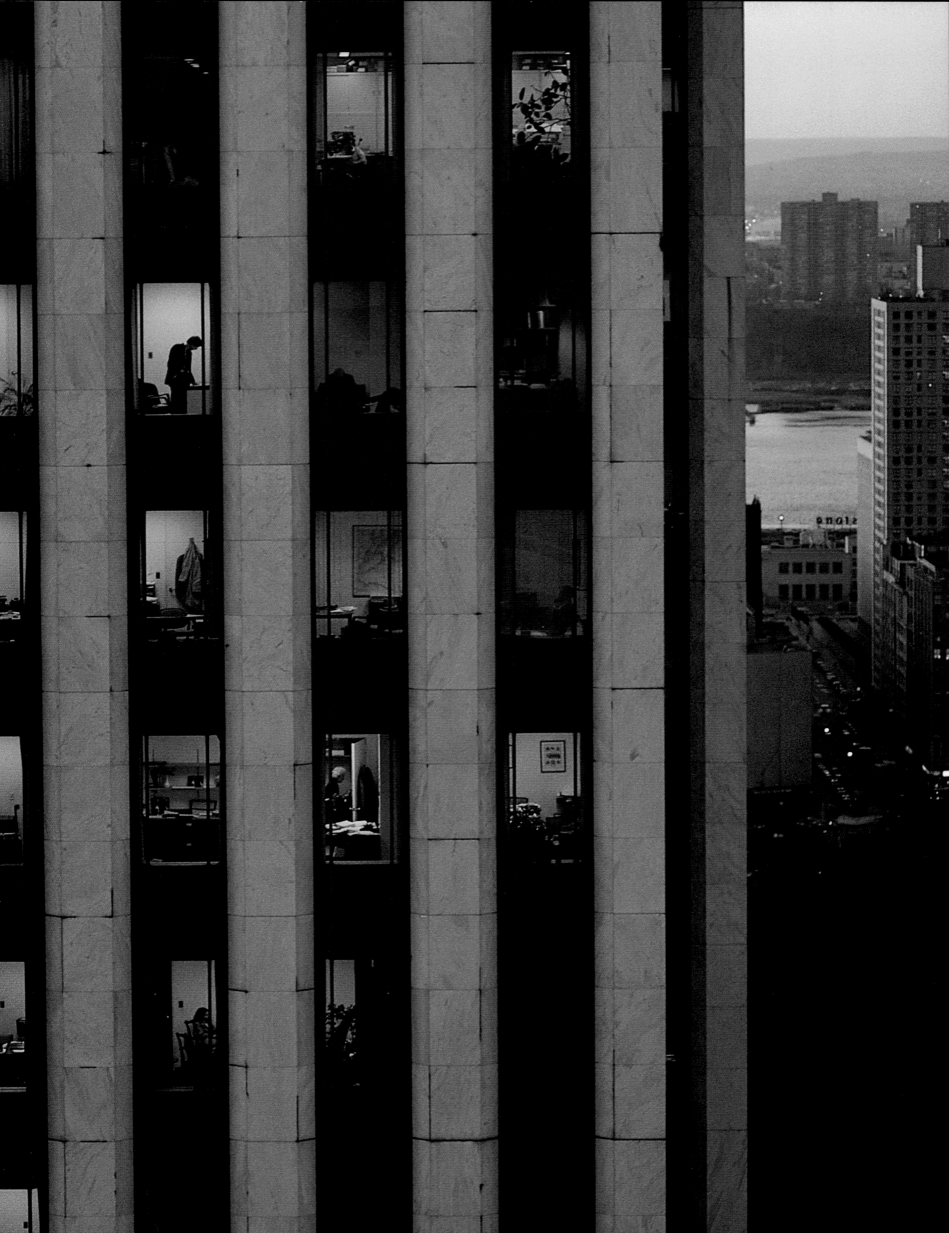

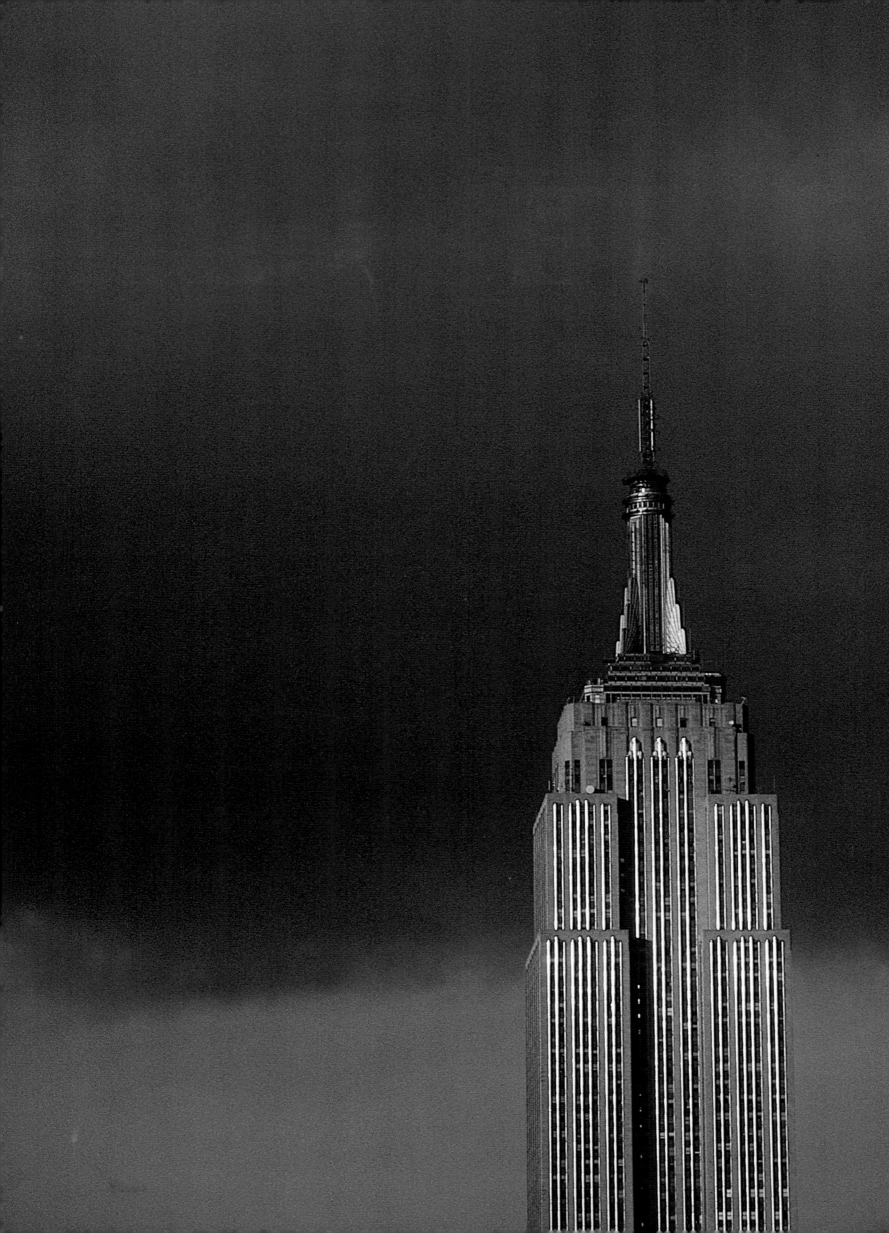

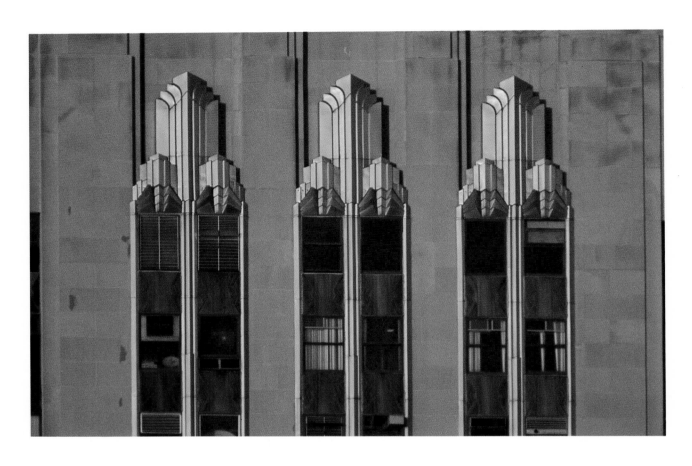

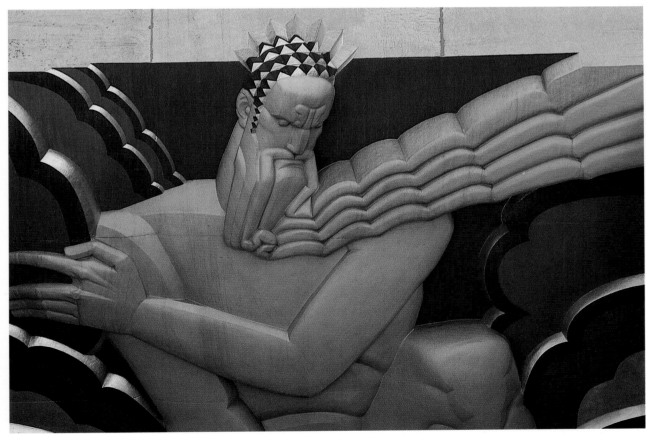

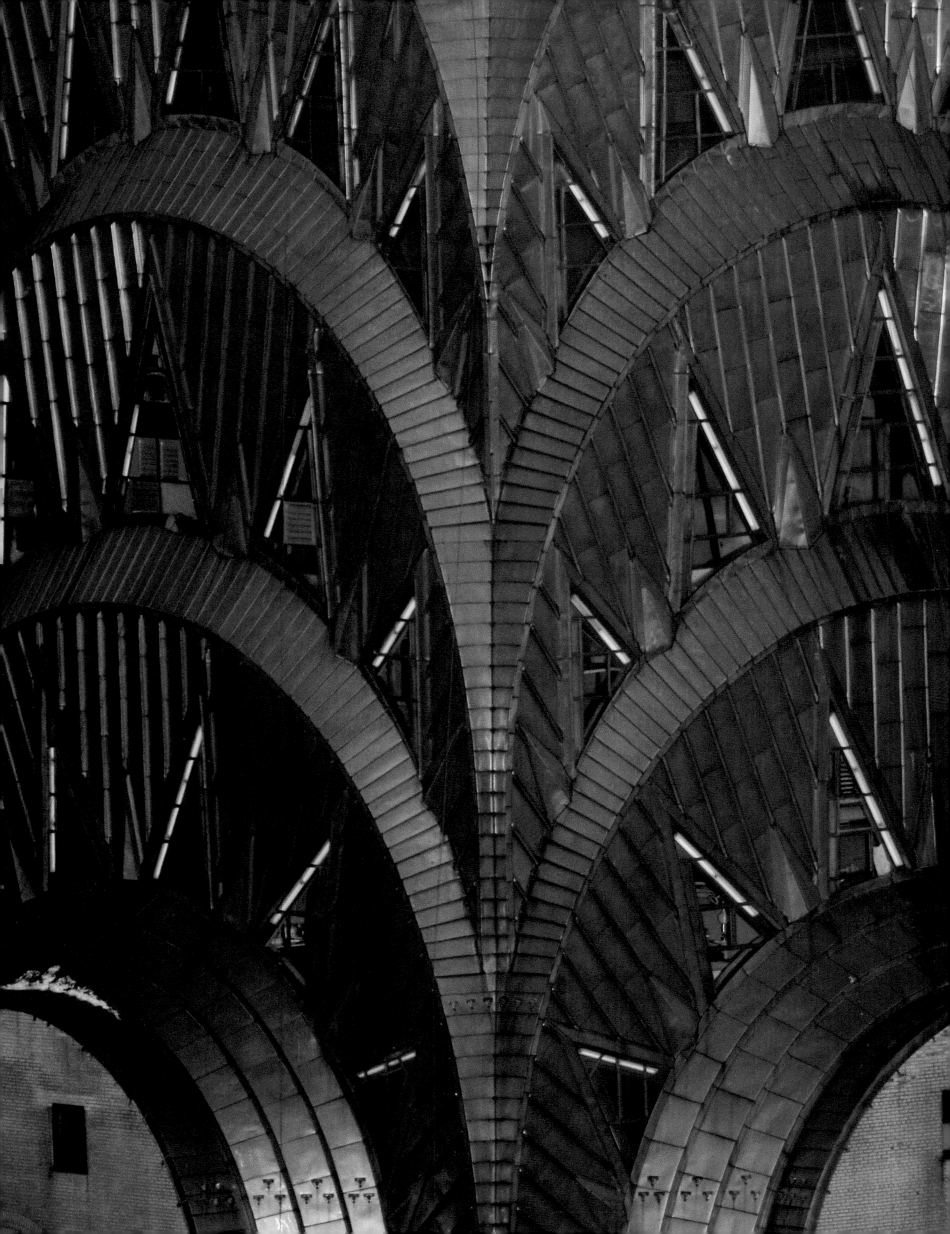

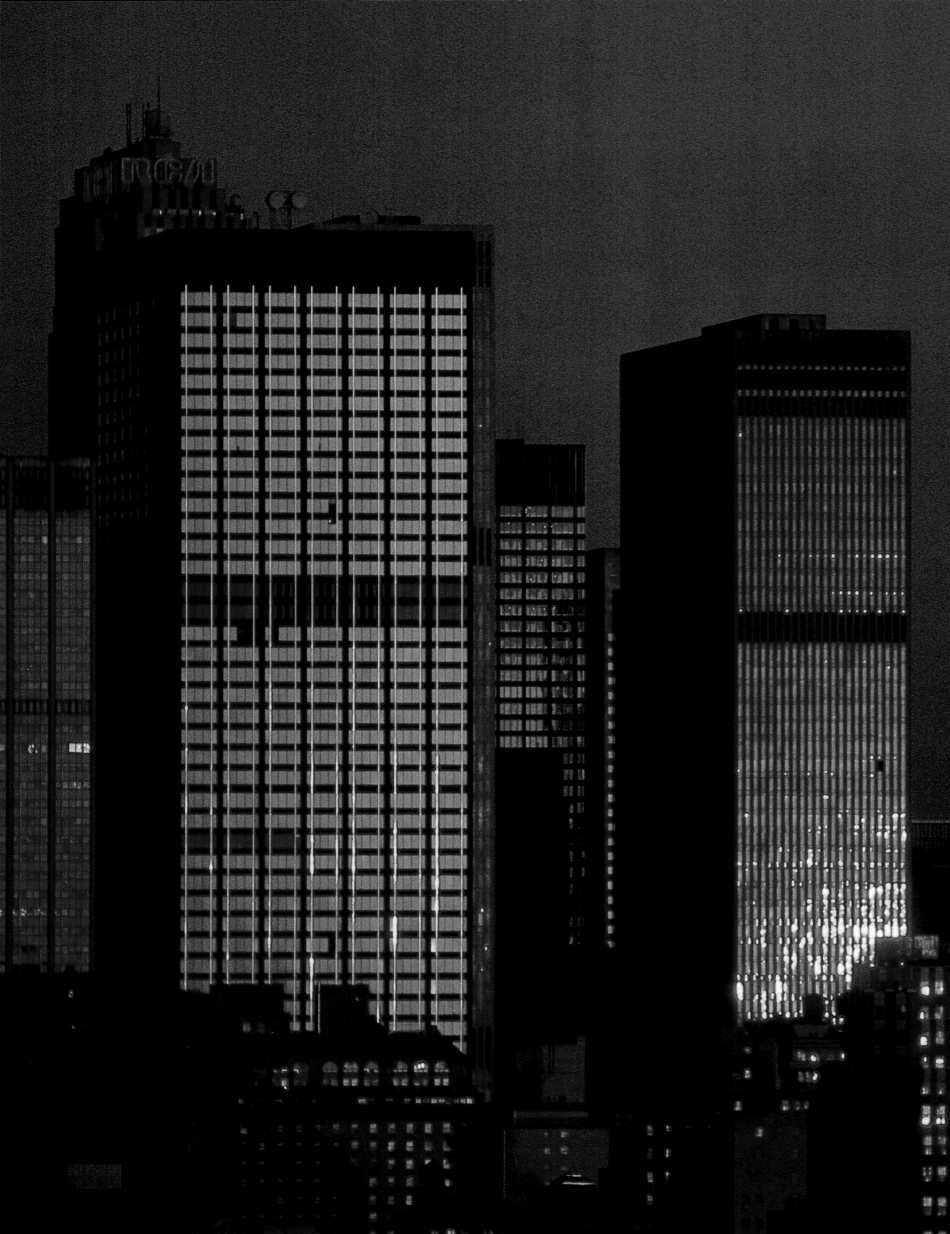

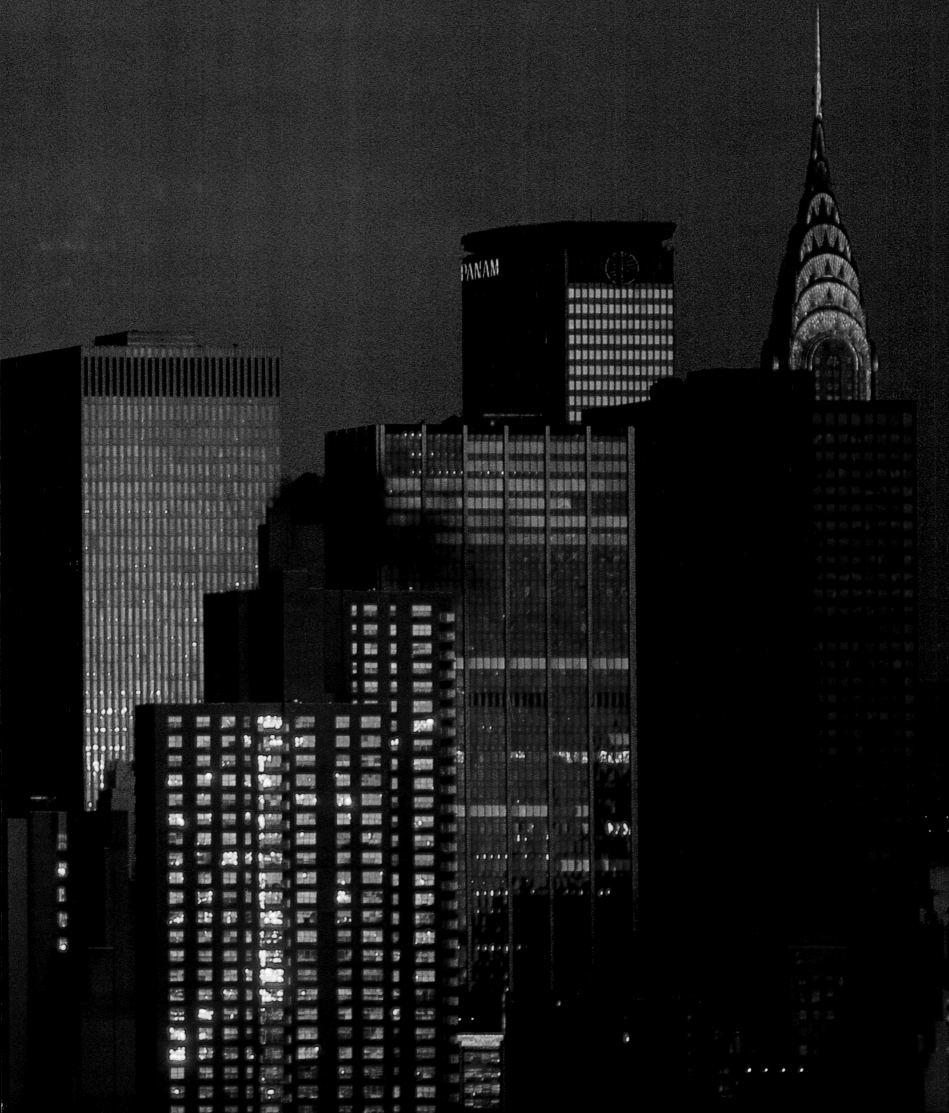

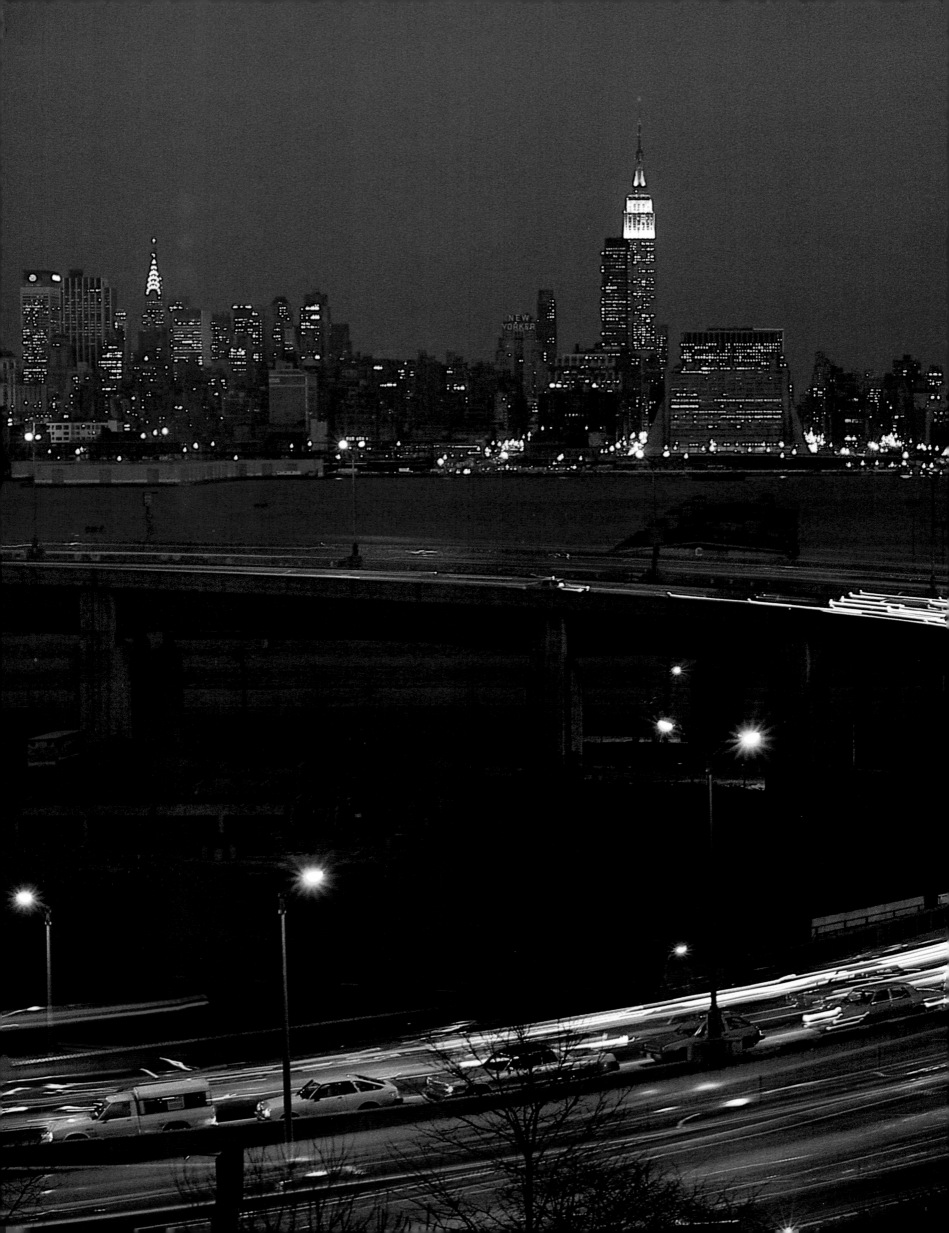

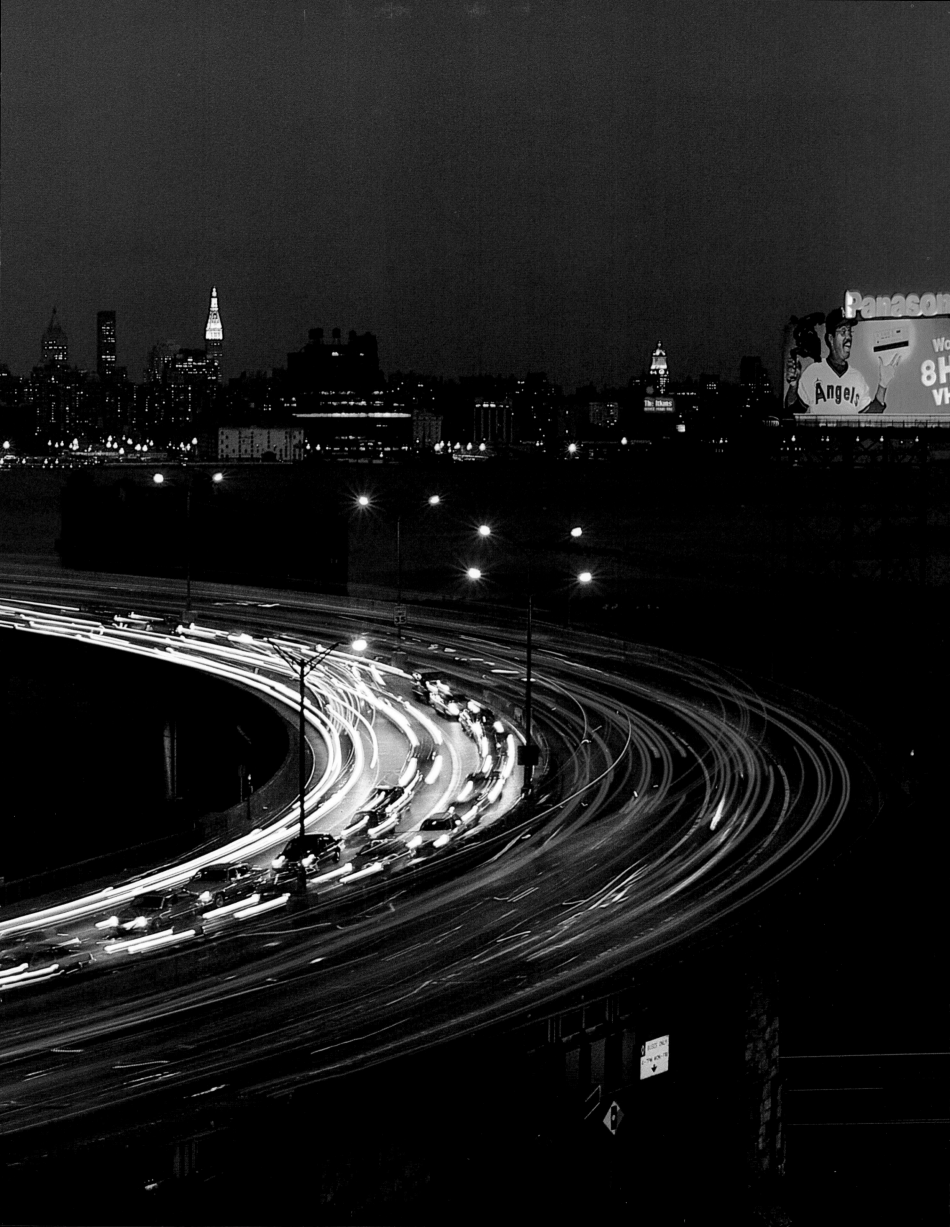

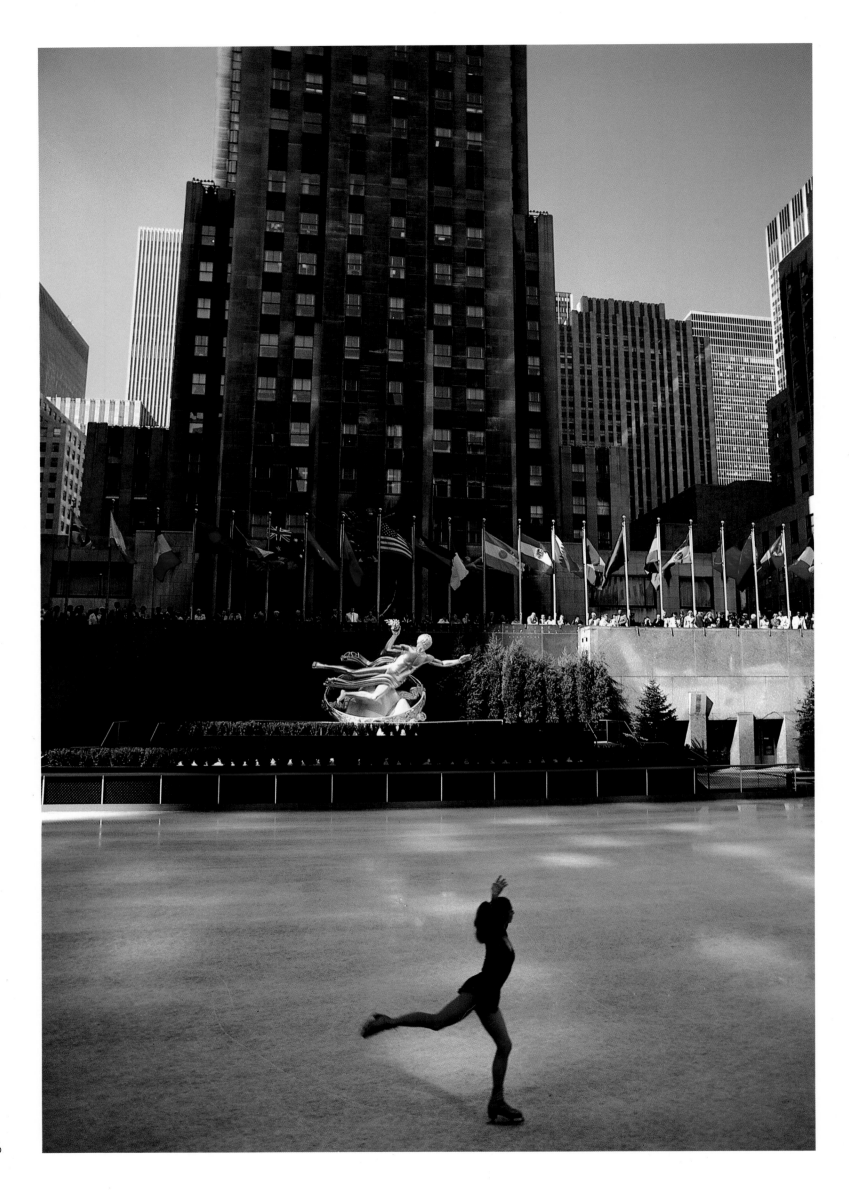

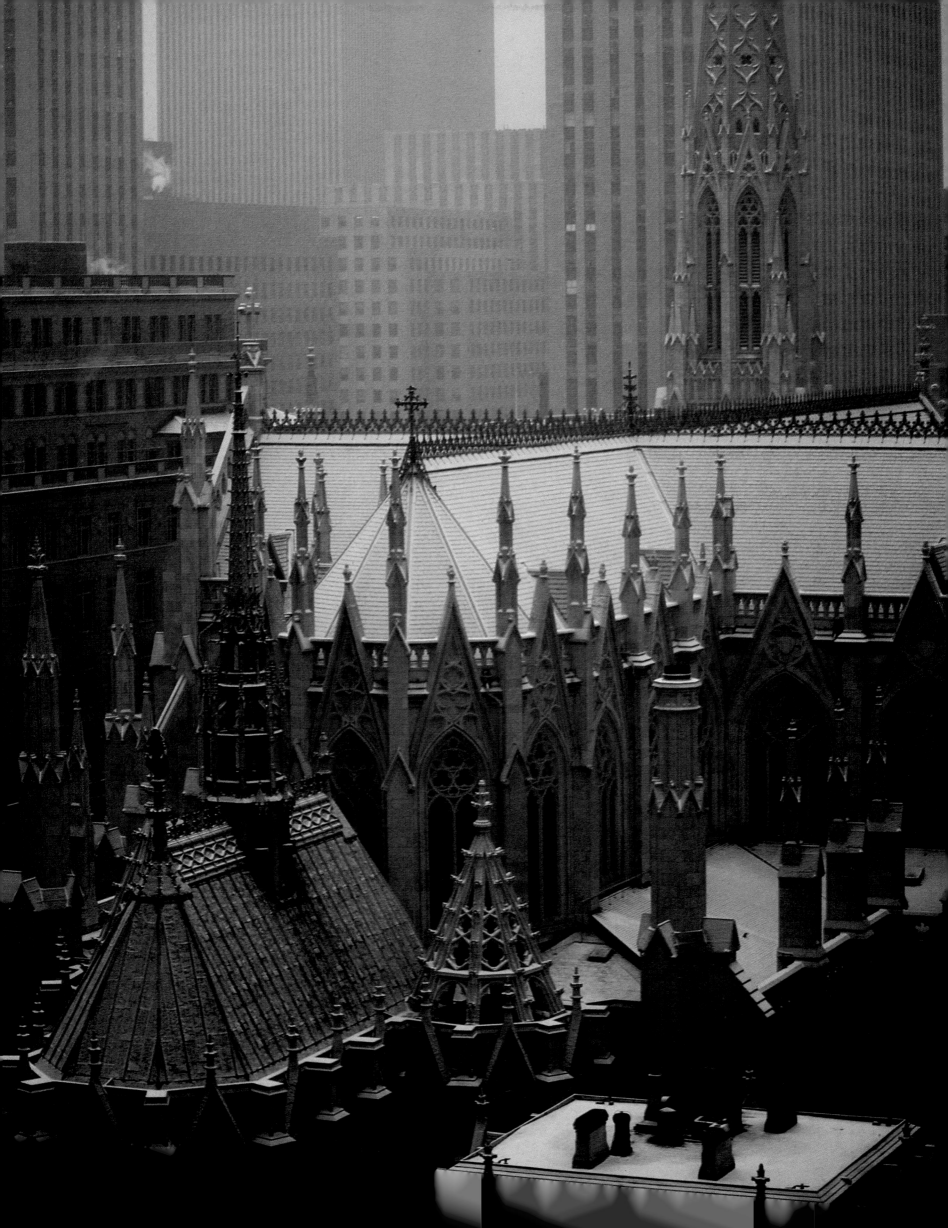

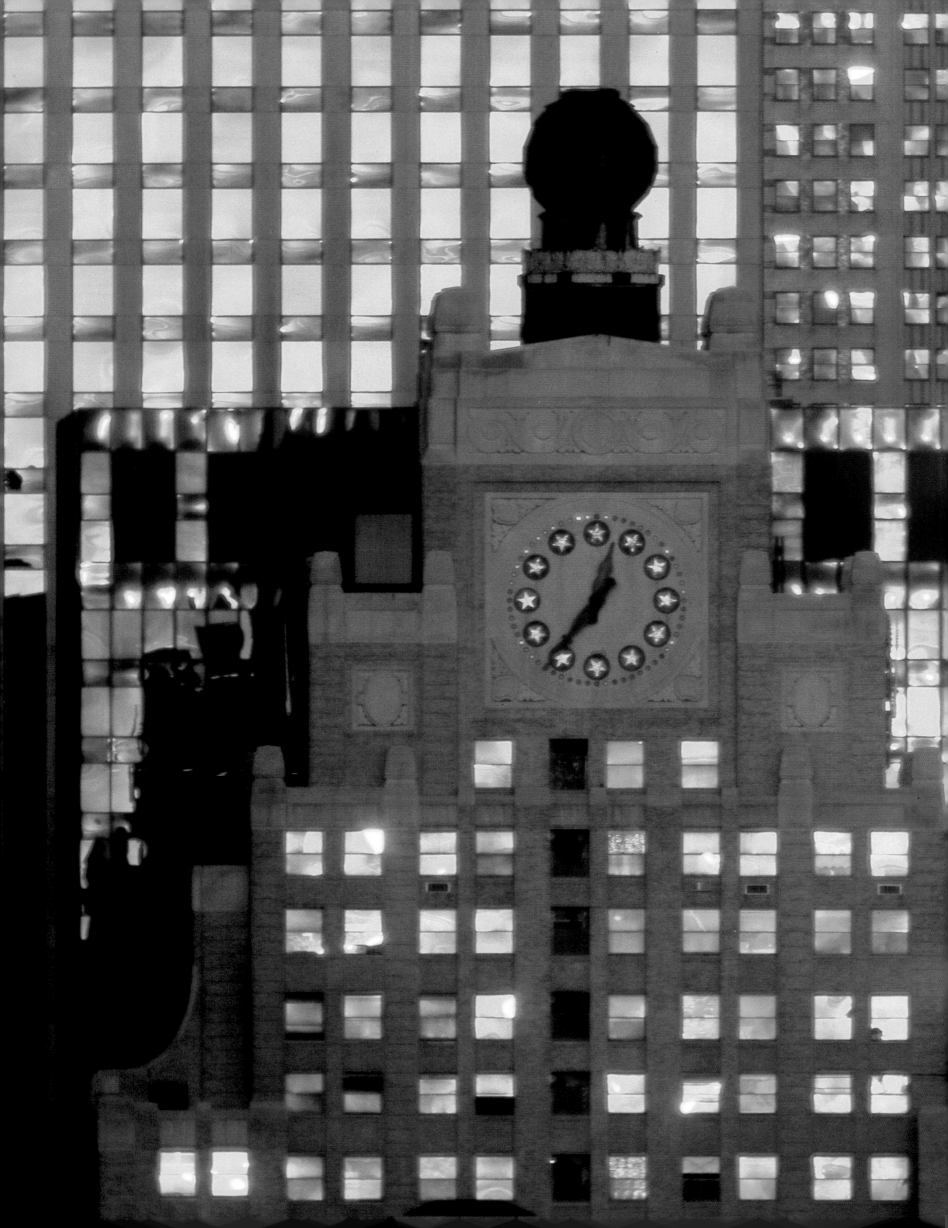

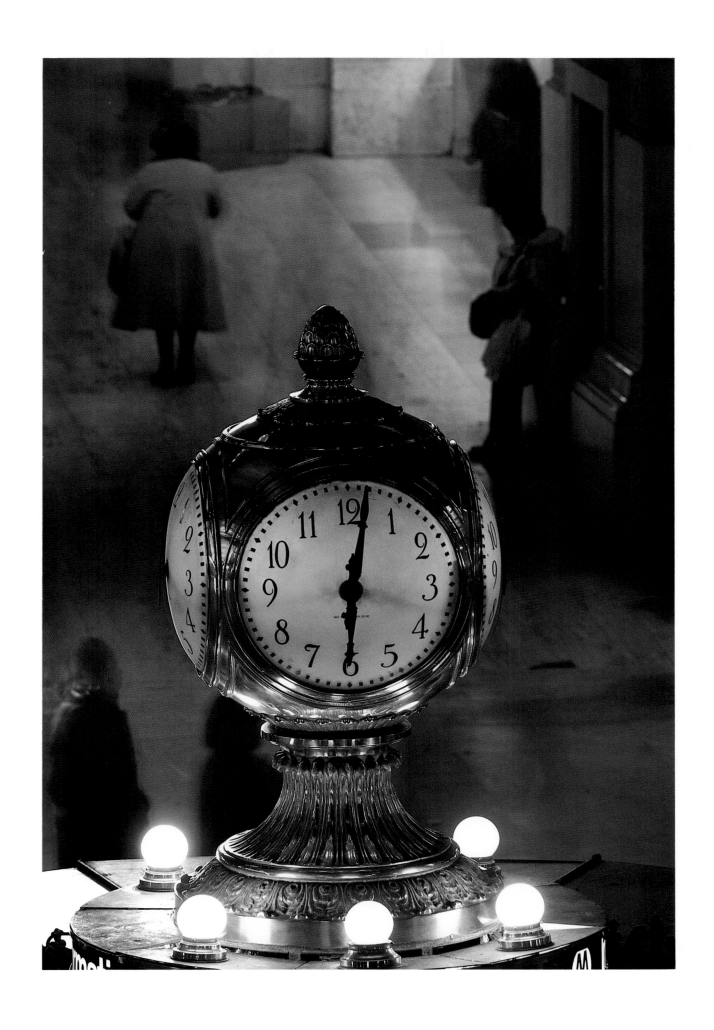

See Manhattan I cried, New York!
even at sunset it doesn't shine
but stands in fire, charcoal to the waist.
 —*Grace Paley*

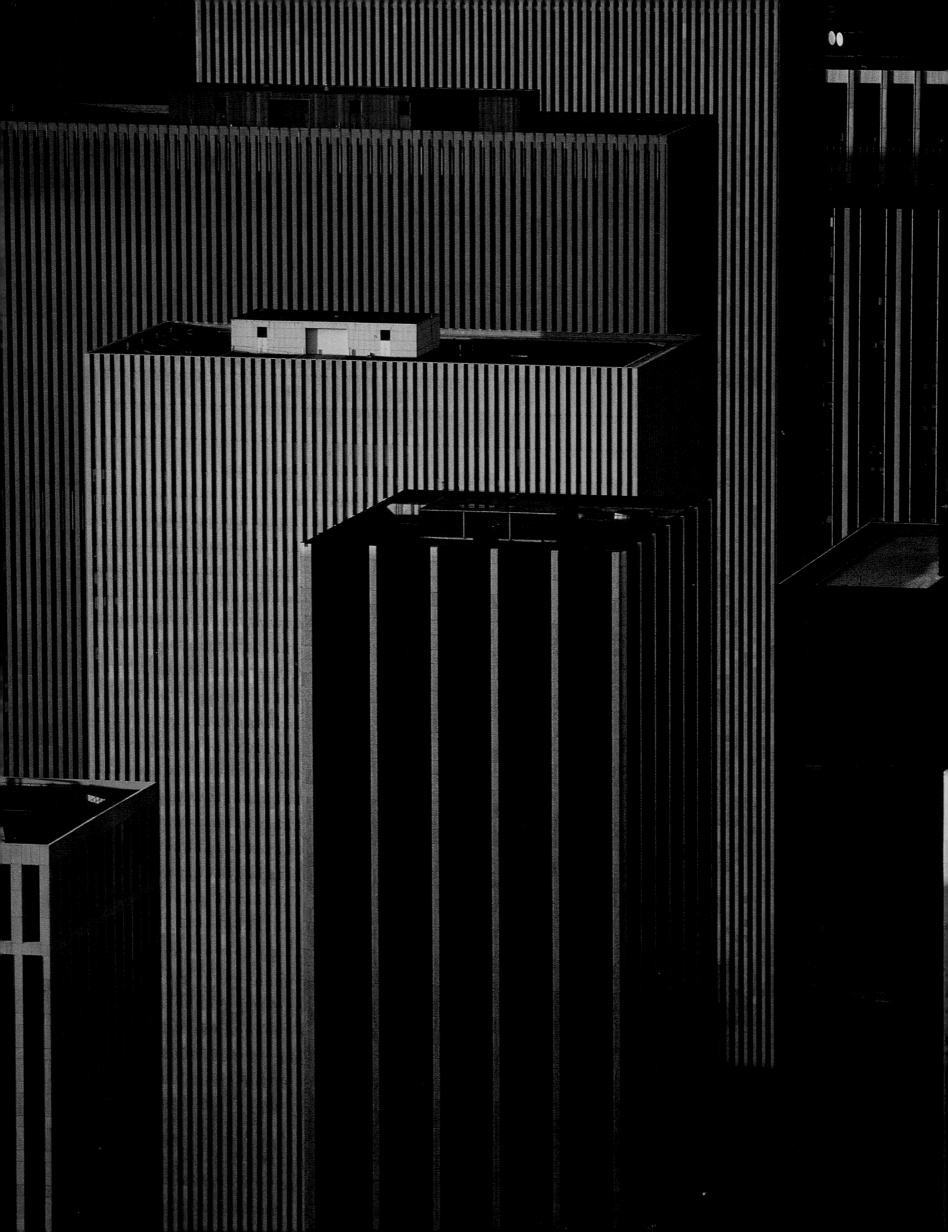

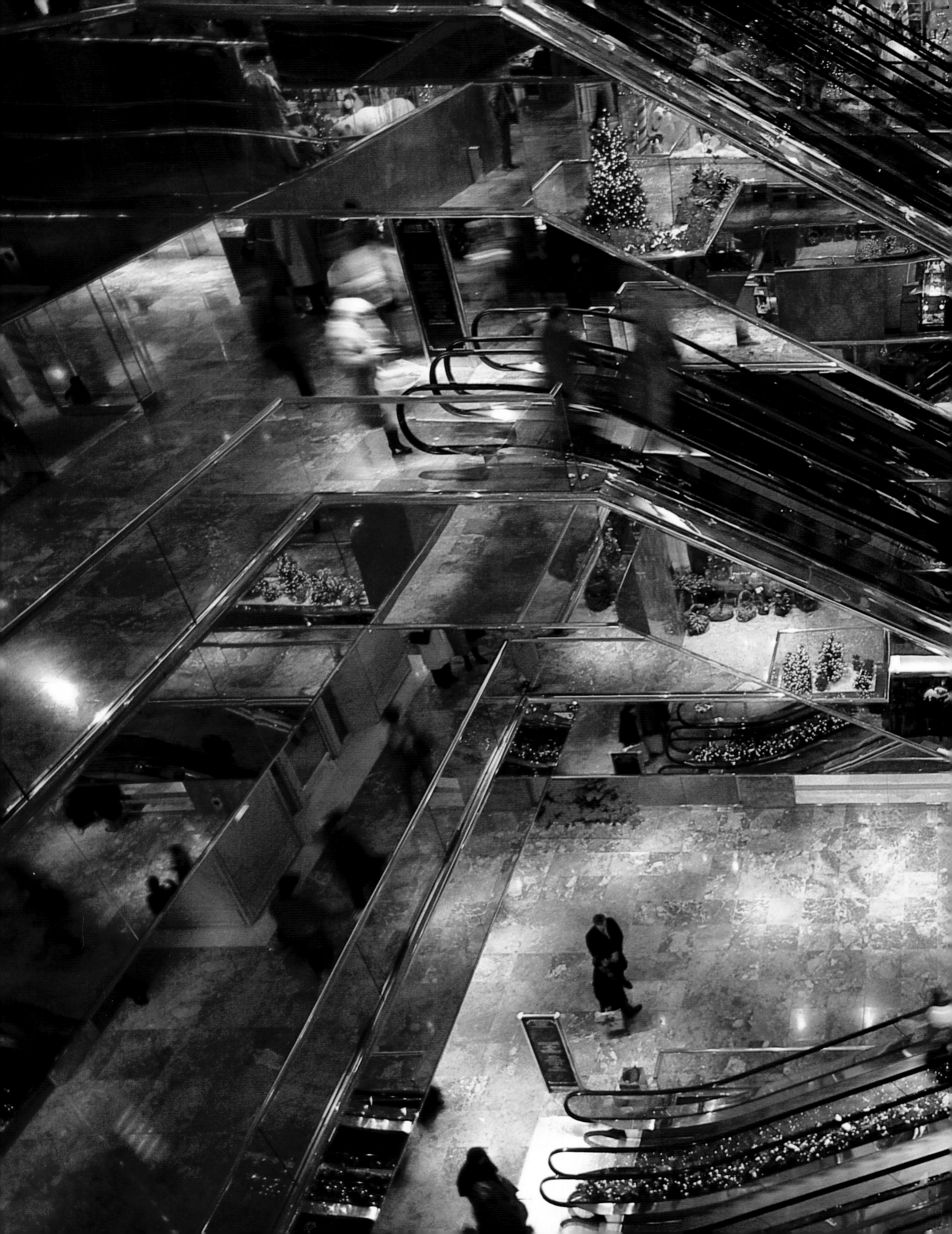

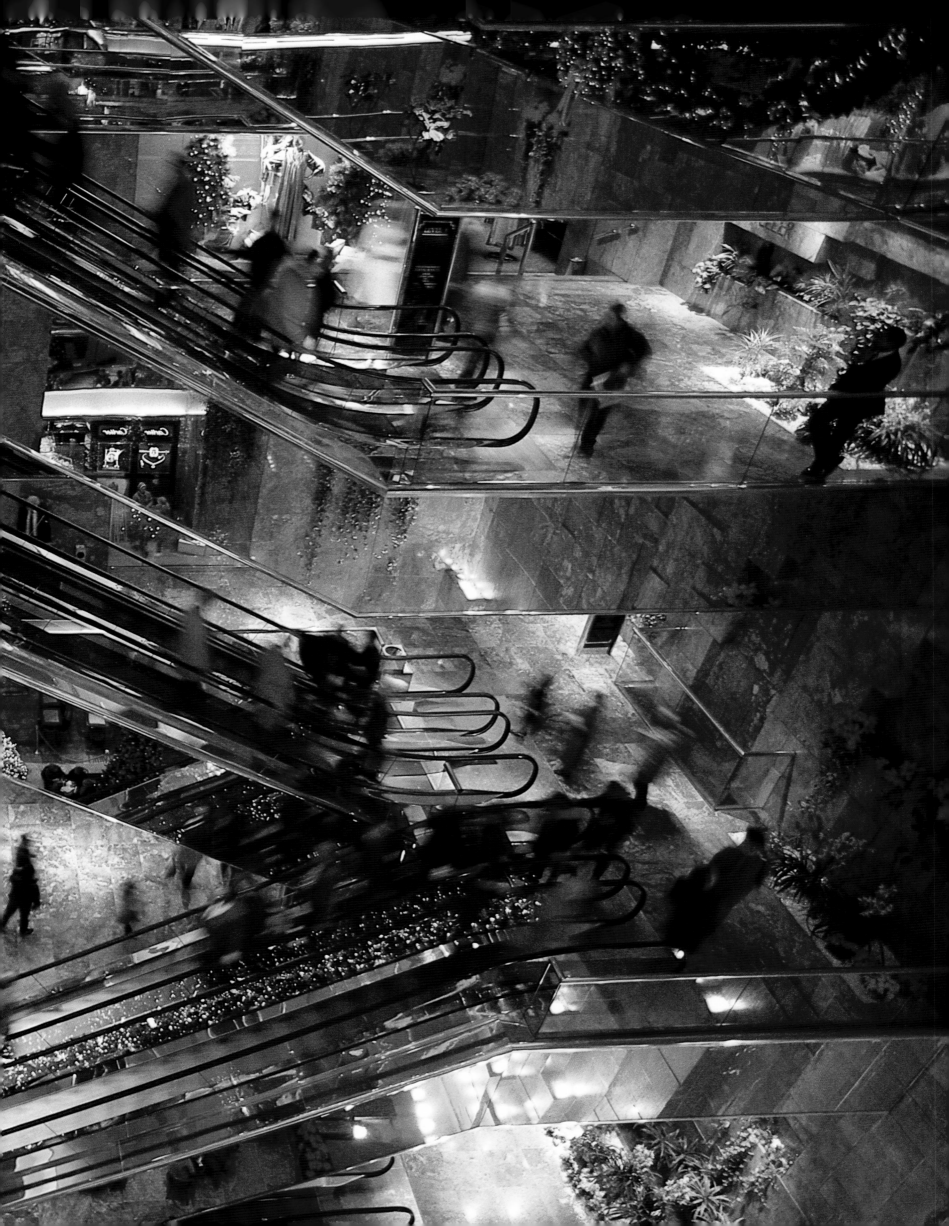

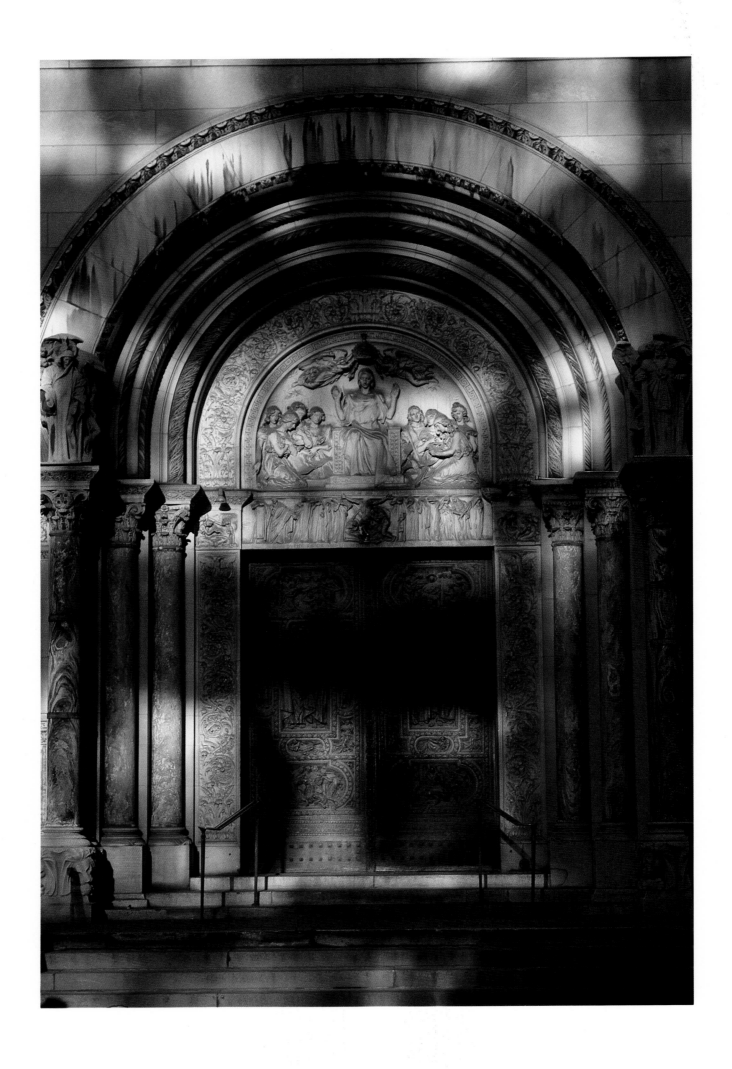

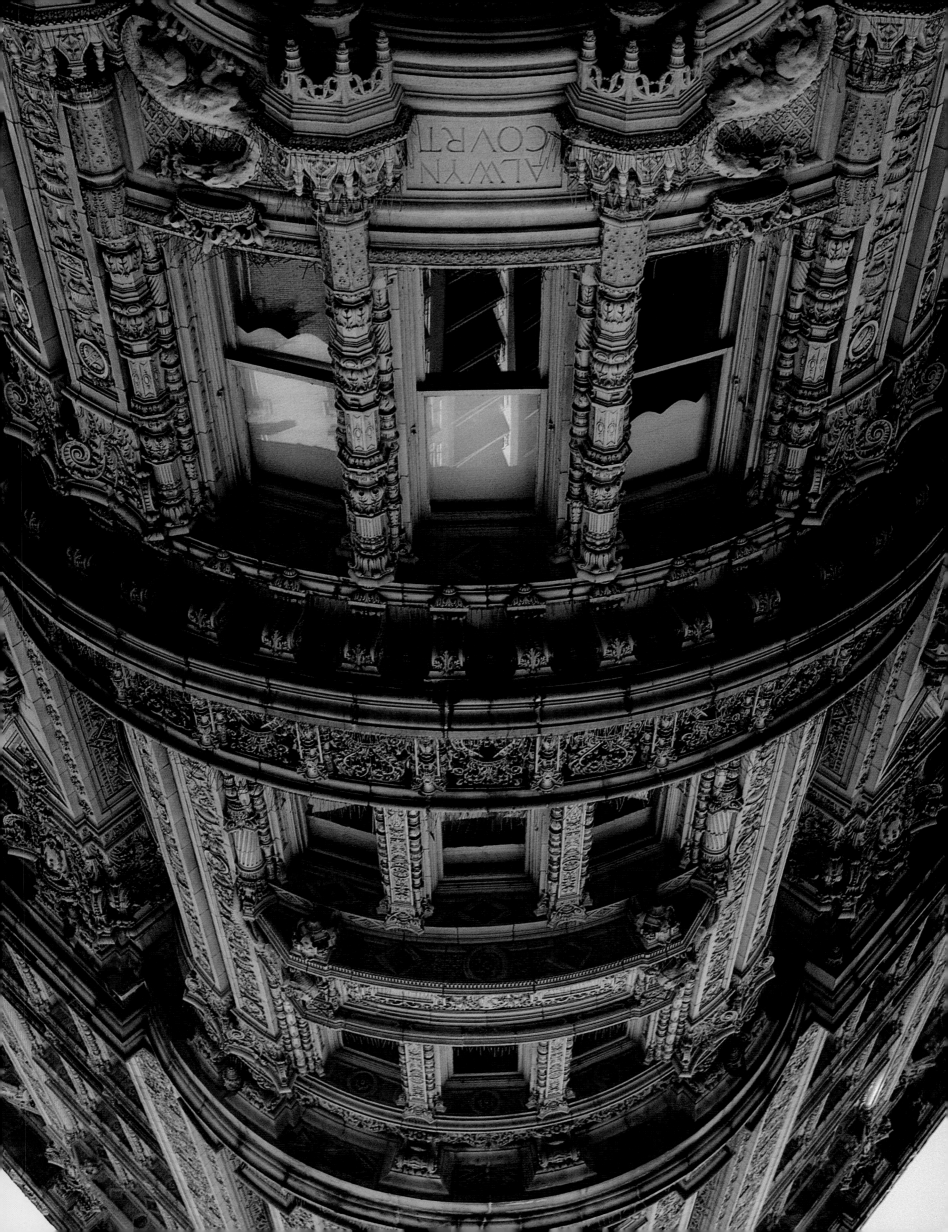

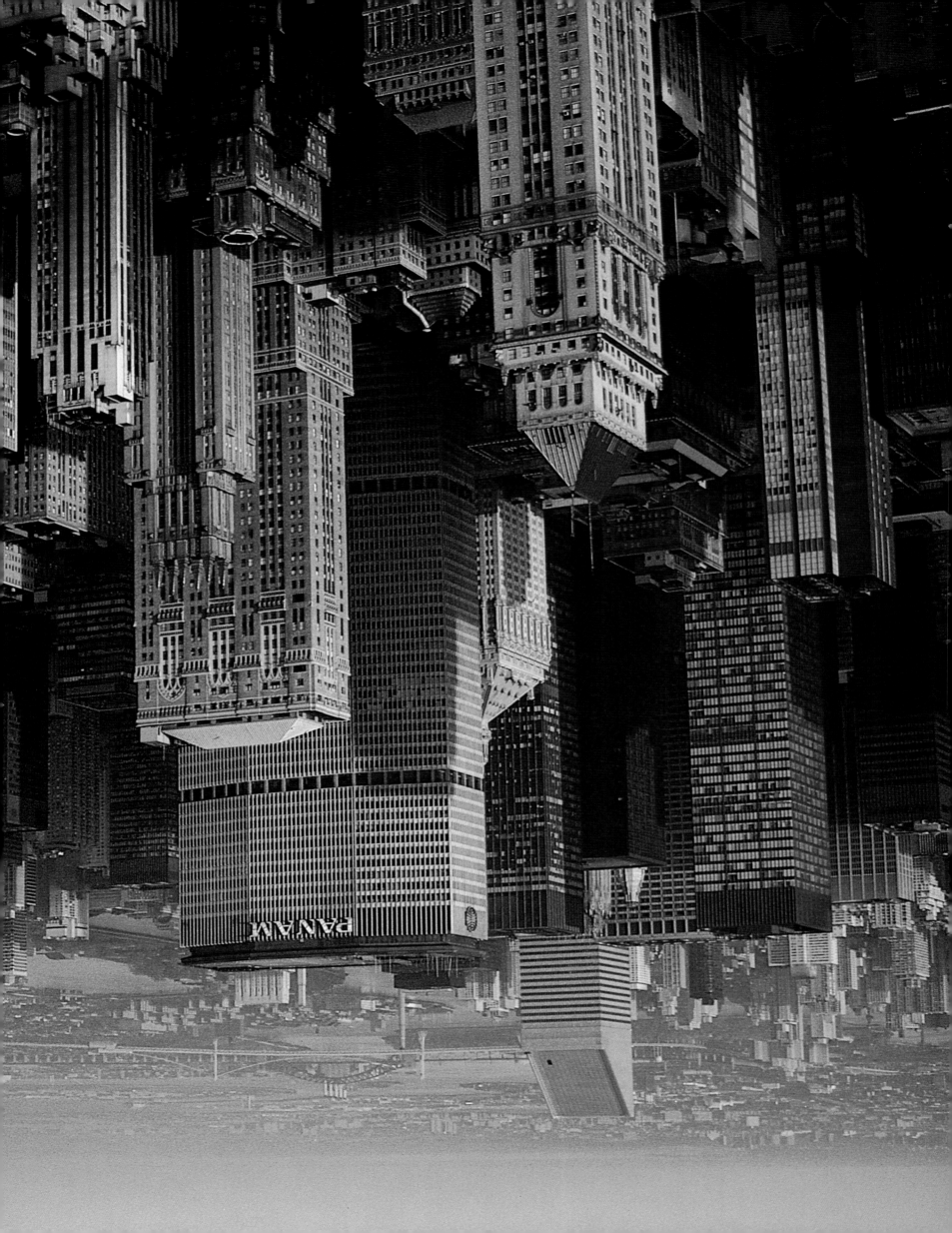

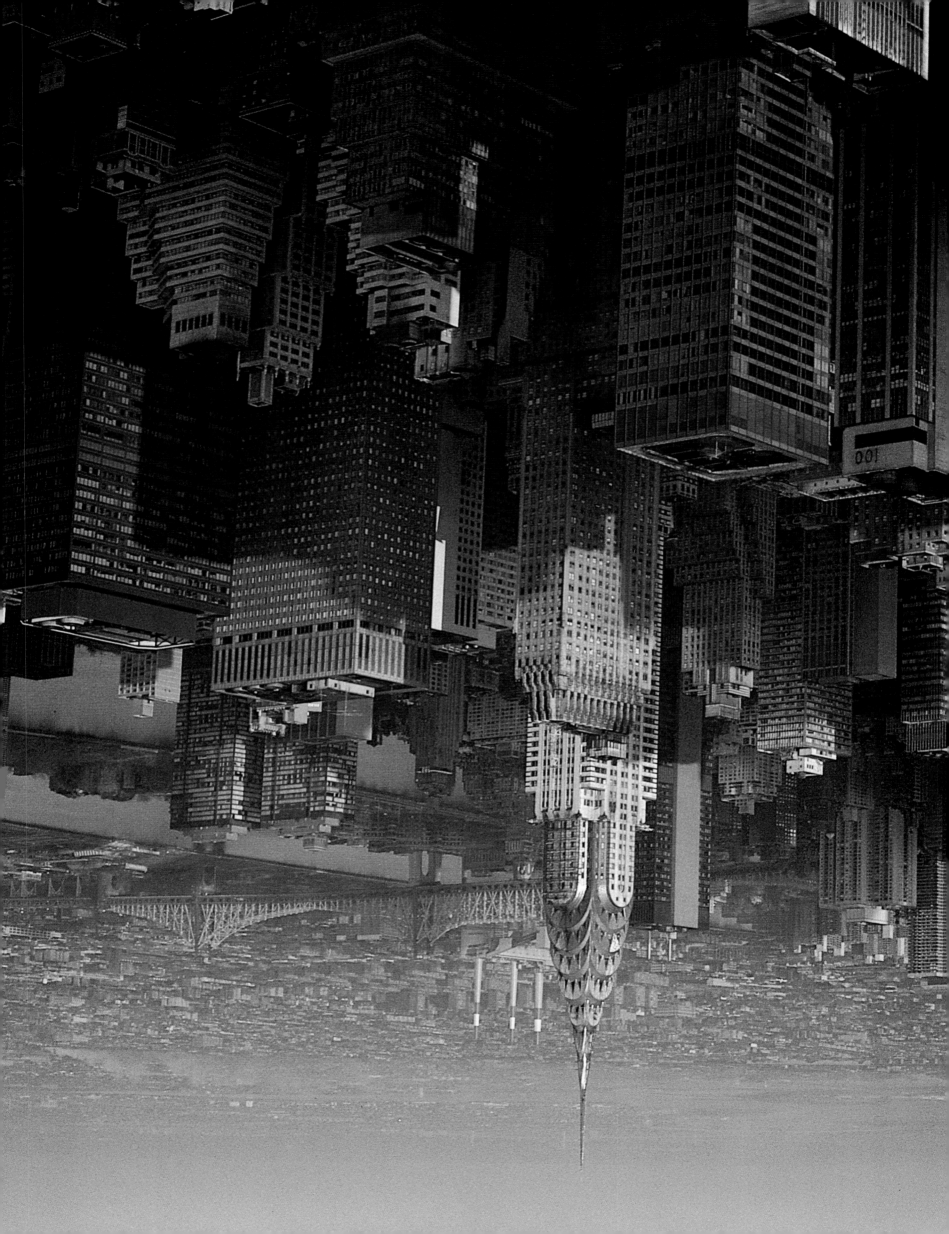

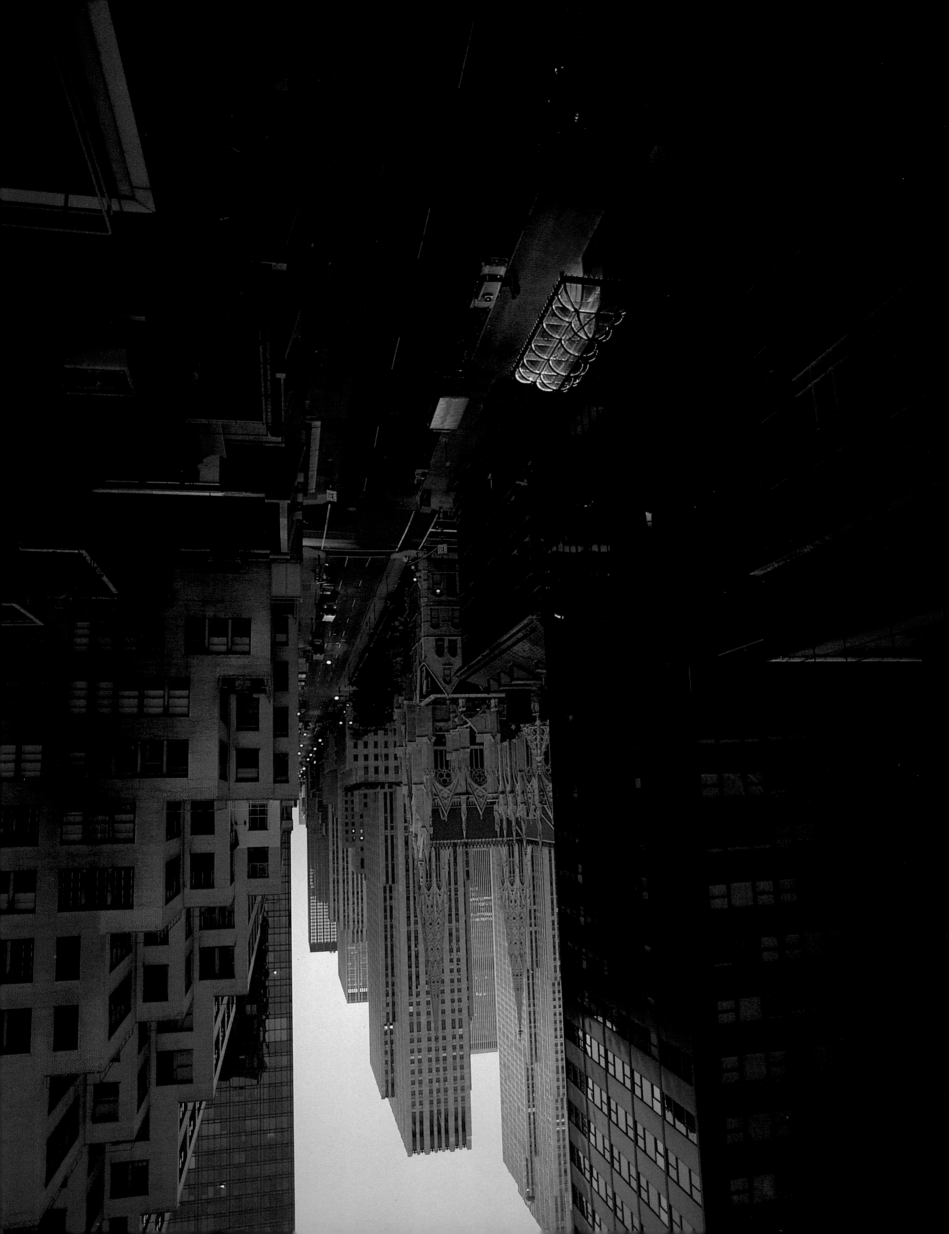

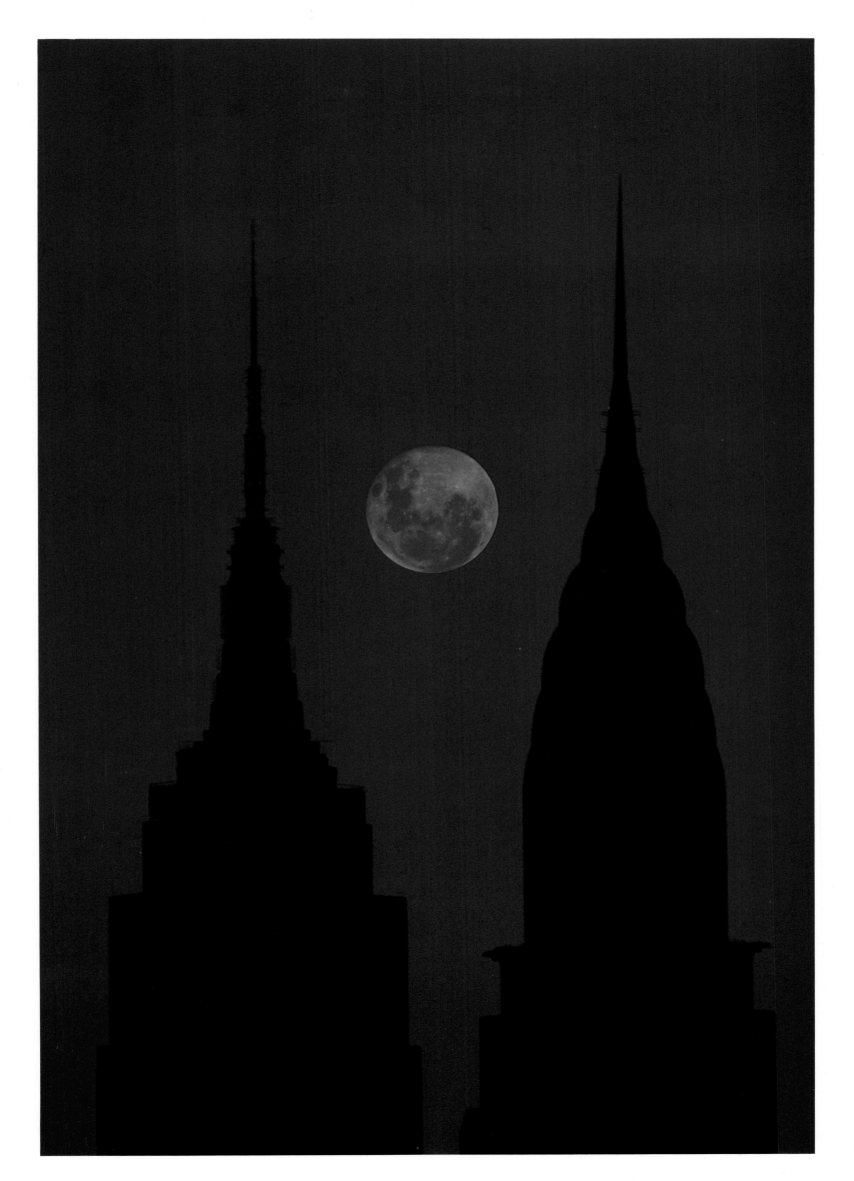

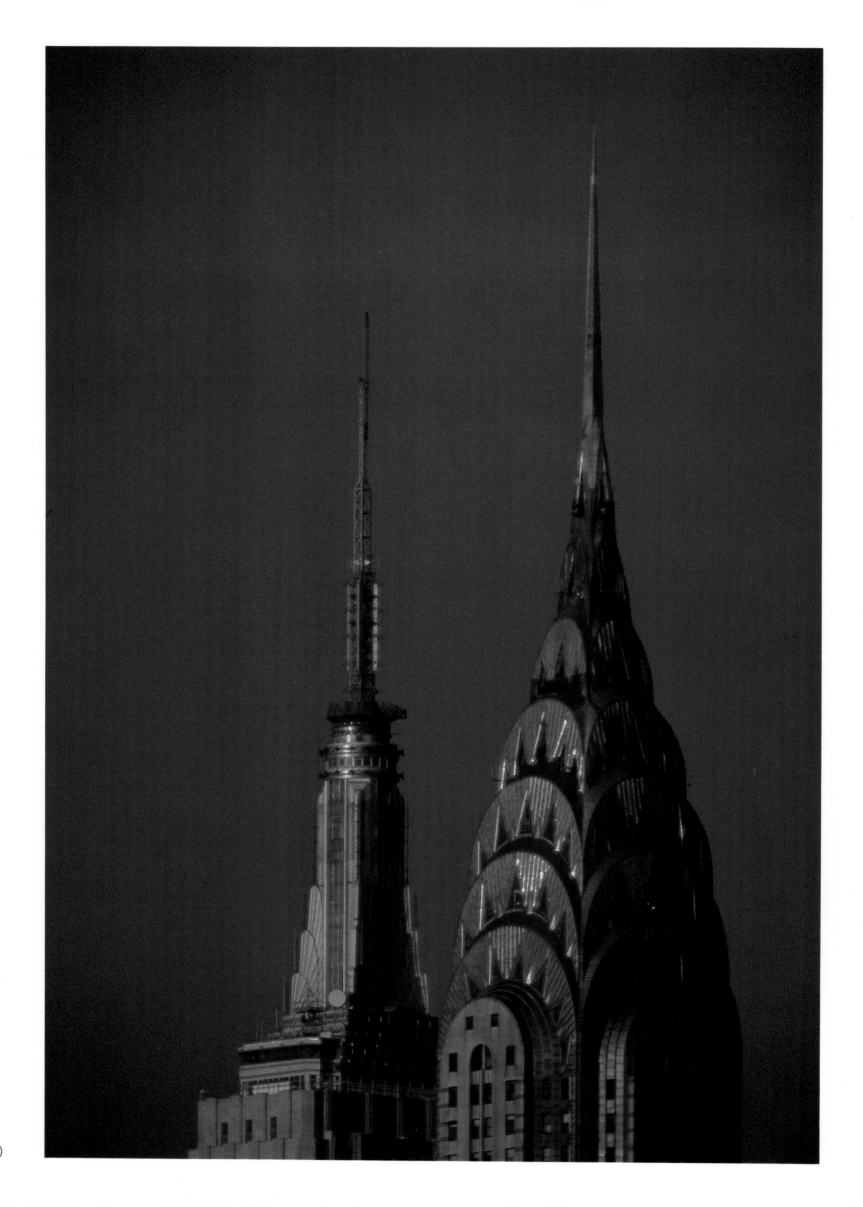

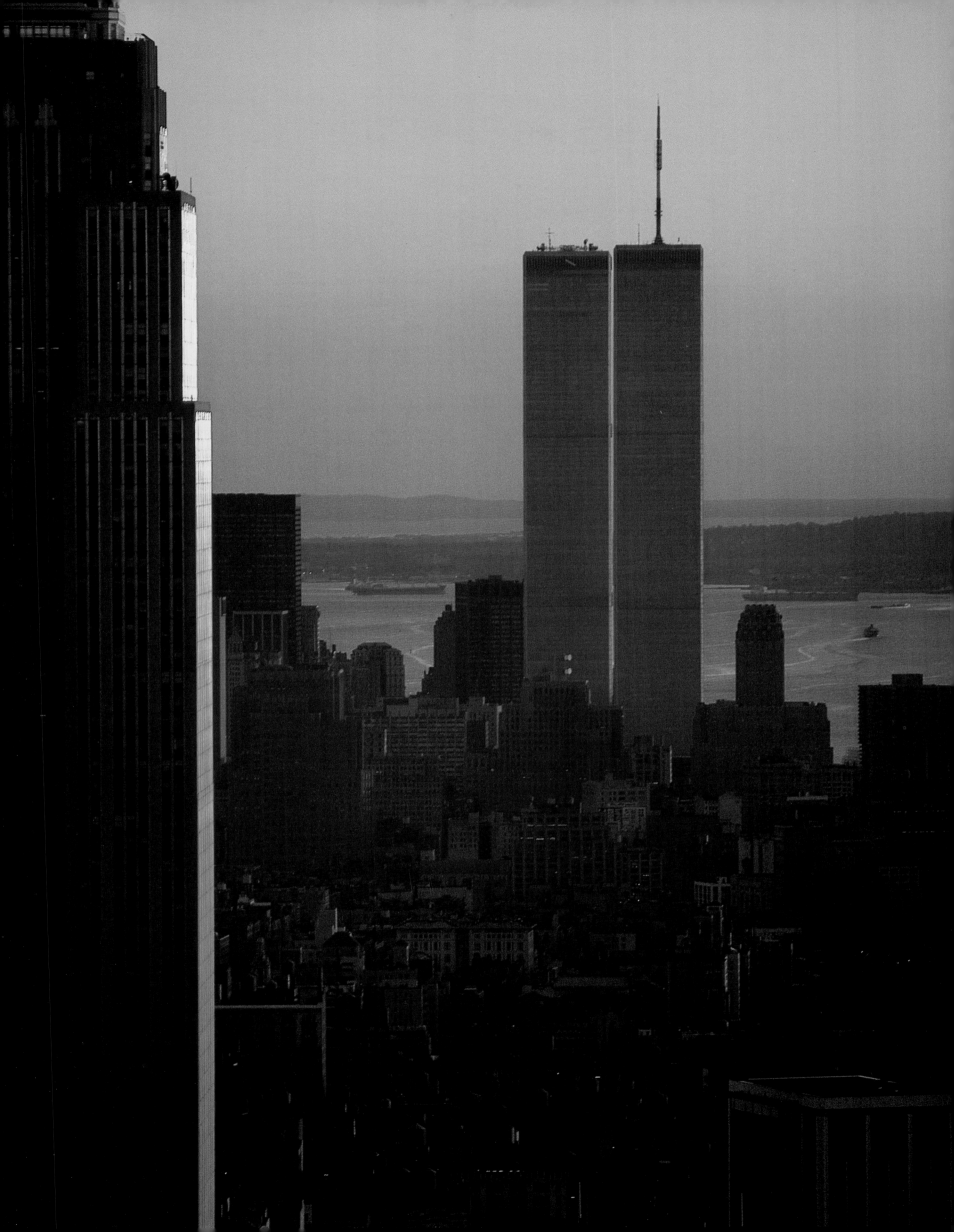

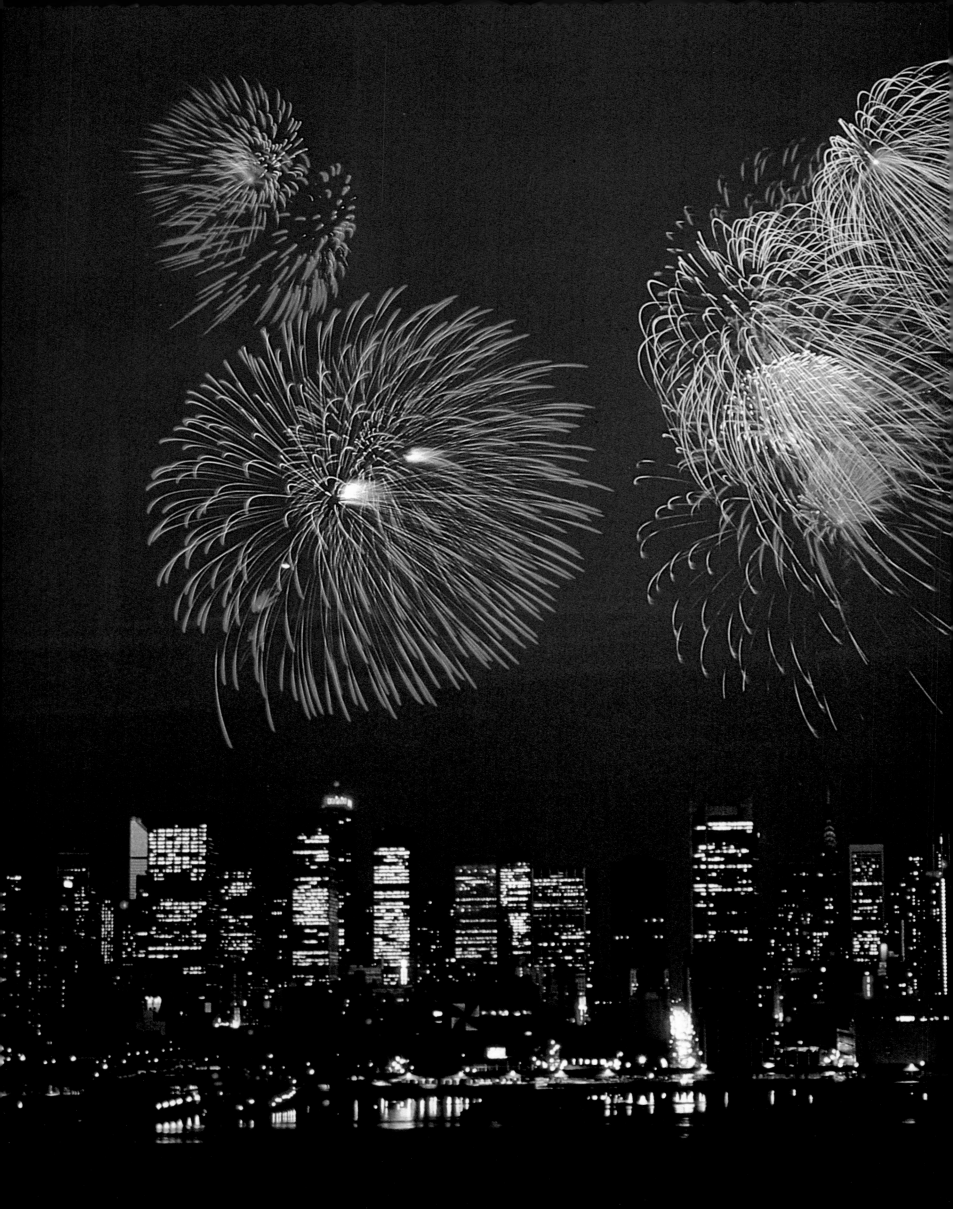

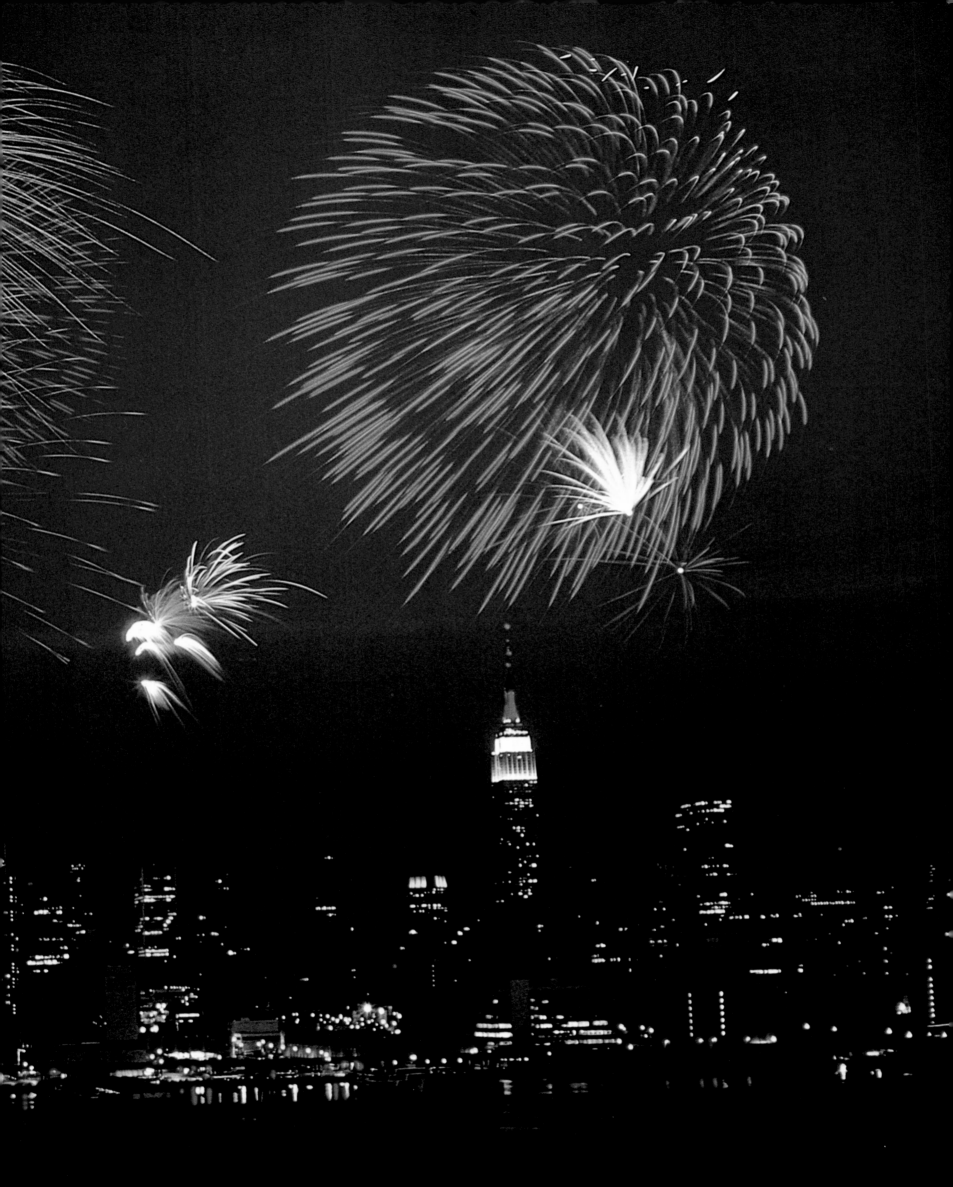

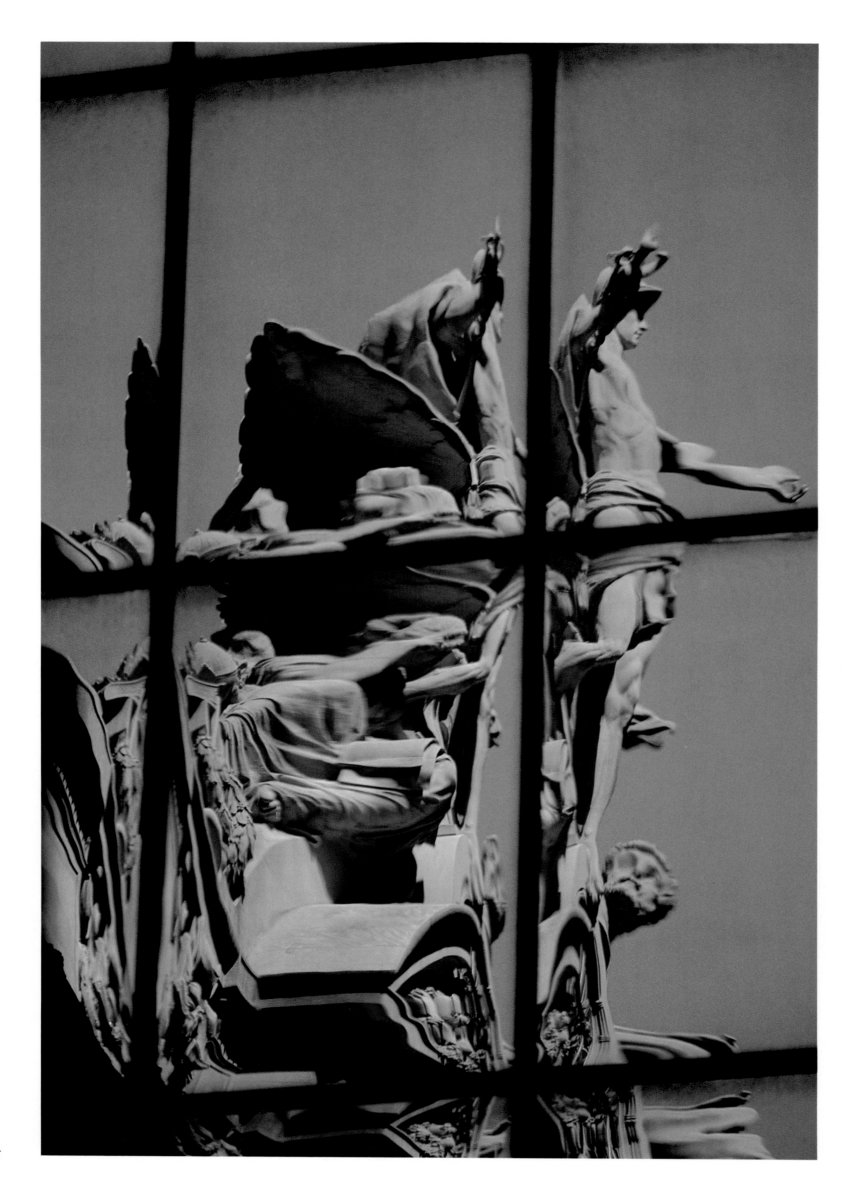

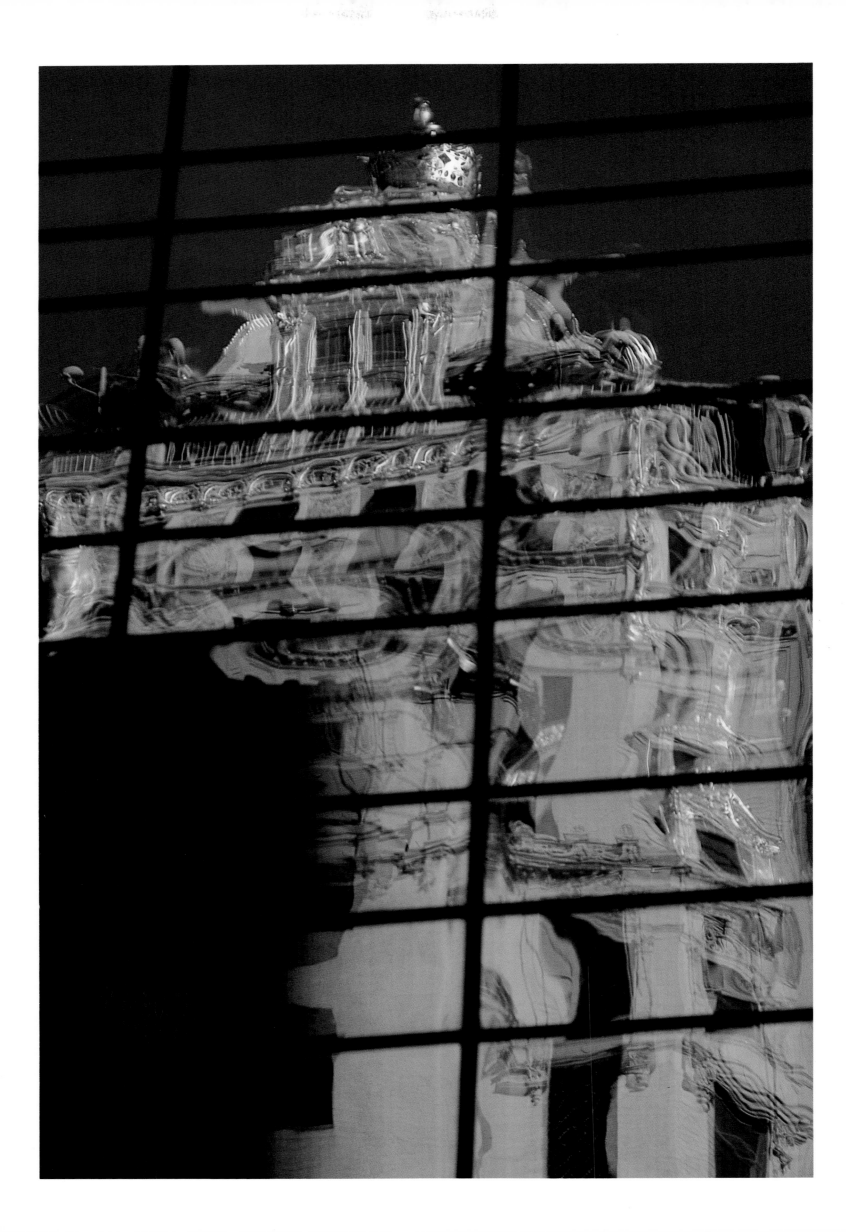

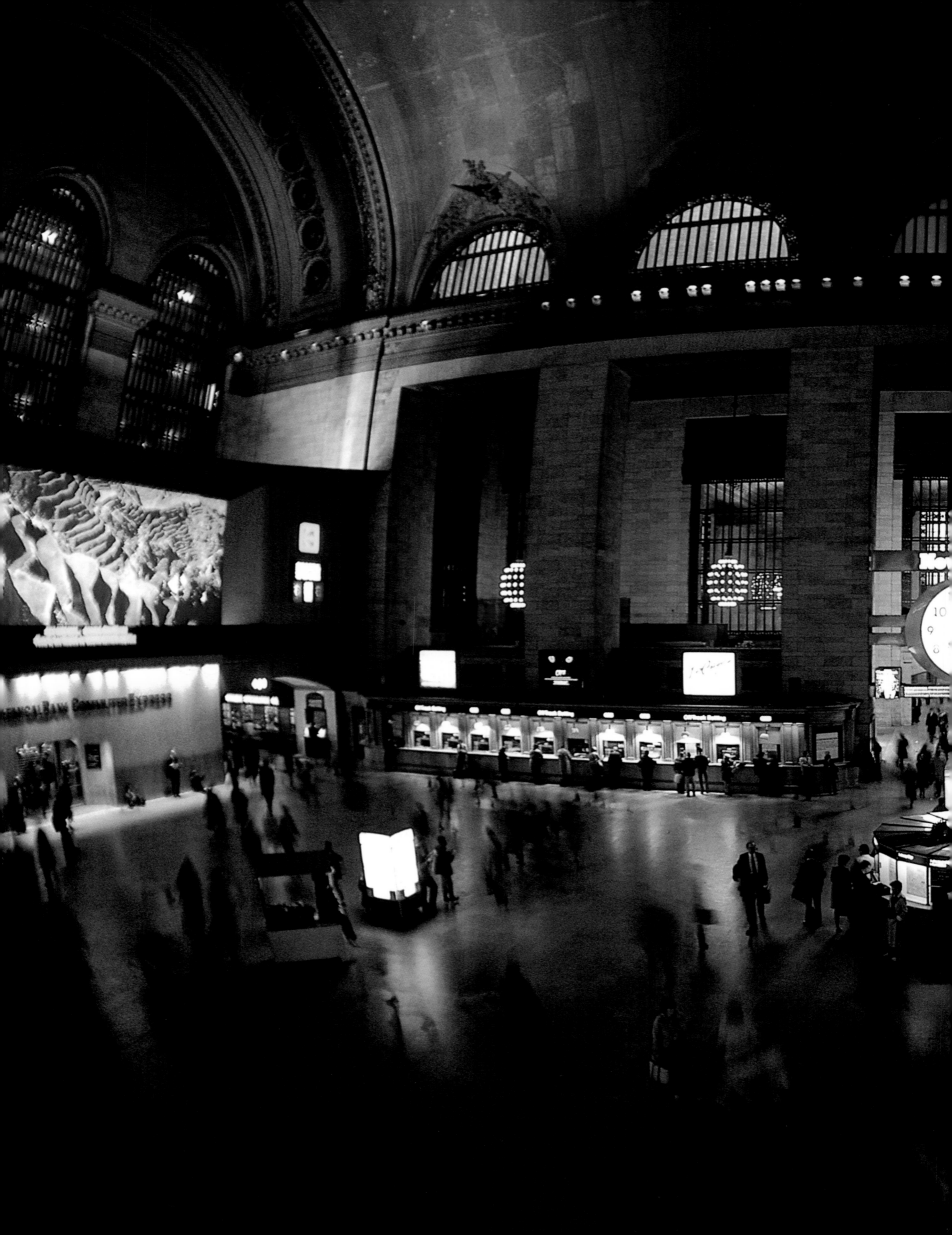

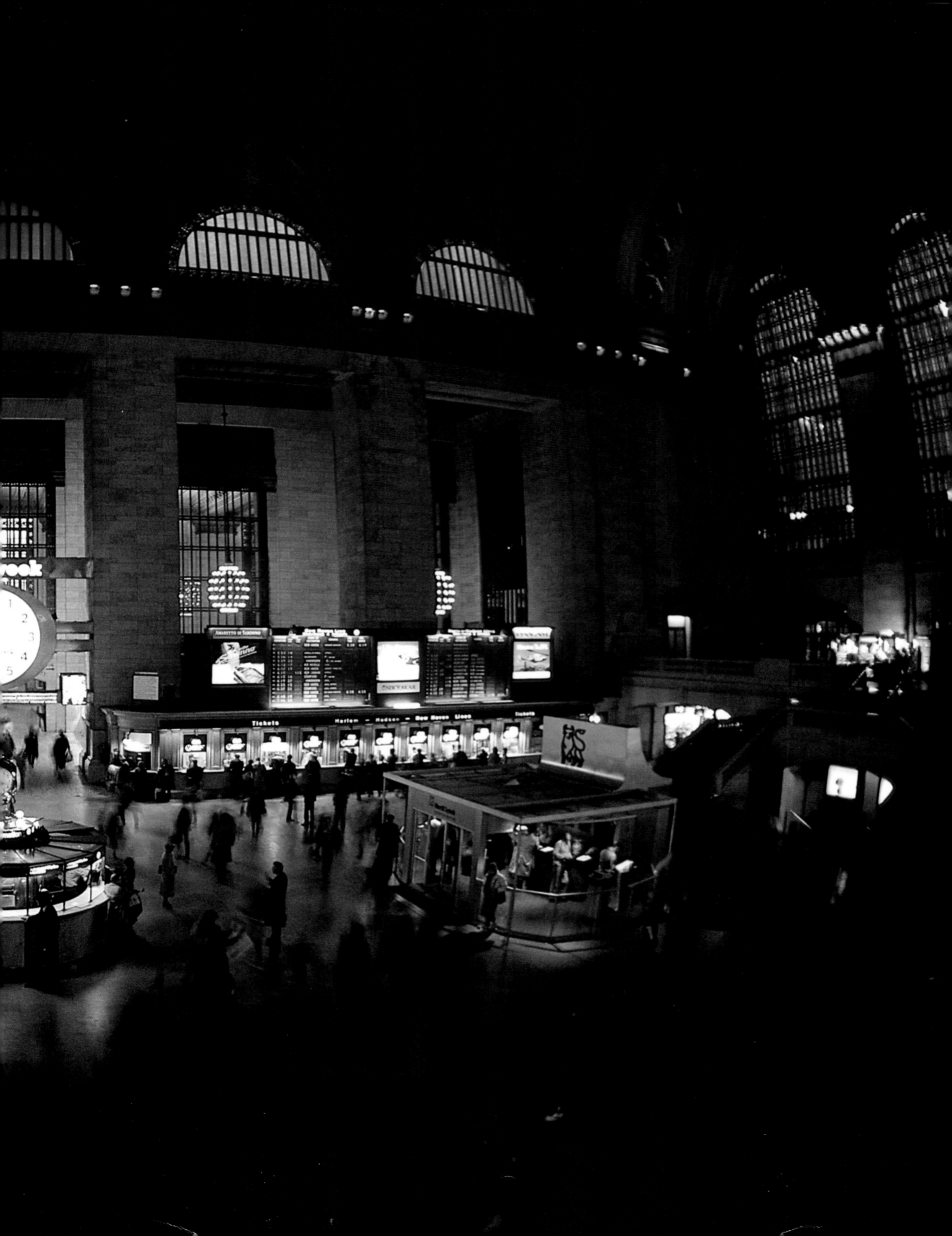

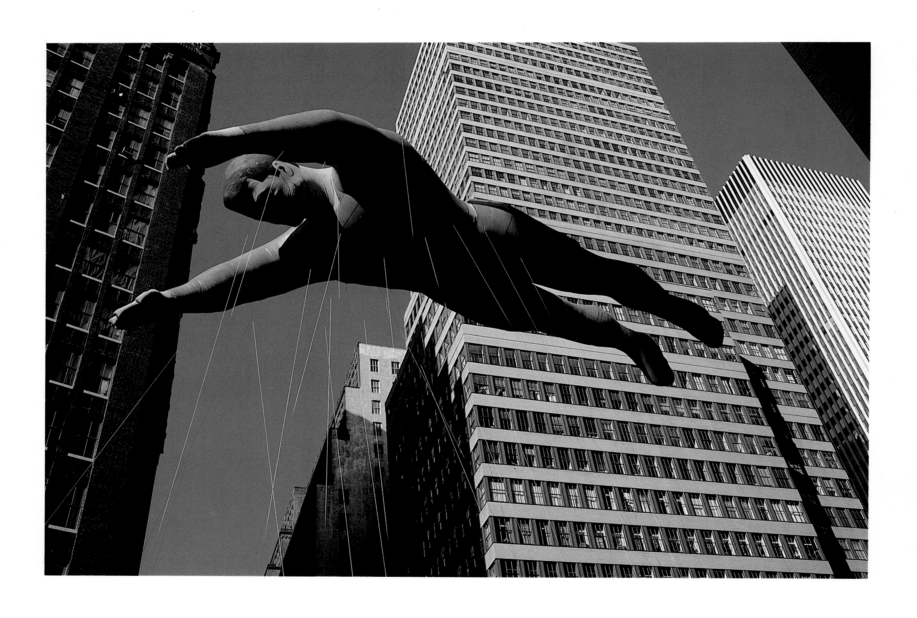

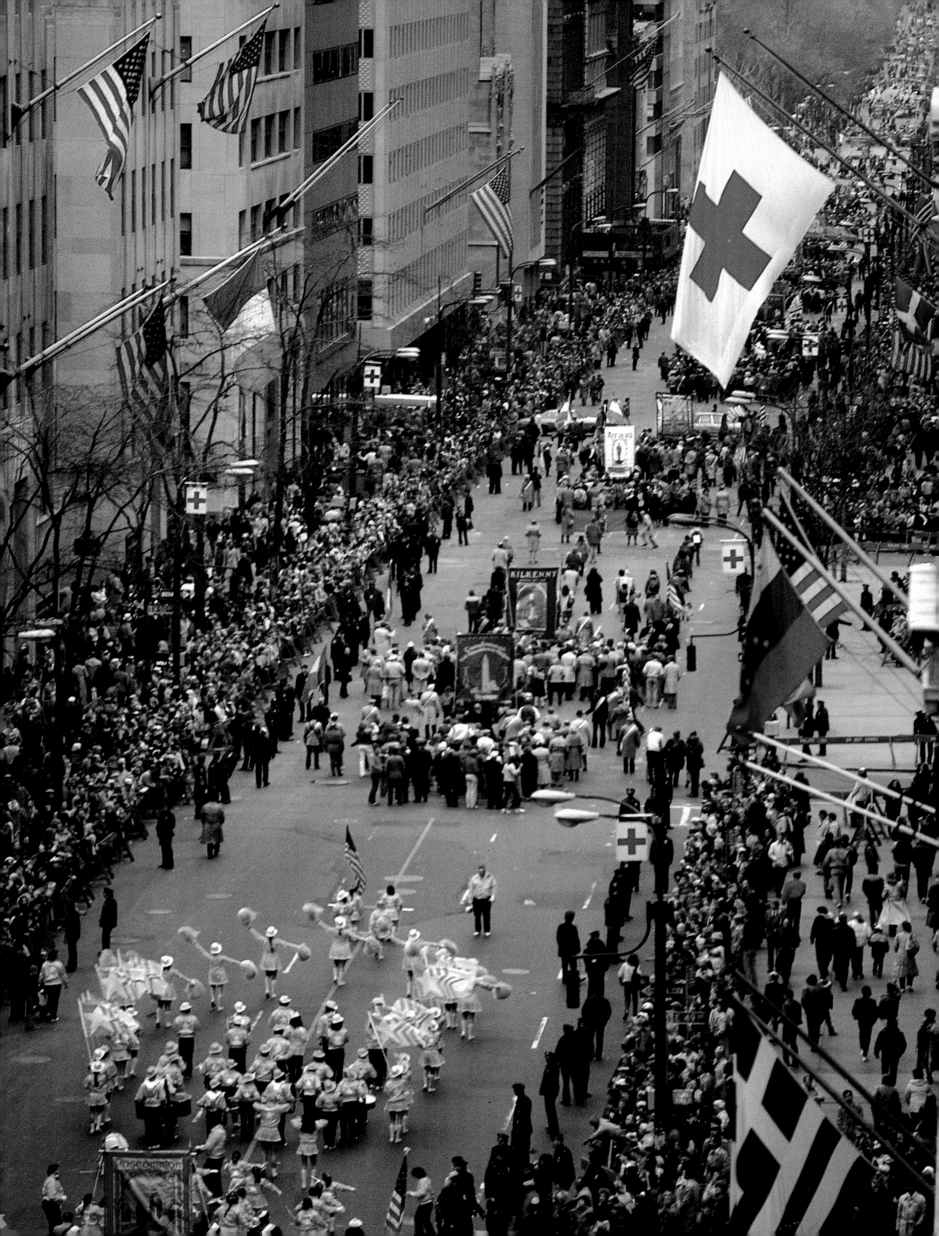

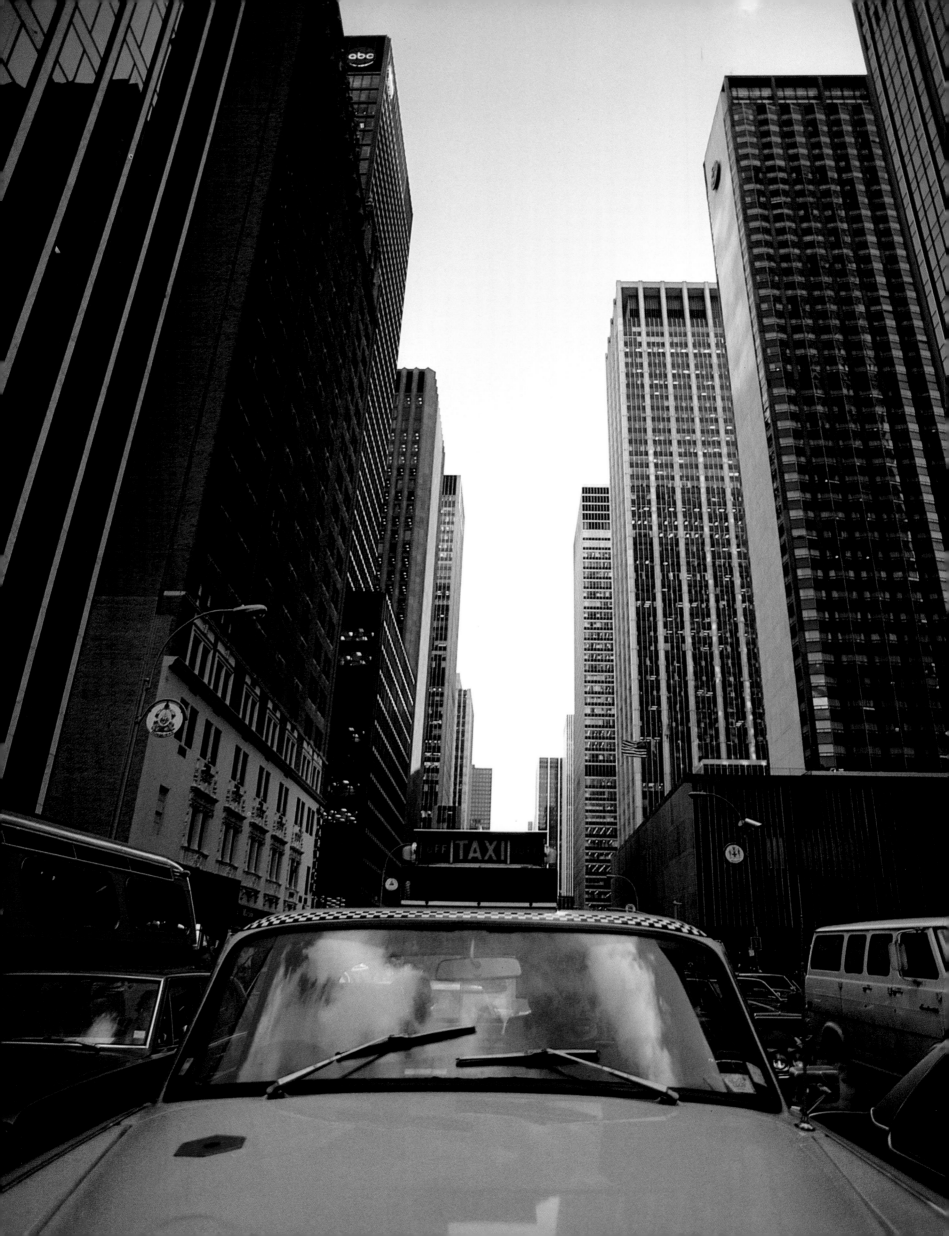

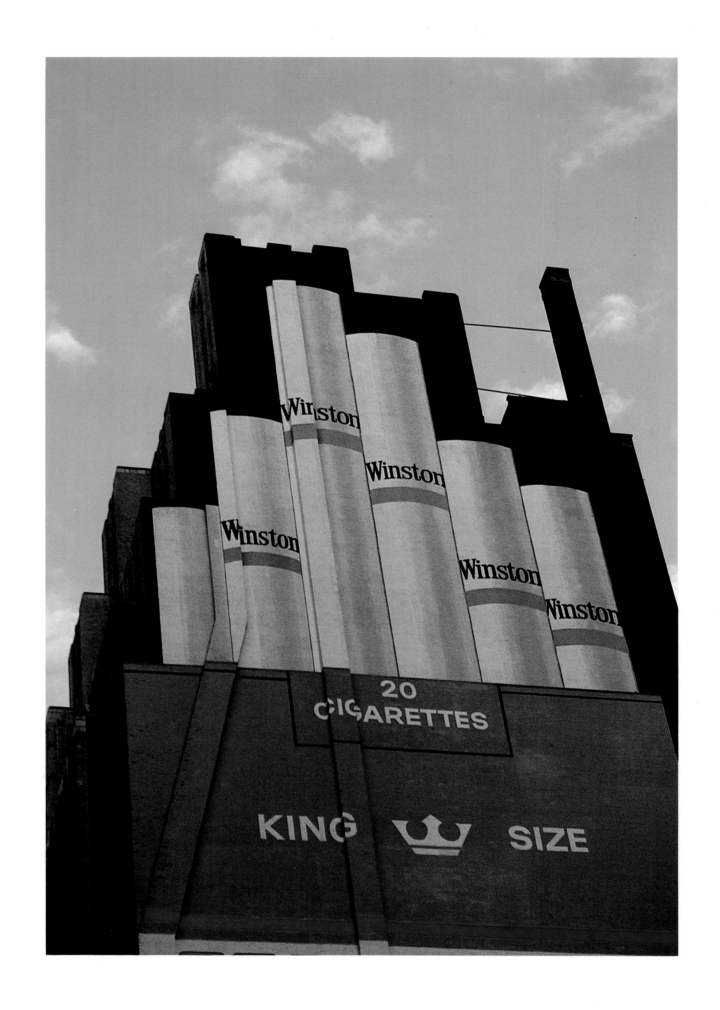

Manhattan—a skyline of unplanned architecture reflecting the unpredictable behavior of its citizens.

—Al Hirschfeld

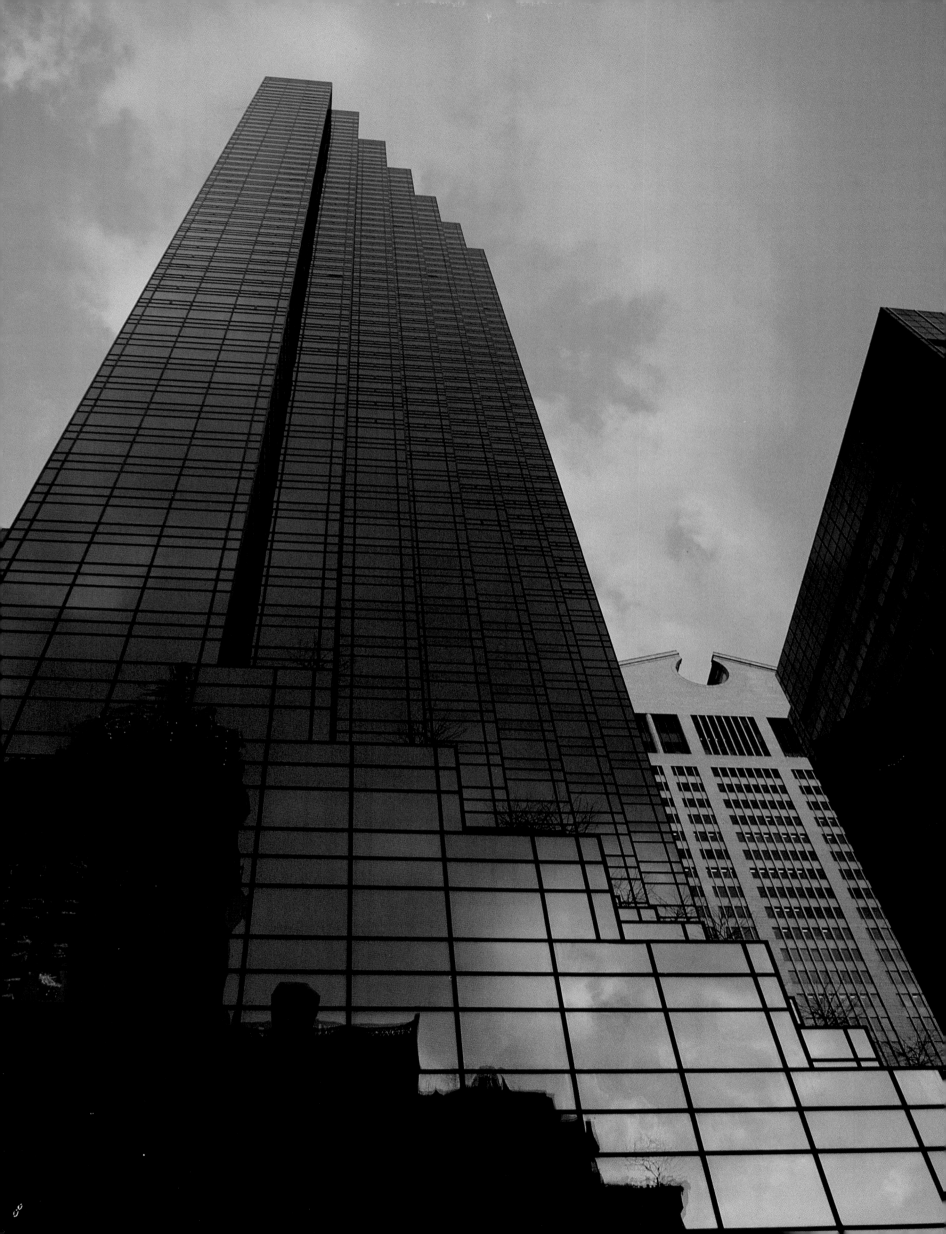

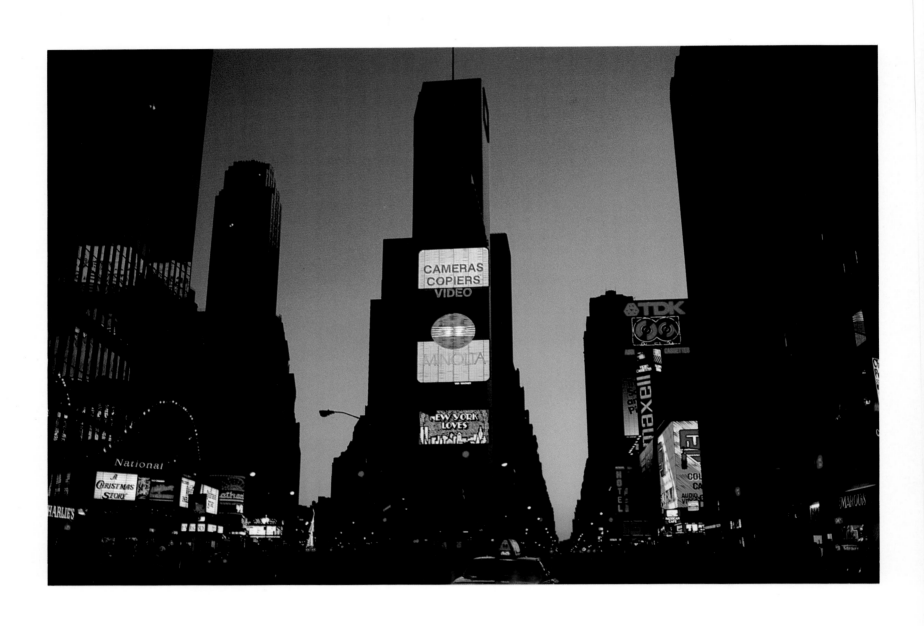

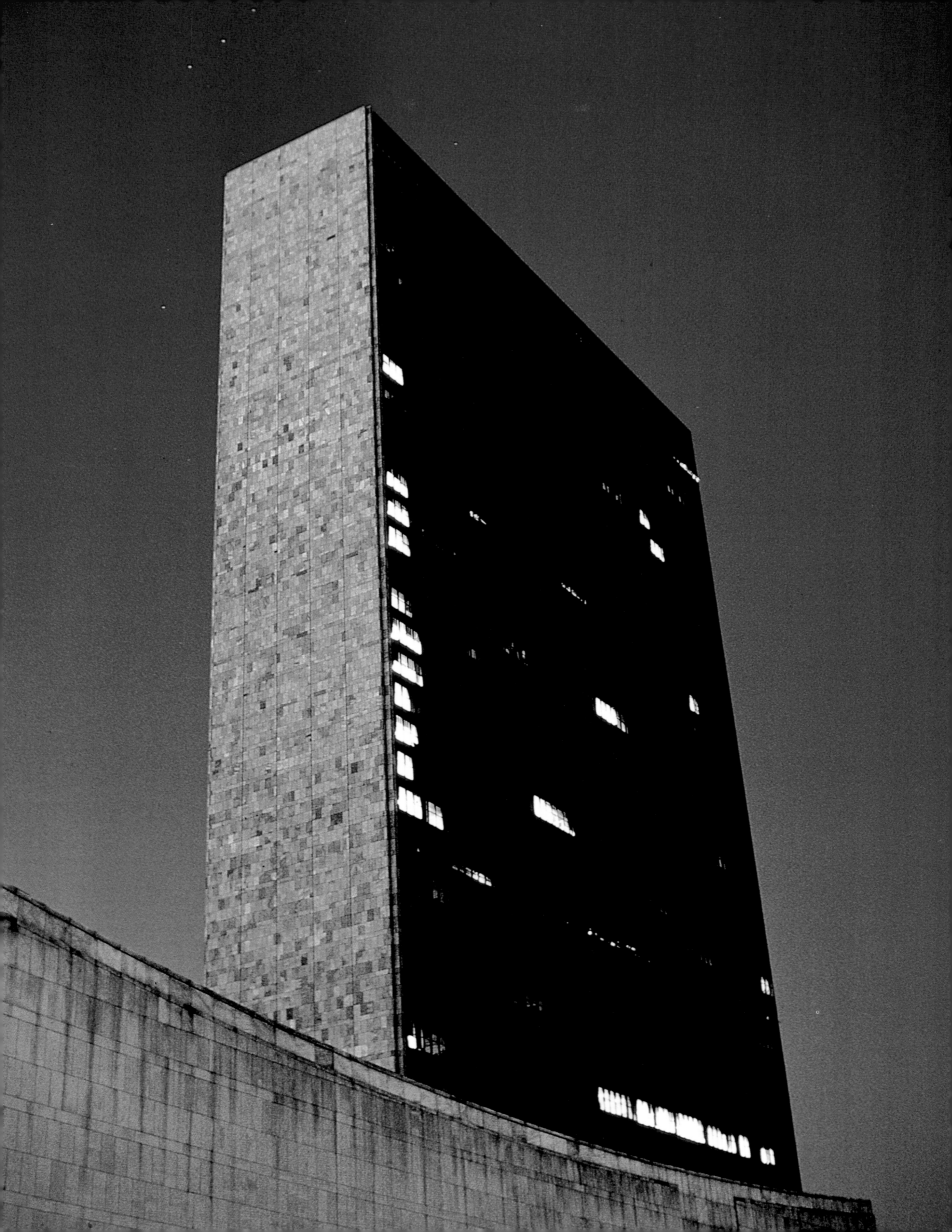

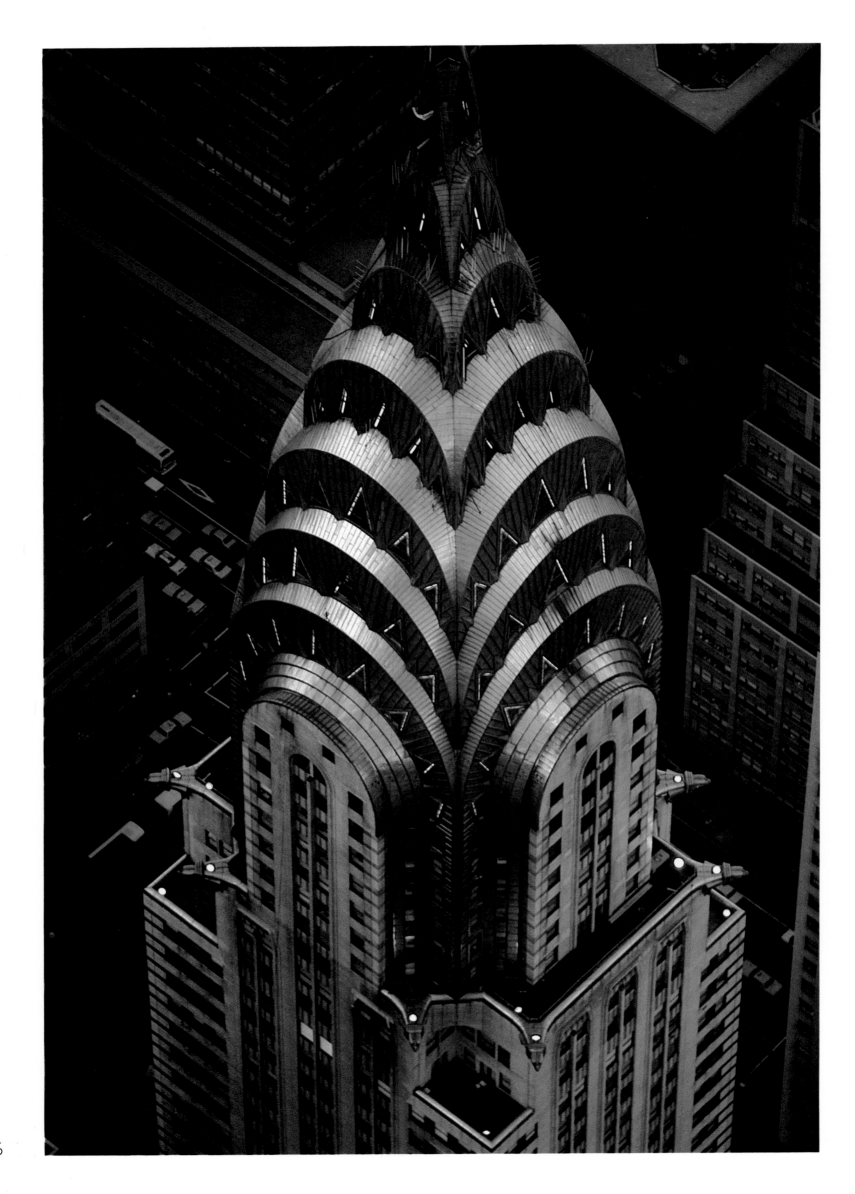

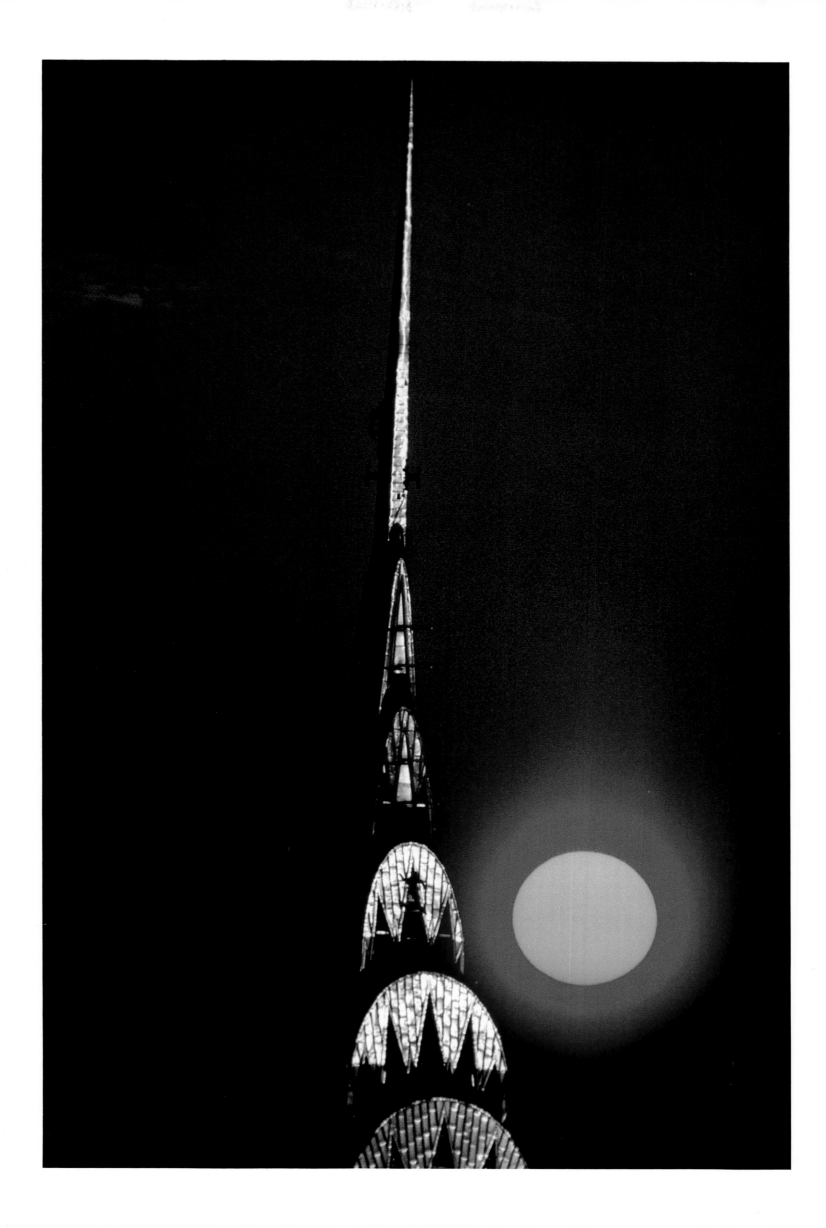

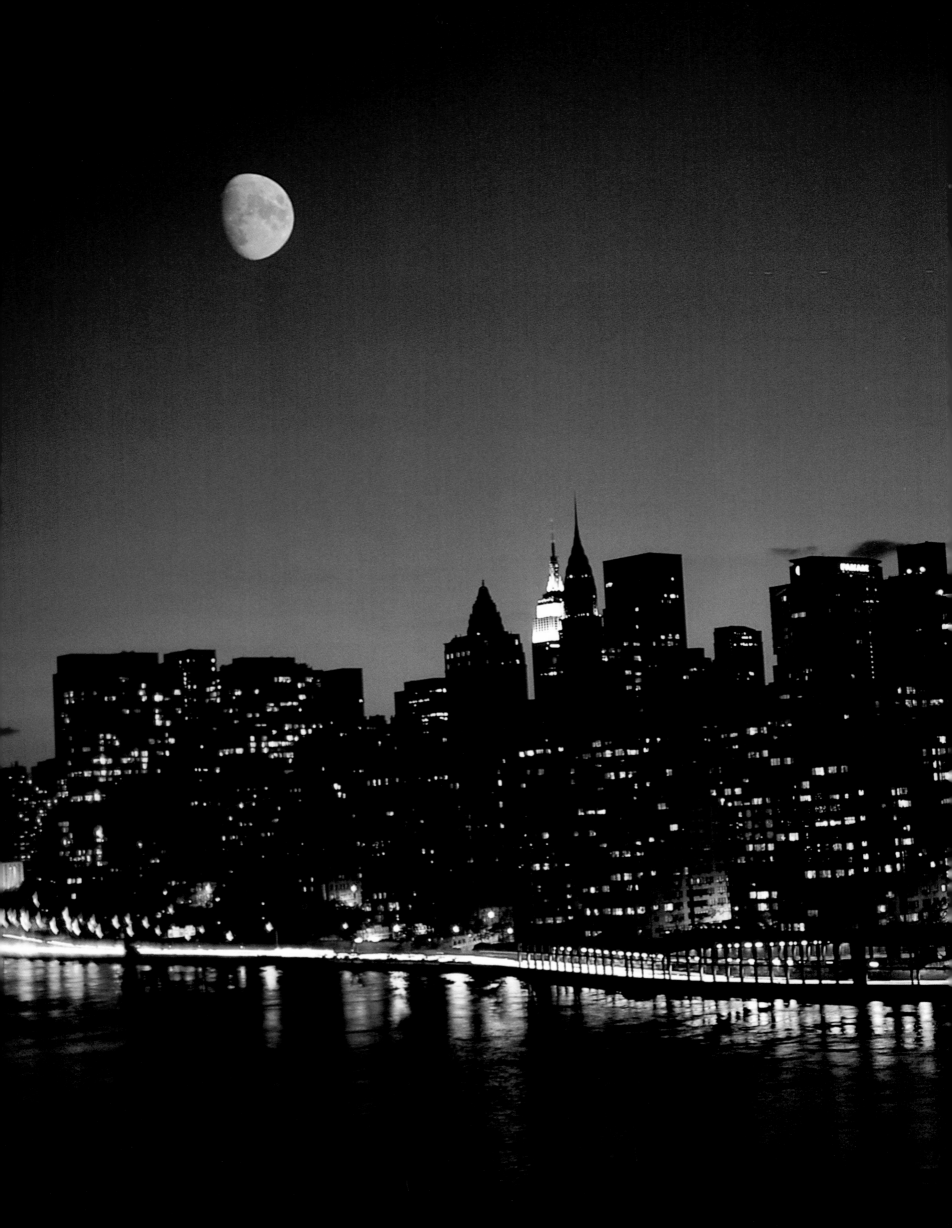

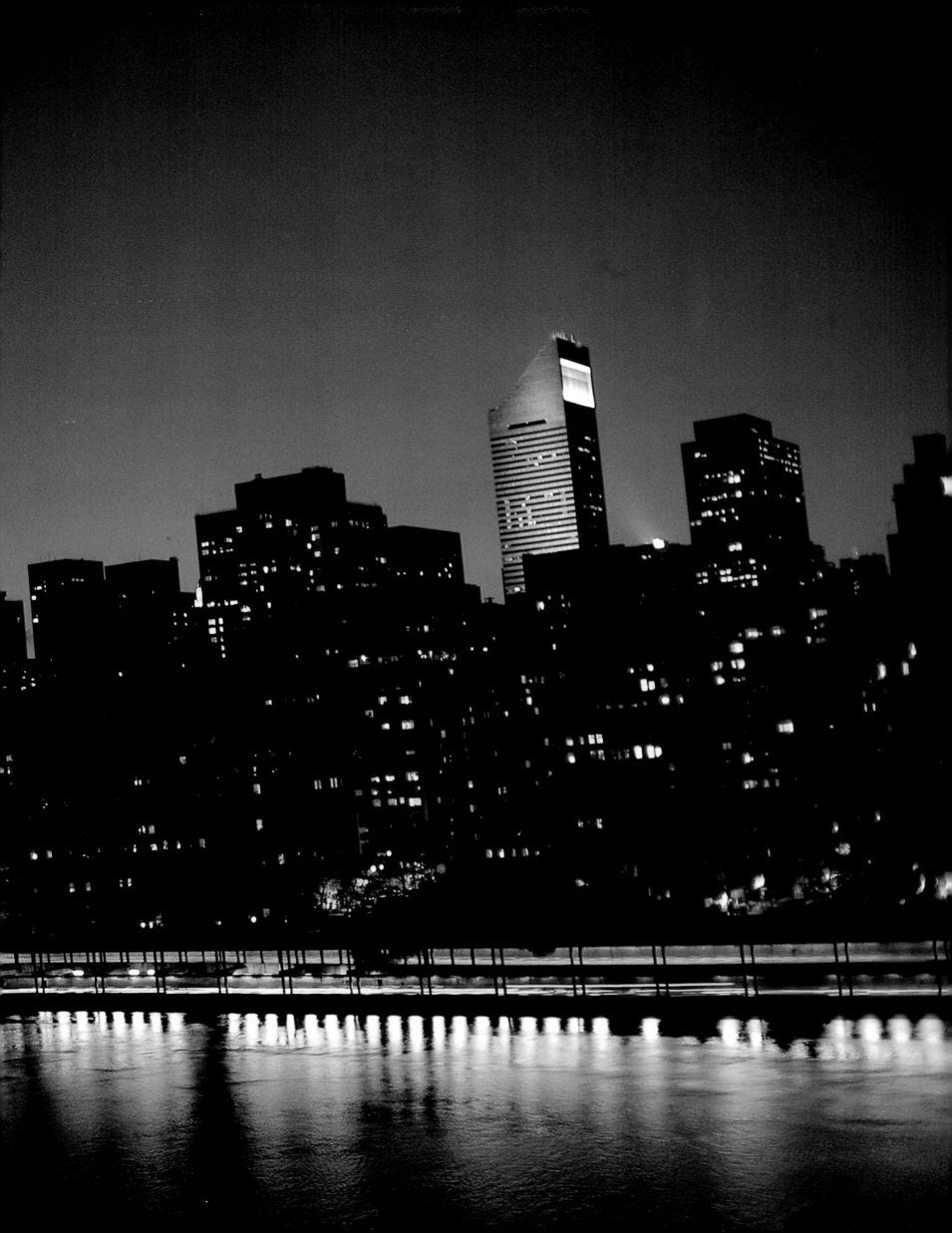

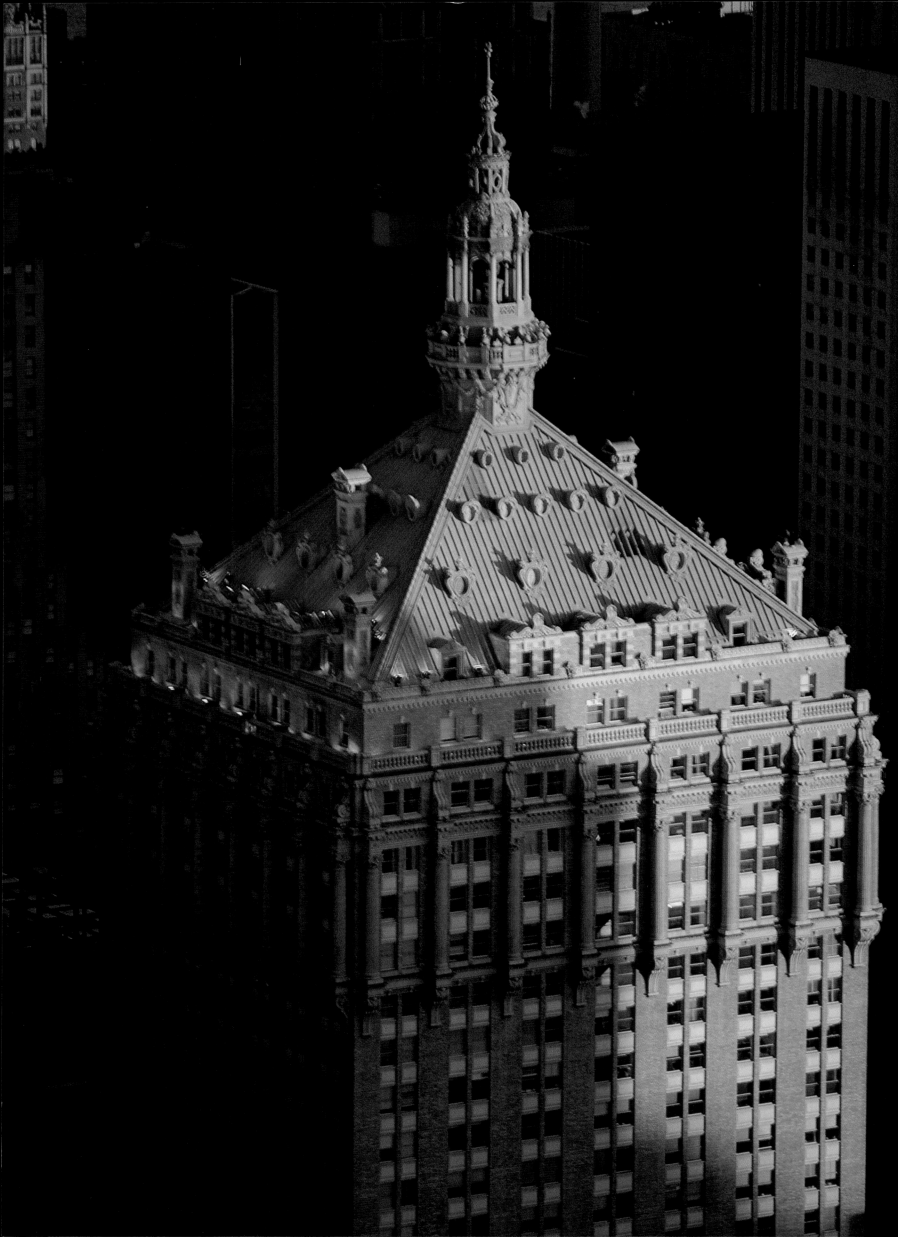

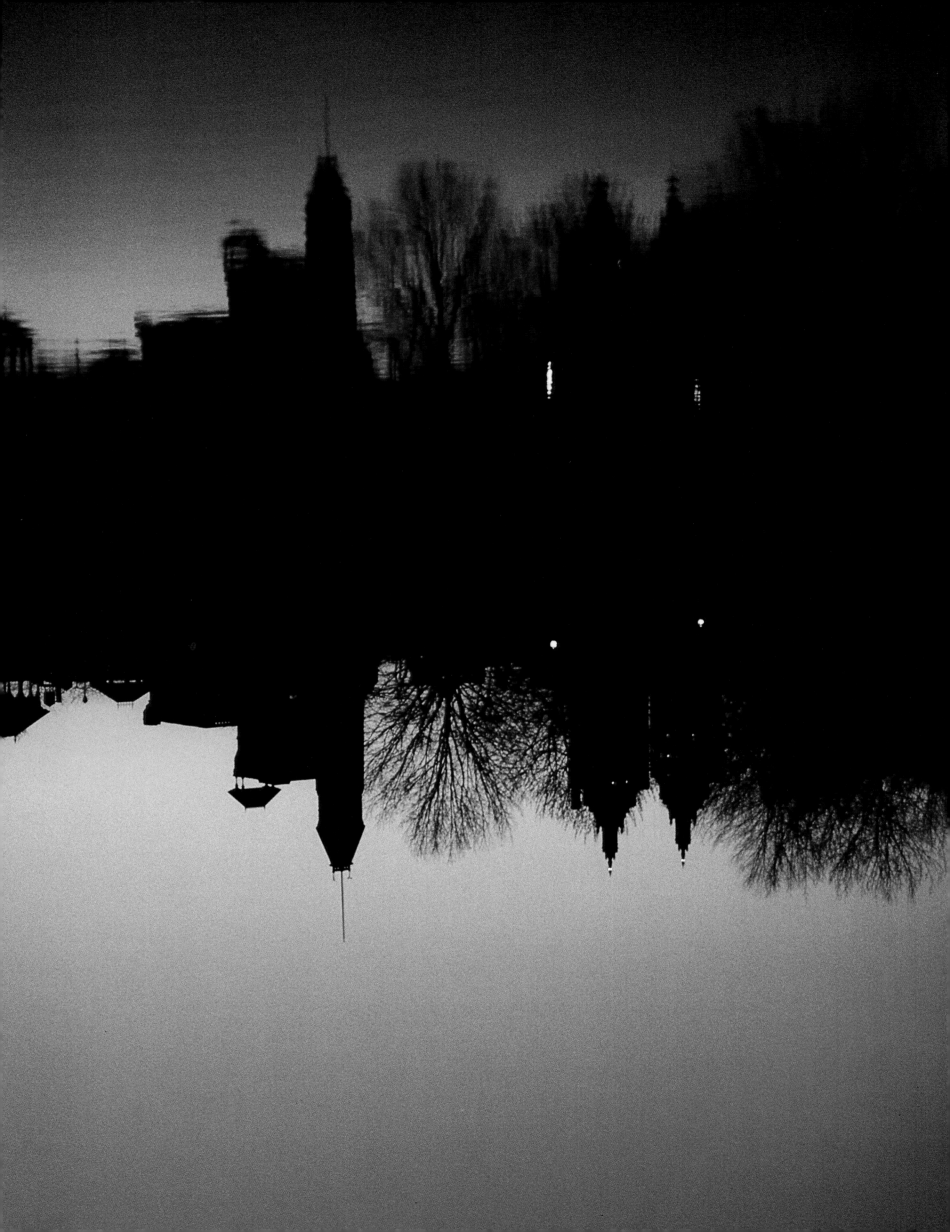

OASIS

Changing seasons in Central Park

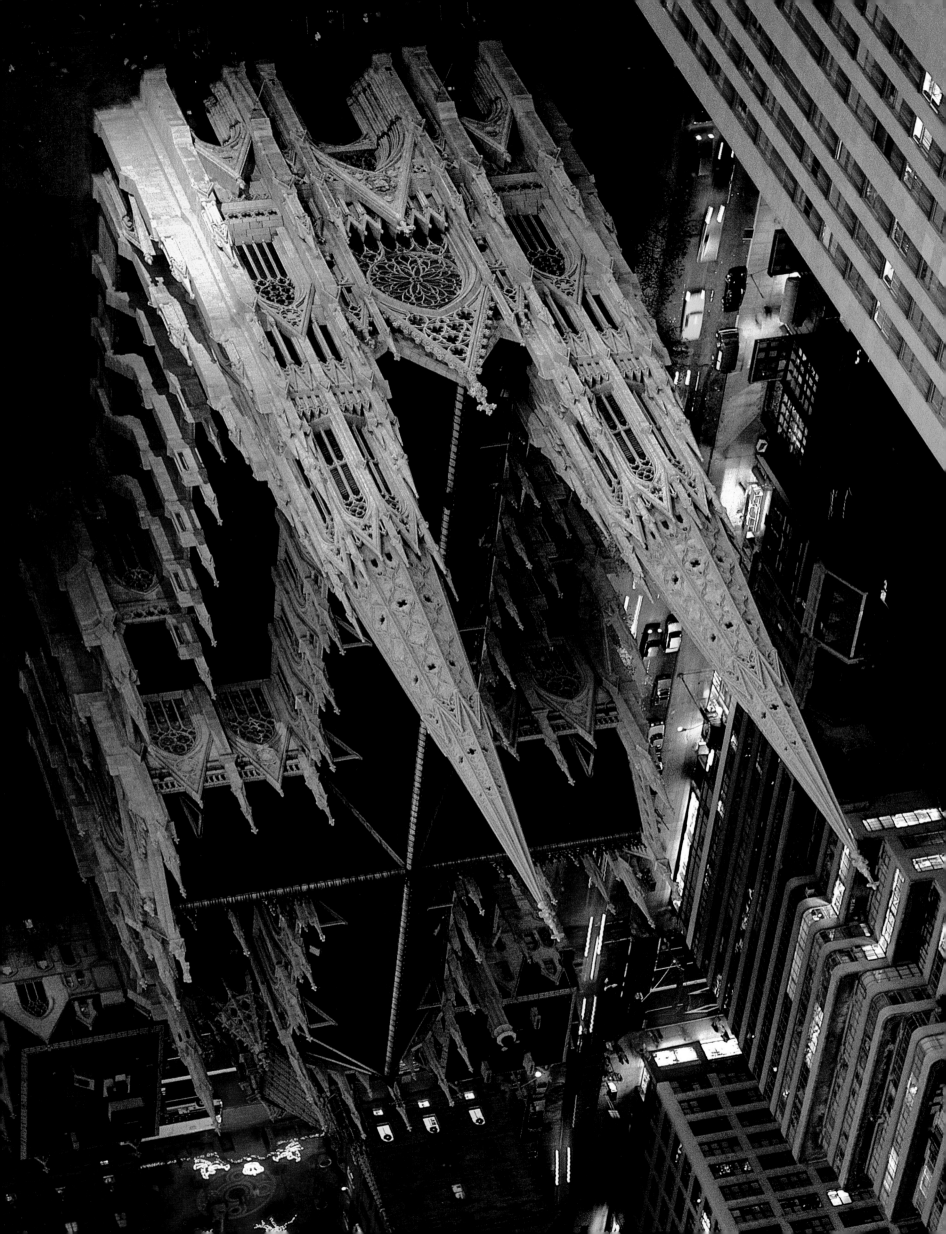

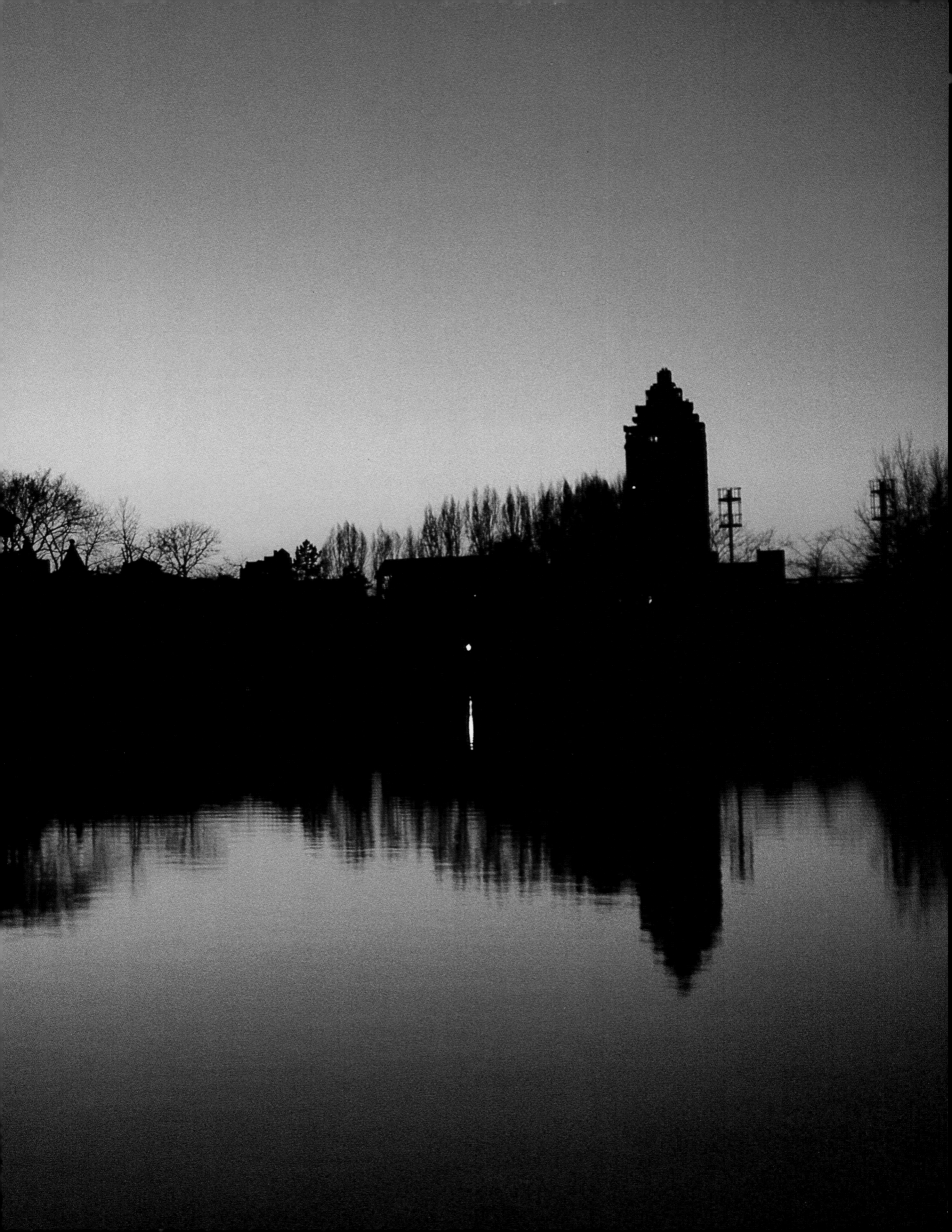

There is a moment when all that is manifestly ugly, noisy, and expensive can suddenly appear beautiful, civilized and desirable. The moment New York plays that trick of vision on you, it is impossible to go back through the looking glass again. The city has made you a New Yorker.

—Robert MacNeil

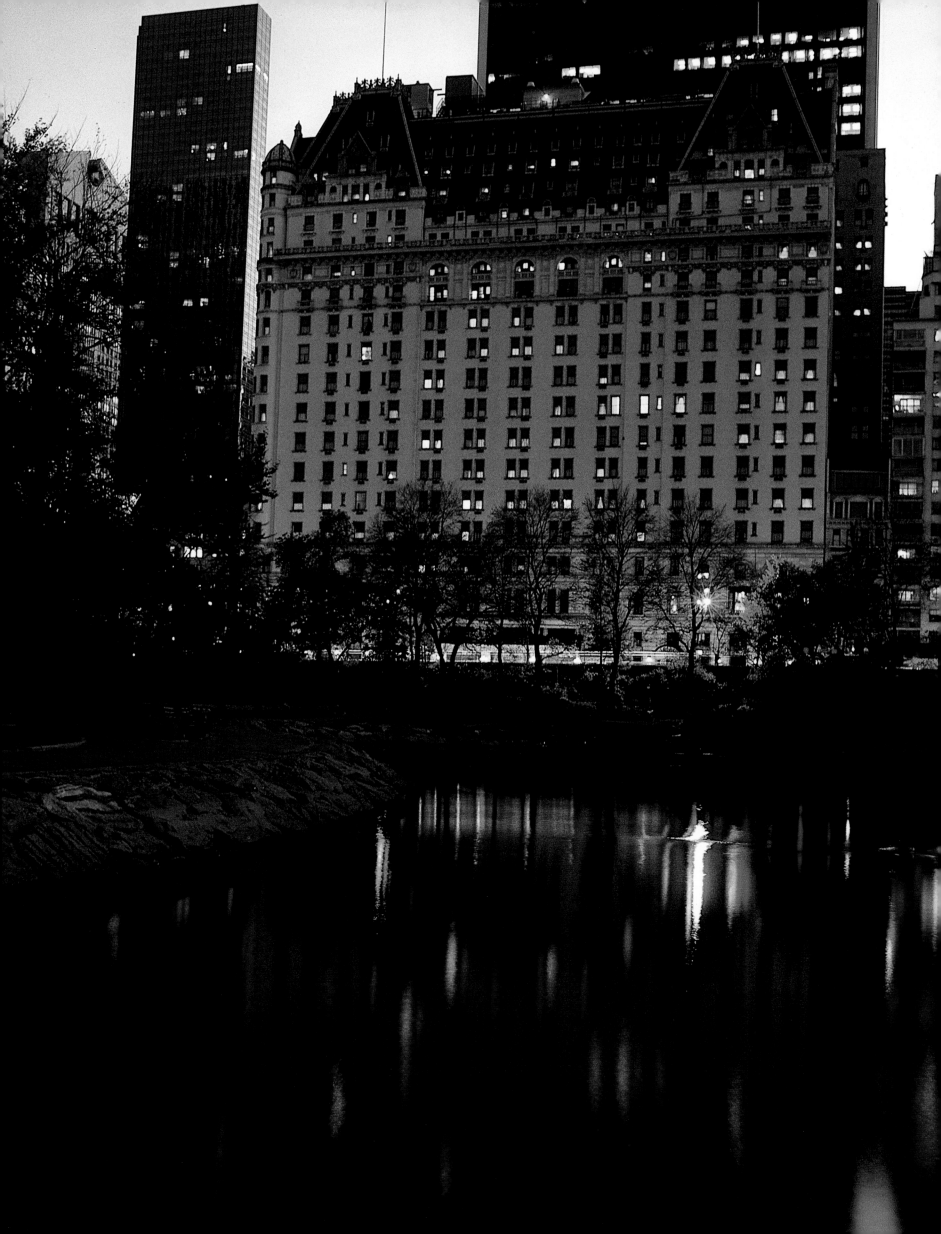

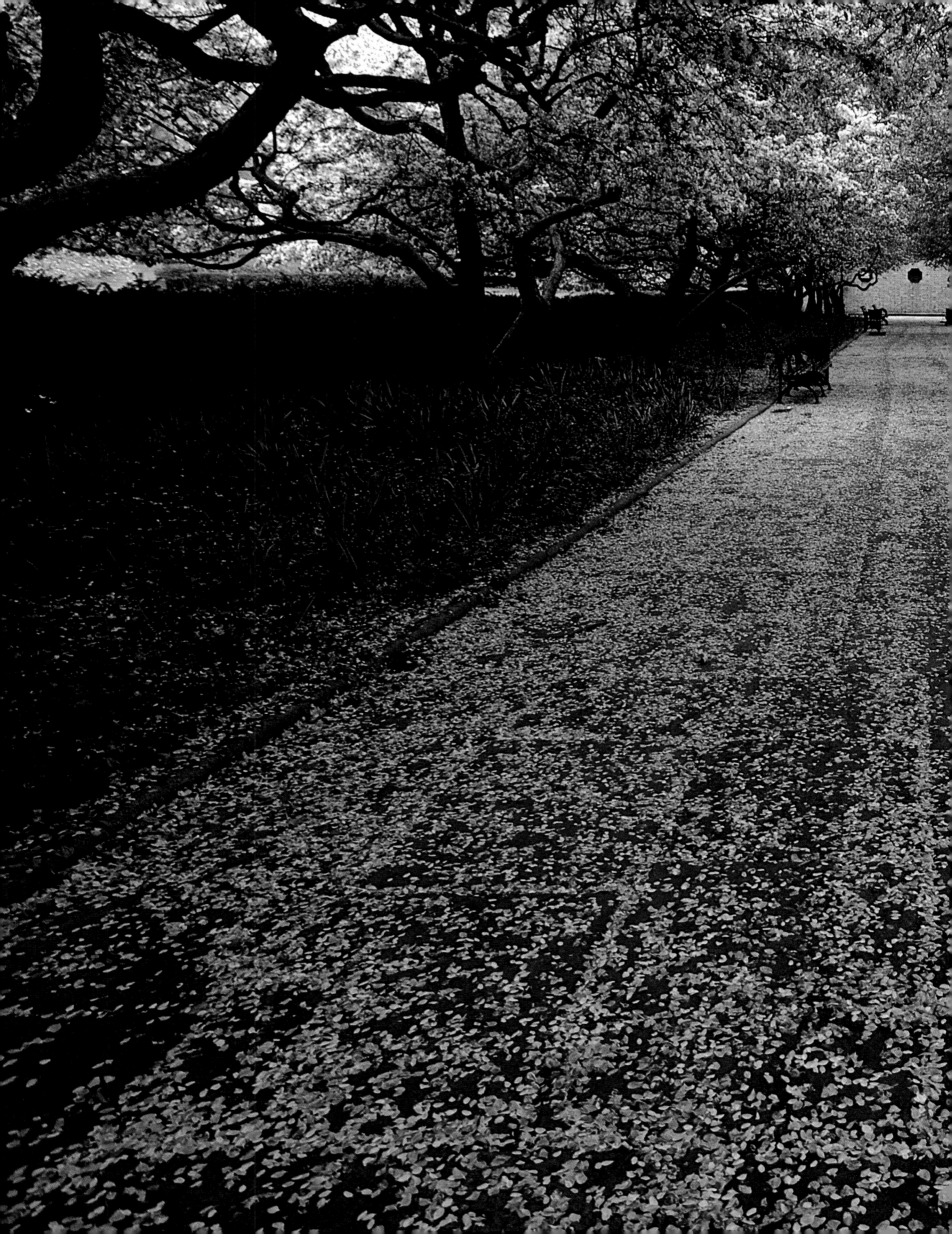

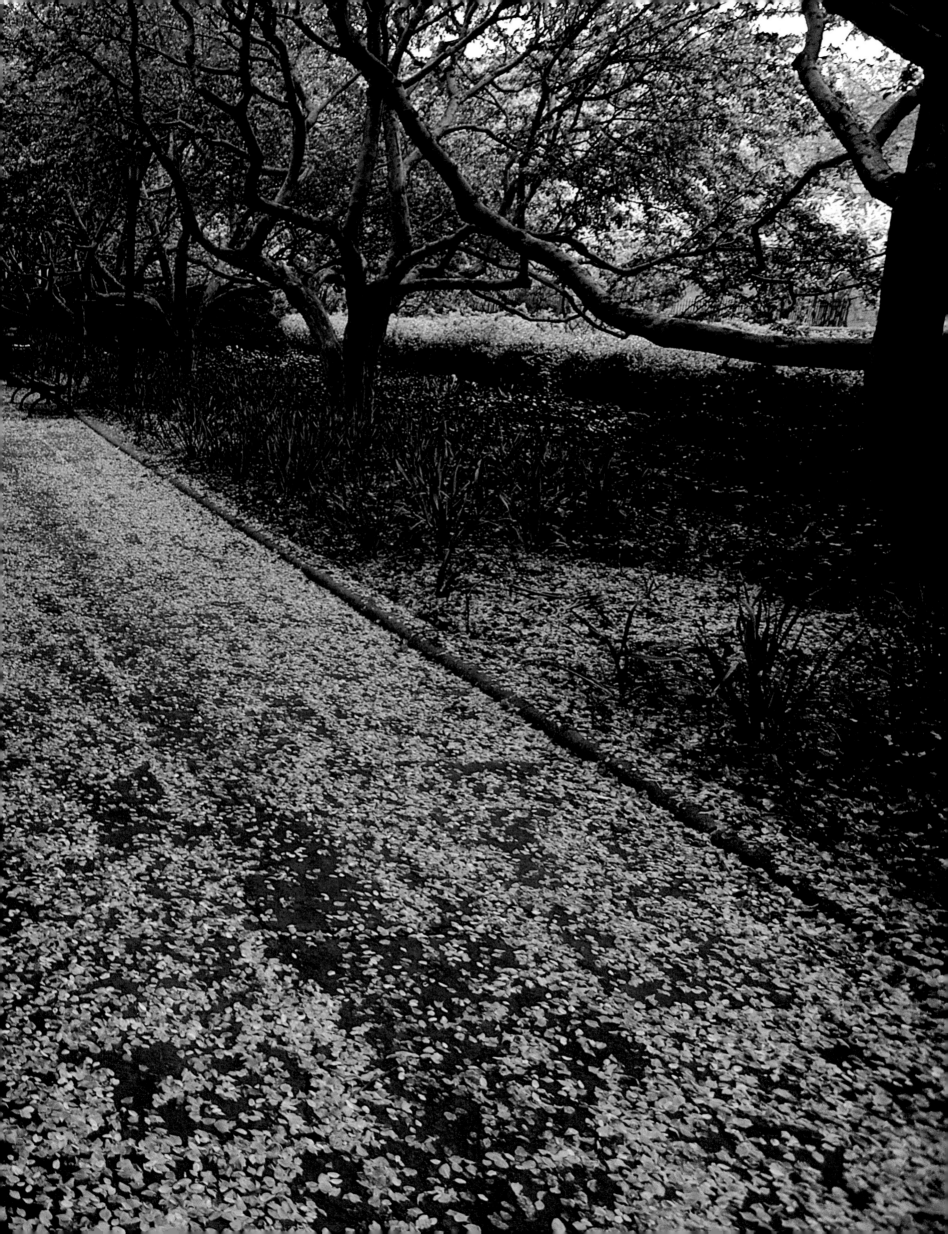

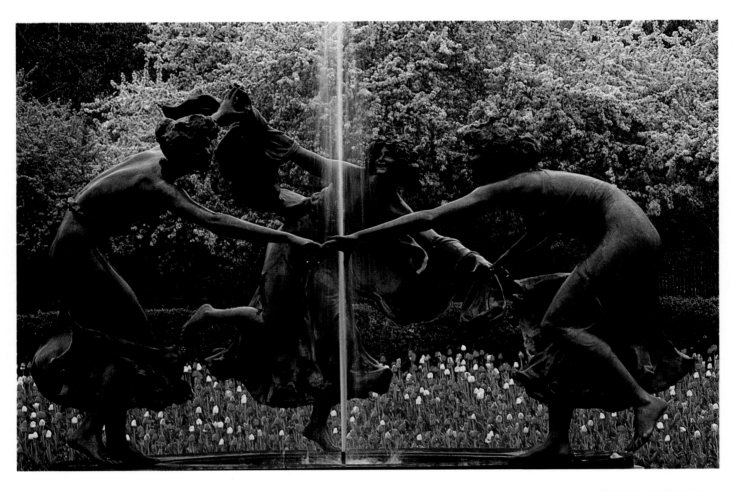

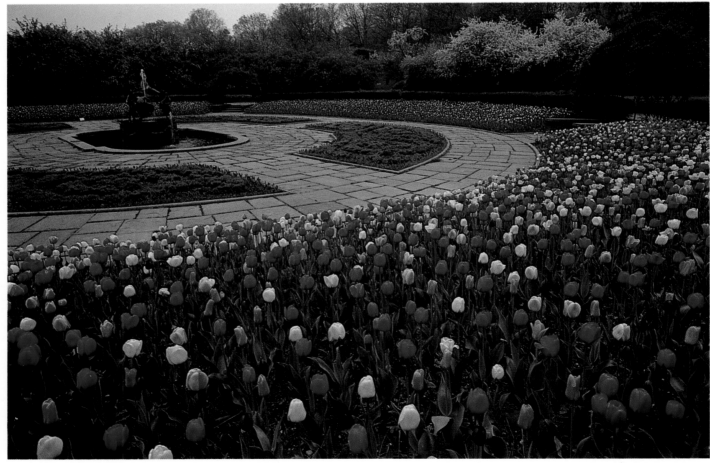

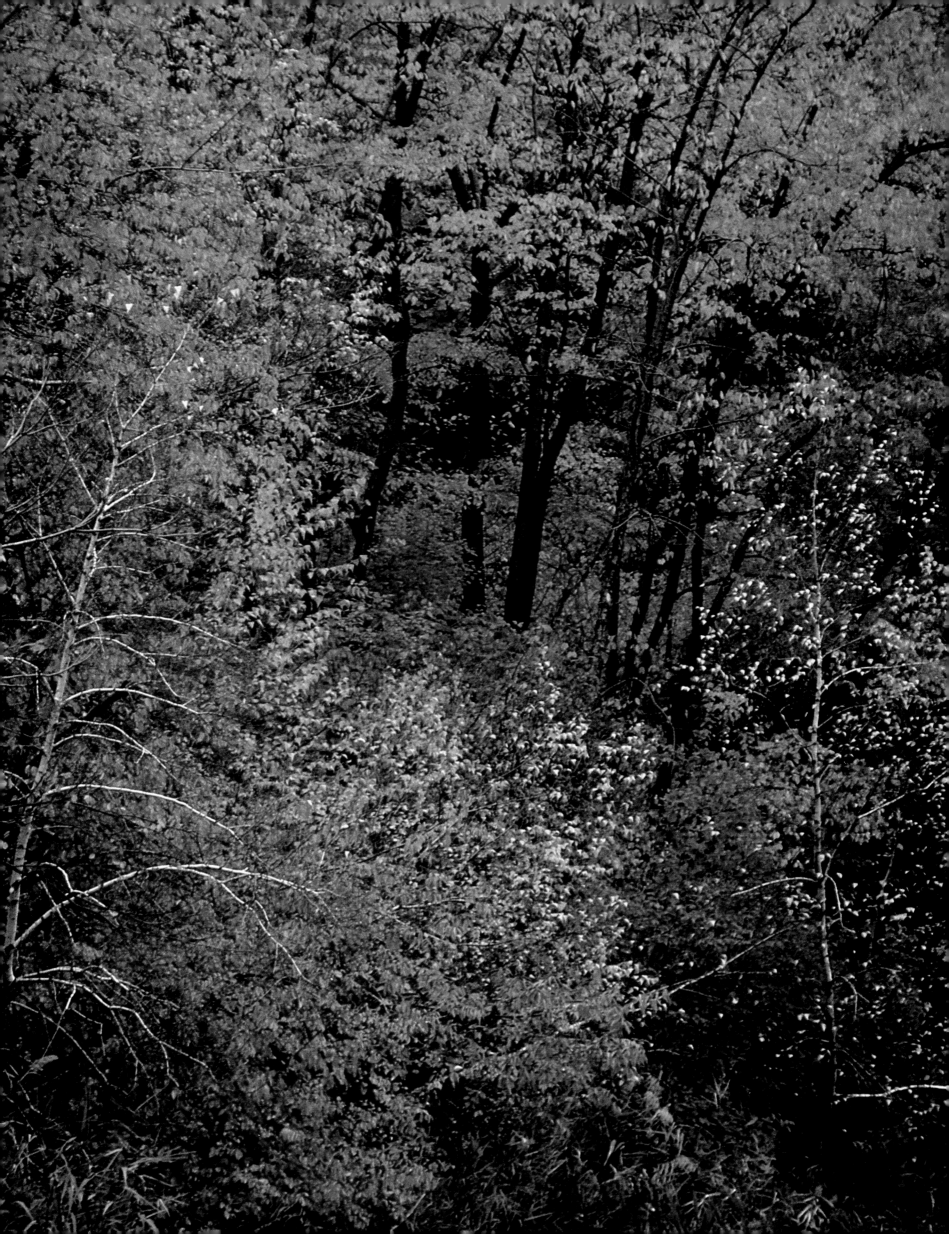

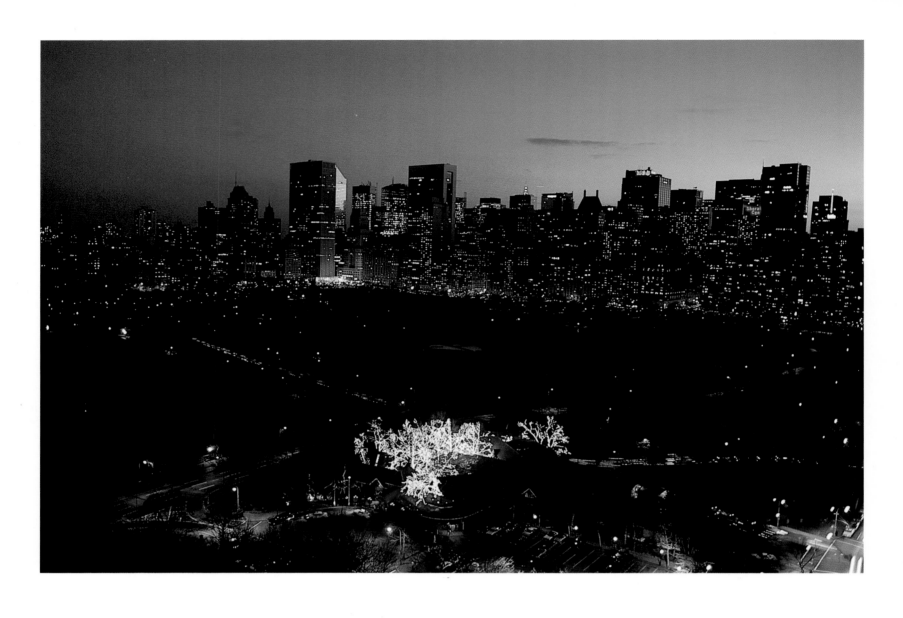

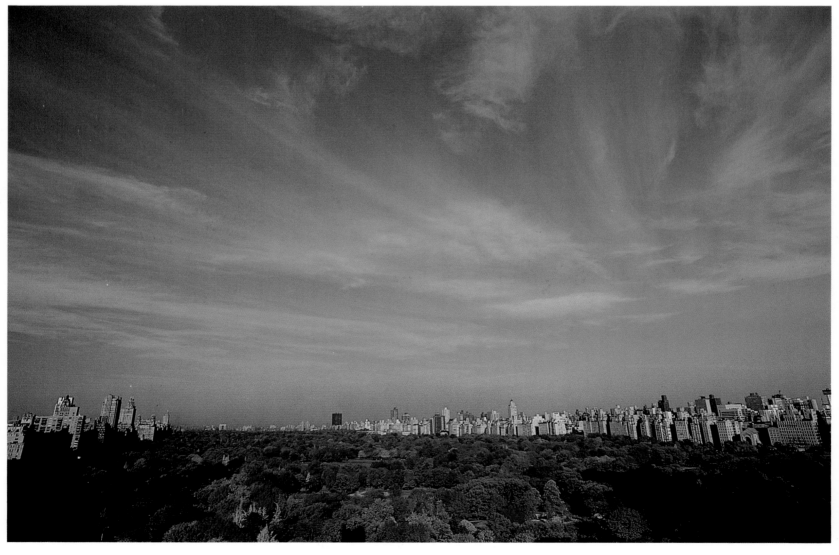

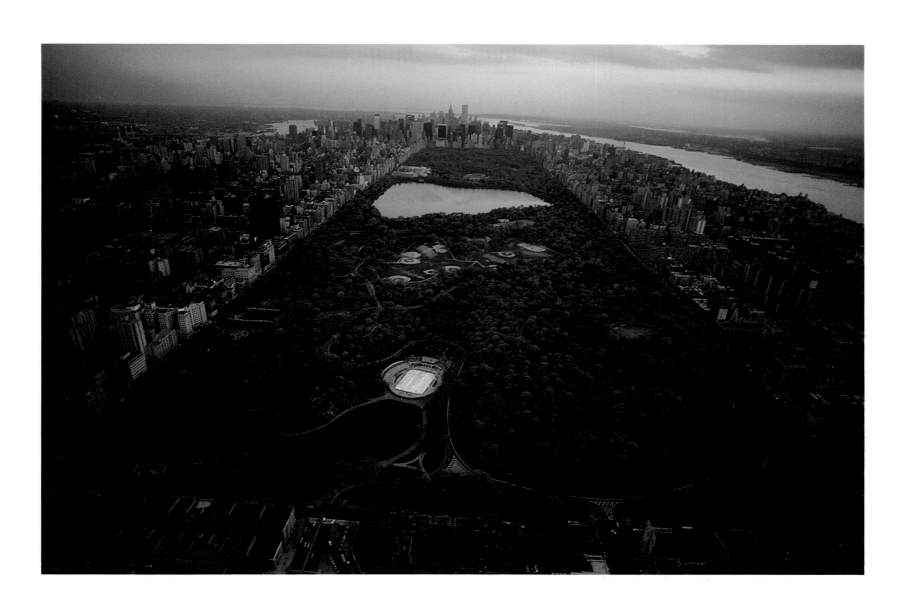

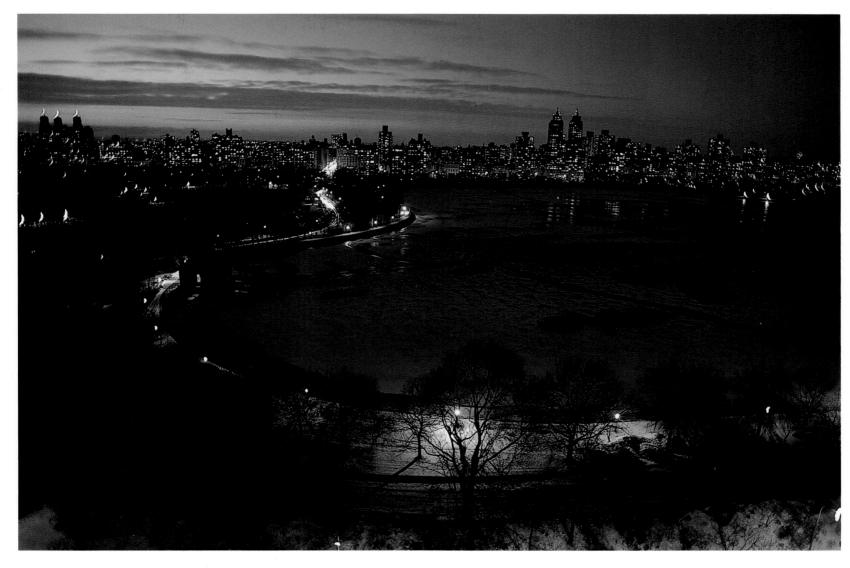

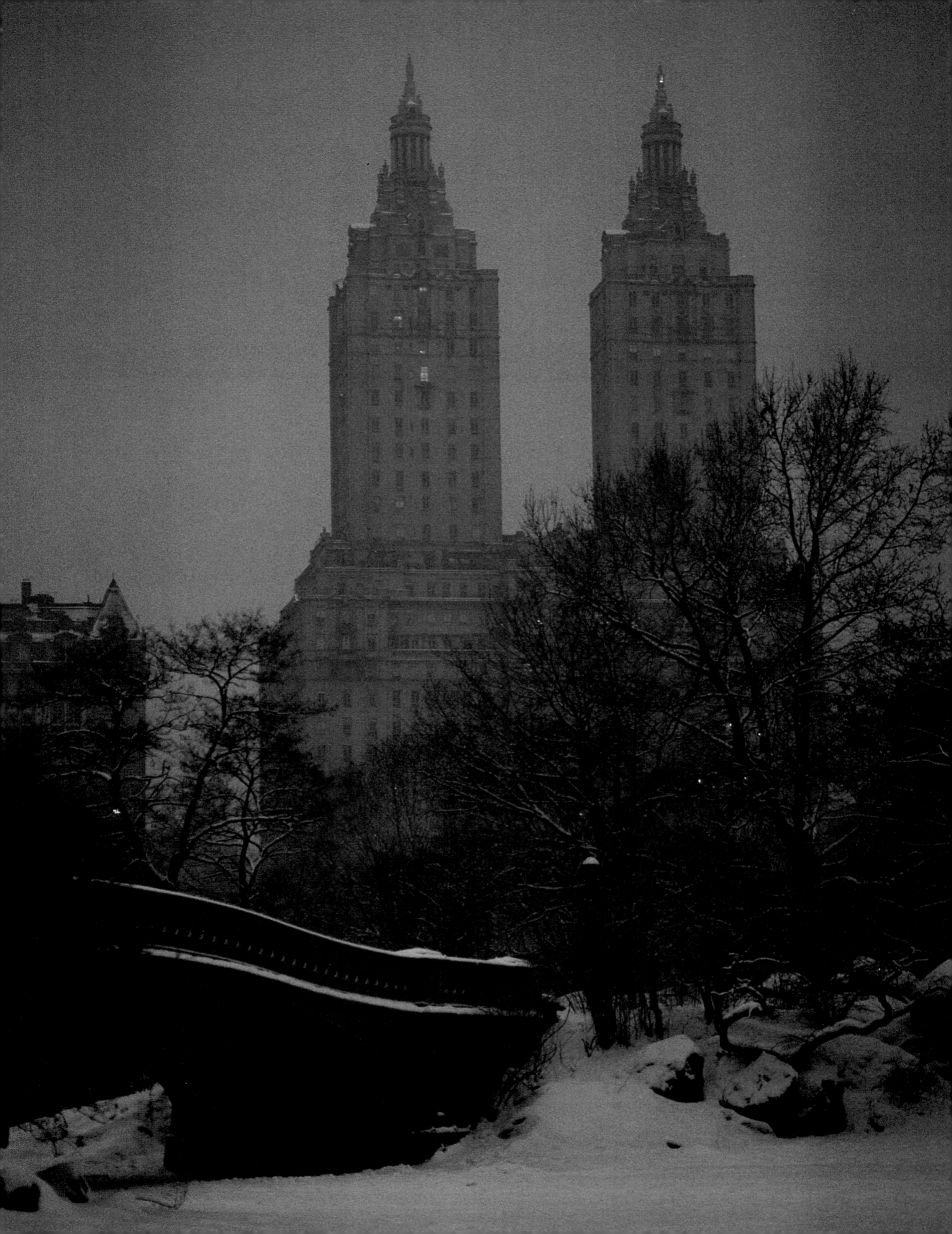

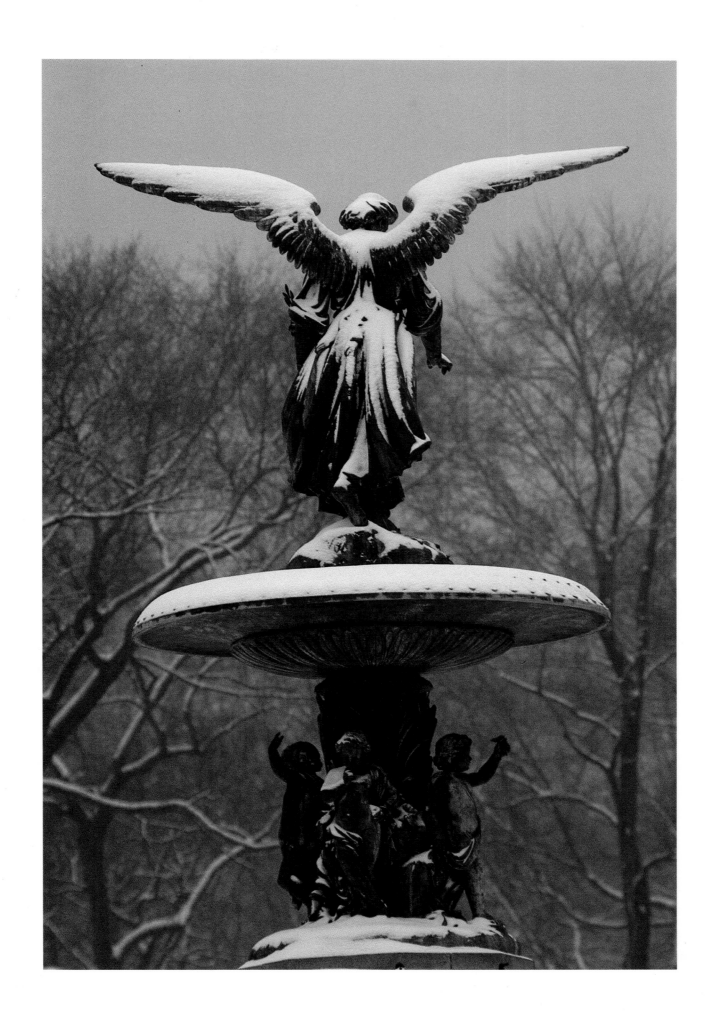

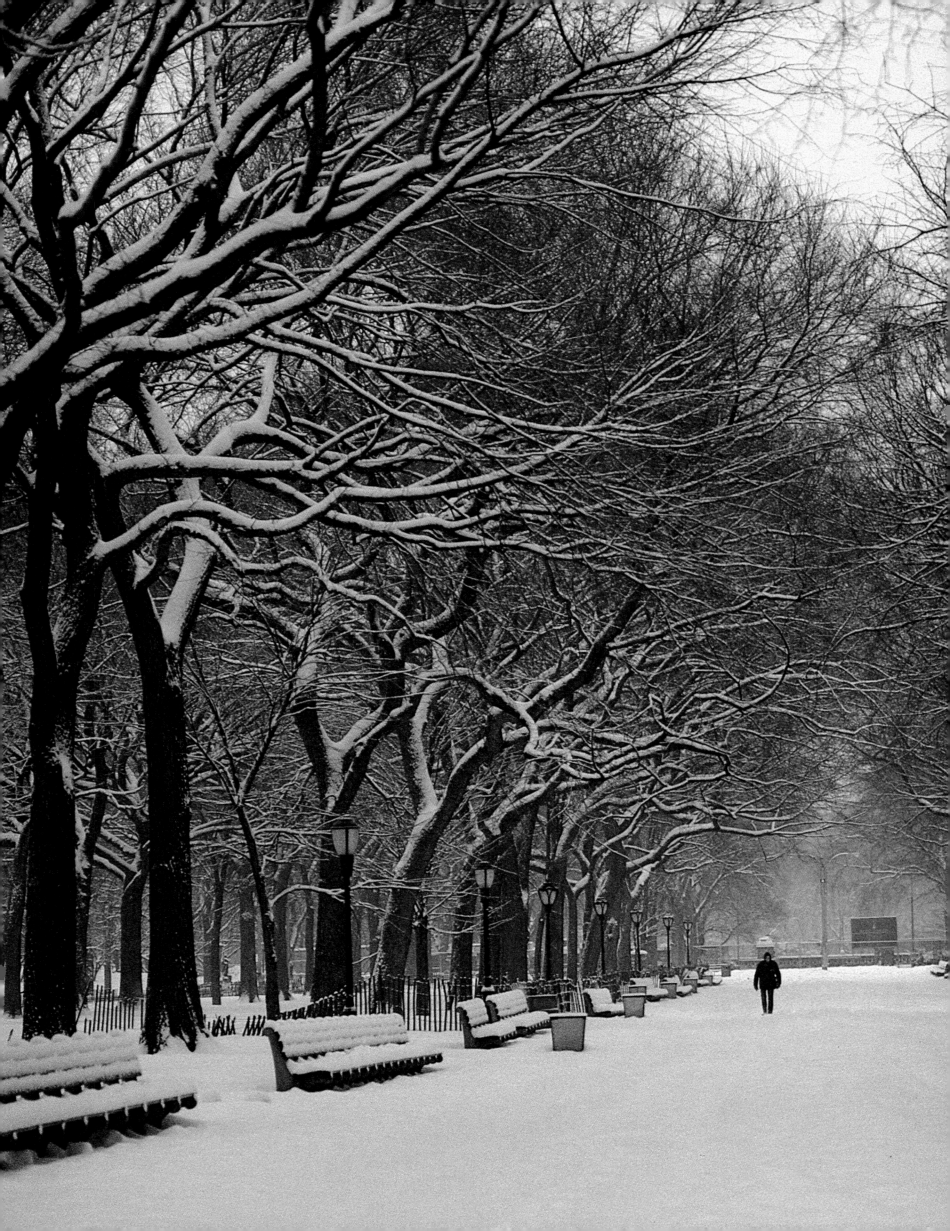

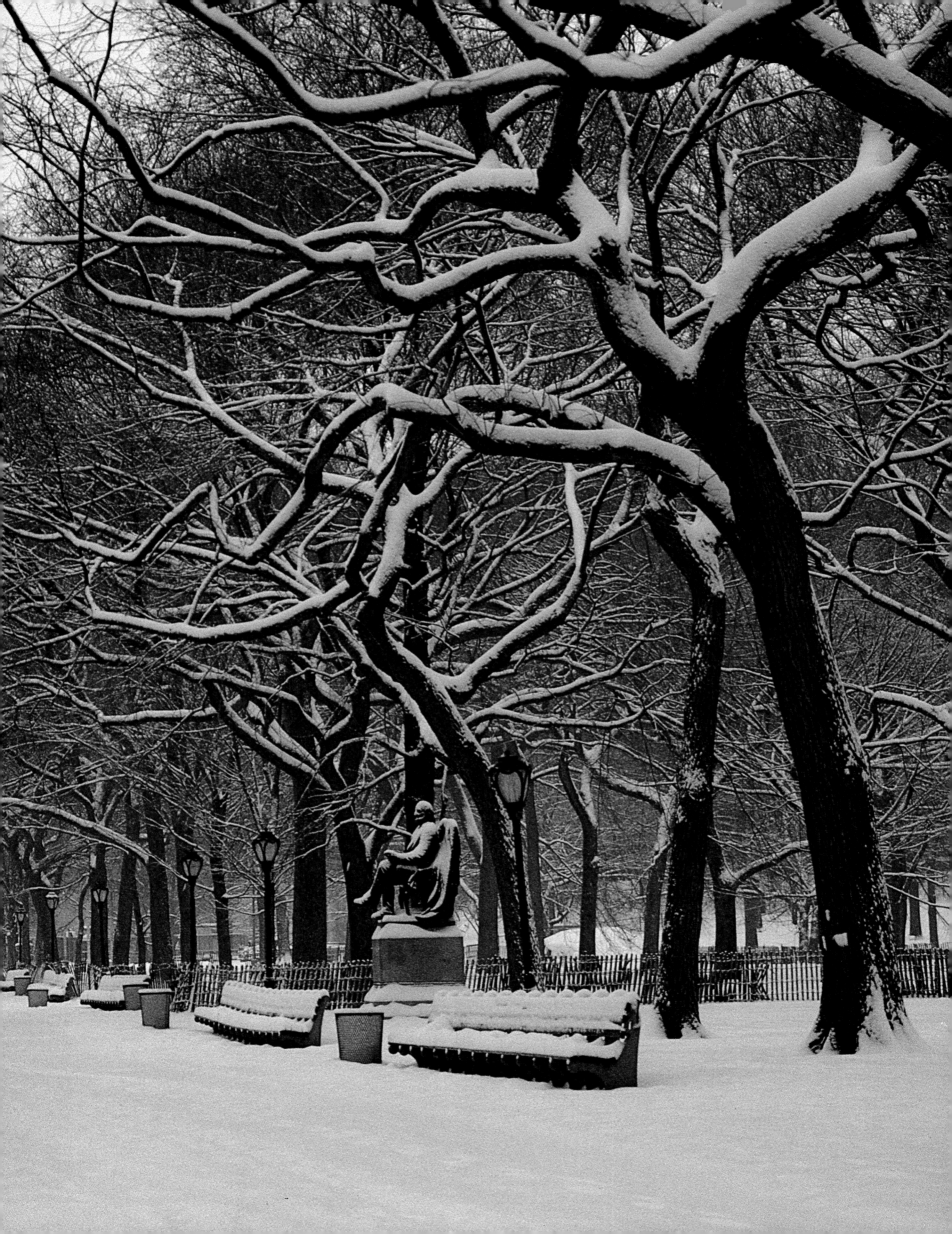

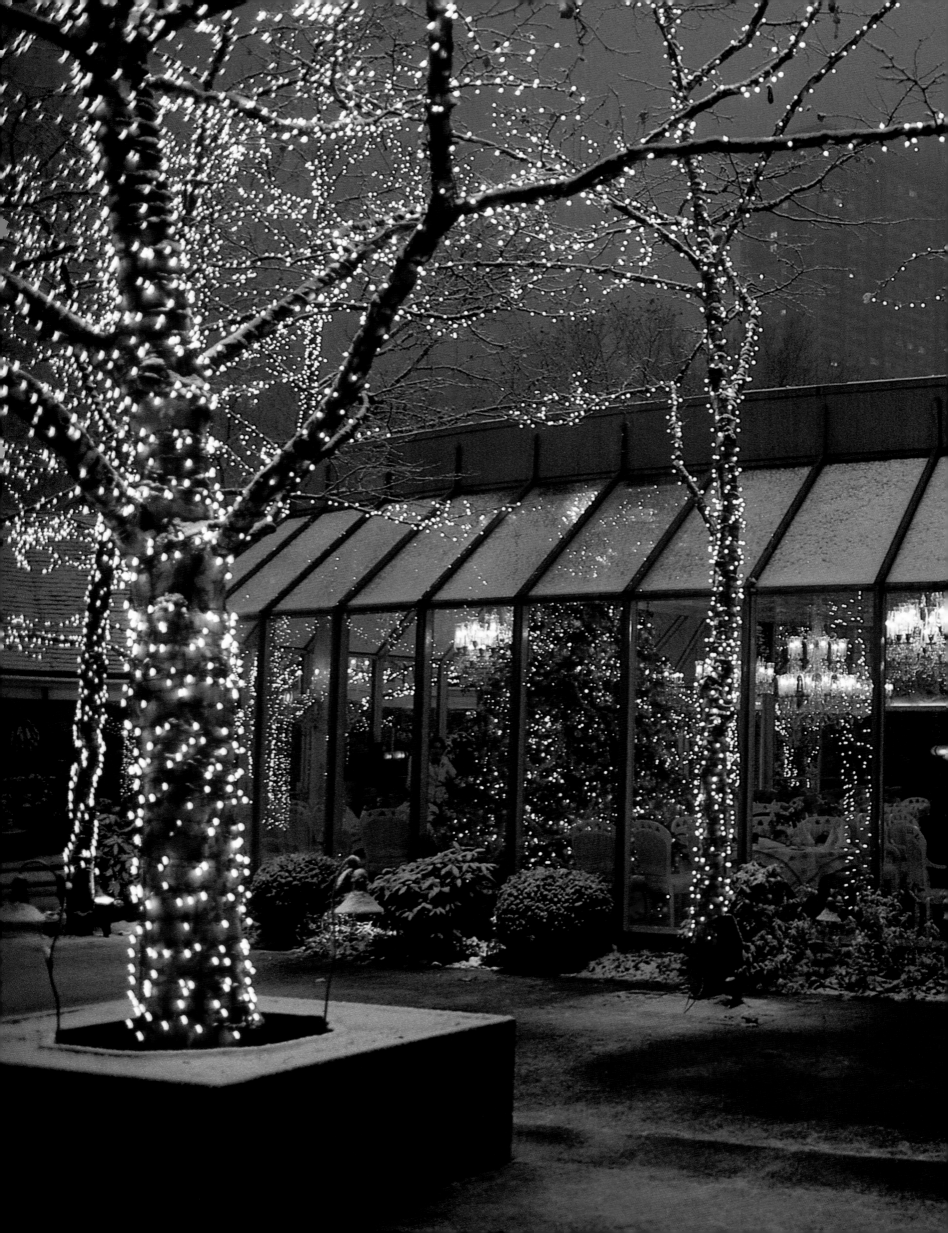

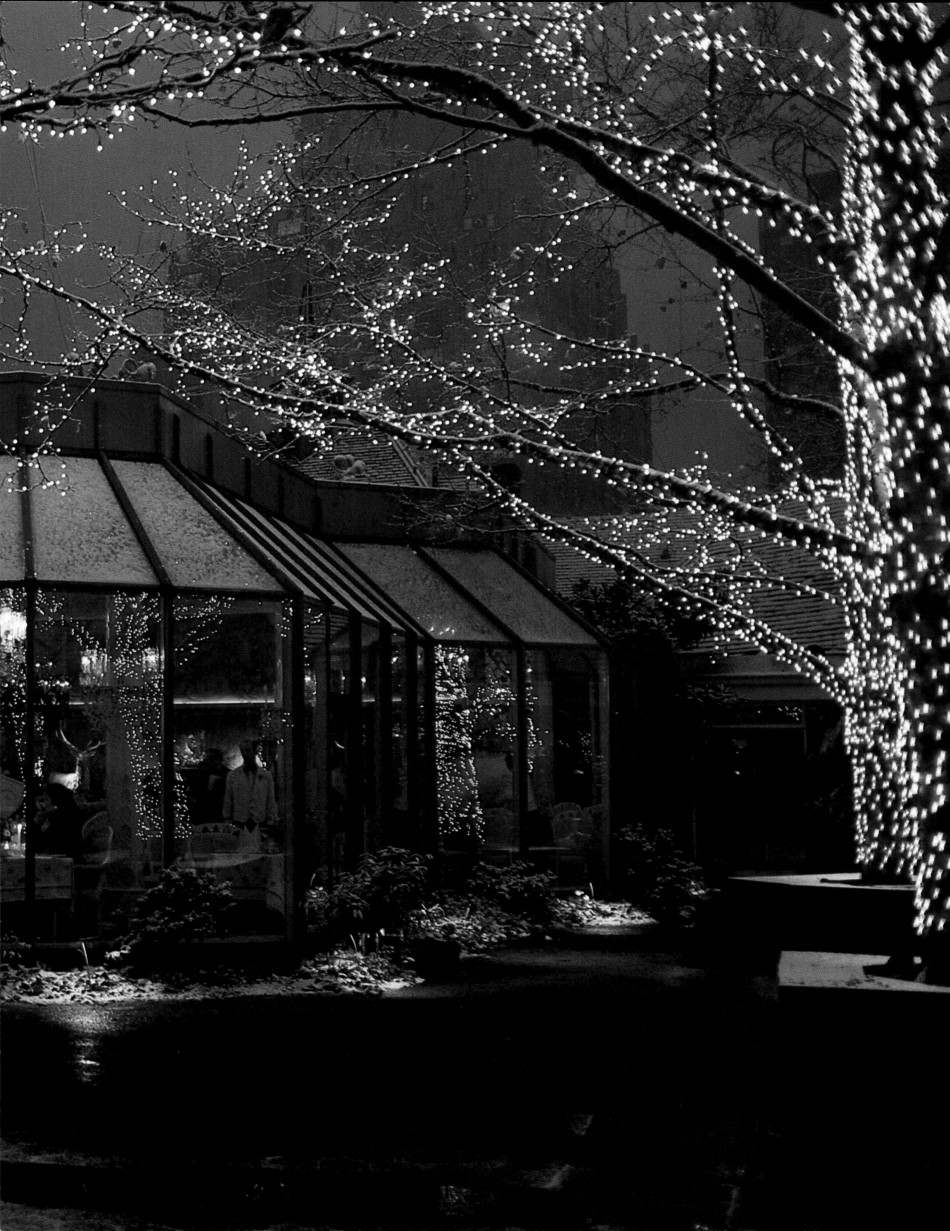

Central Park, that miraculous, man-made, verdant, self-resurrecting gem, conceived by idealism, born in turmoil with graft as a midwife, the lungs of the city, is one of the genuine wonders of the world. How many sighs of pleasure and shouts of joy have floated heavenward from these sacred precincts?
—Thomas Hoving

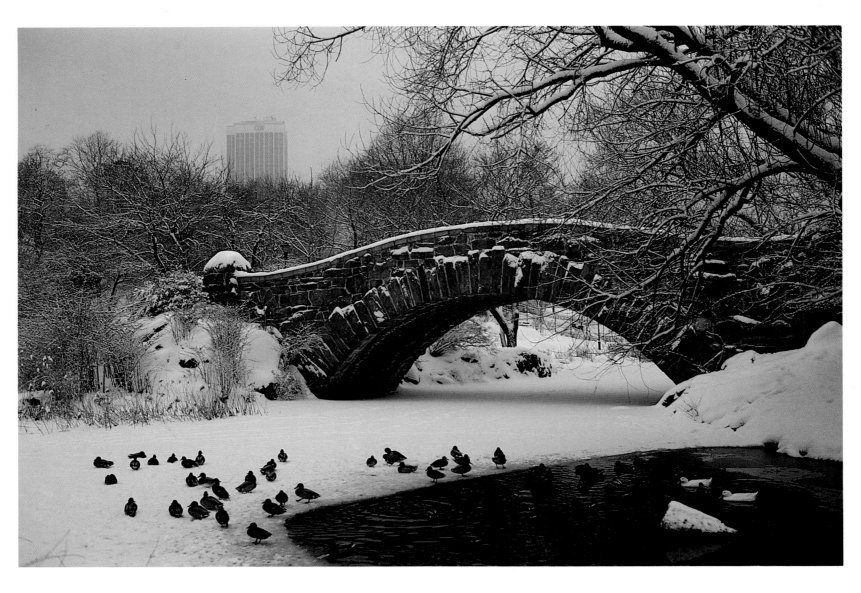

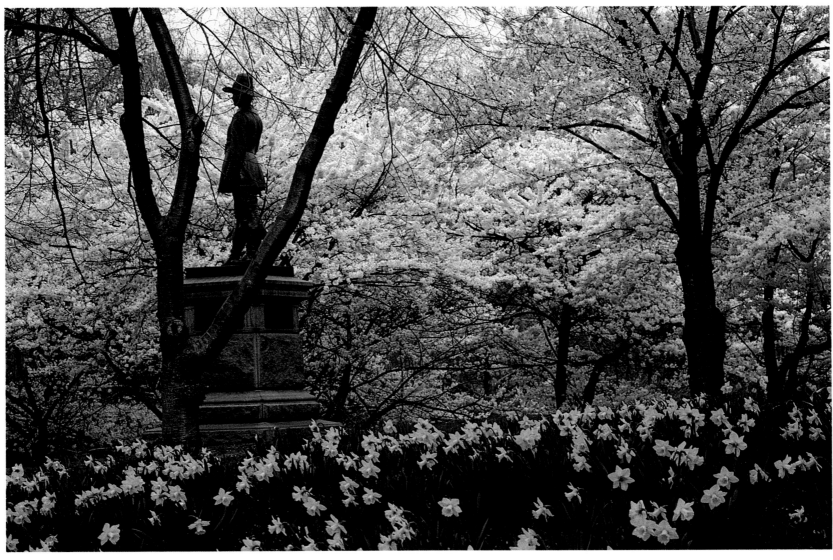

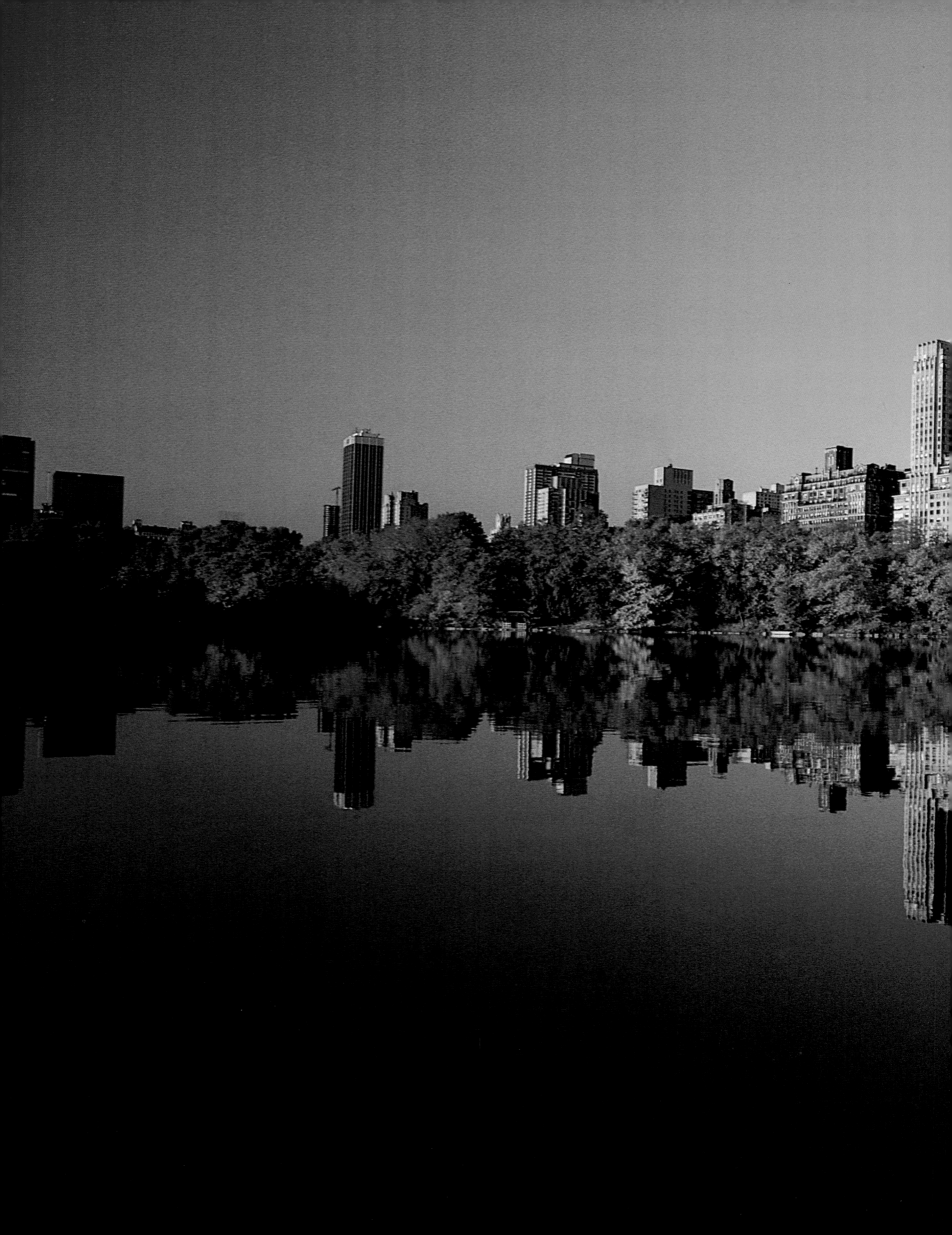

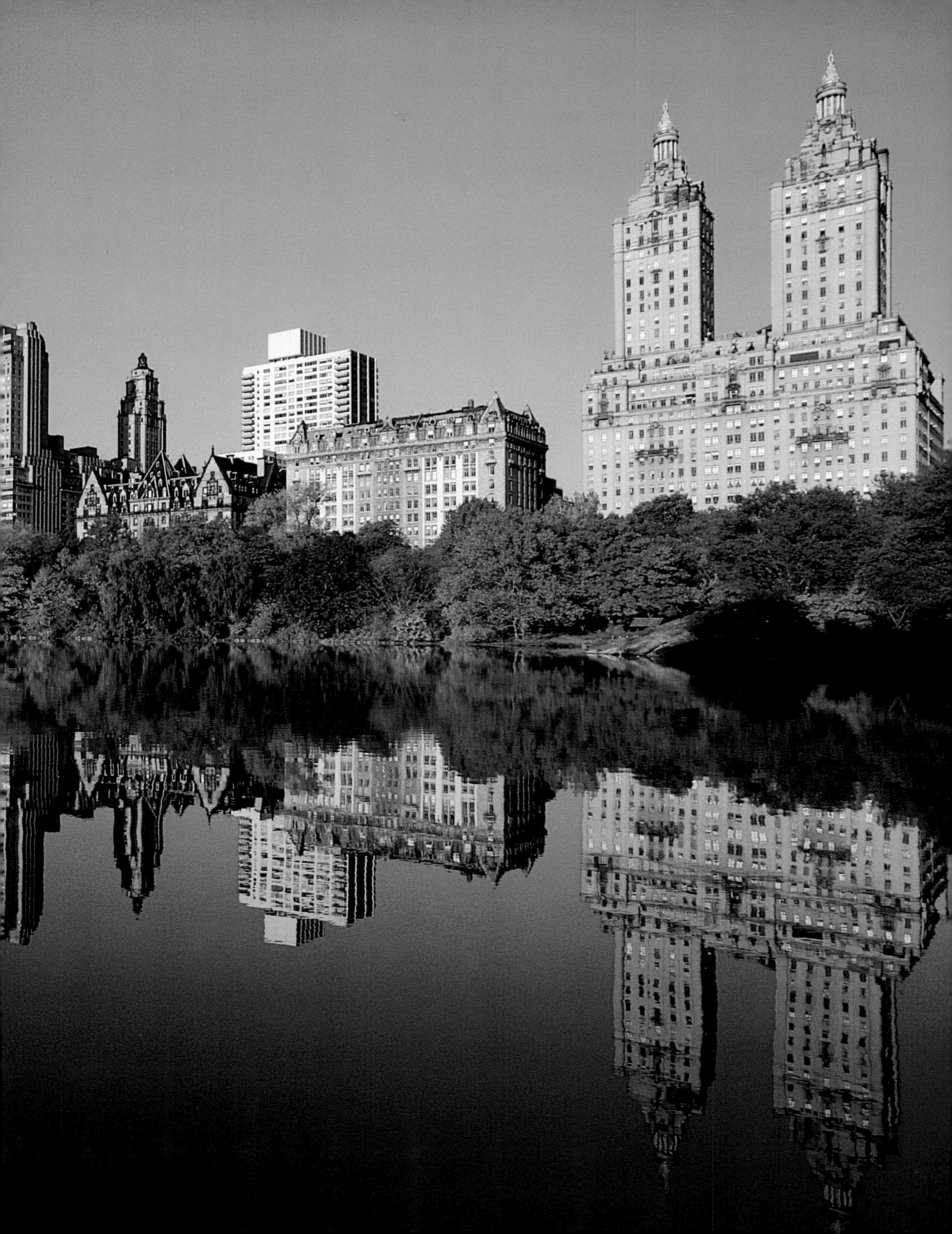

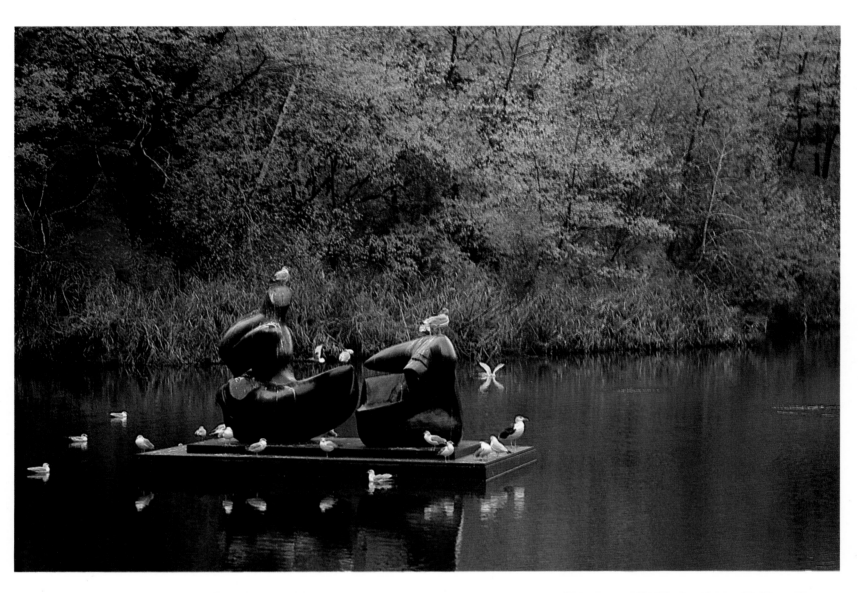

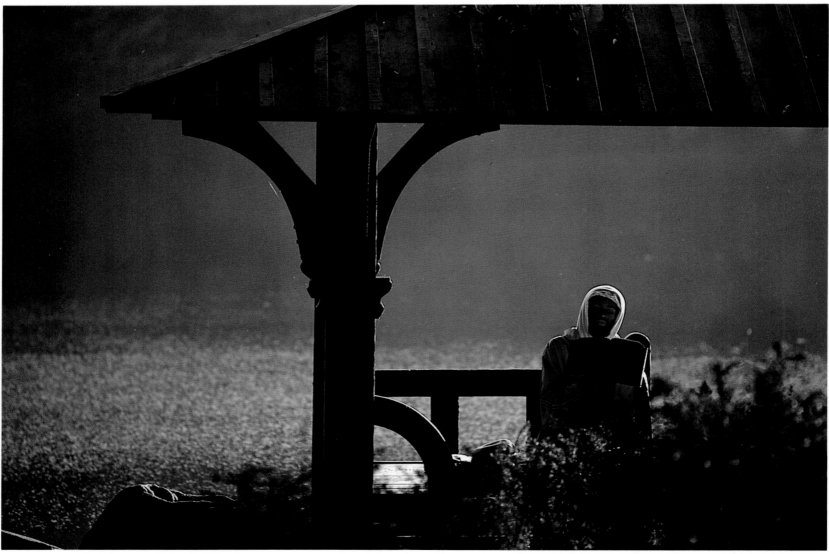

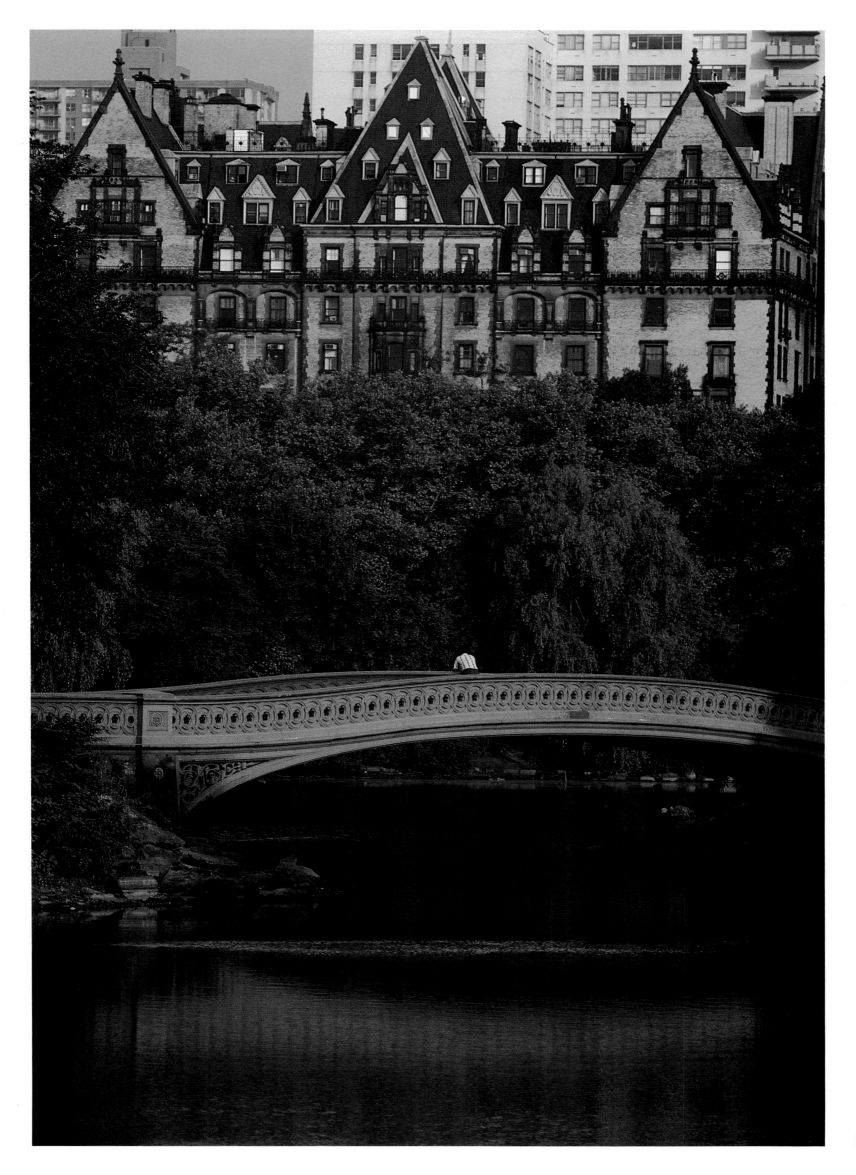

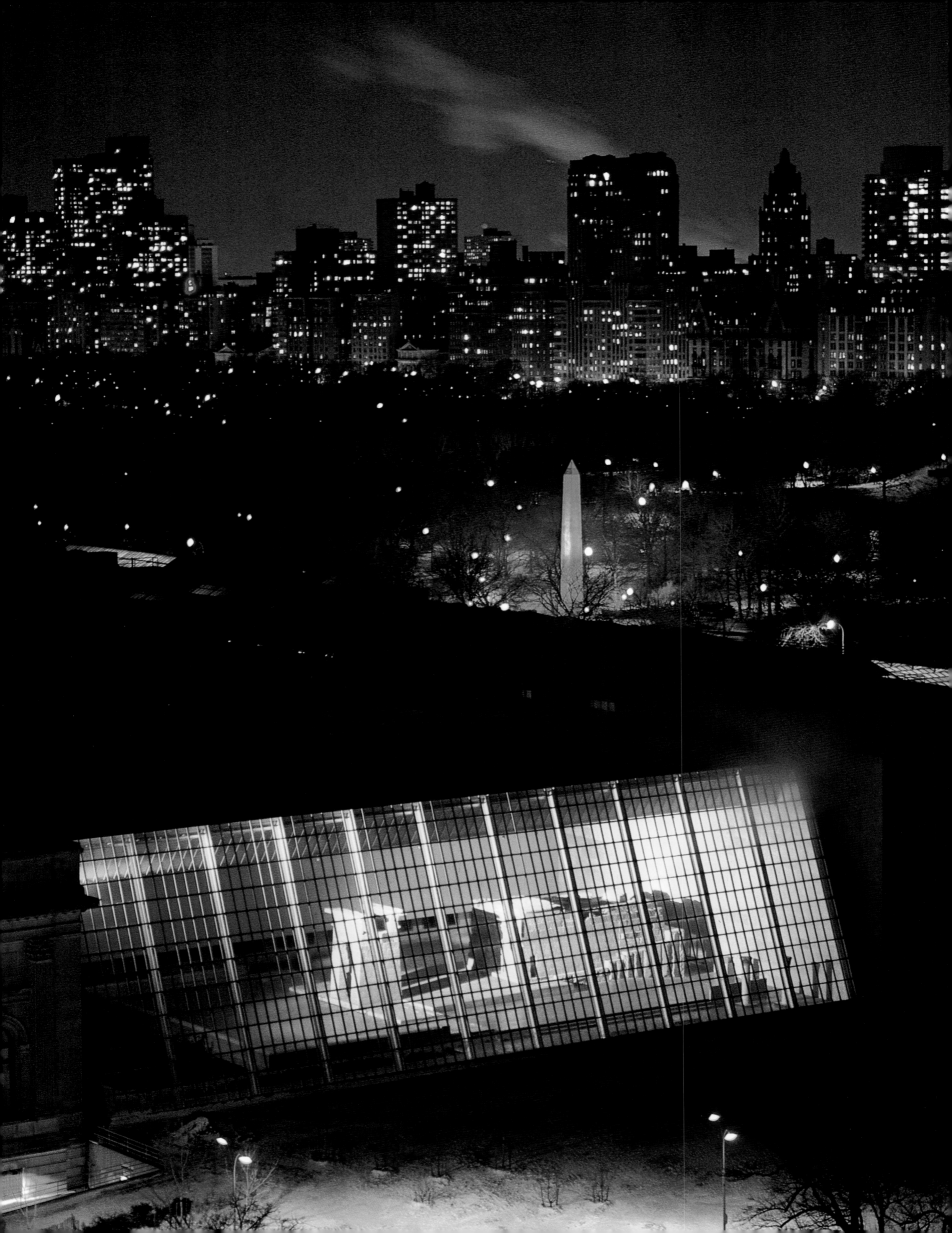

UPTOWN

East and West Sides, Harlem,
and the northern reaches

When I think of New York, the image that comes to mind is not of the harbor or of the skyline or of any vast panorama, but rather of the area just east of Central Park between Ninety-fourth and Eighty-ninth Streets. It is a peaceful area, except for the thundering traffic on Fifth Avenue, and if I have to be reminded that I am living in a metropolis I have only to walk east to Park Avenue and gaze down the length of that great highway to Harry Helmsley's golden tower.

—Louis Auchincloss

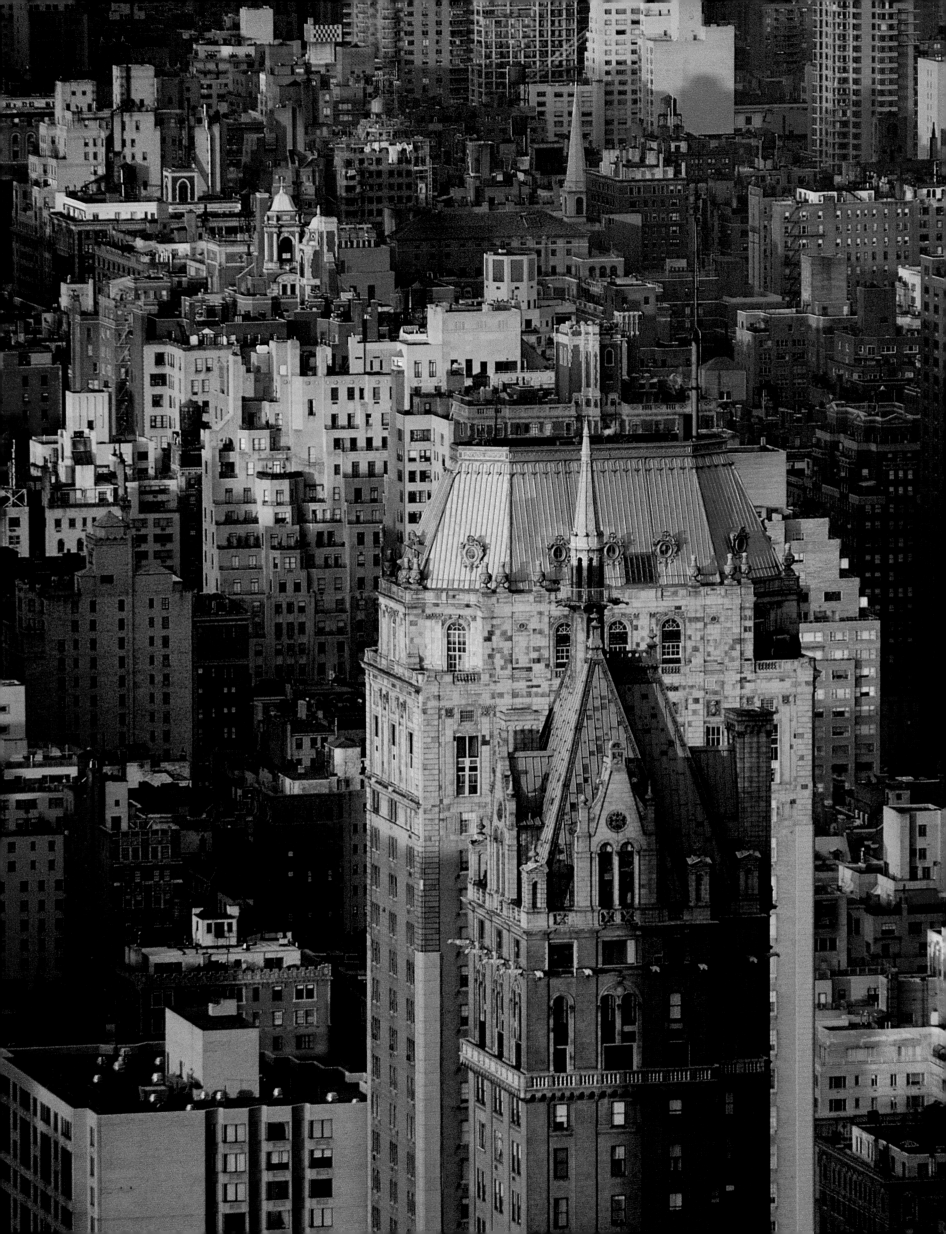

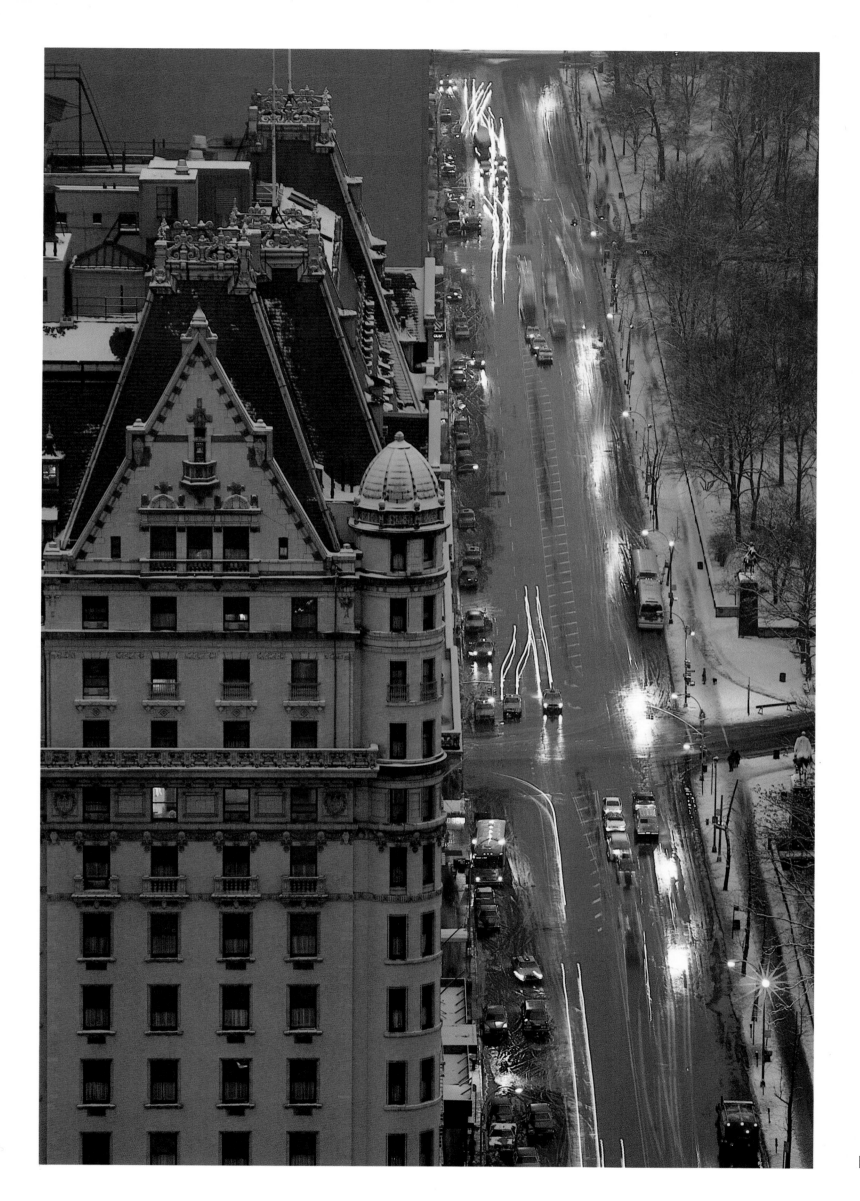

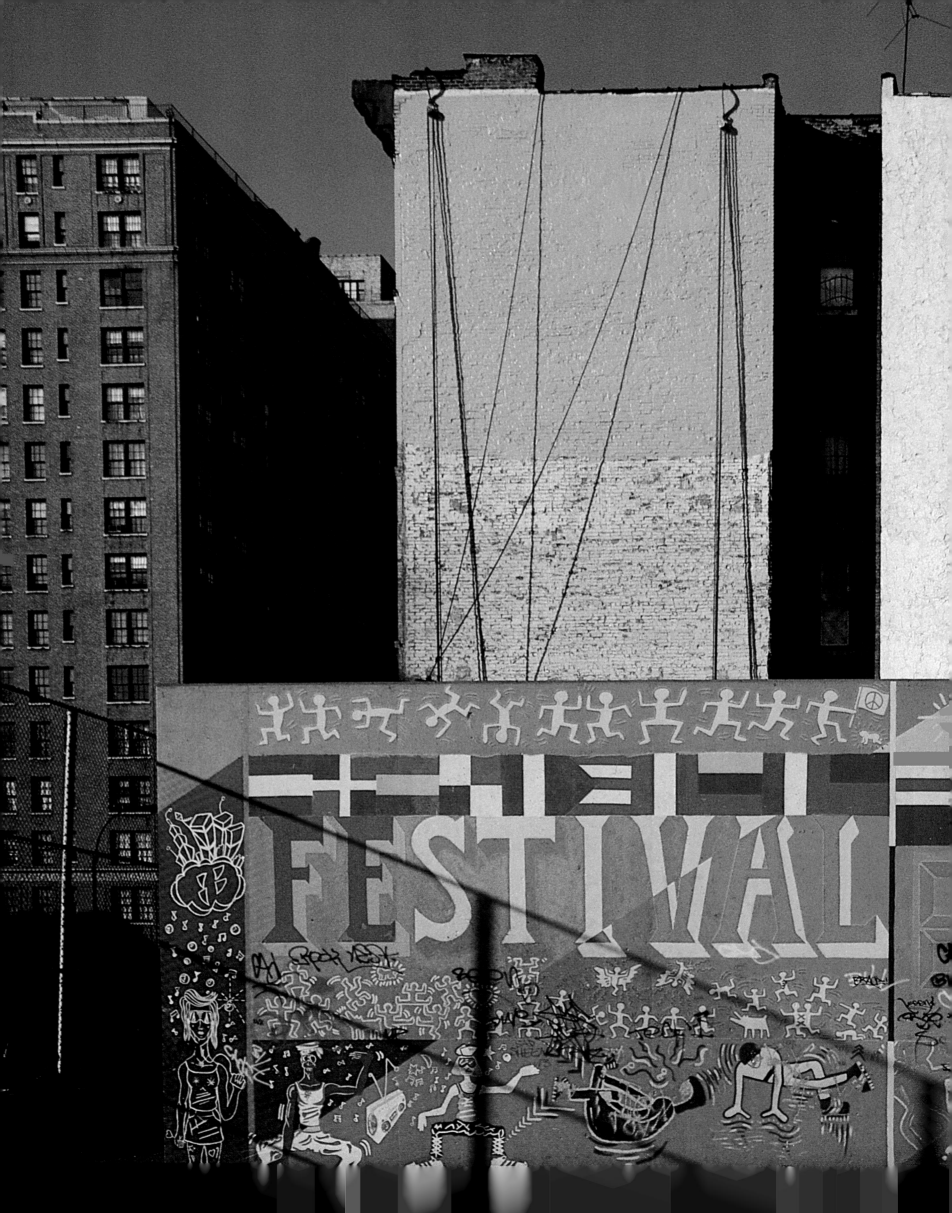

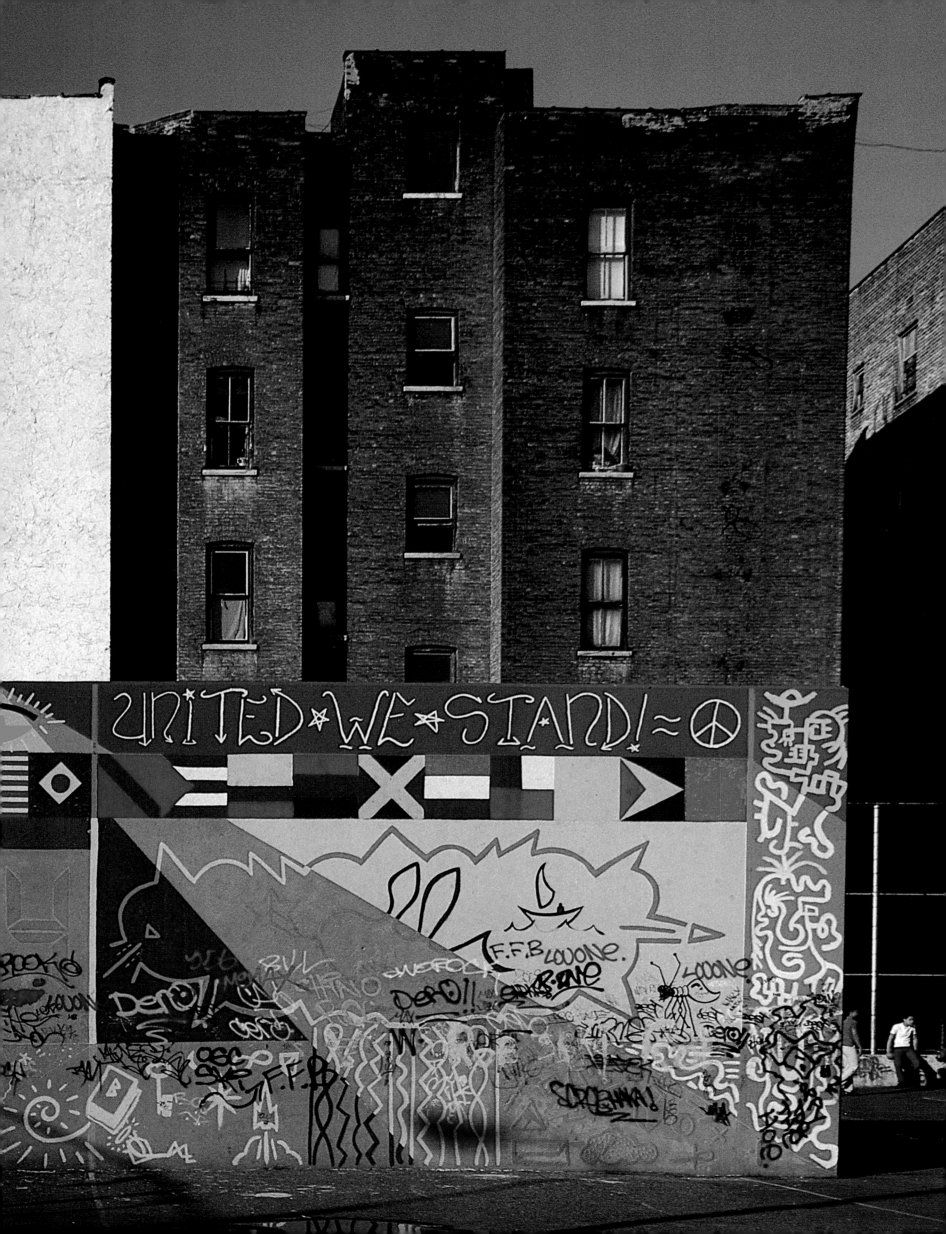

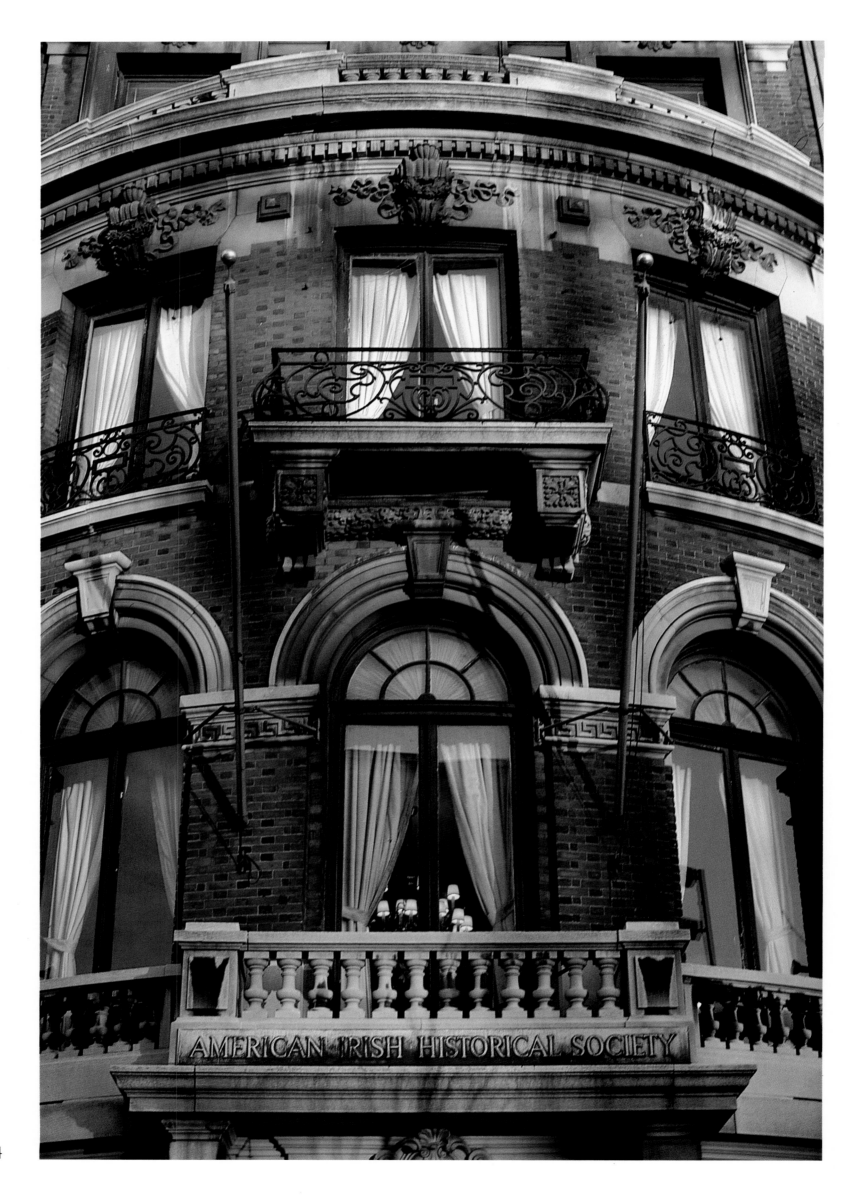

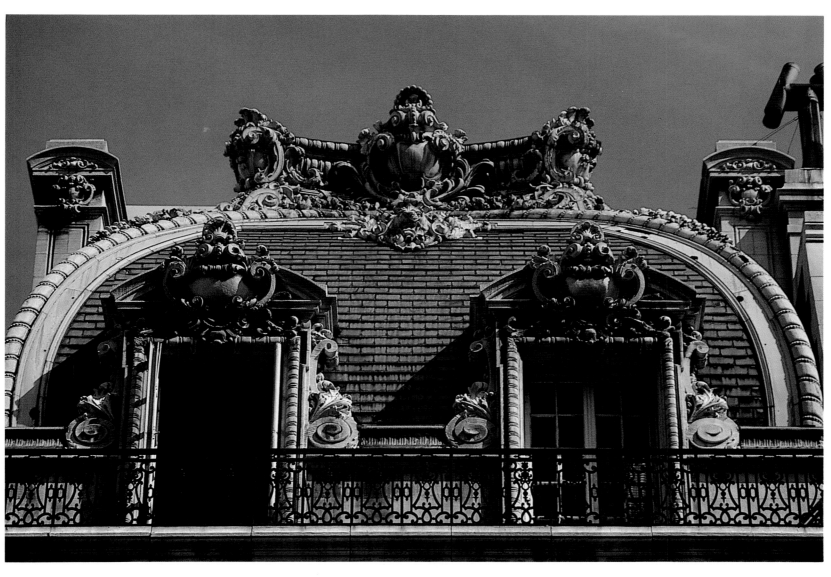

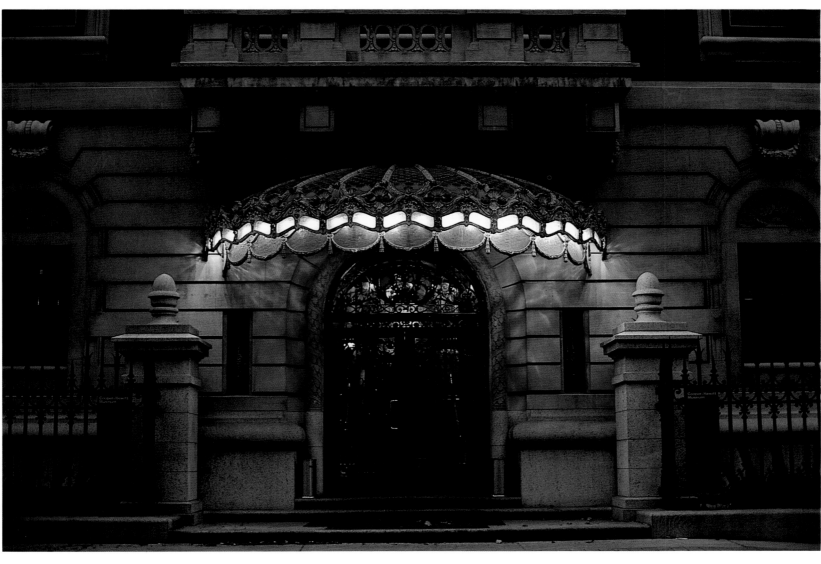

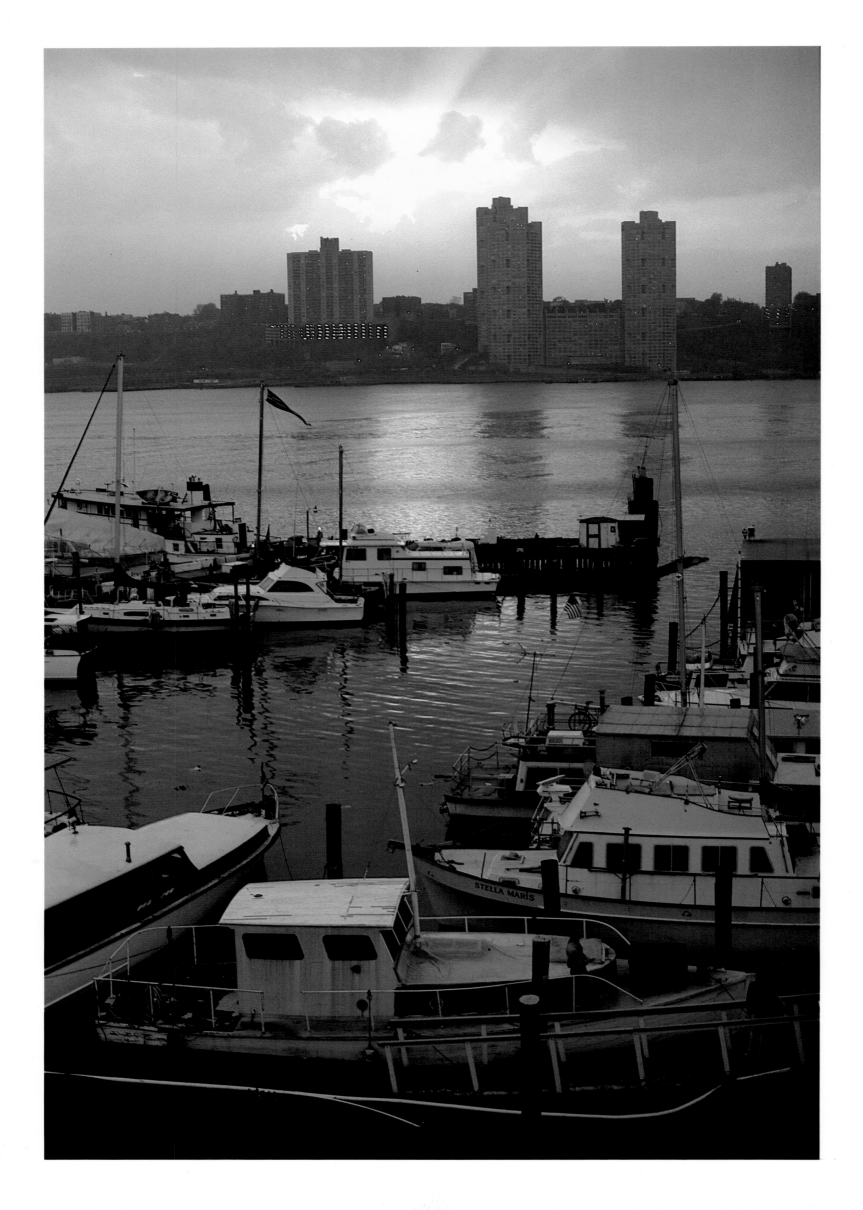

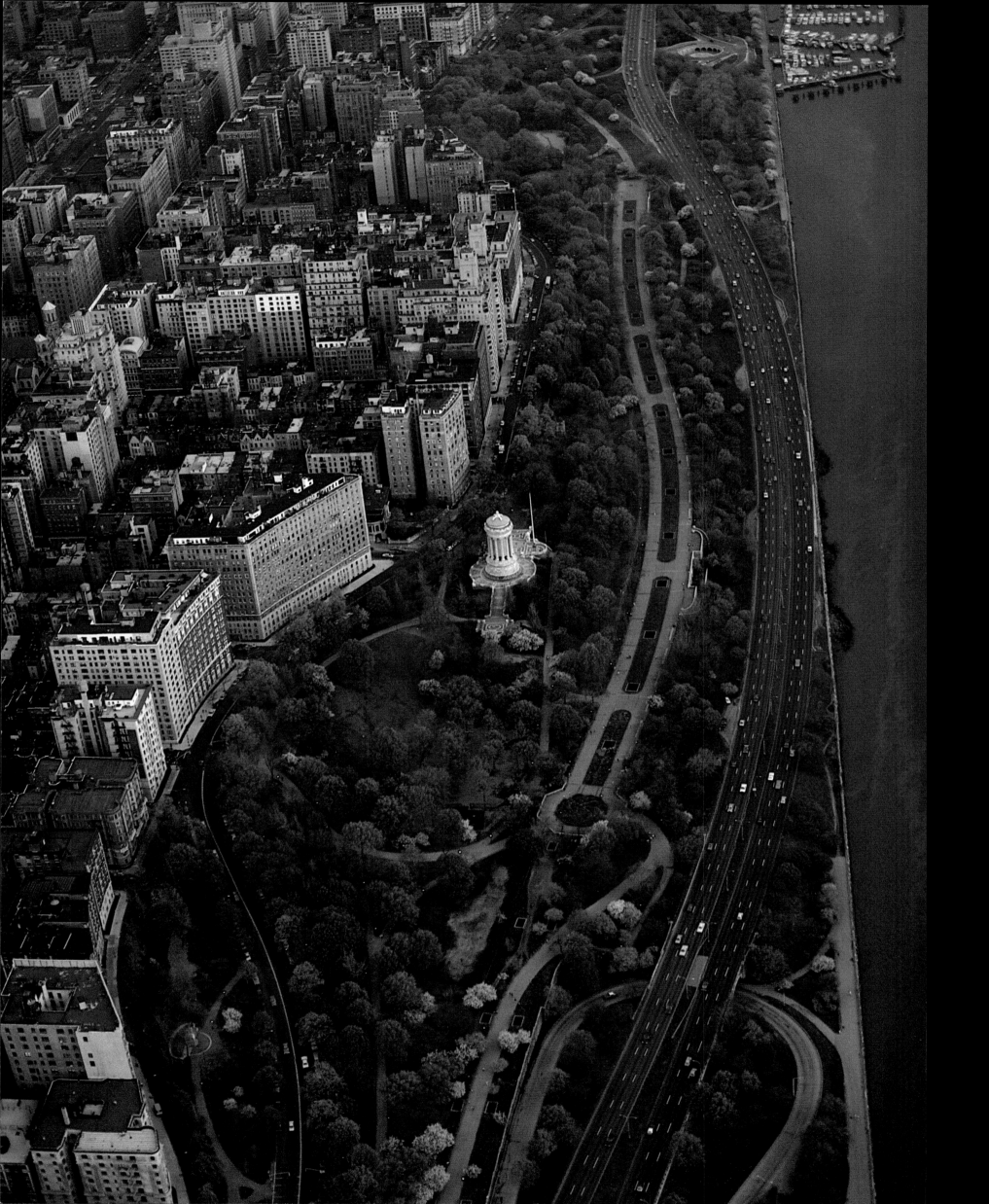

*Manhattan is filled with modern wonders and past treasures
. . . a unique blend of the old, the new and the timeless.
I am inspired by Manhattan—particularly its historical
buildings which provide a window to the past.*

—Ralph Lauren

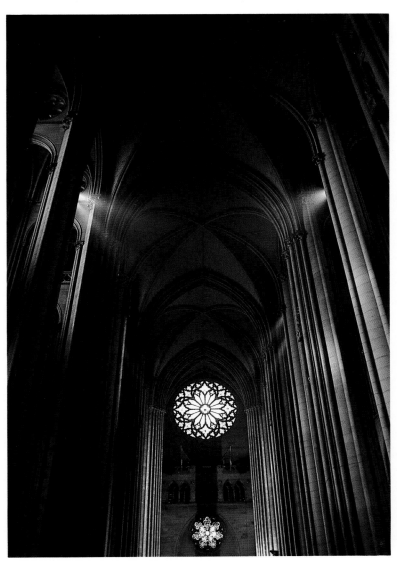

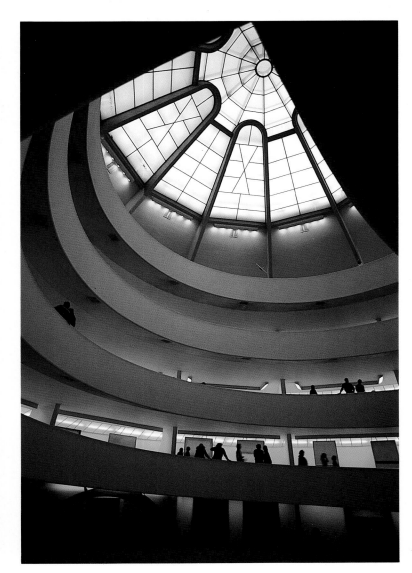

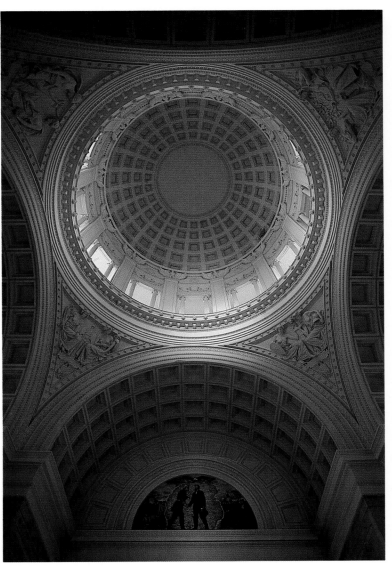

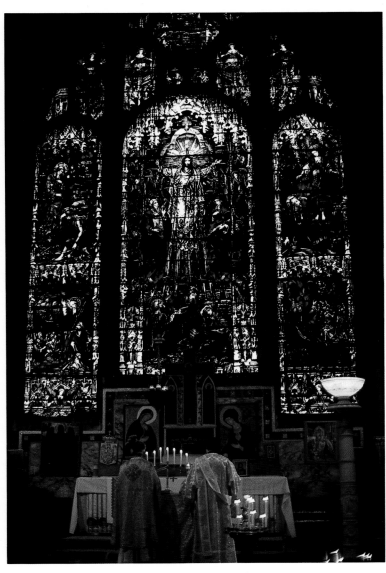

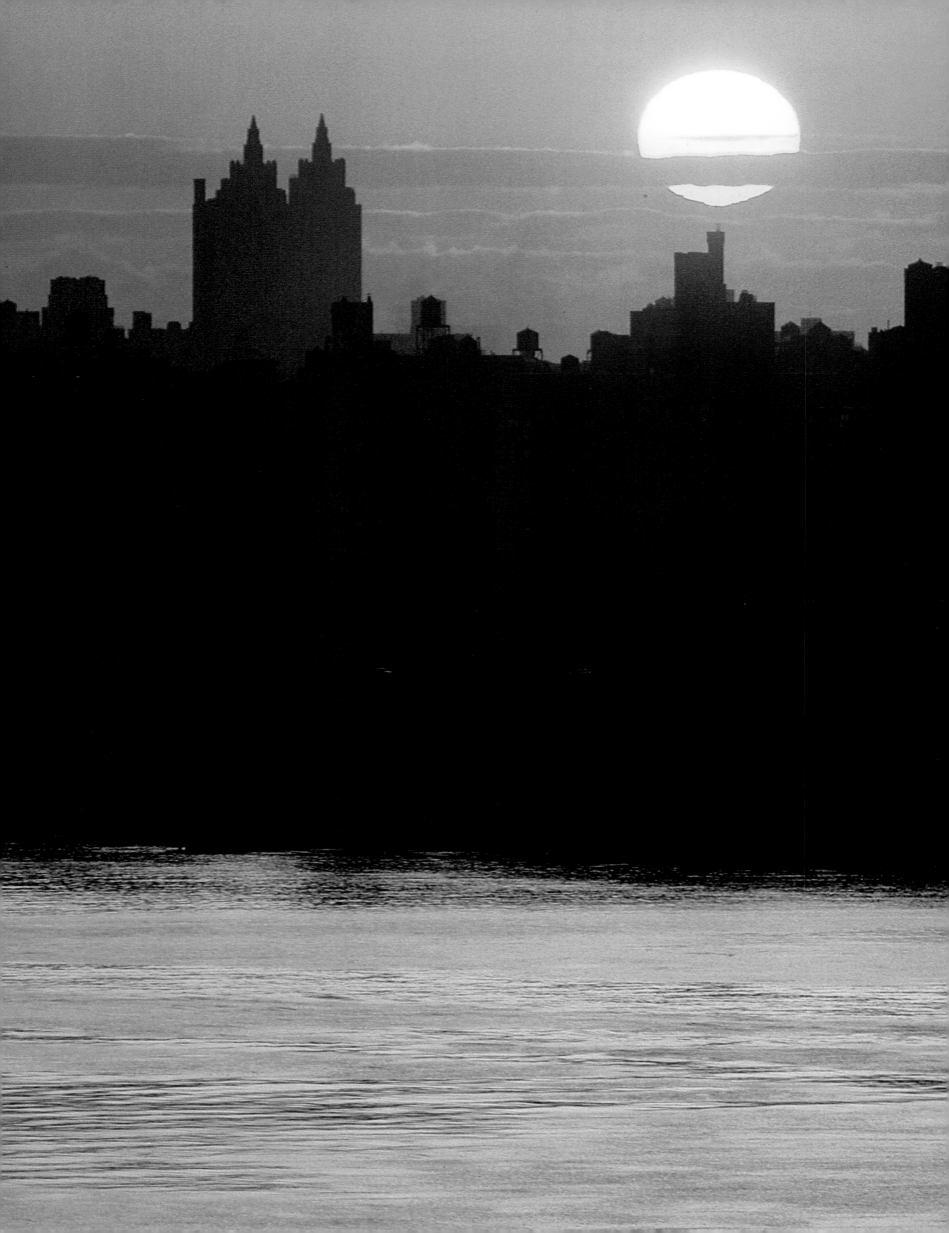

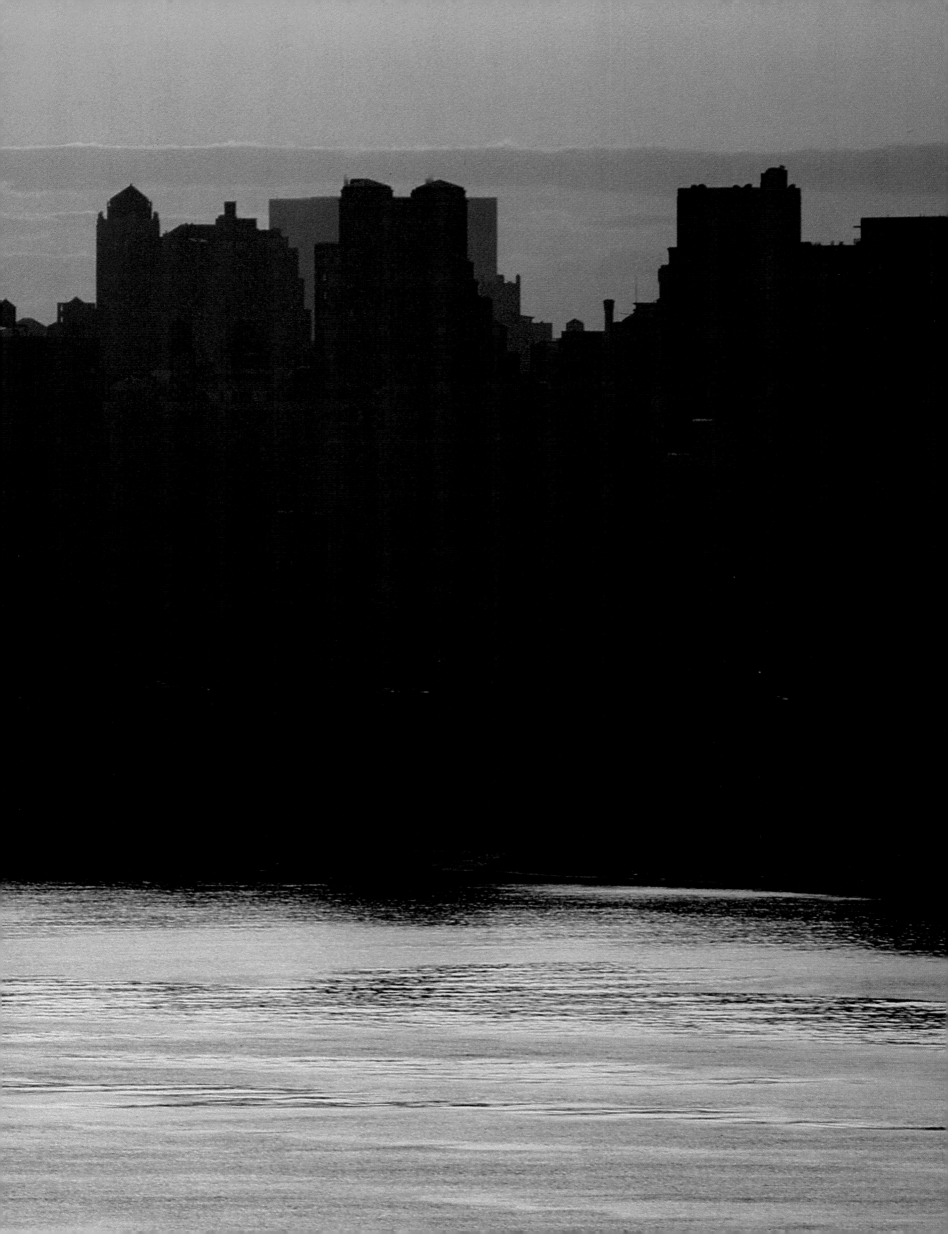

202

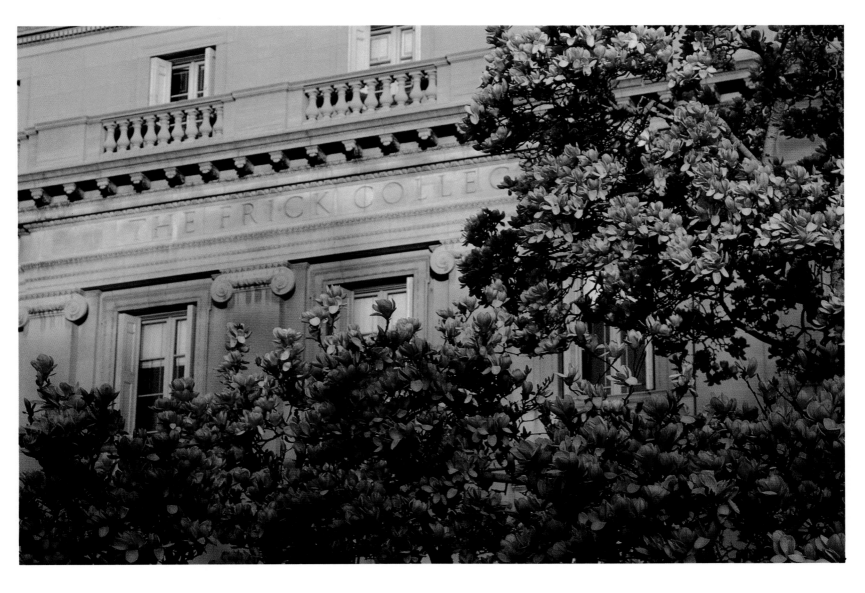

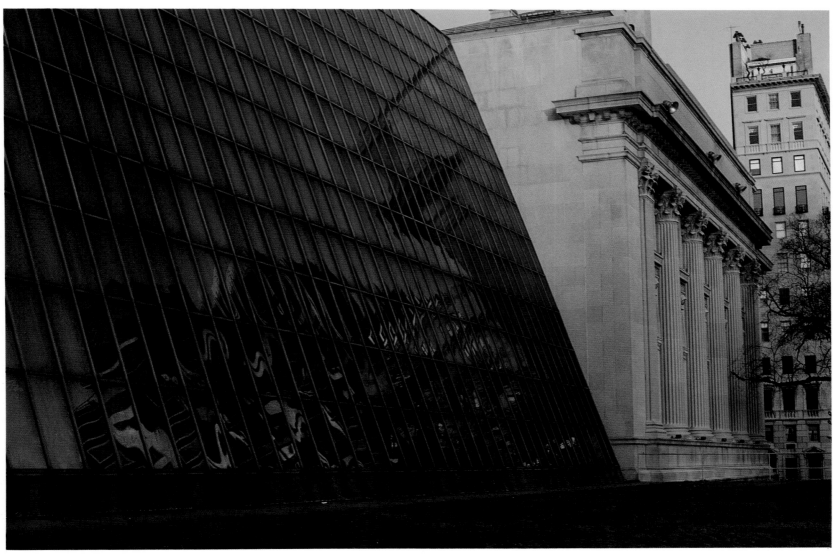

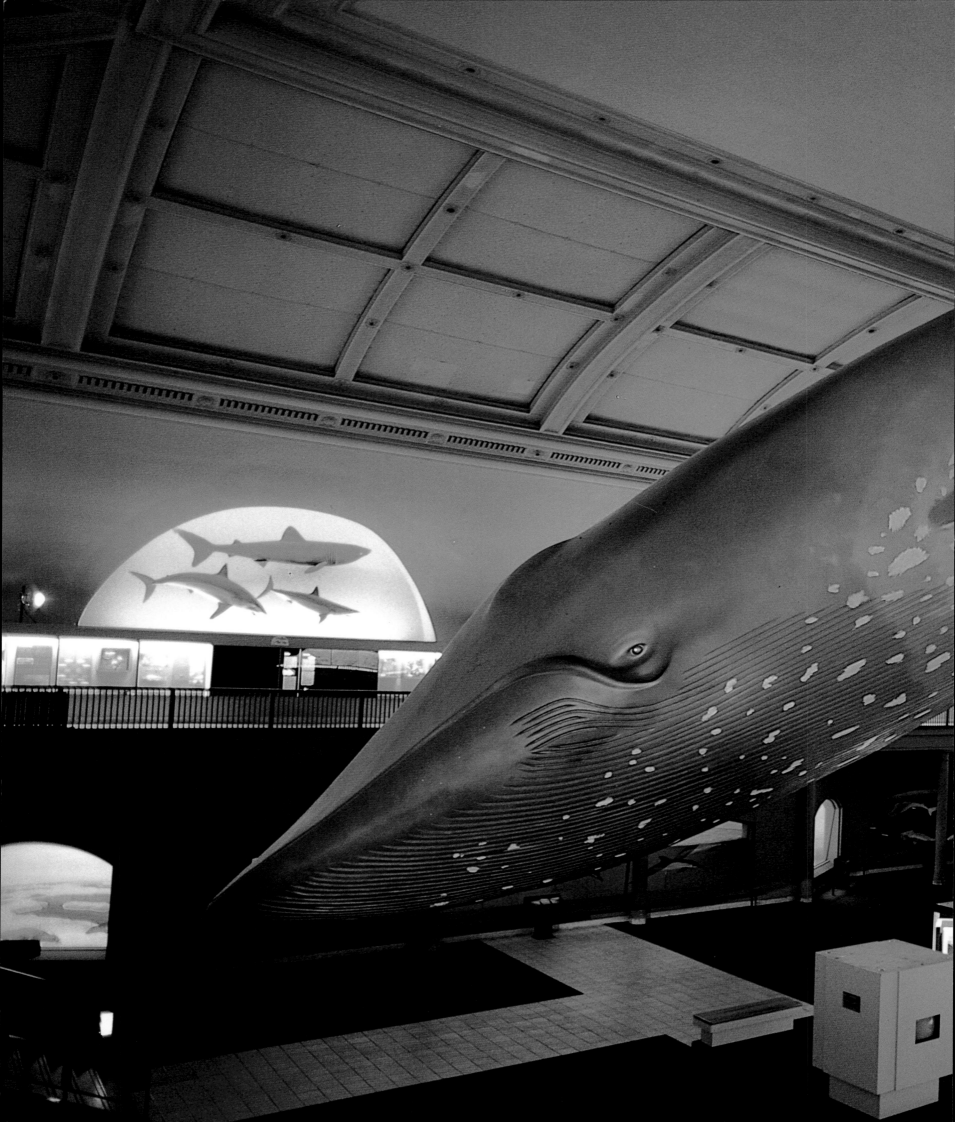

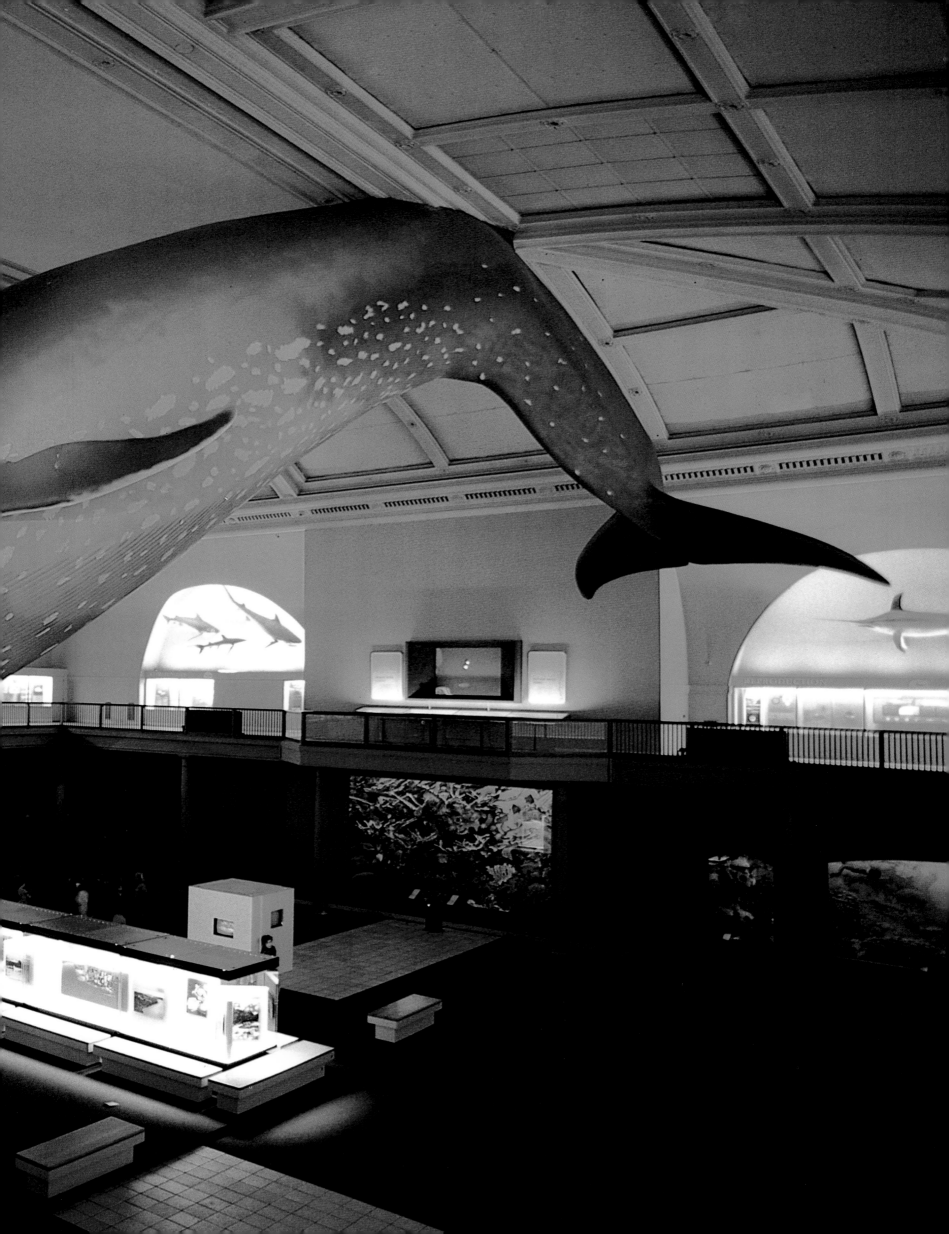

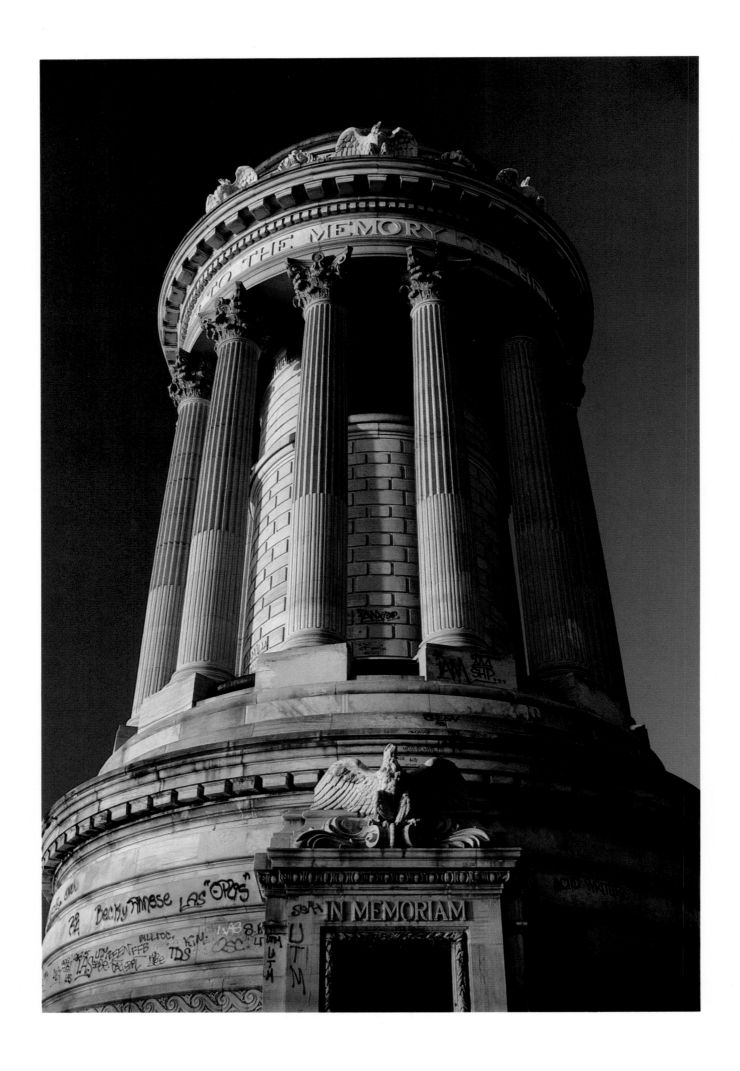

206

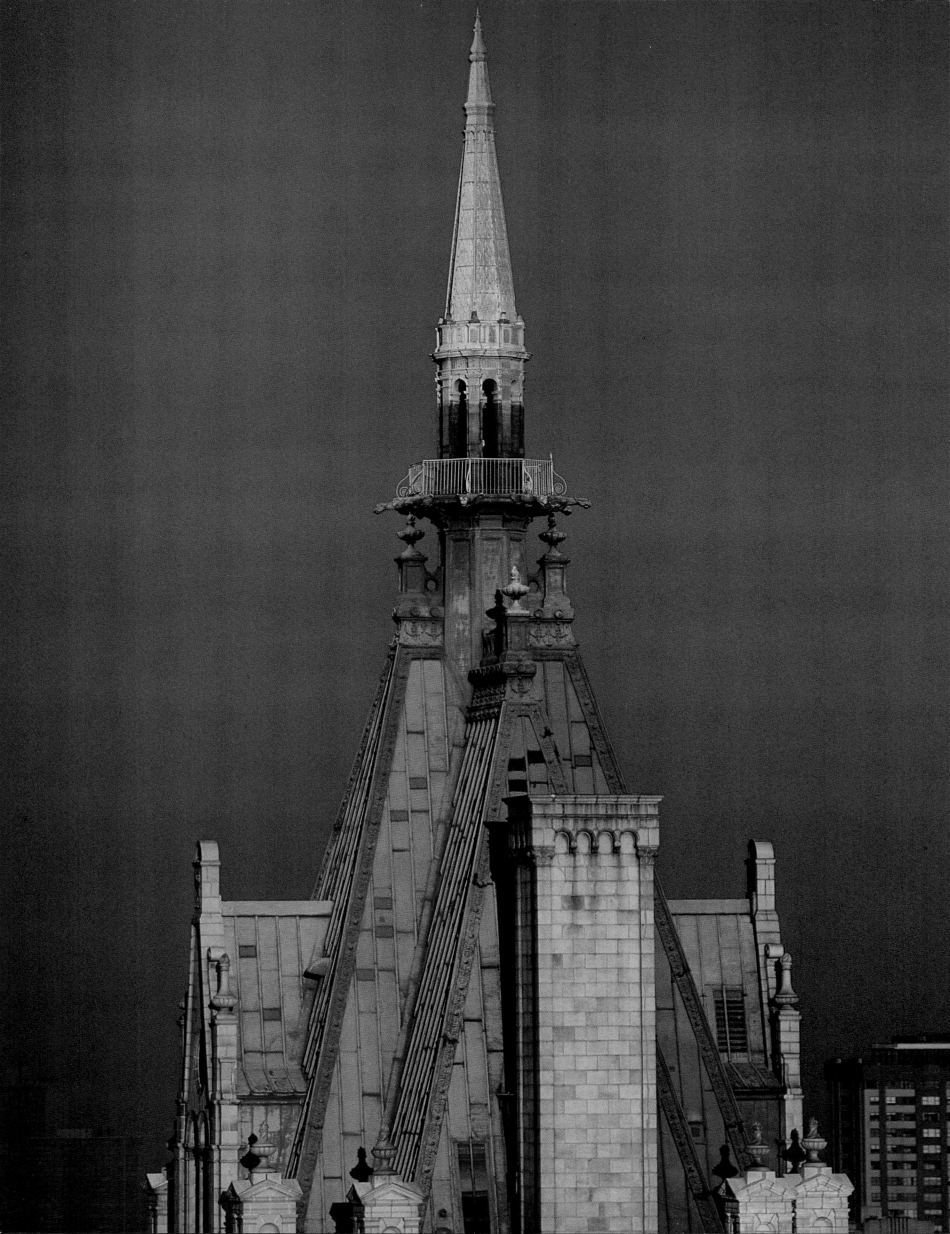

The city is the place for people who like life in tablet form,
concentrated: a forest resolved into a single tree, a lake
distilled into a fountain, and all the birds of the air
embodied in one transient thrush in a small garden.
 —E.B. White

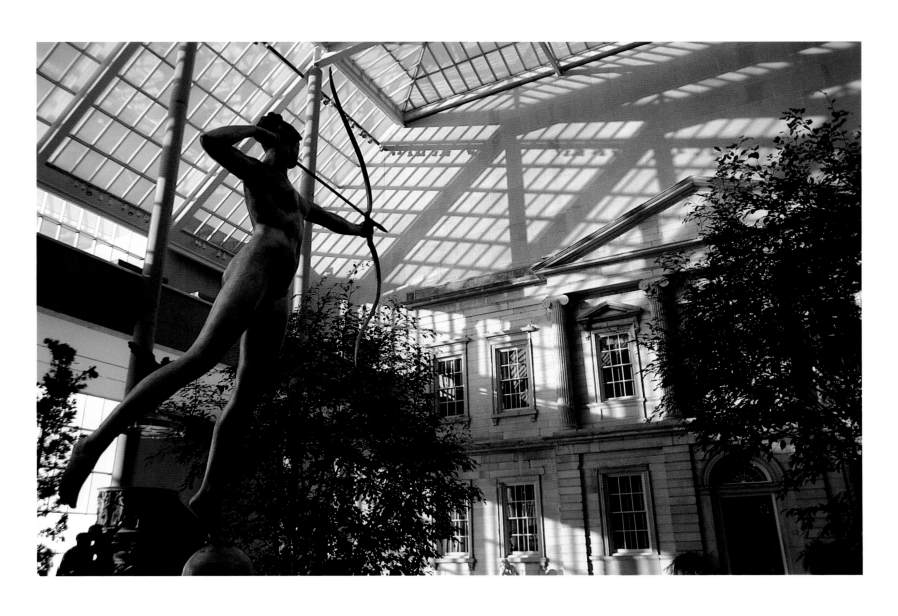

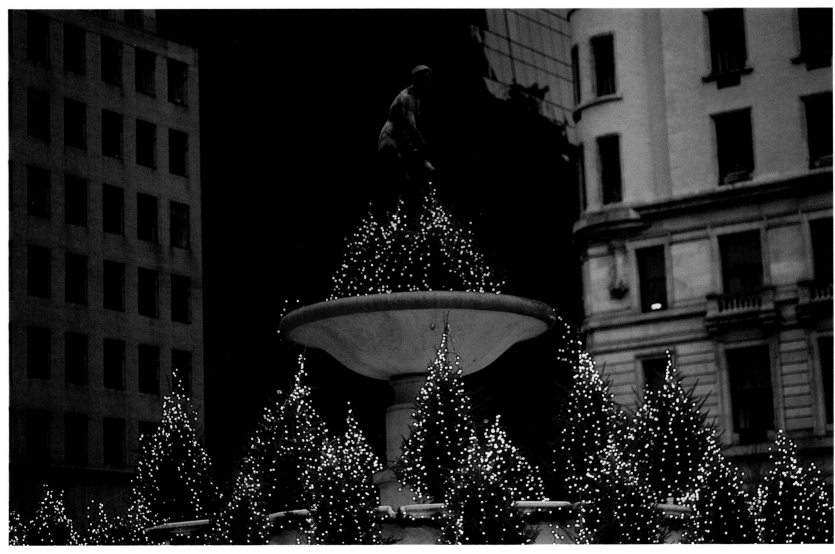

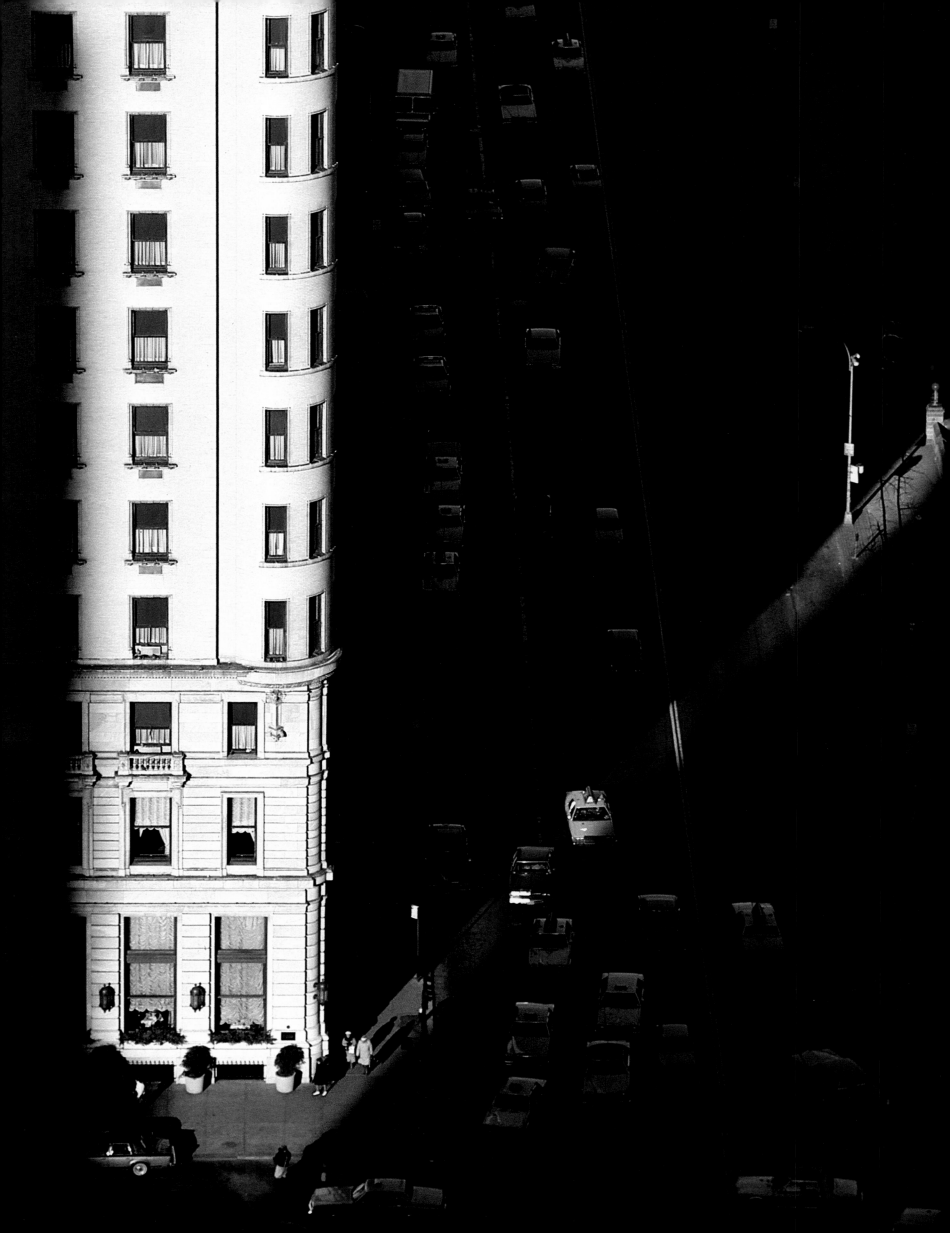

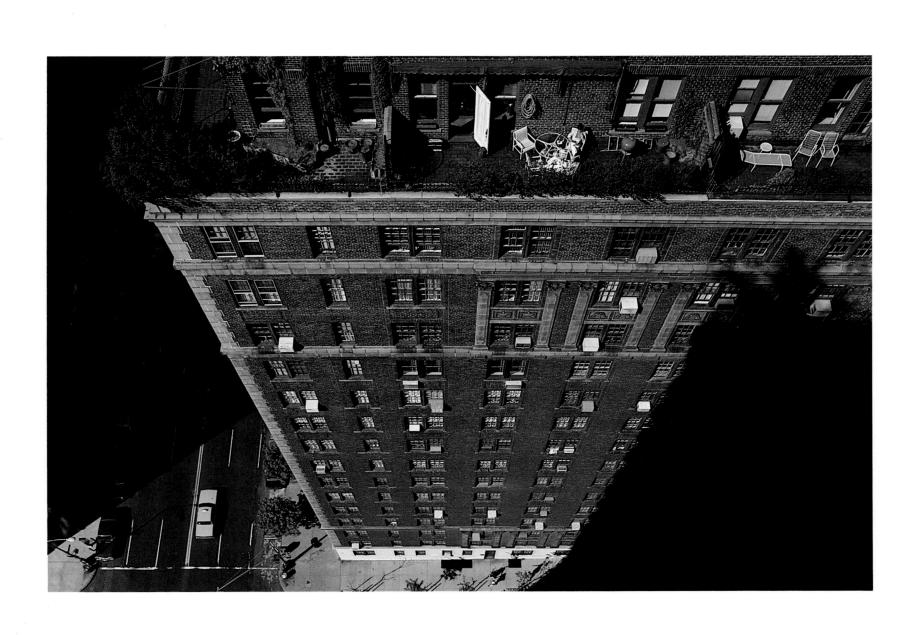

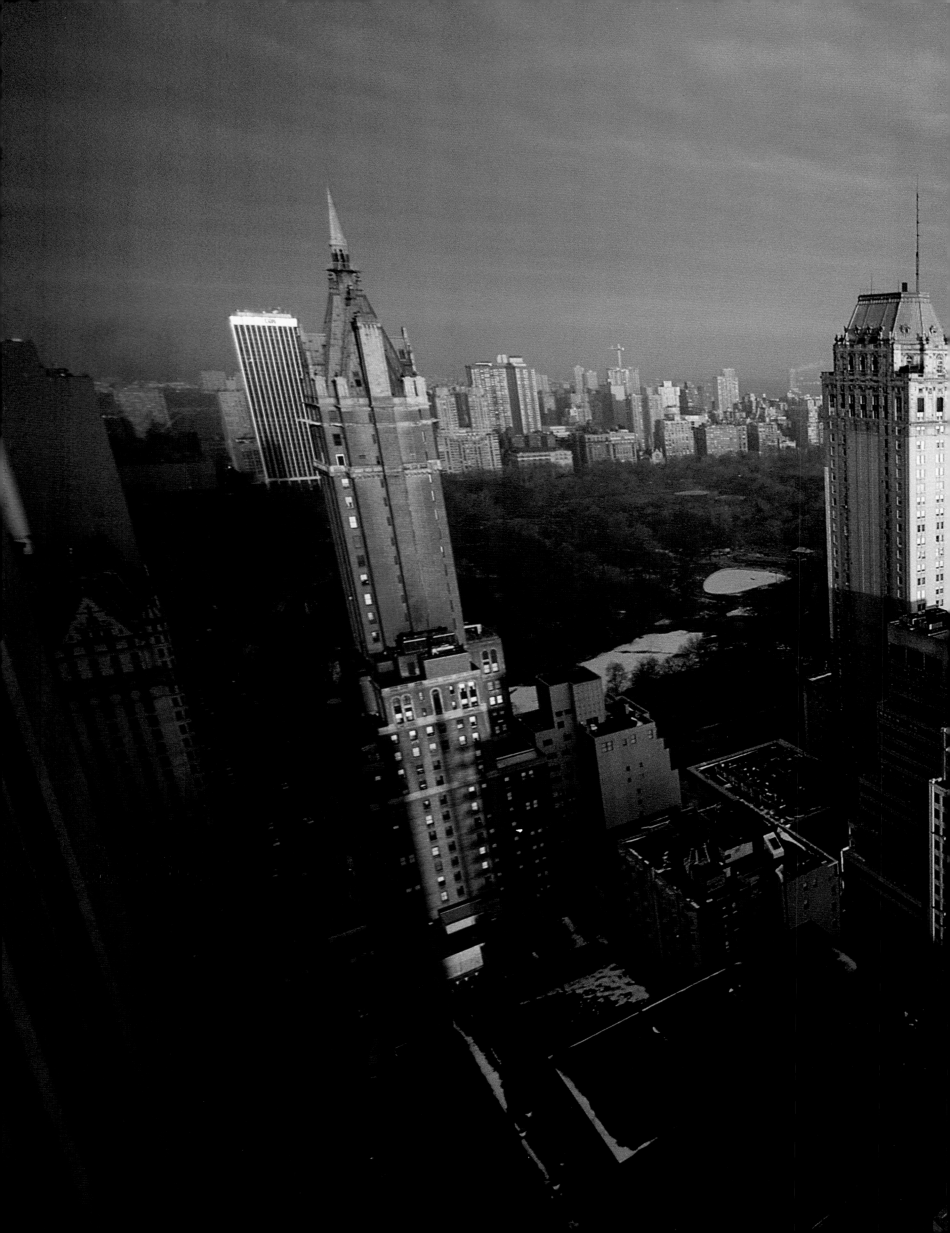

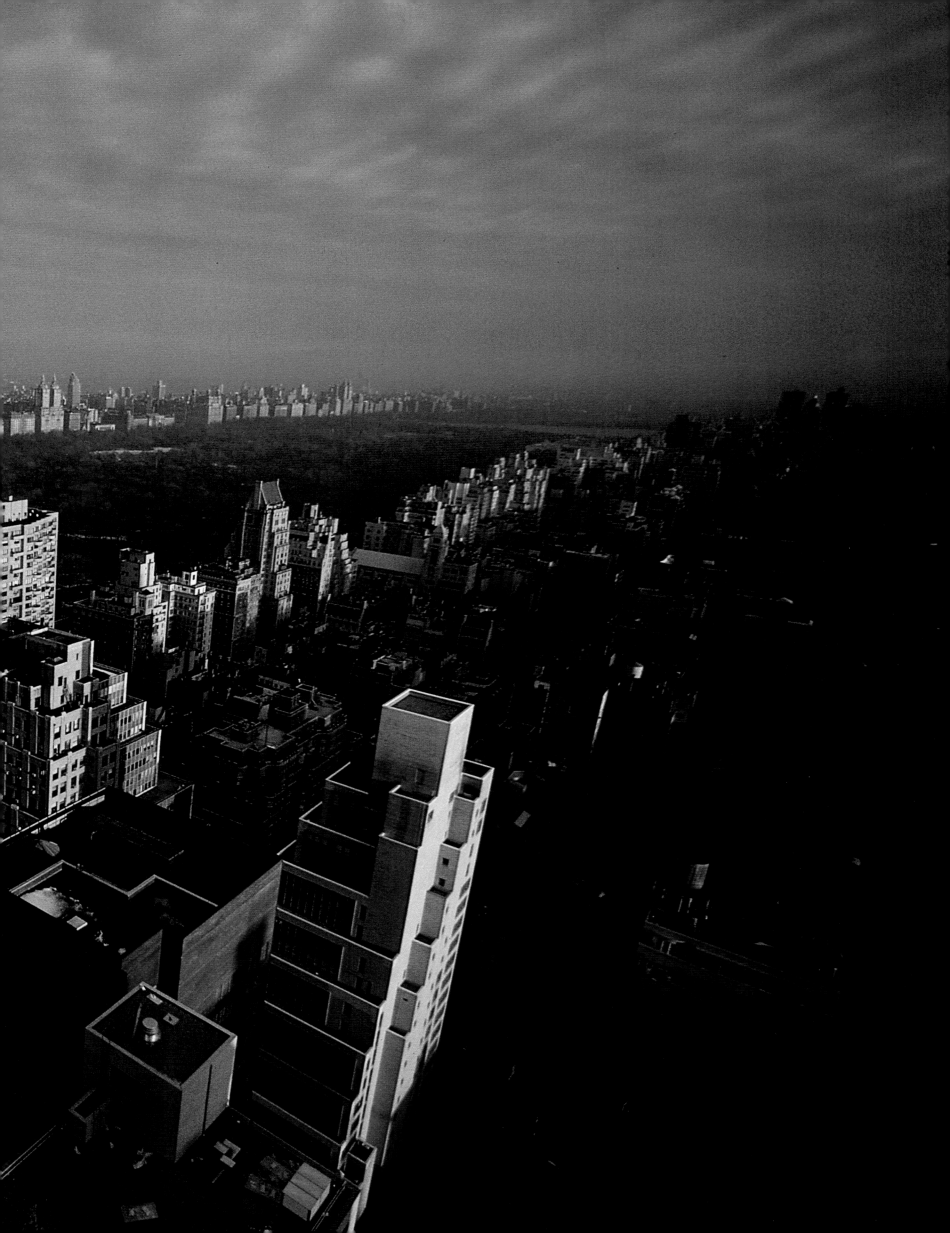

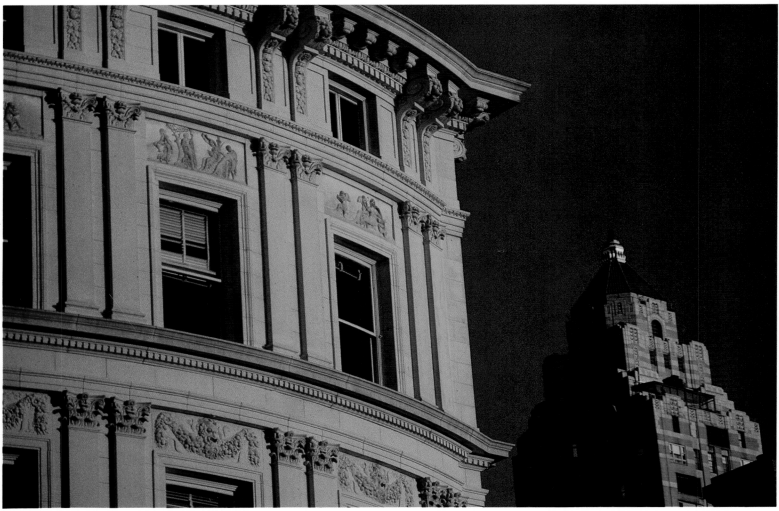

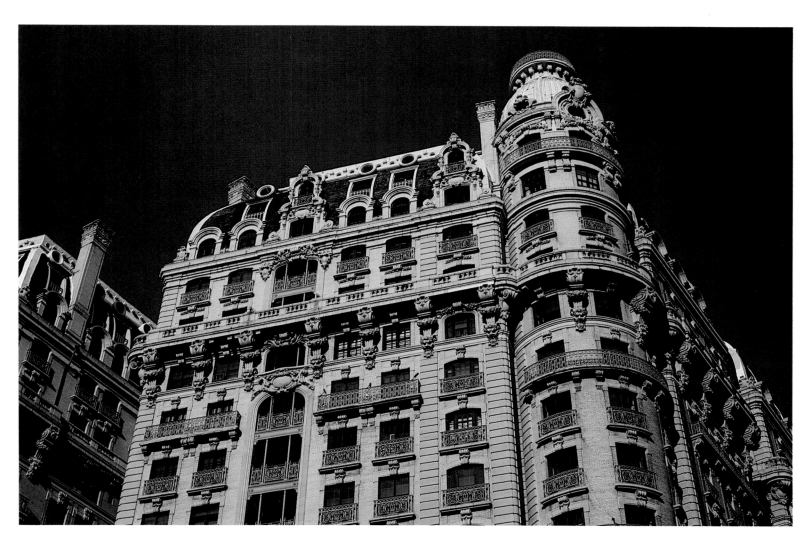

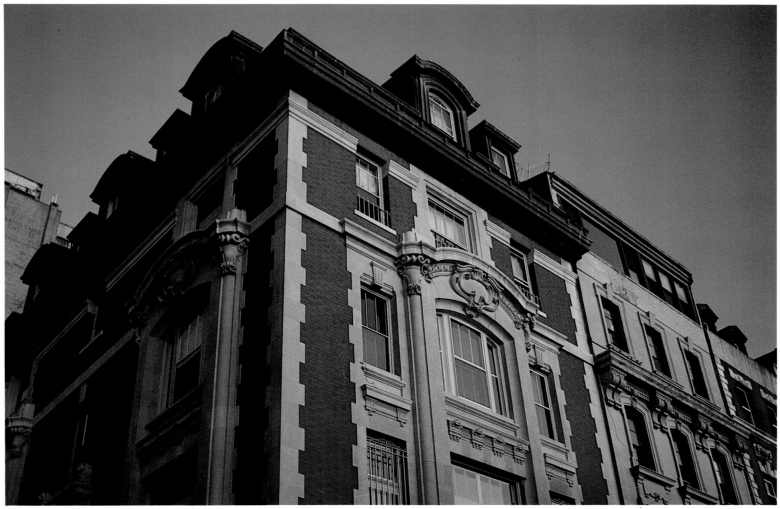

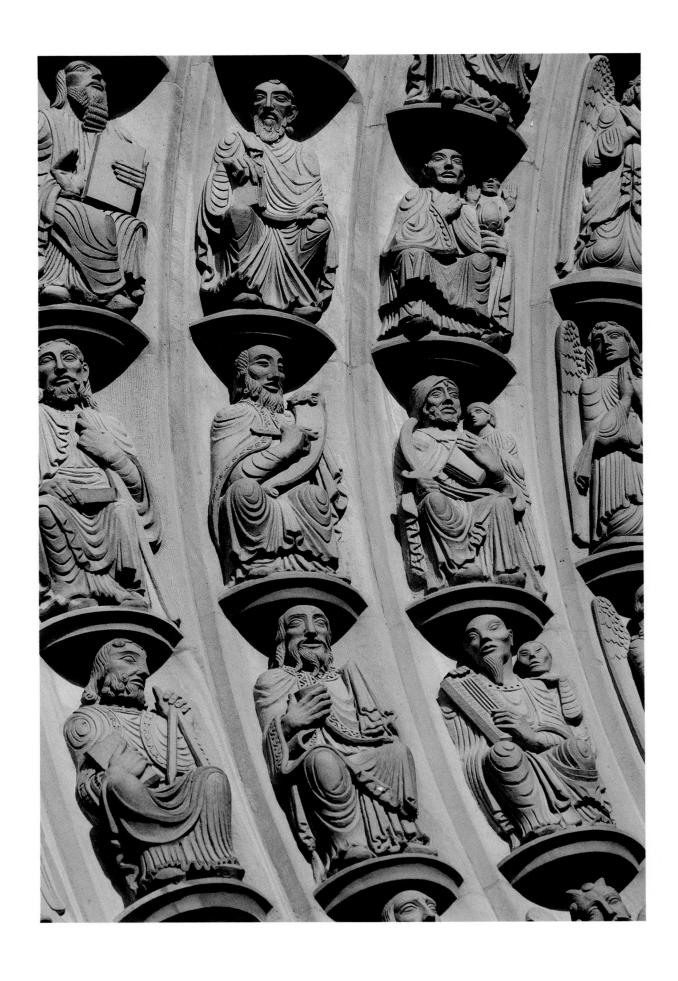

216

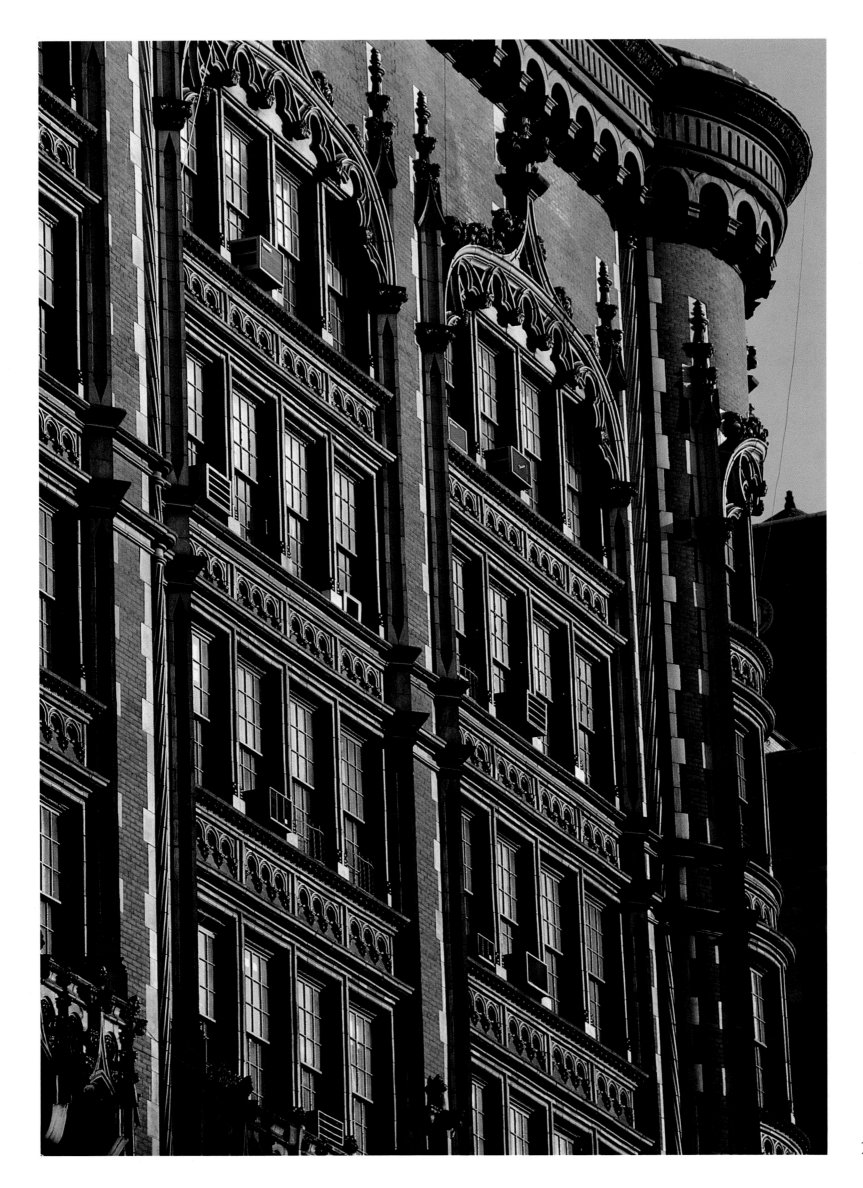

. . . The vision of a great metropolis, throbbing with ceaseless life, pulsating after the fashion of a great heart and extending its influence by means of tracks to all parts of the world, is one of the most inspiring and impressive visions imaginable.
—Theodore Dreiser

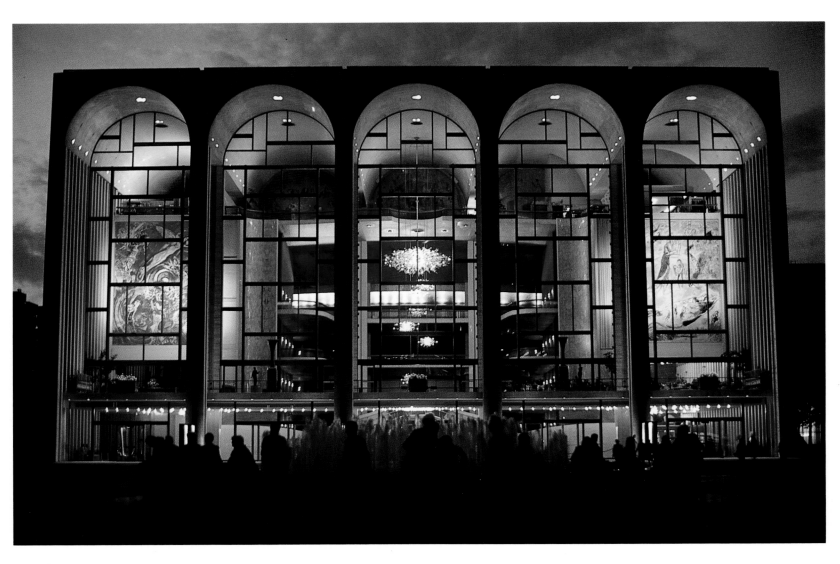

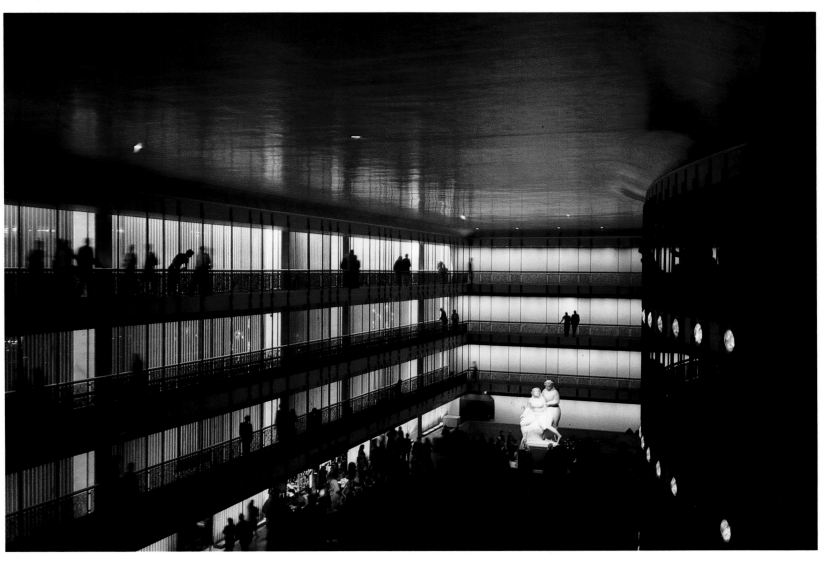

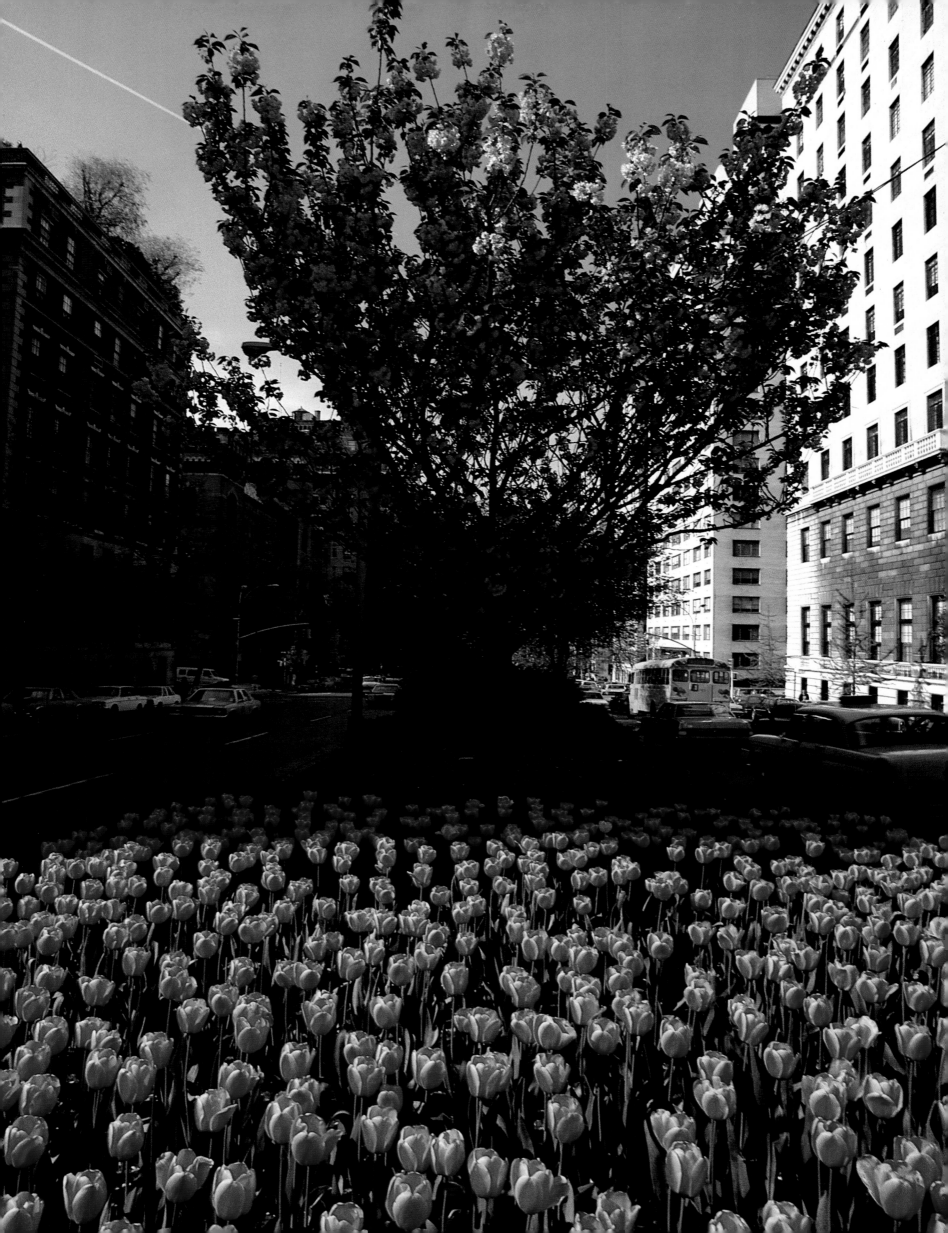

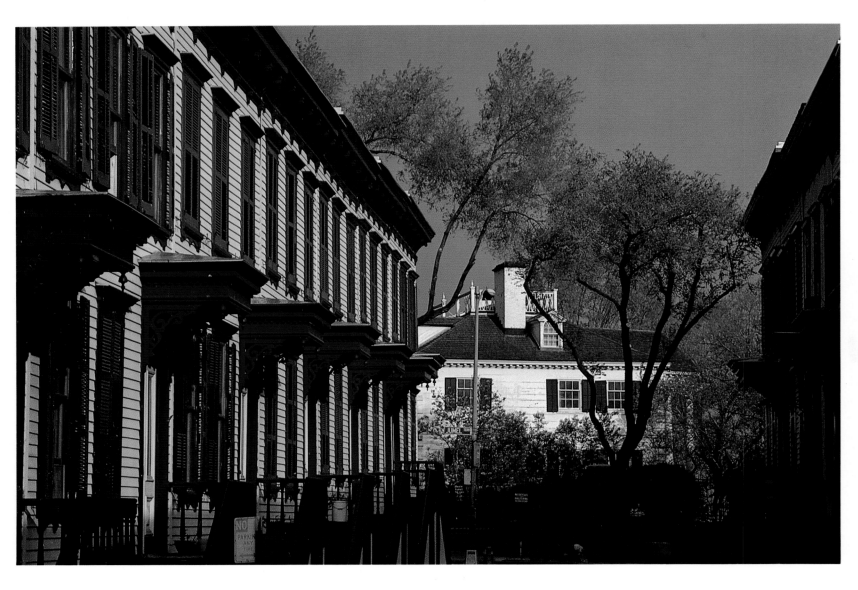

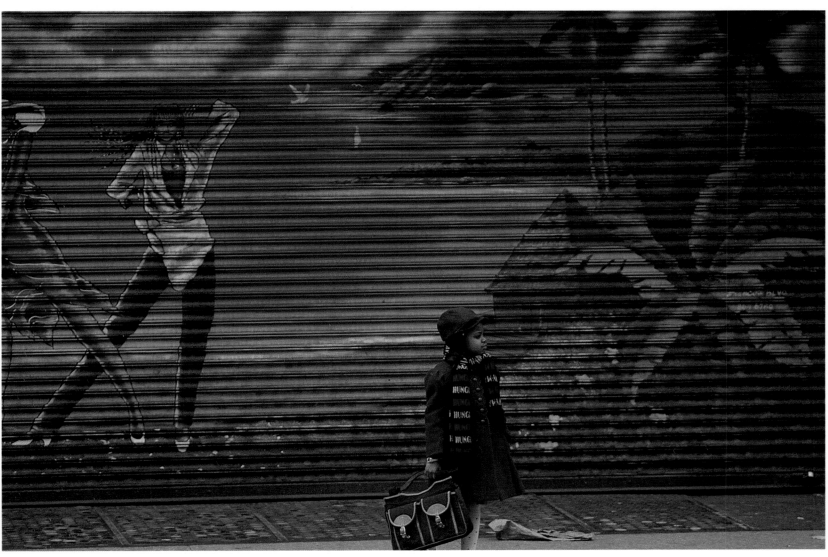

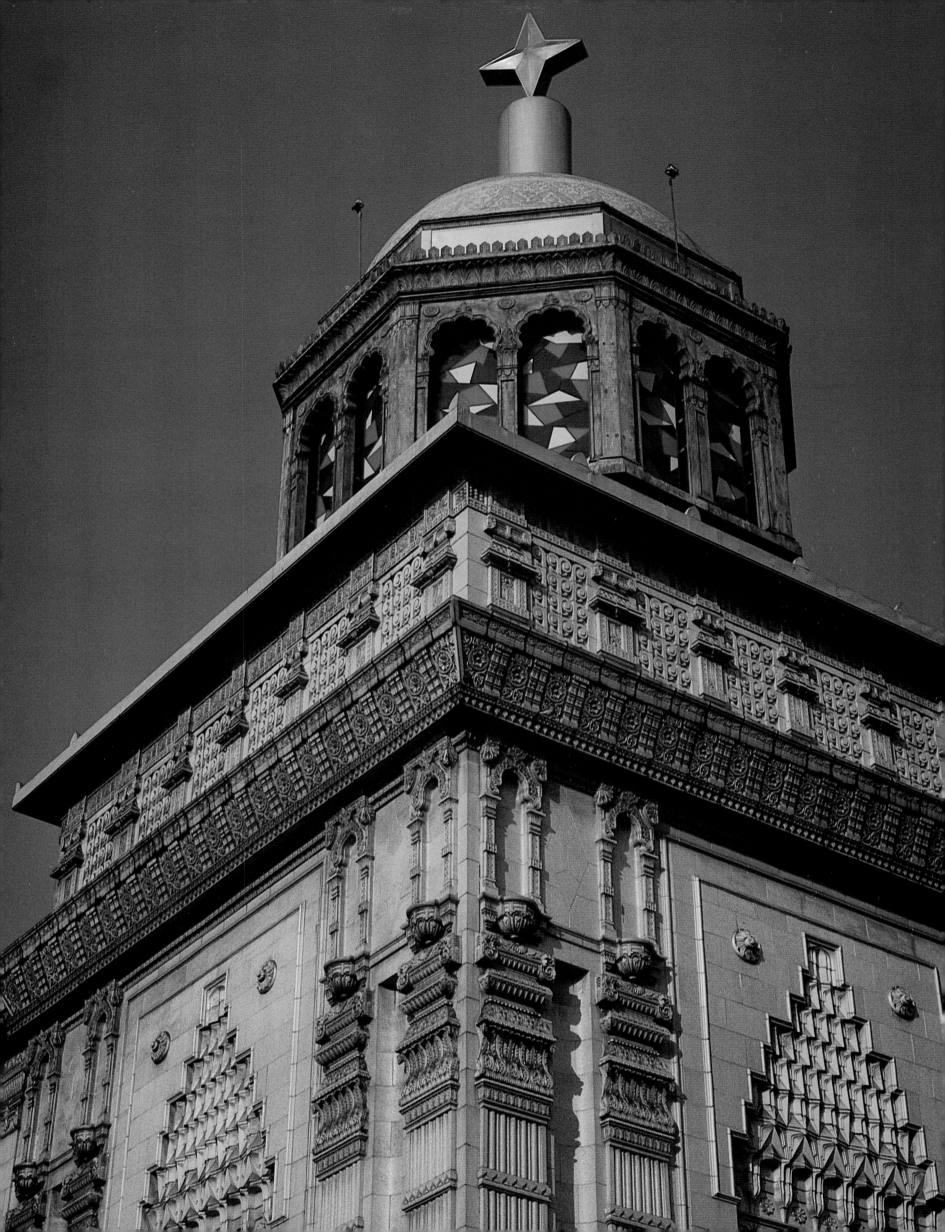

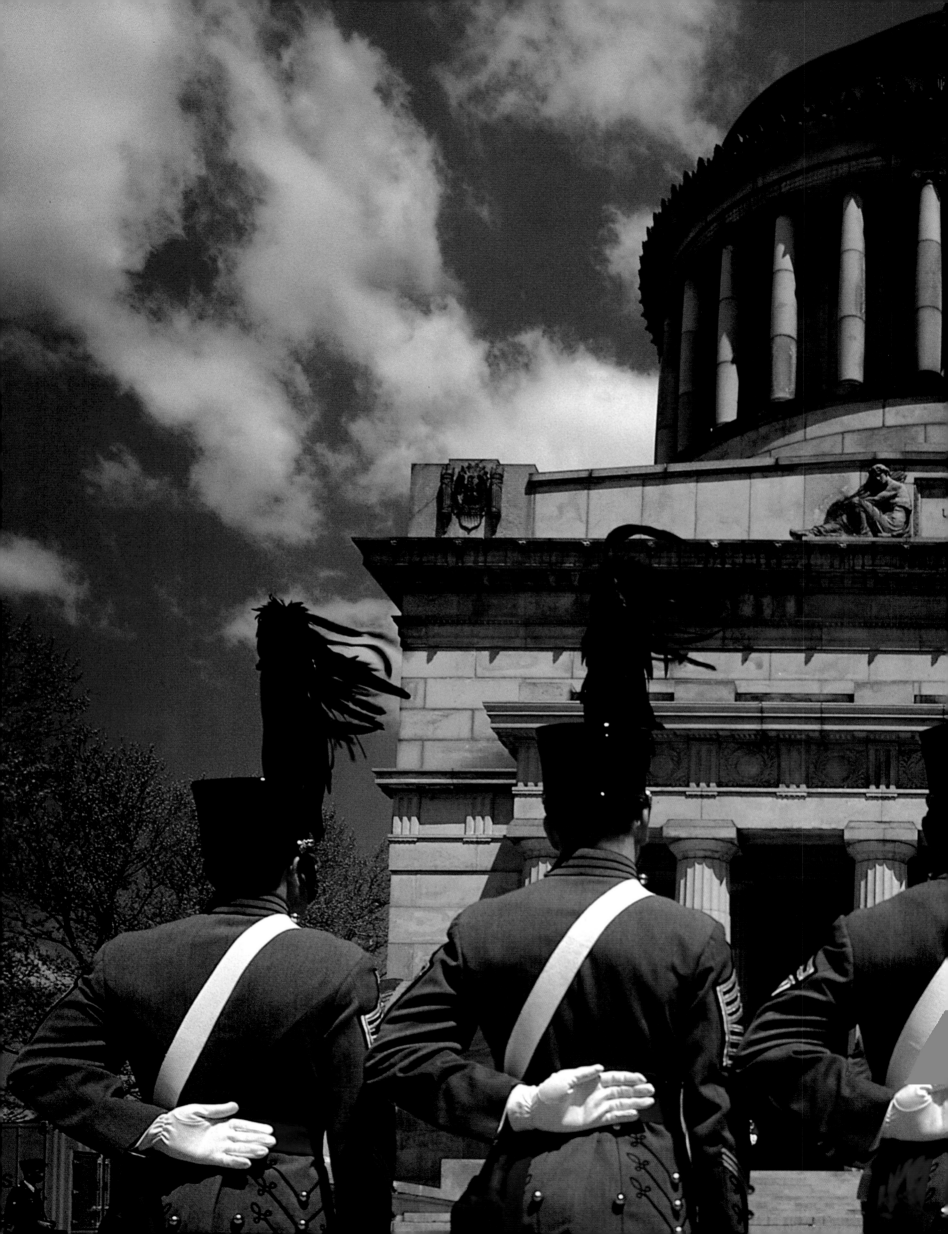

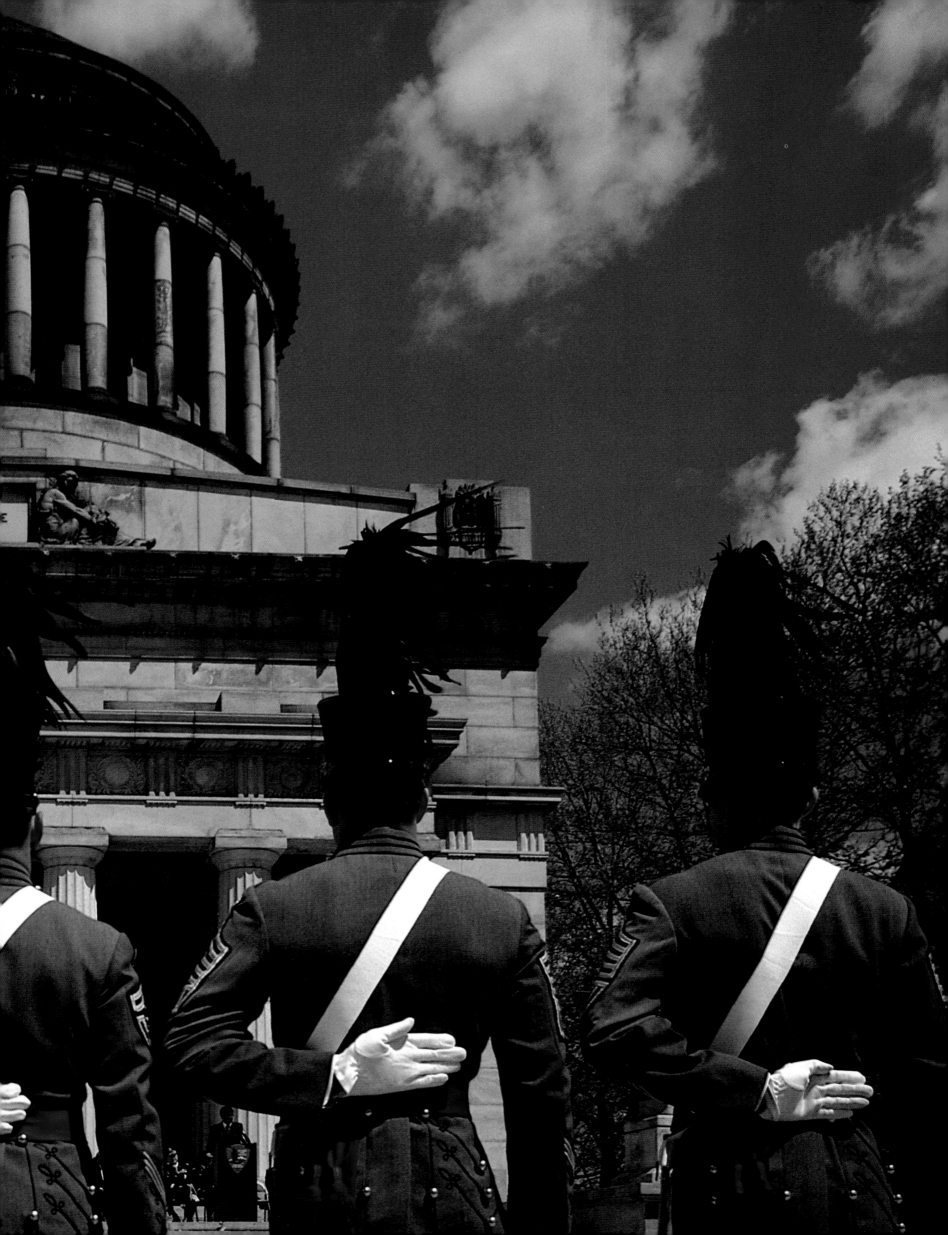

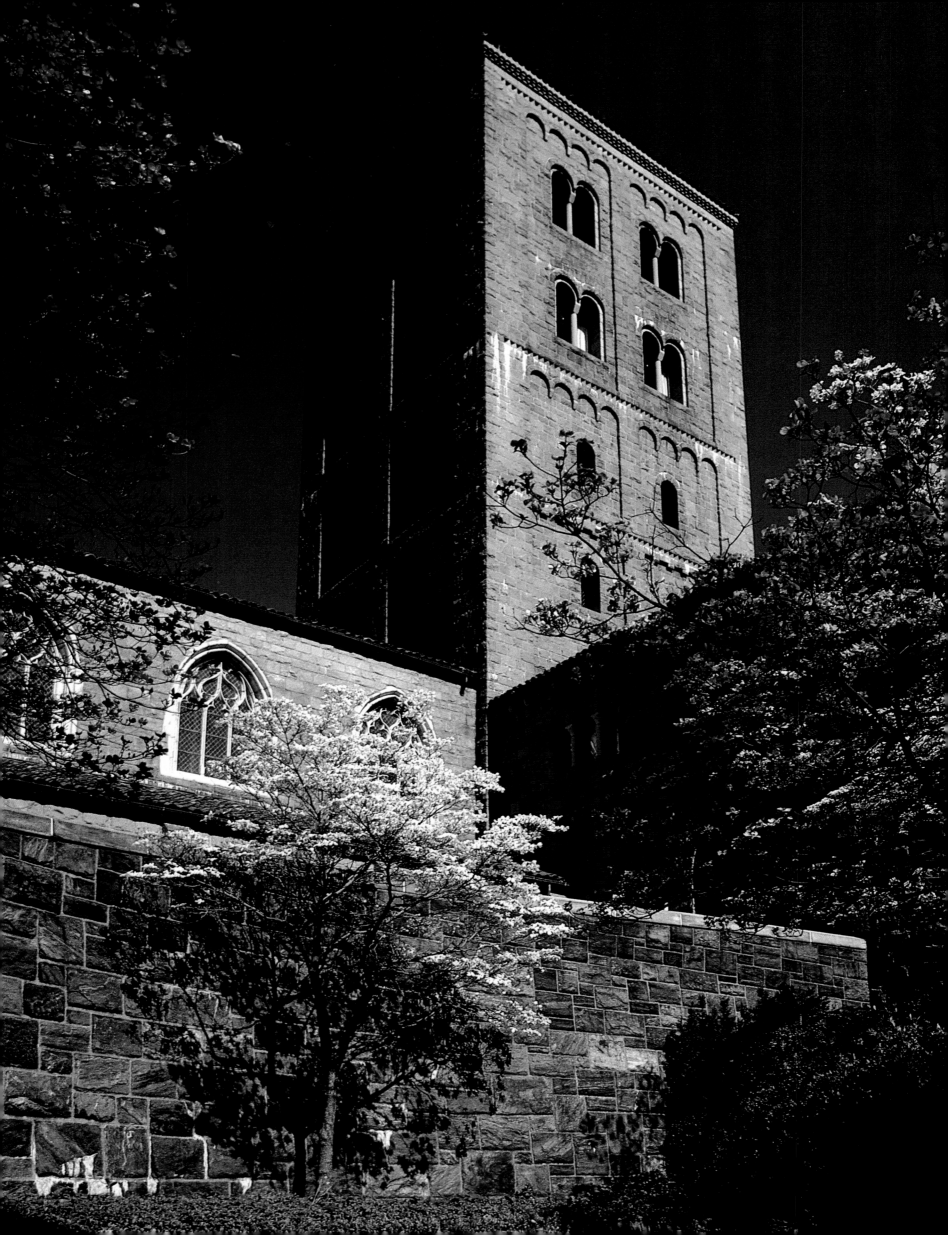

BRIDGES

Manhattan's links to the mainland
and Long Island

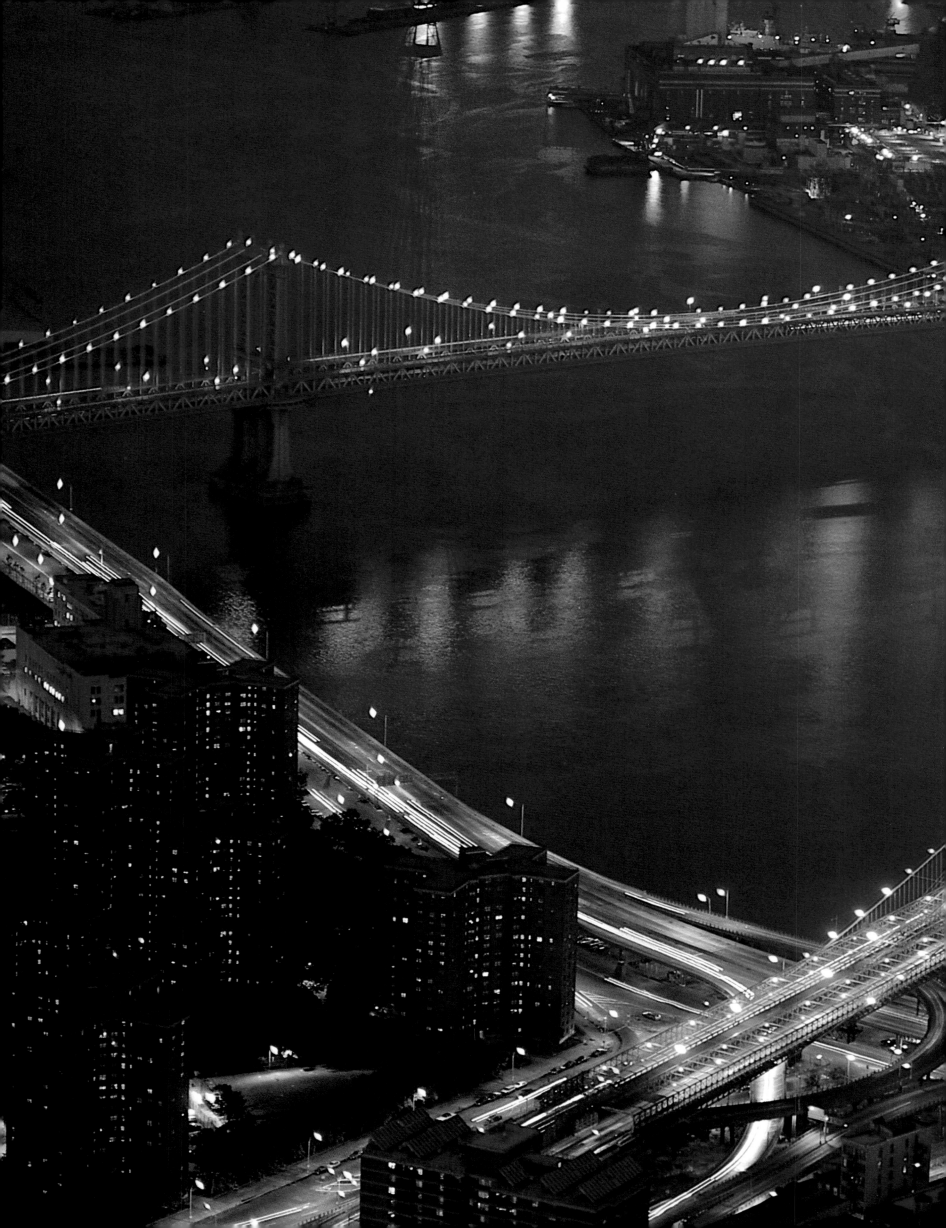

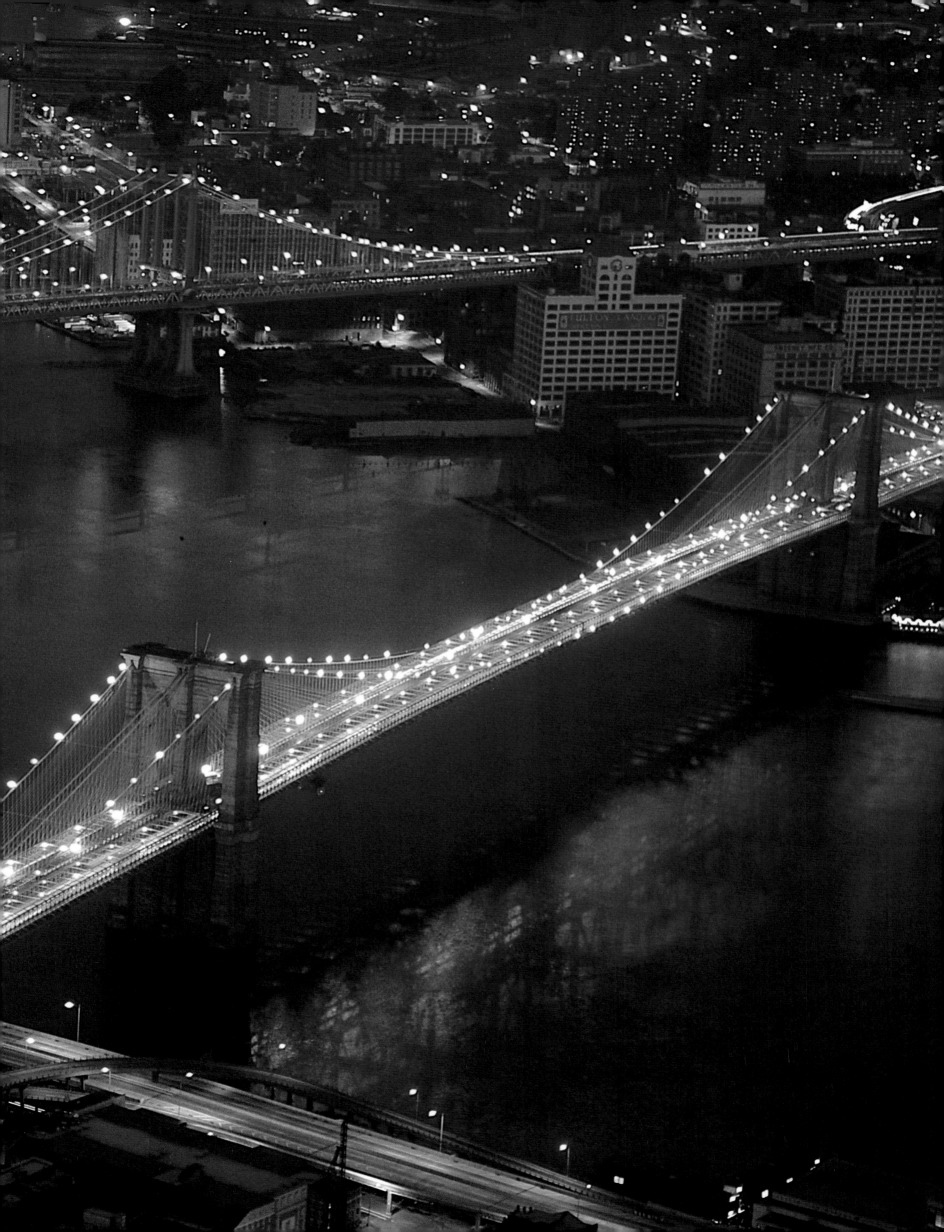

Down Wall, from girder into street noon leaks,
a rip-tooth of the sky's acetylene;
All afternoon the cloud-flow derricks turn . . .
Thy cables breathe the North Atlantic still.
 —Hart Crane, from "To Brooklyn Bridge"

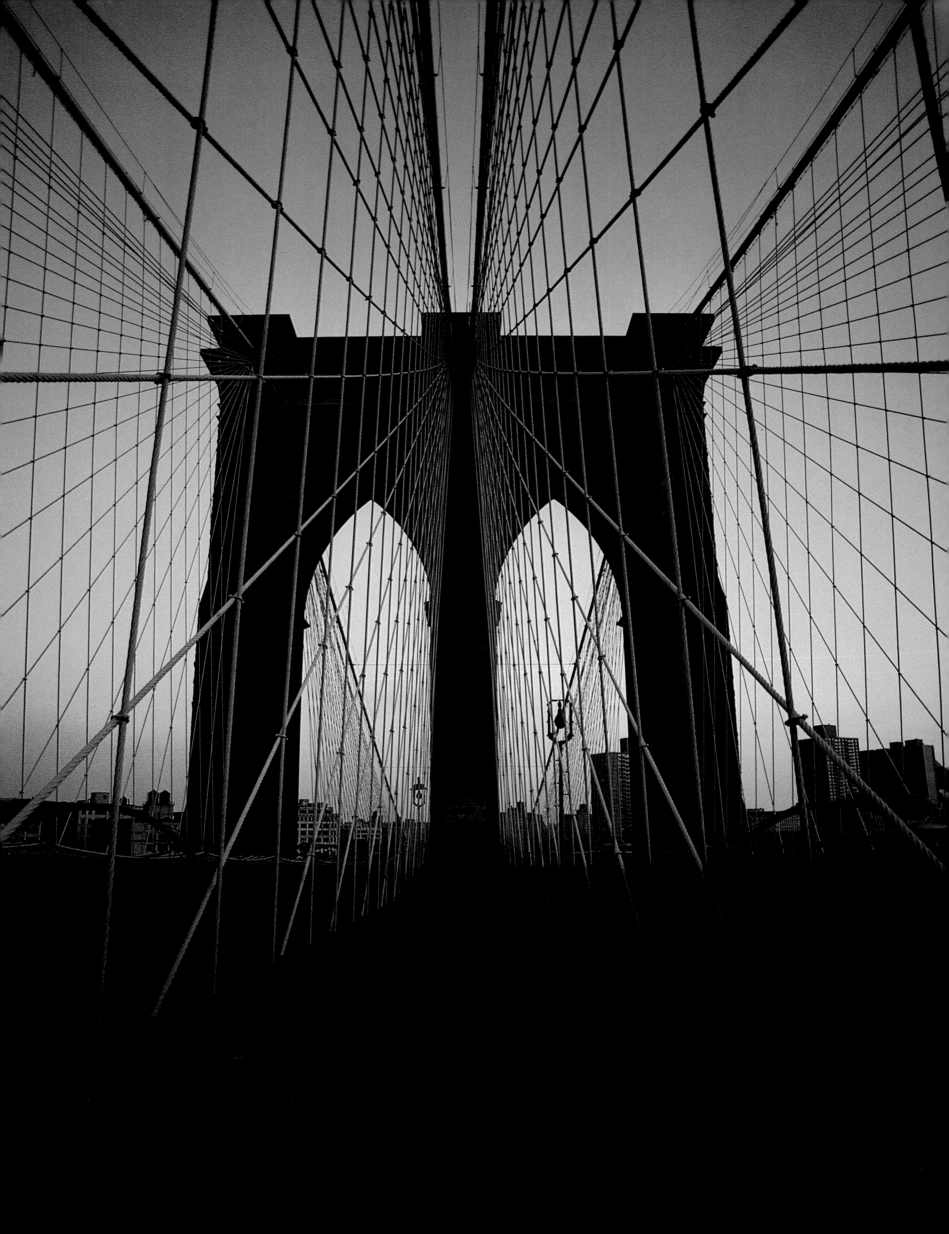

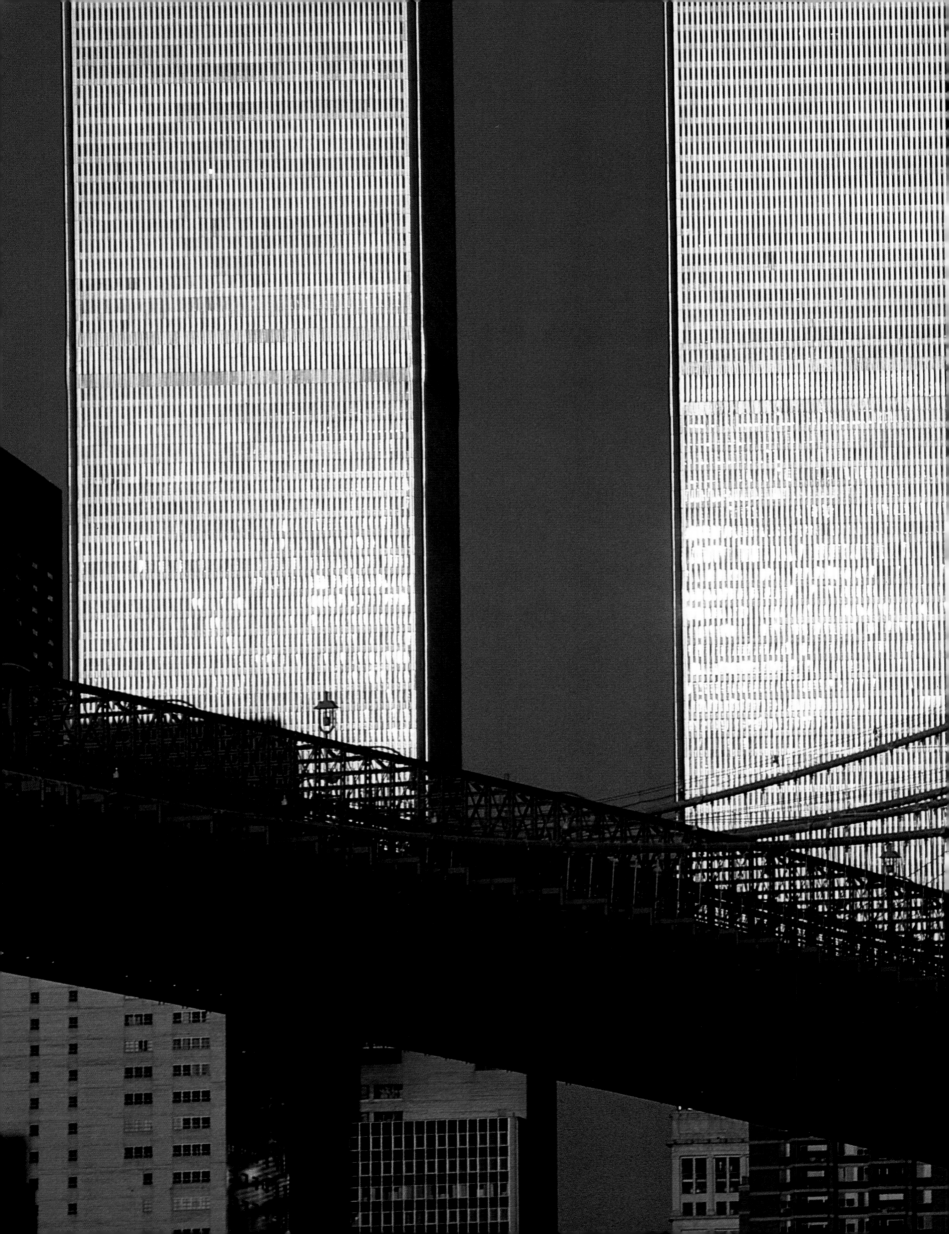

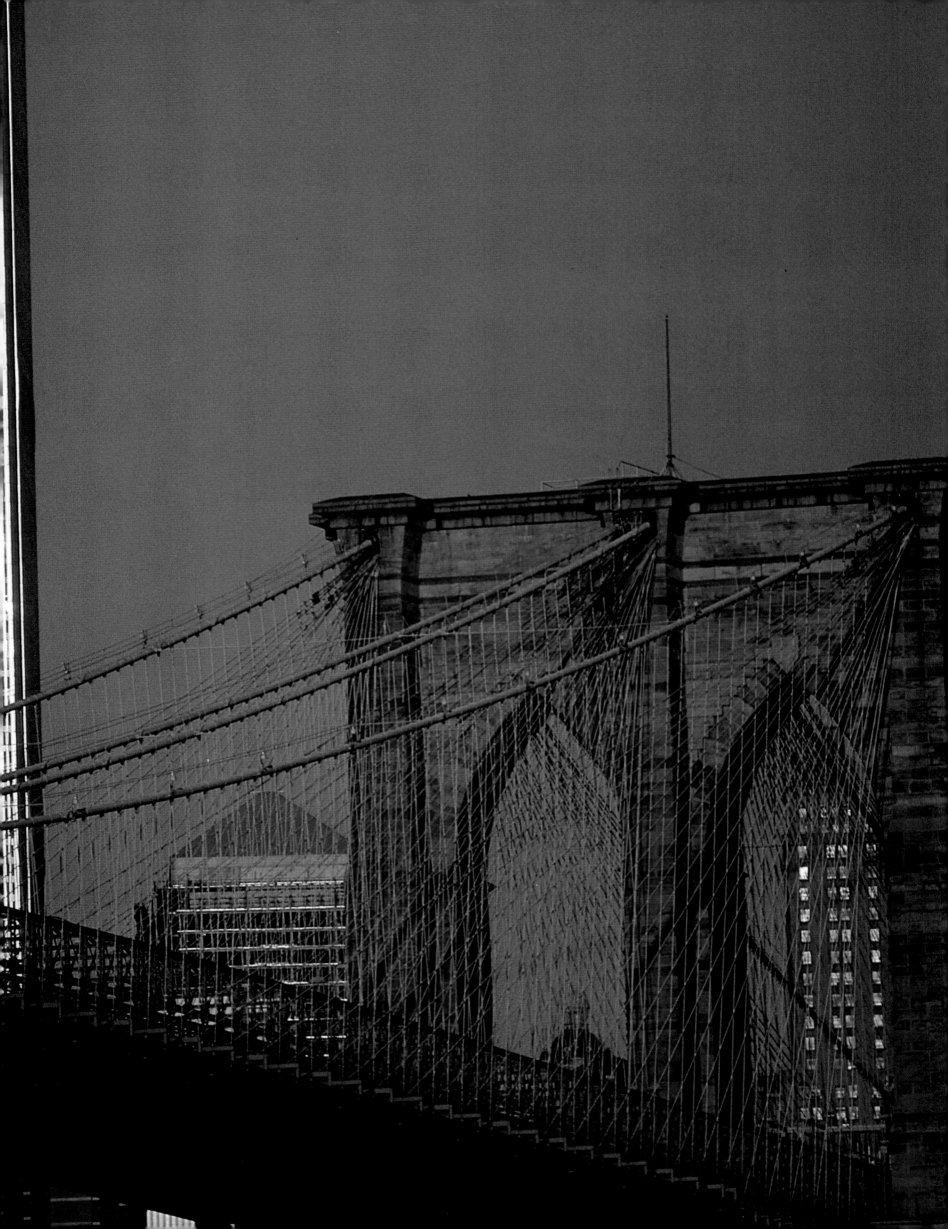

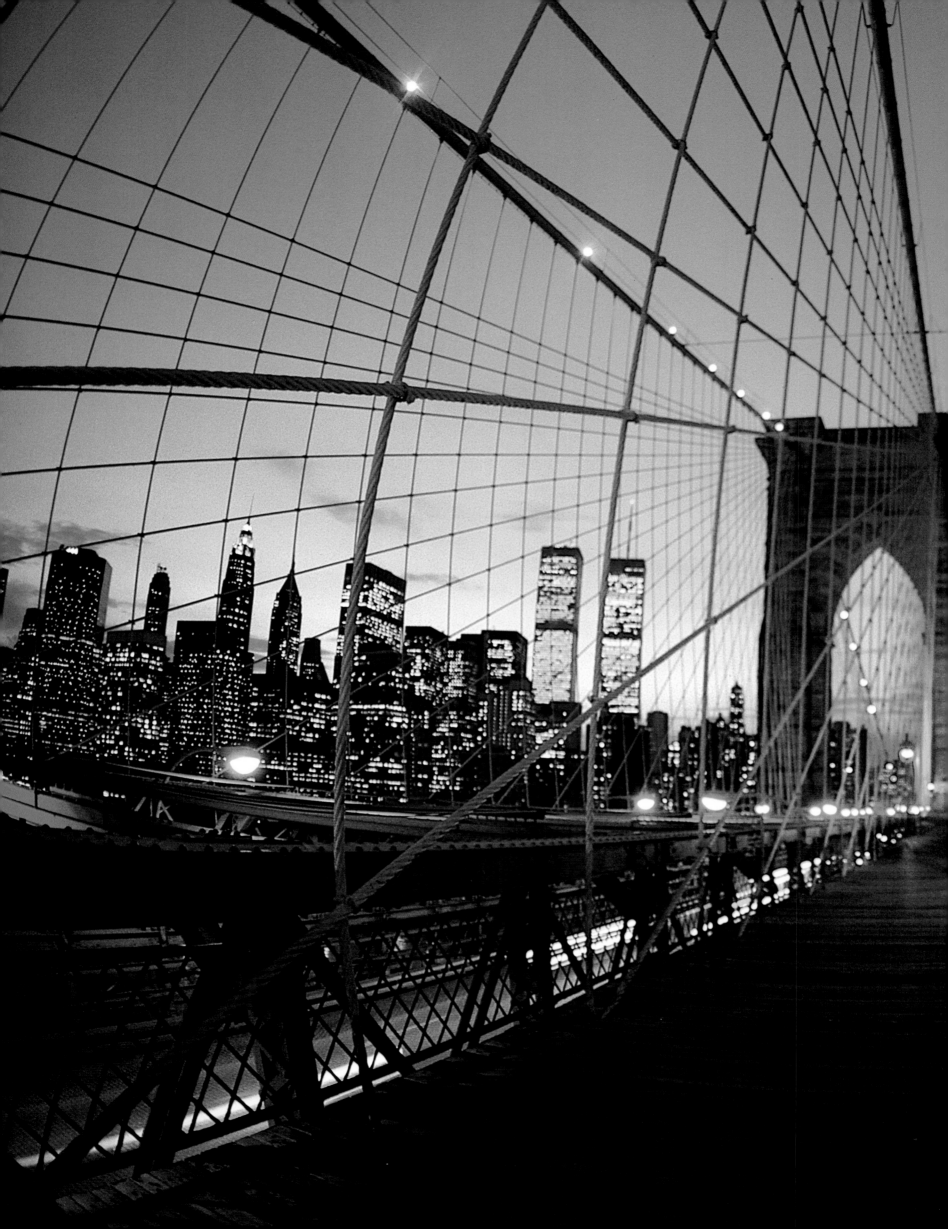

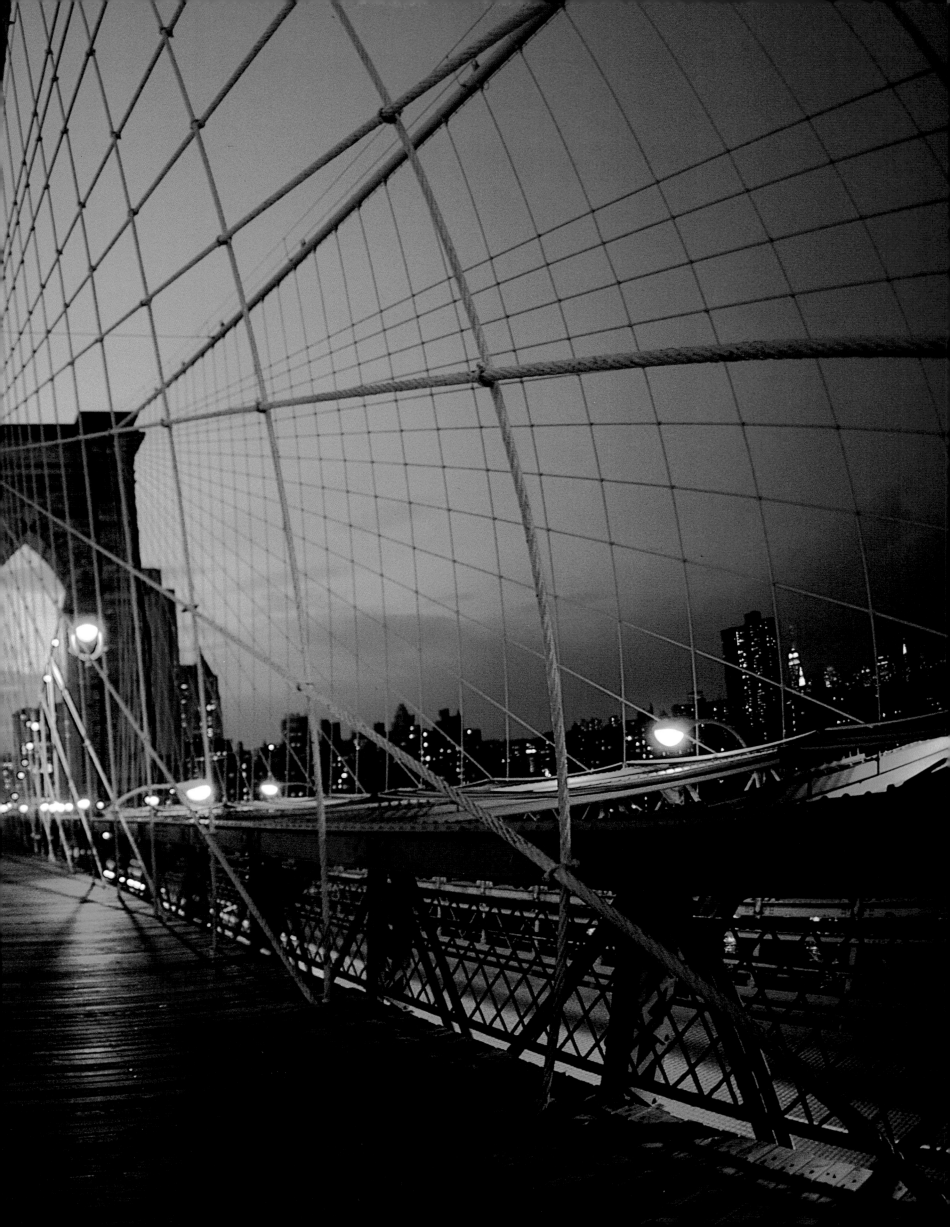

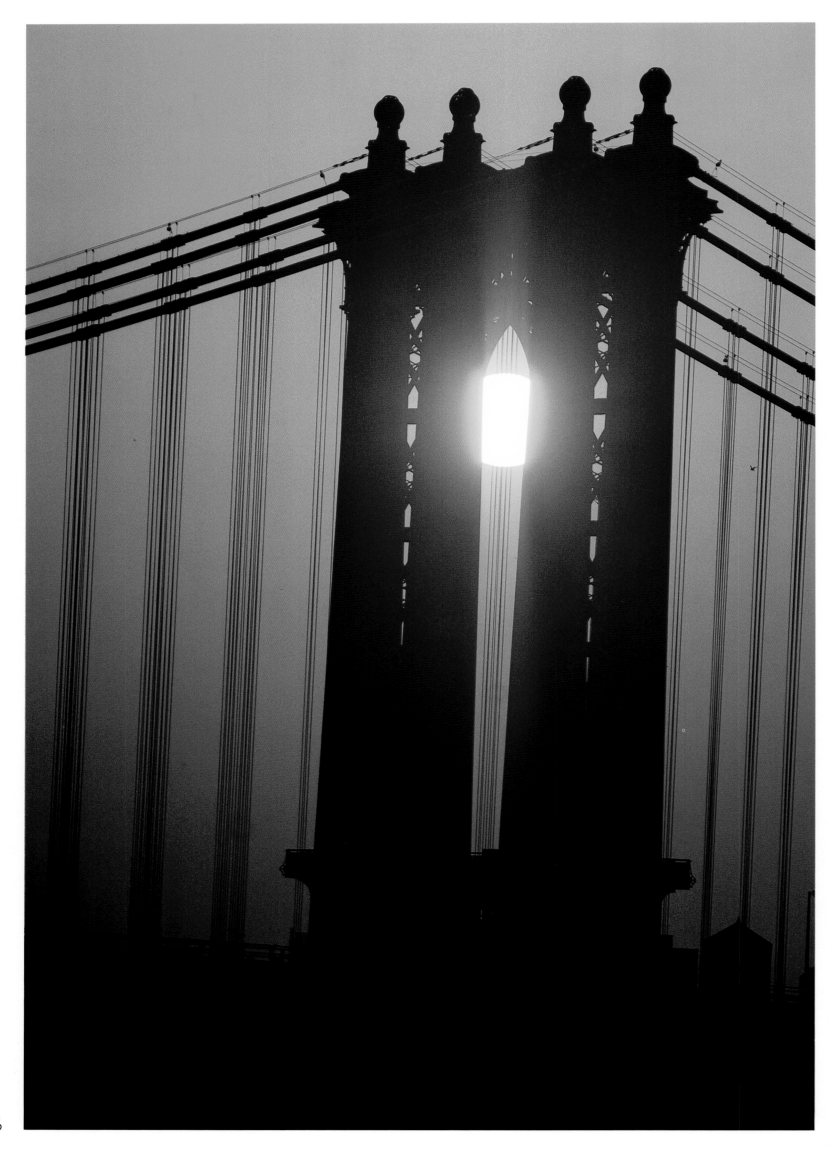

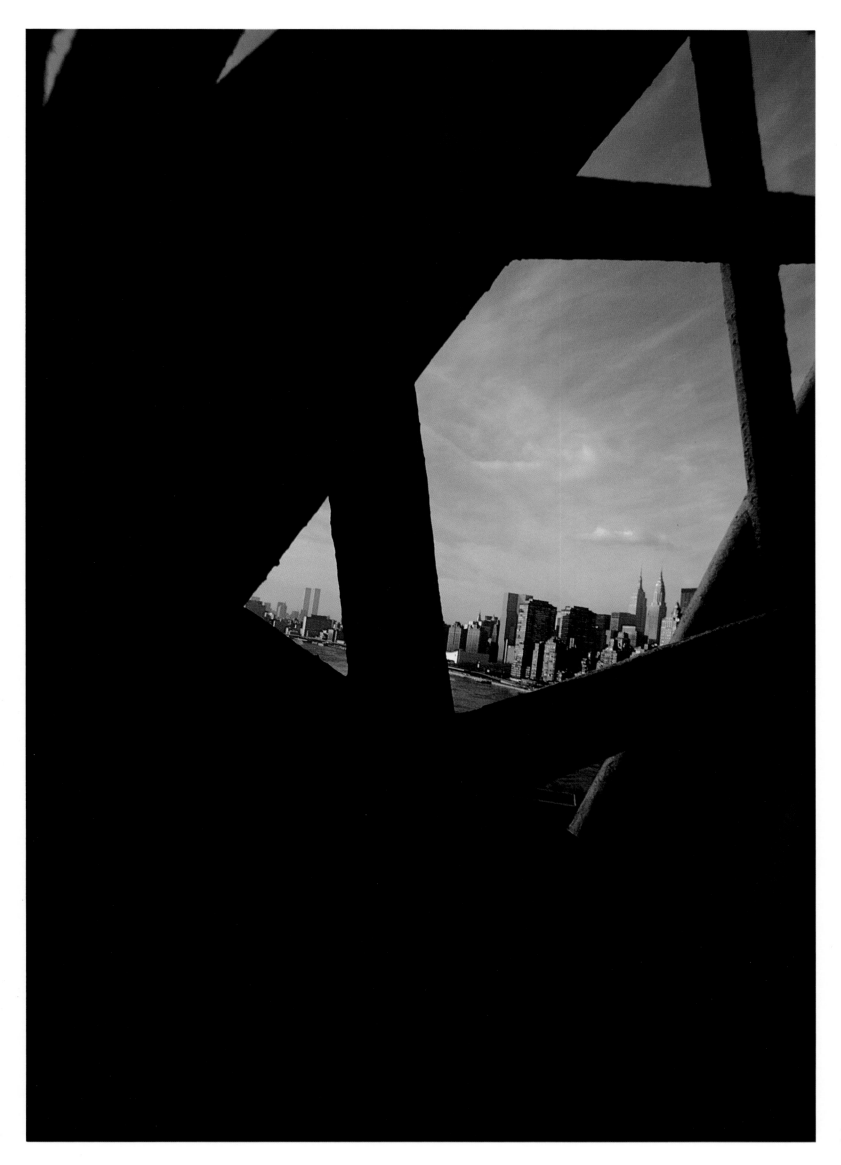

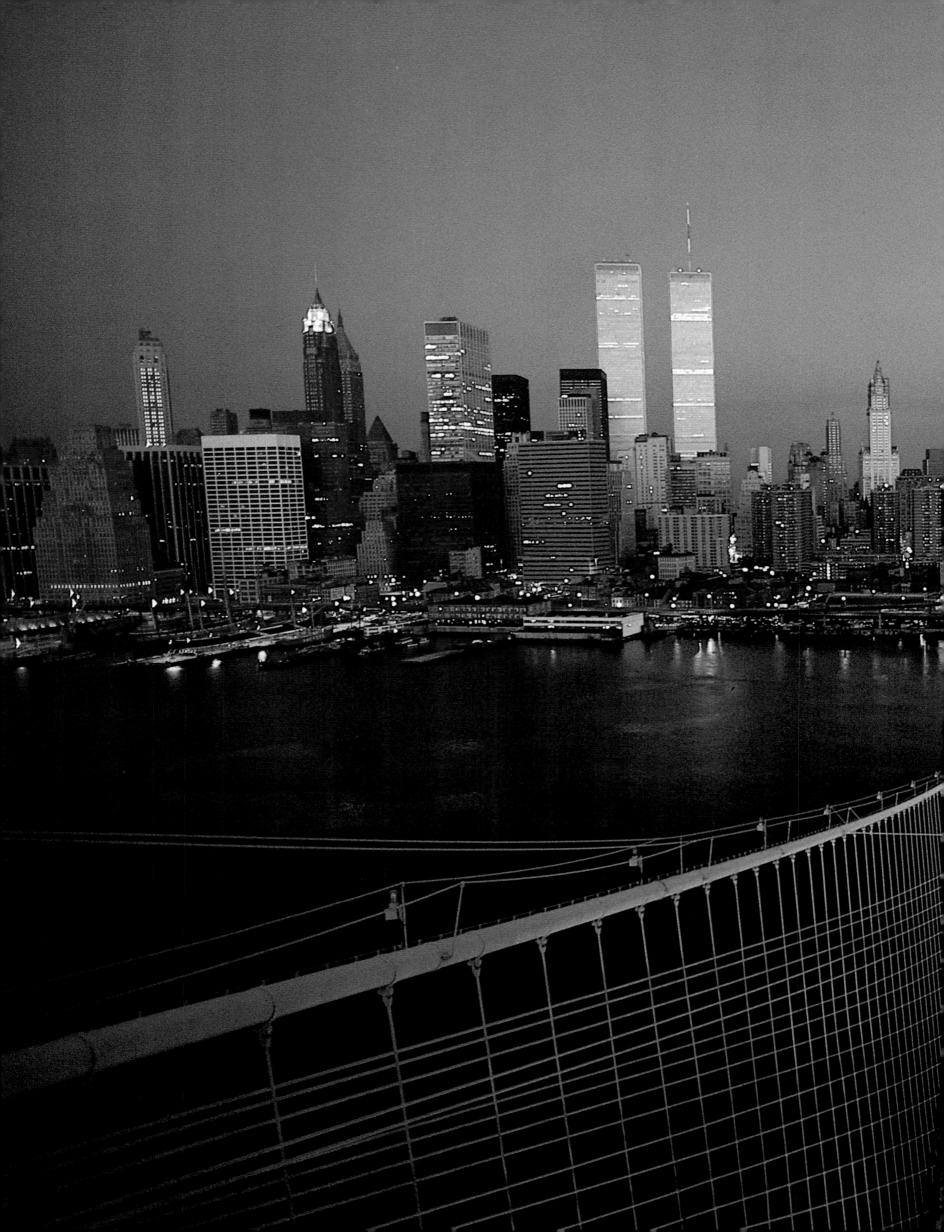

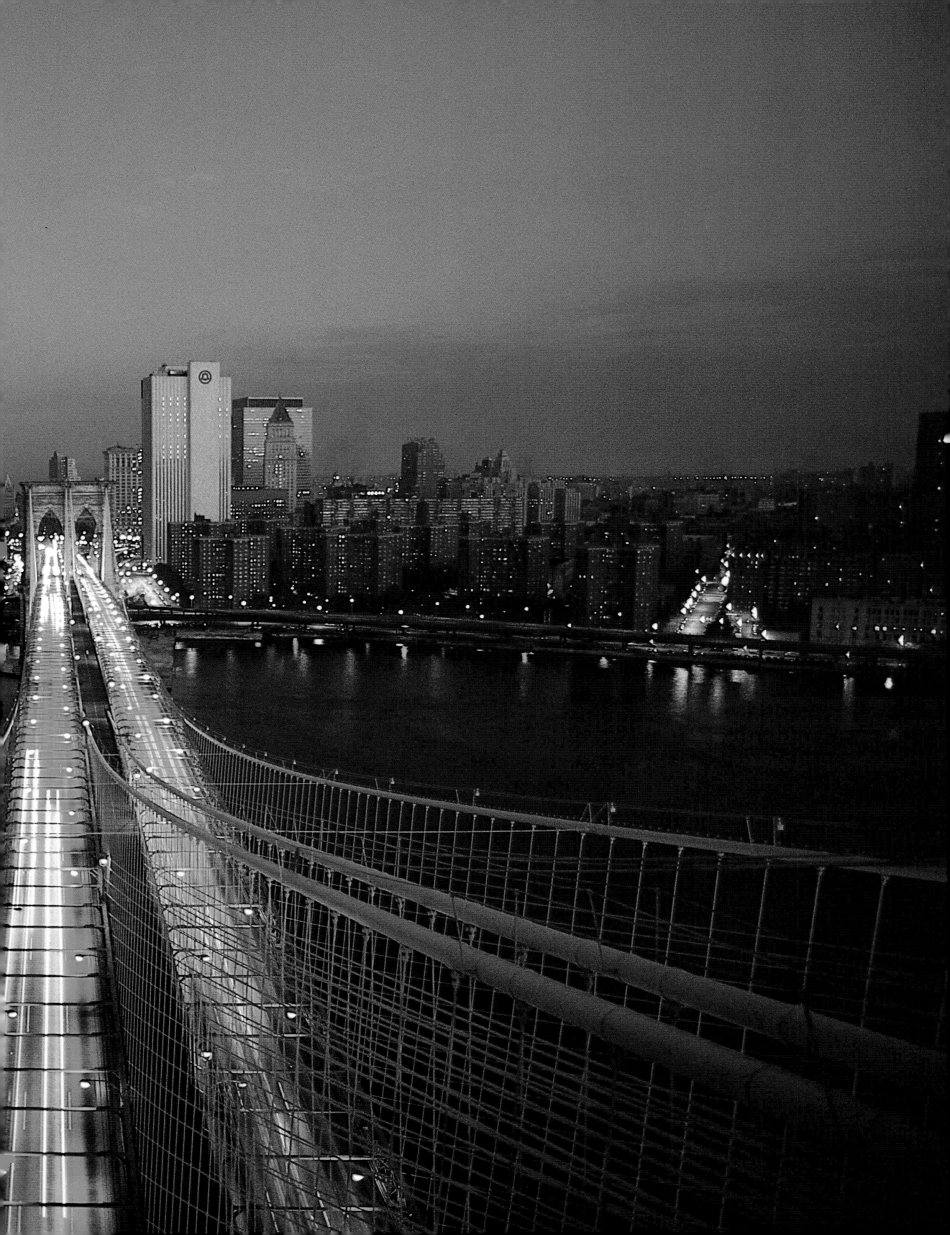

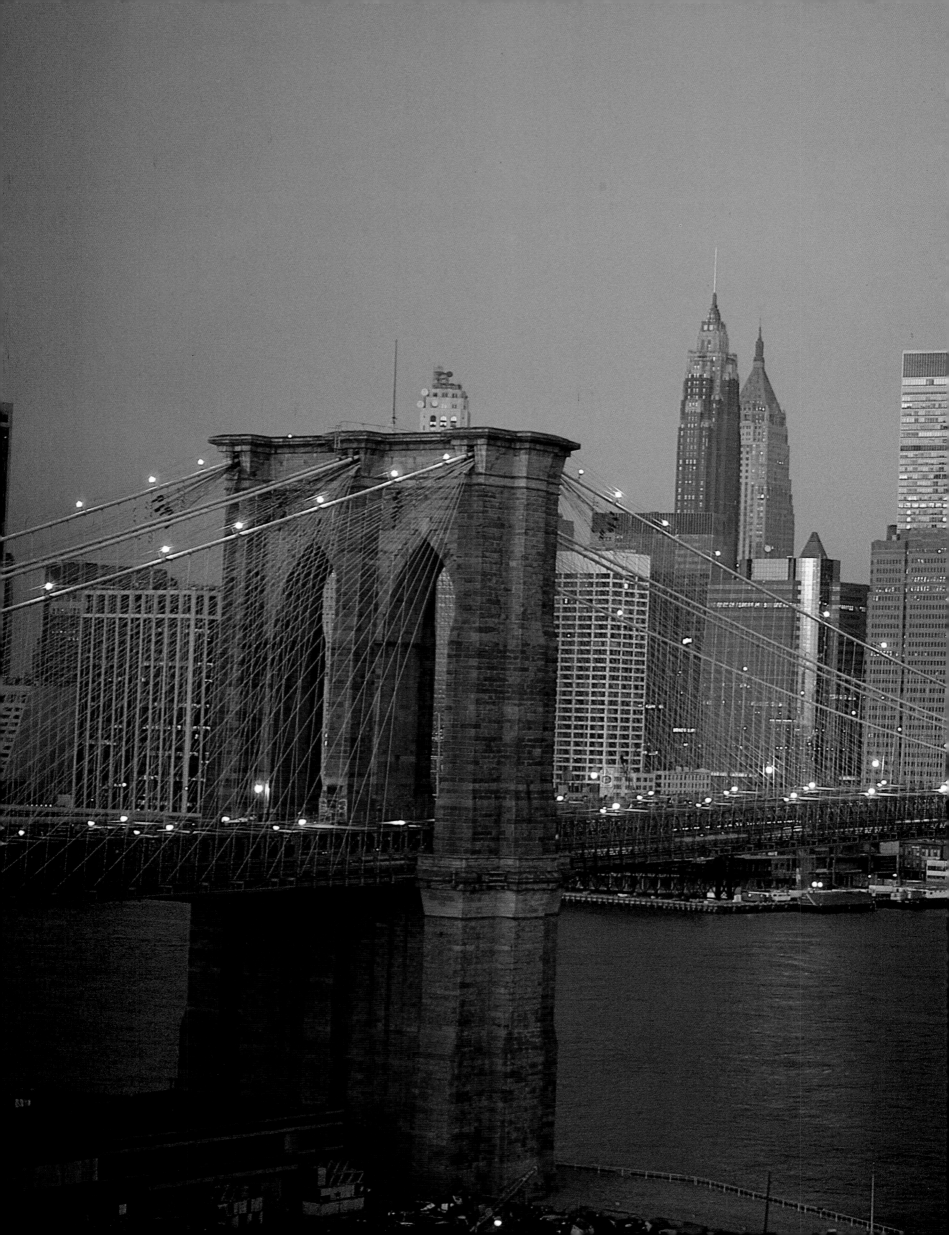

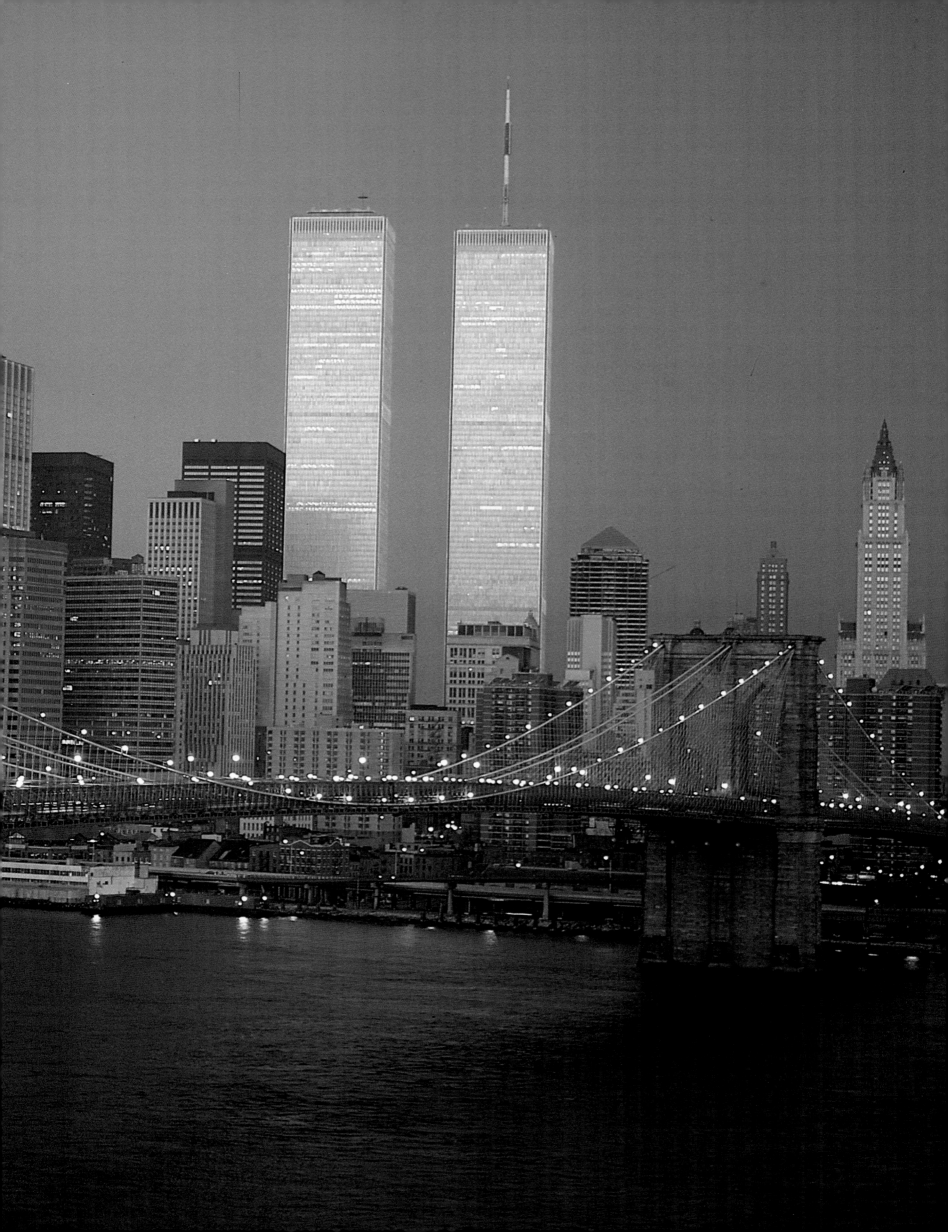

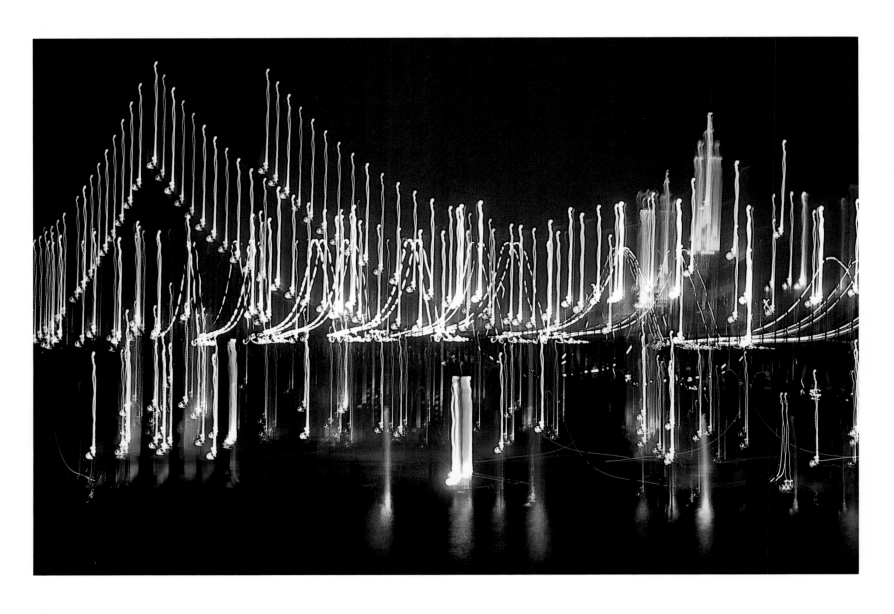

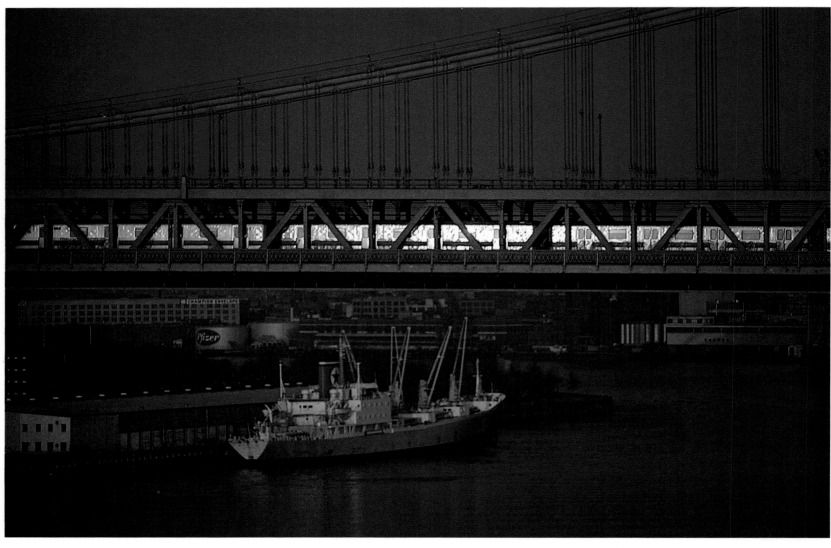

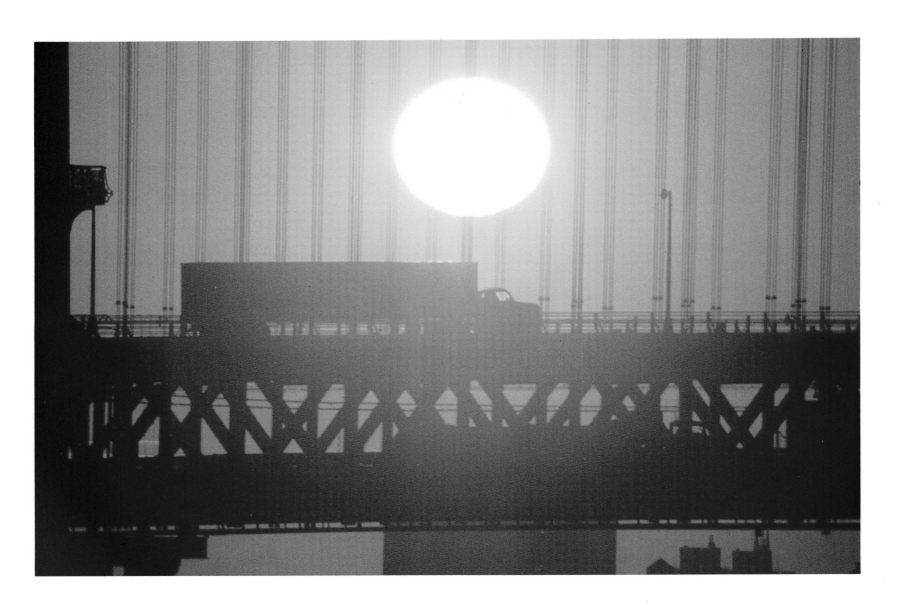

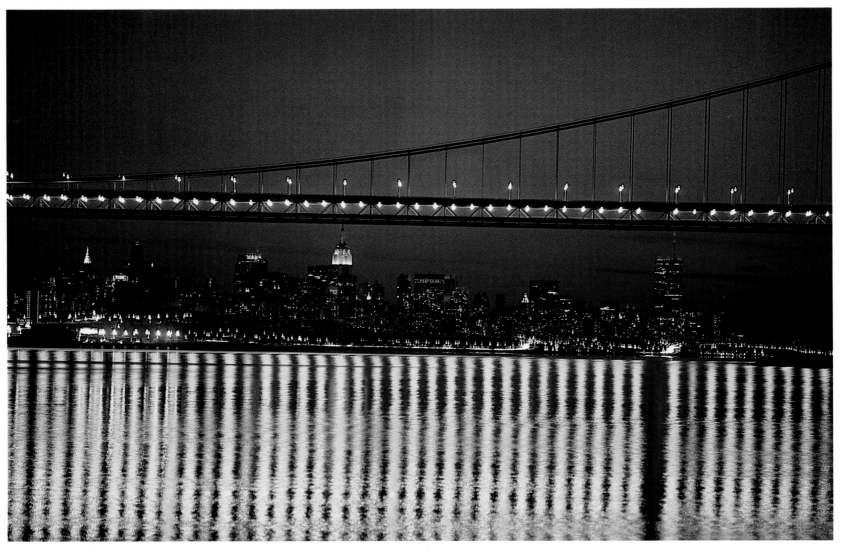

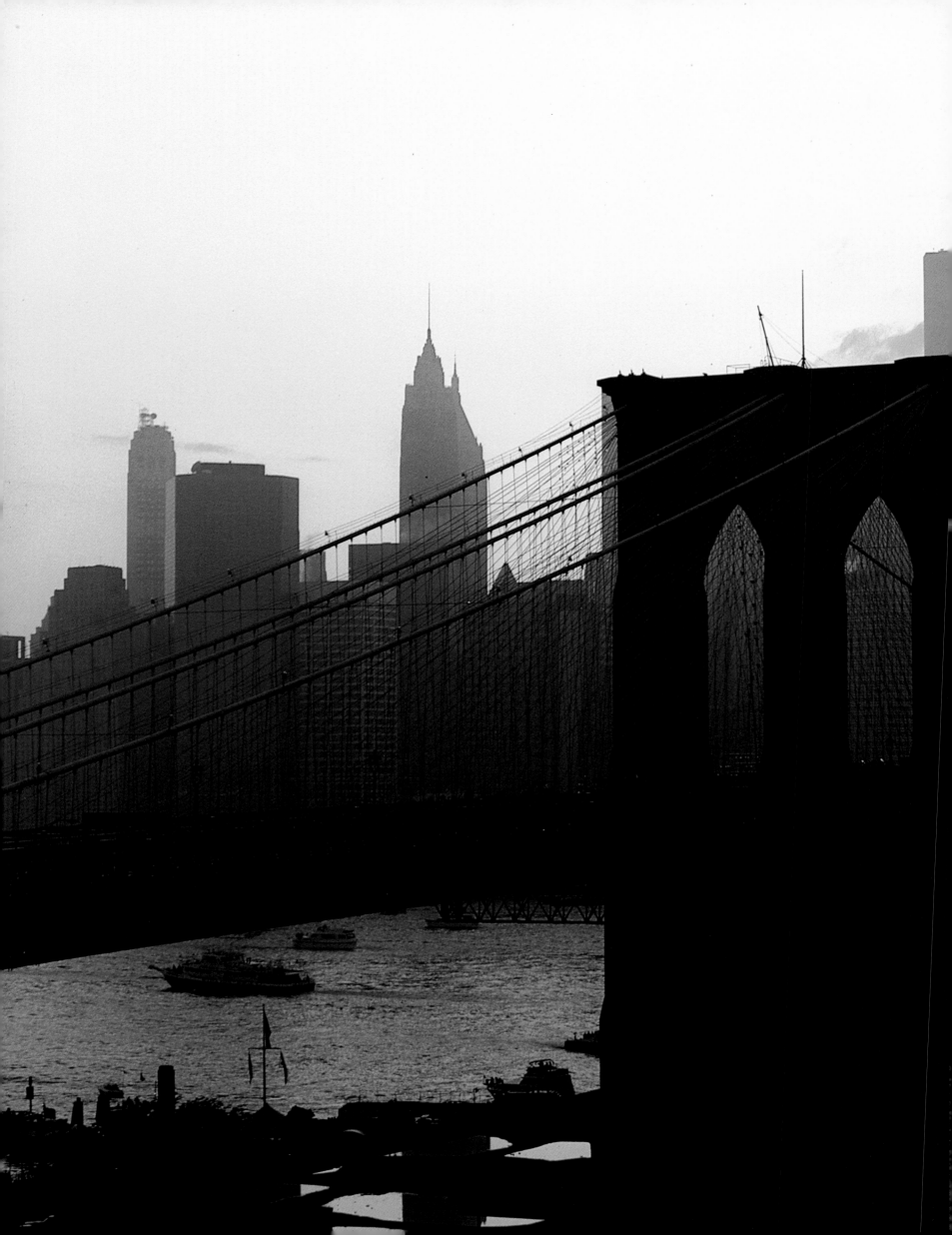

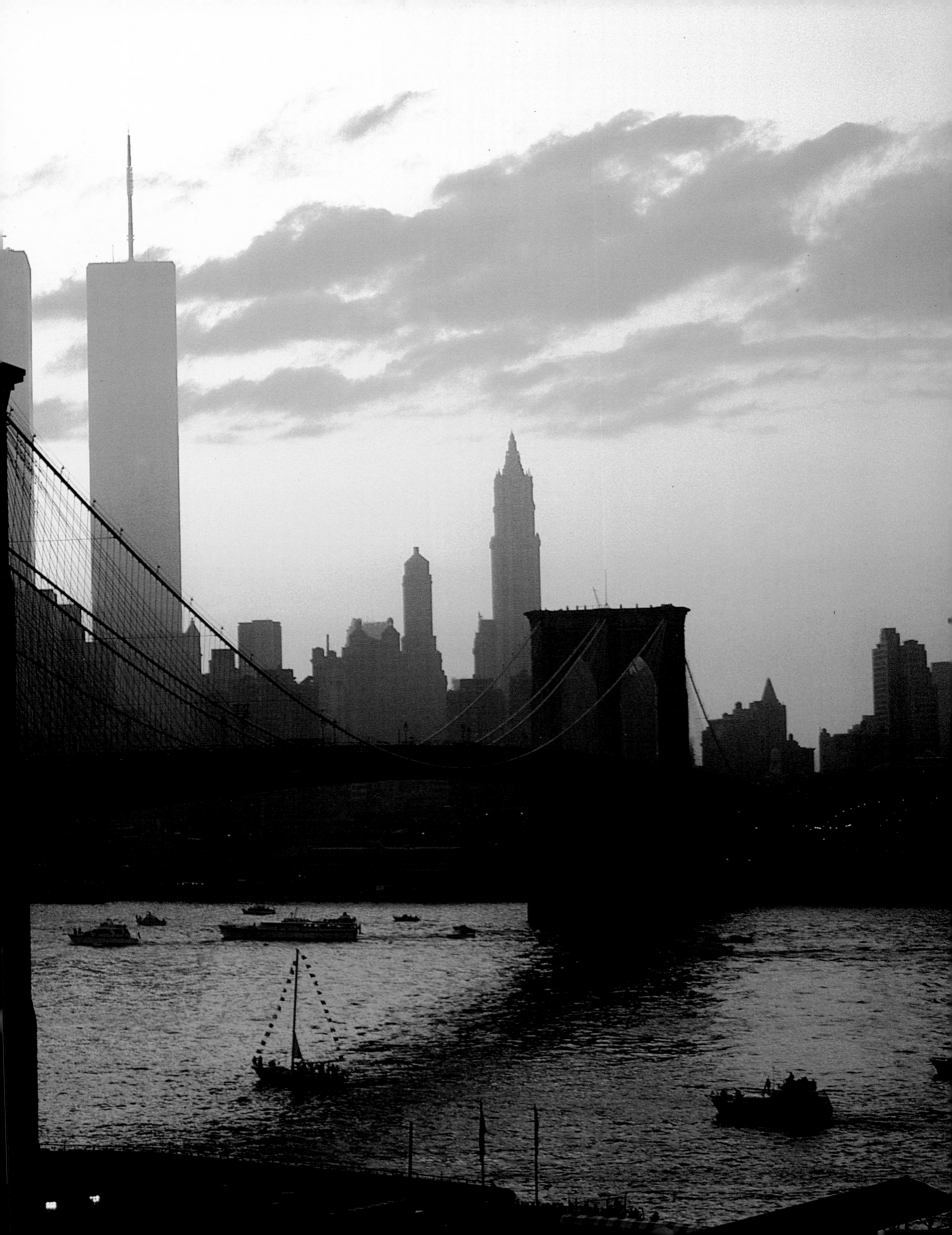

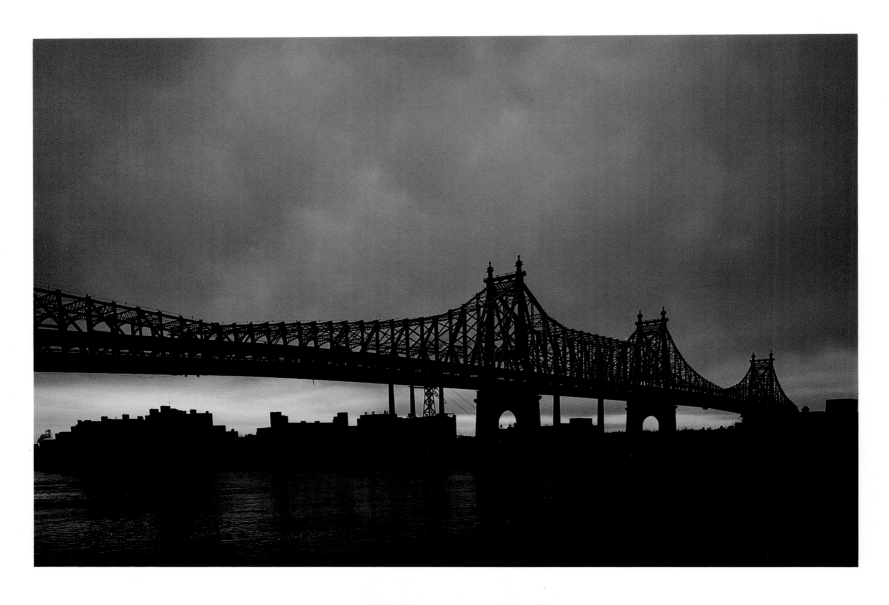

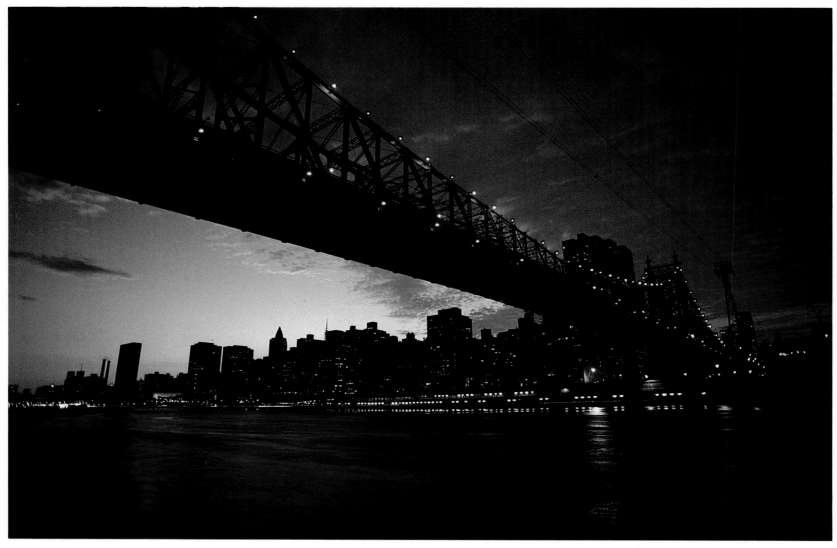

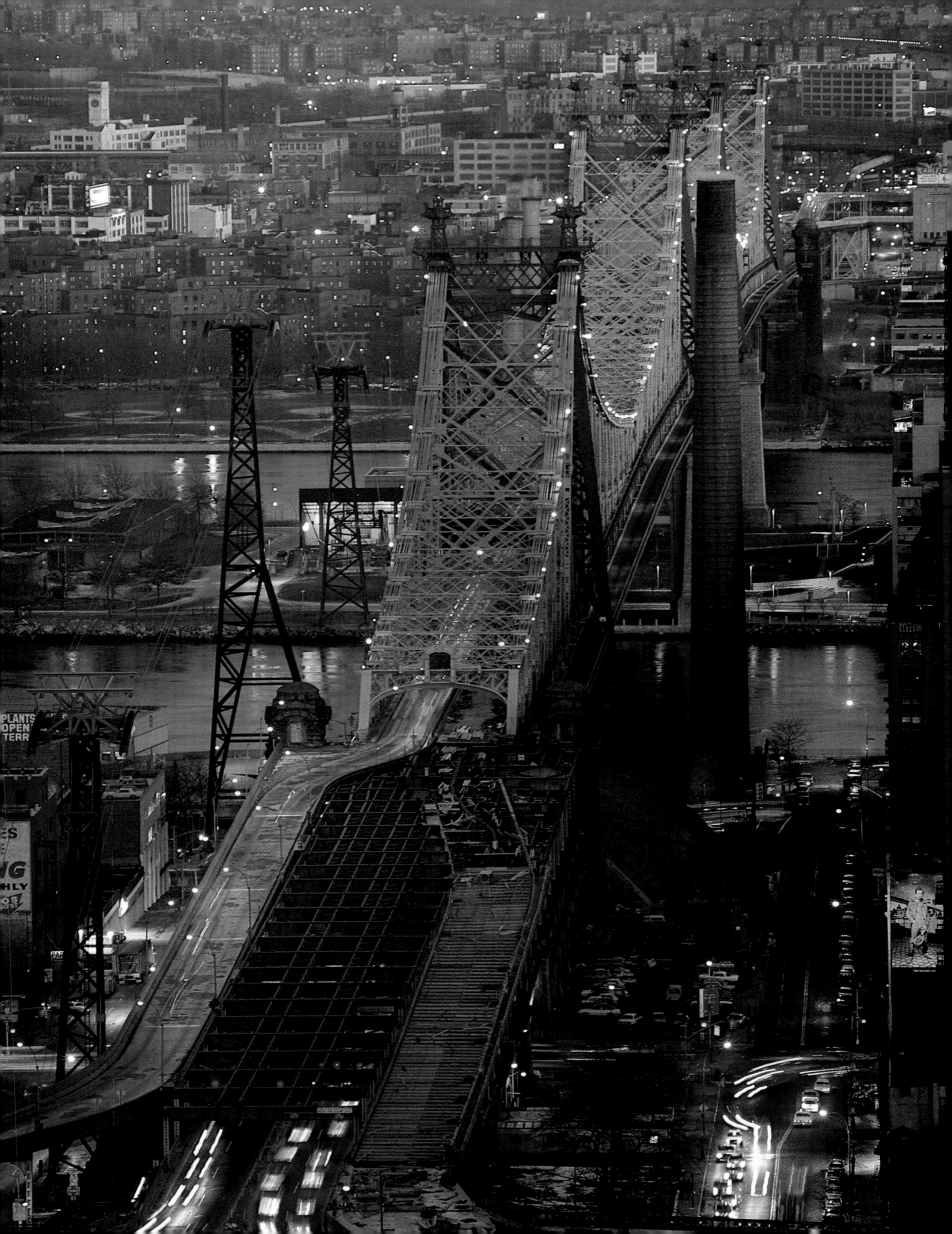

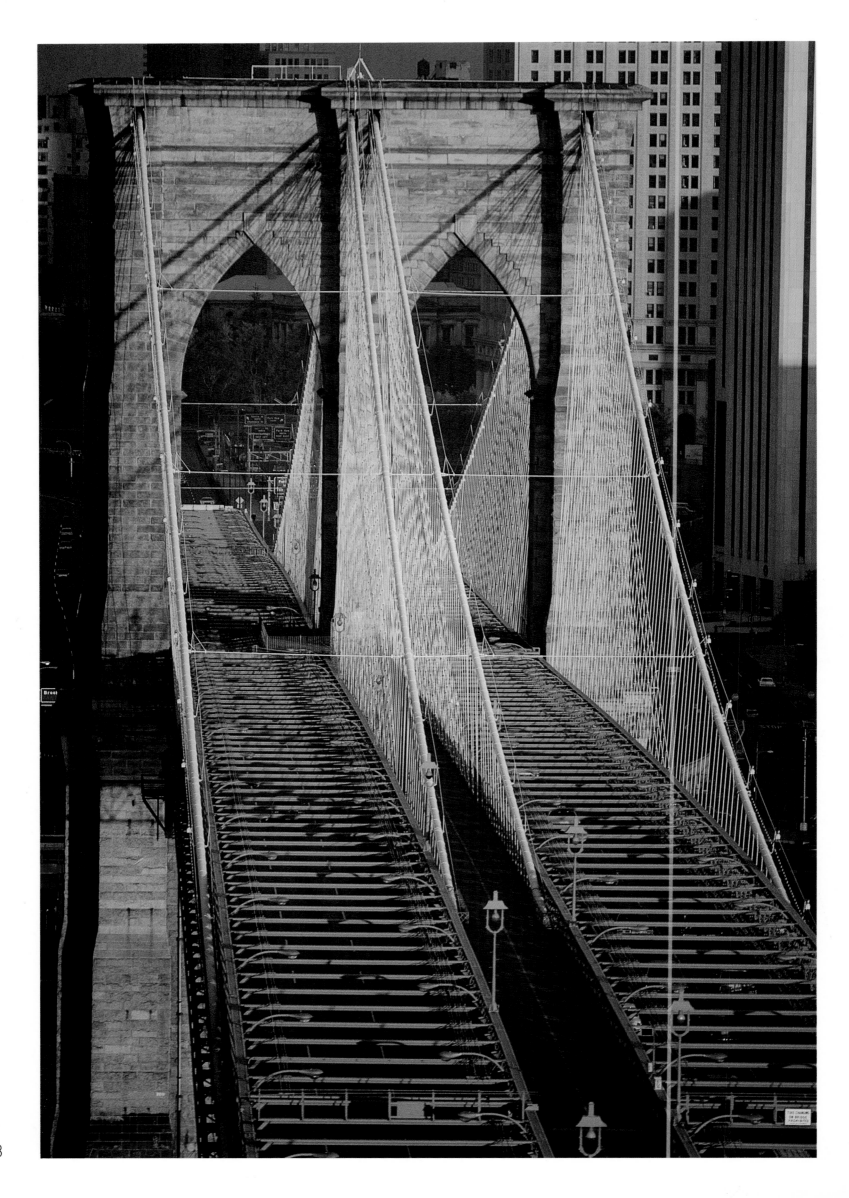

248

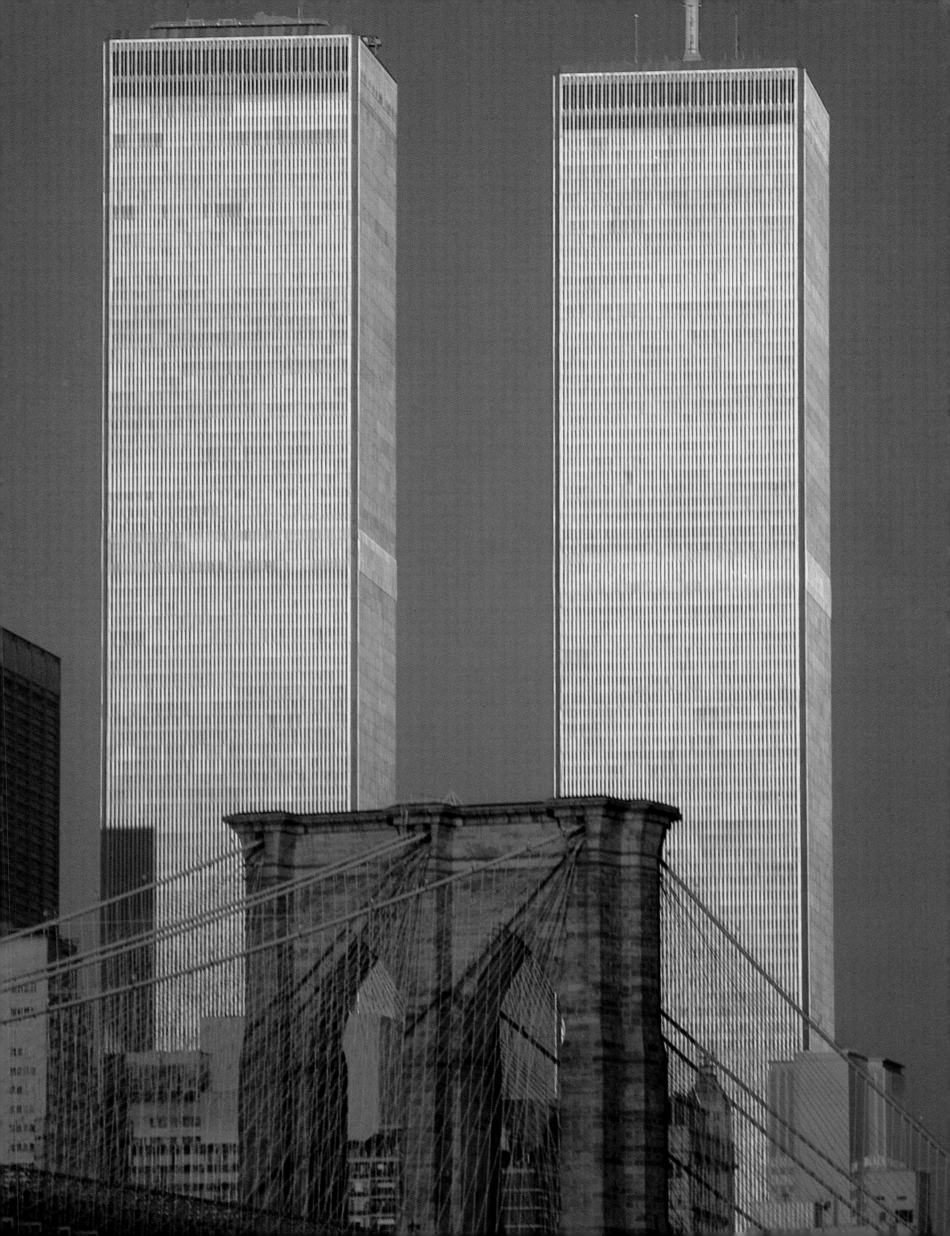

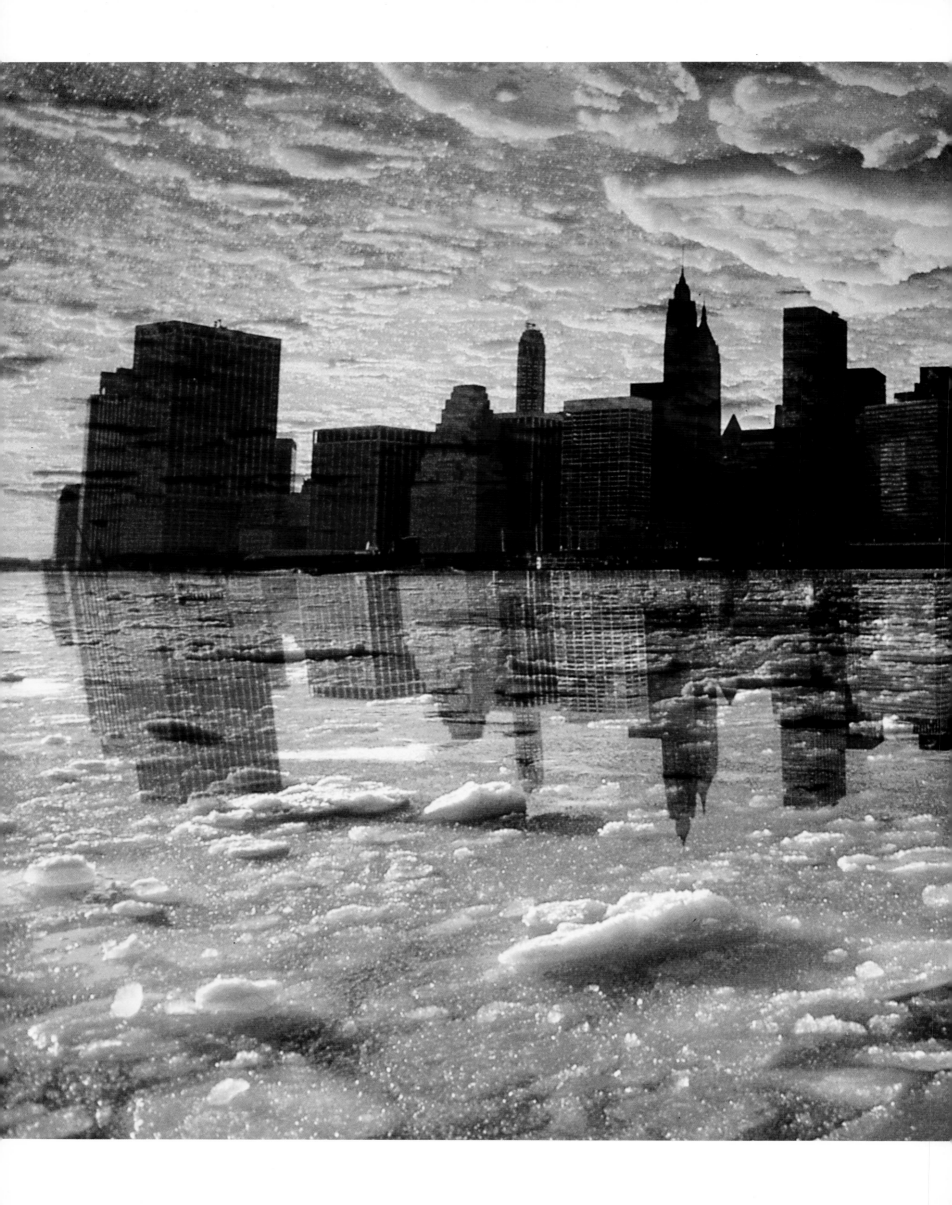

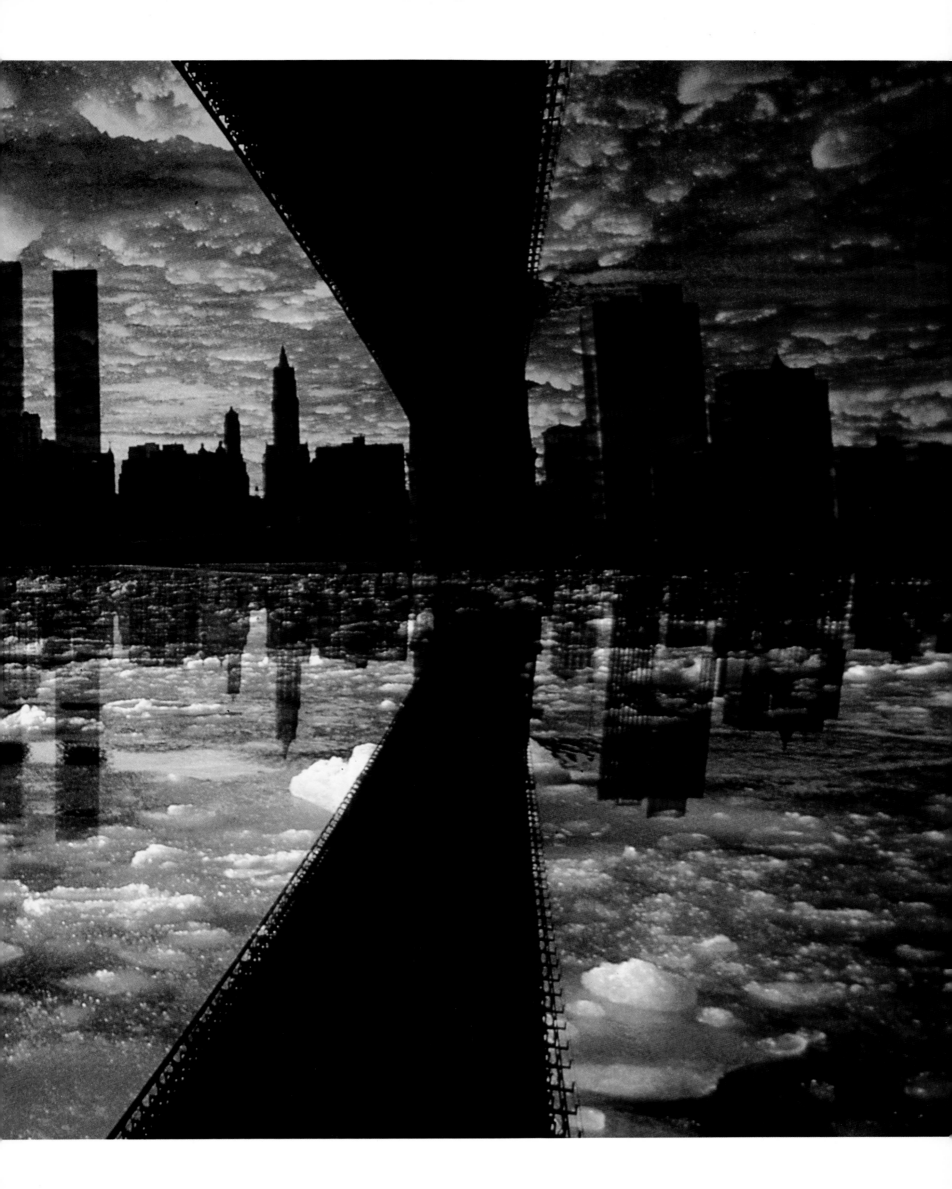

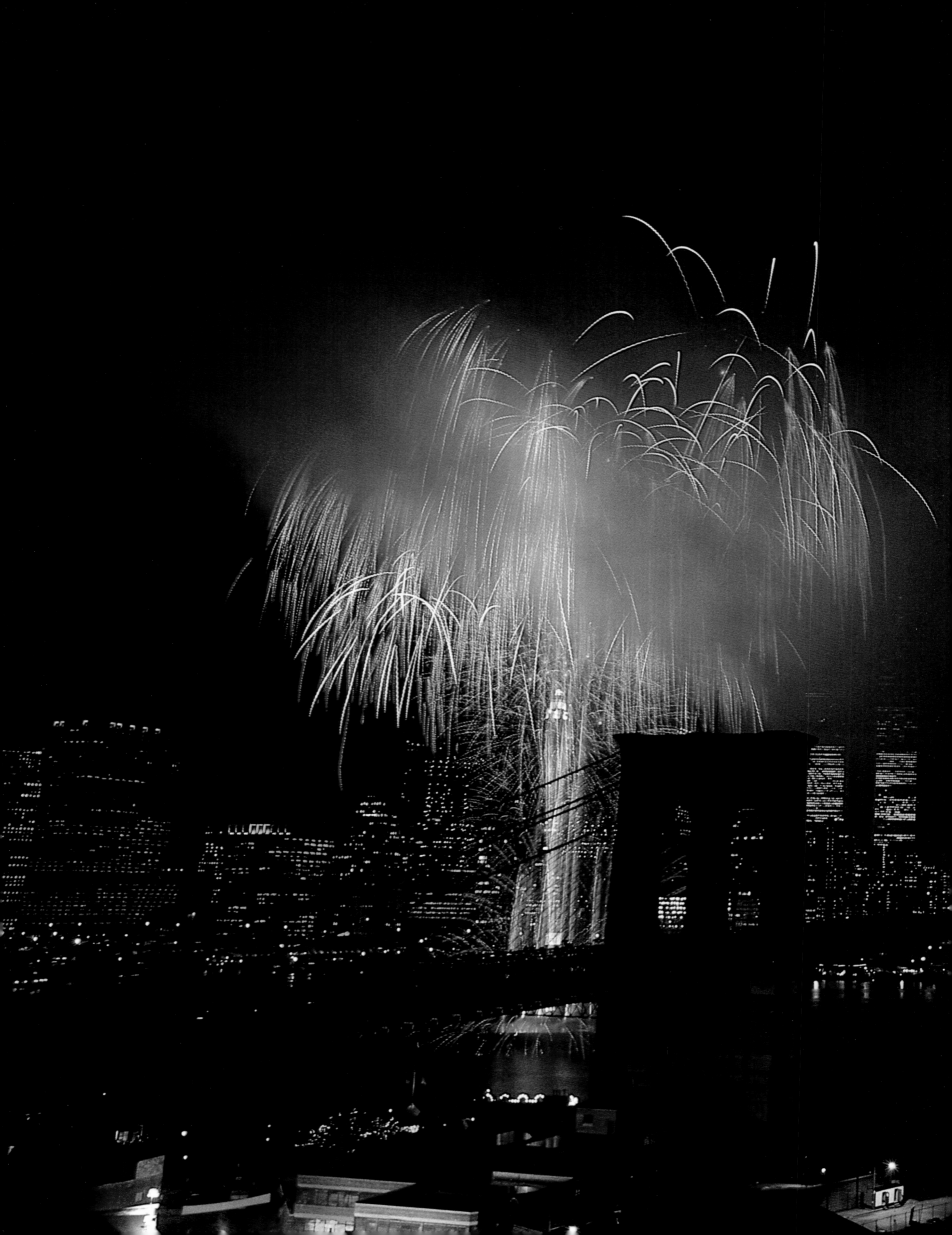

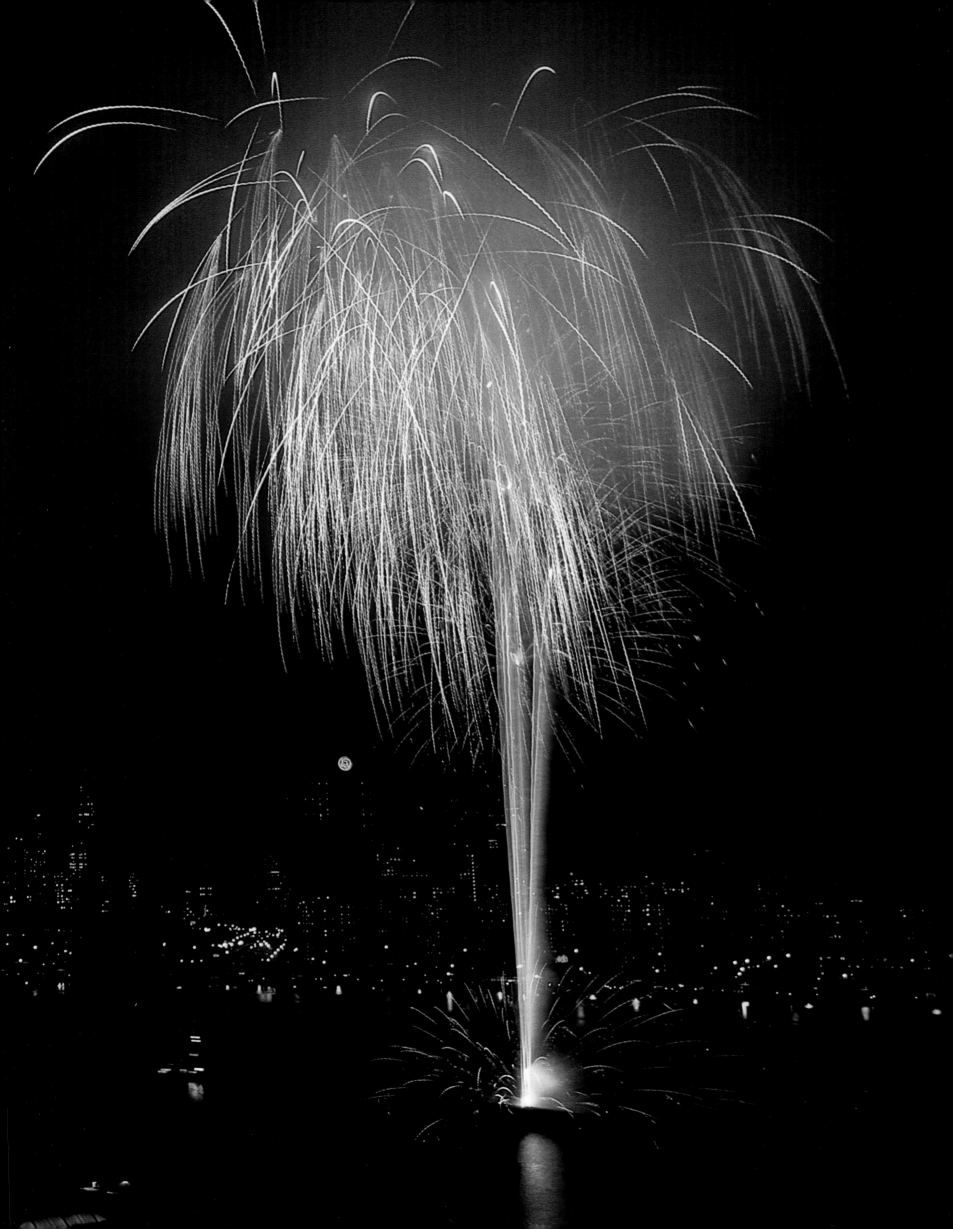

ILLUSTRATIONS